KOREAN BUDDHIST SCULPTURE

KOREAN BUDDHIST SCULPTURE
ART AND TRUTH

KANG WOOBANG

TRANSLATED BY CHO YOONJUNG

ART MEDIA RESOURCES, INC. | YOULHWADANG PUBLISHER

Kang Woobang was born in 1941 in Andong, Manchuria. In 1967 he graduated with a degree in German Language and Literature. After graduation, he served as assistant curator at the National Museum of Korea and did research on Asian art history at Kyoto National Museum and at Tokyo National Museum in Japan. He then went on to gain his Ph.D. in art history at Harvard University in the United States. Upon returning to Korea in 1986 he became a curator at the National Museum of Korea in Seoul, next serving as chief curator at Gyeongju National Museum and then the National Museum of Korea. In 1997, he was appointed director of Gyeongju National Museum. After three years in the post, he wrapped up his 30-year museum career and is now serving as Special Chair at the Department of Art History, Ewha Womans University. He has participated in many international conferences and published widely, some of his major publications being *Religious Harmony and Artistic Harmony: The Principles of Ancient Korean Sculpture I* (1990), *Art and Truth: The Principles of Ancient Korean Sculpture II* (2000), *Essays on Korean Art* (1999), *Pilgrimage to Beauty* (2001), *Photo Essay, Eternity in the Moment* (2002), *Art History, the Flower of the Humanities-Its Methodology of Nacherlebnis* (2003).

Cho Yoonjung grew up in Australia and majored in architecture at the University of New South Wales in Sydney. She worked at the Korea Herald for eight years and is now a part-time lecturer at the Graduate School of Translation and Interpretation at Ewha Womans University in Seoul.

Korean Buddhist Sculpture ⓒ First Edition 2005 by Kang Woobang
Copublished by Art Media Resources Inc. and Youlhwadang Publisher

Art Media Resources Inc.
1507 South Michigan Avenue, Chicago, IL 60605, USA
info@artmediaresources.com www.artmediaresources.com.

This is an abridged English translation of *The Principles of Ancient Korean Sculpture I* (圓融과 調和) and *II* (法空과 莊嚴) originally published in 1990 and 2000 by Youlhwadang Publisher, Paju Bookcity, 520-10, Munbal-ri, Gyoha-eup, Paju-si, Gyeonggi-do, 413-832, Korea yhdp@youlhwadang.co.kr www.youlhwadang.co.kr

Printed in Korea

ISBN 1-58886-087-6 Art Media Resources Inc.
ISBN 89-301-0180-1 Youlhwadang Publisher

This book is published with the support of the Korean Literature
Translation Institute in commemoration of Korea being
the Guest of Honor at the Frankfurt Book Fair 2005.

Library of Congress Cataloging-in-Publication Data

Kang, U-bang.
 [Wonyung kwa chohwa & Beopgong kwa Jangeom. English]
 Korean Buddhist sculpture : art and truth / by Kang
Woobang.-- 1st ed.
 p. cm.
 Includes bibliographical references and index.
 ISBN 1-58886-087-6 (hardcover : alk. paper)
 1. Gods, Buddhist, in art. 2. Sculpture, Buddhist--Korea. 3.
Sculpture, Korean--To 935. I. Title.

NB1912.B83K36313 2005
730'.9519--dc22
 2005024522

Preface

This book is a collection of seven essays that give an overview of the history of Korean Buddhist sculpture and that represent the most important part of my research. Unlike the general surveys of Korean sculpture that have already been introduced overseas, they are in-depth investigations and therefore comparatively lengthy pieces.

Korean art, even today, is often considered to be subordinate to Chinese art or a bridge between China and Japan. Moreover, as most Korean art history is known through the work of Japanese and Euro-American scholars, there is room for misunderstanding on the subject. But while Korean Buddhist sculpture was certainly influenced by and is similar to Chinese sculpture at first glance, it went beyond such influence to develop many unique characteristics. The essays in this book investigate in-depth beautiful as well as profound examples that show this aspect of Korean sculpture—pensive images, architecture and sculpture of Seokguram cave temple, and the Divine Bell of King Seongdeok, which date from between the 6th to 8th centuries. It also includes a short survey of Korean Buddhist sculpture. Though the divine bell is a functional bell, the elaborate and diverse relief decorations on its surface are so strongly sculptural that they can be treated as sculptures.

These seven essays deal not only with the iconographical and stylistic aspects, but also the philosophical side, and thus attempt to demonstrate that there is an inseparable relationship between religious truth and artistic style. Generally, it is said that truth in the end cannot be expressed in words. Historically, however, human beings have tried to express truth through the written language through such forms as poetry. On the other hand, the formative arts—architecture, sculpture, painting—have tried to give form to truth

through beauty, and especially in Buddhist art endless experimentation has been carried out toward this end.

It is from this perspective I have approached Buddhist art, and rather than focusing on how truth has been given form I have tried to show through analysis of works of art that the artwork itself is truth. The delight and catharsis that we experience when we stand before a wonderful work of art comes from the artwork being the beauty of truth. There are not that many works of art in this world that stand for beauty and truth, but the works dealt with in this book are those that show that truth is beauty and beauty is truth. Indeed, it is impossible to express absolute truth in formative language without achieving absolute beauty. And through the formative arts I have endeavored to understand the zeitgeist that gave birth to such works.

In a situation where there is a shortage of good translated books that can help foreign readers to understand Korean art, I am pleased and honored to have my book selected for translation and participation in the 2005 Frankfurt Book Fair. I would like to thank those who have helped me in my research including John Rosenfield, Professor Emeritus at Harvard University; and Jan Fontein, former director of the Museum of Fine Arts, Boston; and also Cho Yoon-jung who worked so hard in translating my detailed essays.

September, 2005
Kang Woobang

Contents

3. Gilt-Bronze Pensive Image with Lotus Crown

4. The Application of *"La Porte d'Harmonie"* to Seokguram

5. The Iconography of the Buddhist Sculptures in Seokguram

6. Iconology of the Buddhist Sculptures of Seokguram

7. The Art and Philosophy of the Divine Bell of King Seongdeok

1

A Brief History of Ancient Korean Buddhist Sculpture

The main Buddha image of Seokguram cave temple marks the high point in the history of Korean Buddhist sculpture. Korea began making Buddhist statues during the Three Kingdoms period when Buddhism was introduced to the country, and while Korean artisans continued to be influenced by China, they came up with original new iconographies and developed stylistically on Chinese examples to achieve greater perfection. In addition, as material is a determining factor on style, the use of granite resulted in giving Korean sculpture a unique abstraction and massiveness. All of these elements reached artistic heights in the sculptures and architecture of Seokgruam cave temple.

1. Introduction

Buddhism stimulated the desire of human beings to express themselves, thus promoting freedom of expression and leading to a flowering of the arts including architecture, sculpture, painting and handicraft. Originating in India, the religion and the art then crossed the vast desert of Central Asia and reached China. When China first accepted Buddhism it had its own unique, flourishing culture, but on the other hand Buddhism's sophisticated philosophy and profound system of faith stimulated the creativity and imagination of the Chinese people and led to brilliant development of the religious arts.

China, however, did not just accept and imitate Indian Buddhism. From the very beginning cultural assimilation took place so that Buddhism passed through a very short period of imitation before being transformed to the Chinese style. When translating the sutras written in Sanskrit, the Chinese used terminology that incorporated Taoist and Confucian concepts and although it cannot be positively stated that they changed the faces on Buddhist statues to Chinese ones, they certainly changed them according to their ideals for a human figure and also the Indian robes to the royal robes of the Chinese emperor. Such artistic activity accompanying Buddhism rapidly spread across the whole of China and leading to a rapid succession of changes in the style and form of Chinese Buddhist sculpture.

The iconography and styles of Buddhist art are not fixed. They have changed according to period, race, country, and region without clashing with any existing religion. In world art history it would be hard to find another genre that has changed as quickly as

Buddhist sculpture according to time, people and place. This is because Buddhist statues were not fixed idols but reflections of the sense of aesthetics of a certain people of a certain region and their desire to create and reverence for their own conceptions of the ideal human figure. In other words, Indian Buddhism accommodated the pursuit for the most ideal beauty and freedom to express this beauty in any way.

In China, it was some 200 years after Buddhism entered the country that related artistic activity began. Likewise, in Korea the introduction of Buddhism from China in the 4th century was followed for some unknown reason by a silent period of 150 years before the production of Buddhist statues began in the 6th century. However, in the early 5th century, before the start of Buddhist sculpture, various Buddhist motifs such as Buddhas, bodhisattvas, apsaras and lotus blossoms were depicted in Goguryeo tomb murals. As in China, Korea also passed through a period of imitation and then established its own iconography and styles. But because most Westerners are familiar with the Chinese iconography and styles, when they look at Korean Buddhist sculpture they see the dominant Chinese influence and often overlook any new elements. Even if they do notice them, they are likely to regard them as peripheral features of Chinese Buddhist art.

While Korea did not effect such great changes as China, it created its own unique iconography from the start, an indication that it adopted Buddhism with a clear sense of its own identity. The spread of a culture in any country is not simply a process of imitation and passive acceptance. From the first, accepting a new culture is a selective process where some things are kept and others rejected, and the culture is changed according to the cultural milieu and nature of the people. So Korea, for example, did not adopt the Bodhisattva Maitreya seated with crossed ankles, which was very popular in China, nor the very high pedestals of the early gilt-bronze Buddhas, nor the Buddha Shakyamuni and Prabhutaratna sitting side by side as described in *Saddharma-Pundarika* (*Lotus of the True Law*). It accepted early esoteric Buddhism but not that of post 9th century. Thus in Korea and elsewhere, Buddhism was accepted within the country's unique cultural milieu with a clear sense of identity, and consequently it went through many changes as it crossed from India, to China, to Korea and then to Japan. However, Buddhism did not simply go through changes but different stages of development as well. This essay is an examination of the evolutionary process of a culture as it spreads, introducing some representative examples of Korean Buddhist art to illustrate my point.

2. Buddhist Images of Three Kingdoms Period

Buddhism was introduced to the Goguryeo and Baekje Kingdoms in 372 and 384, respectively, and judging by records that show Silla did not officially acknowledge Buddhism until 528, the dominant theory is that Silla adopted Buddhism later than the other two kingdoms.

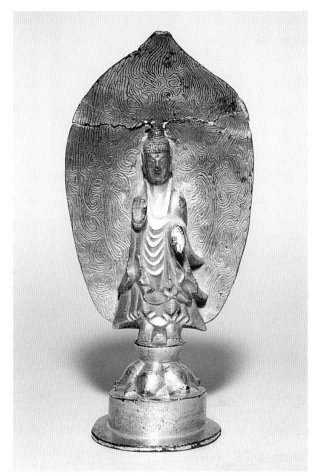

1. Gilt-Bronze Standing Buddha, inscribed "seventh year of Yeonga" (539). Goguryeo. H. 16.2 cm. National Treasure No. 119. National Museum of Korea, Seoul.

Ancient tomb murals in Tomb No. 1 at Jangcheon-ni, Tong-gu, show that paintings of a Buddhist nature appeared in the first half of the 5th century in the Goguryeo Kingdom. But as evidenced by the Gilt-Bronze Standing Buddha (Fig. 1, hereafter the "Gilt-Bronze Yeonga Buddha," 延嘉七年銘金銅如來立像) inscribed with characters indicating "the seventh year of Yeonga," or the year 539, Buddhist images as objects of worship were not produced until the capital was relocated to Pyongyang. Goguryeo (高句麗, 37 B.C.−668 A.D.) had constructed Geumgangsa, a big national temple, as early as the late 5th century, a little before Baekje (百濟, 18 B.C.−660 A.D.) or Silla (新羅, 57 B.C.−668 A.D.). Baekje built its first national temples, like Daetongsa in Ungjin (Gongju), in the early 6th century; but all remaining Buddhist images from Baekje date from 538, after the relocation of its capital to Buyeo. Silla built big temples such as Heungnyunsa (興輪寺) and Hwangnyongsa (皇龍寺) in the mid-6th century and also began to make Buddha statues at that time.

Therefore, although there is some time difference in terms of when Buddhism was introduced to each of the Three Kingdoms, it wouldn't be entirely correct to conclude that just because the Silla royal court accorded the religion official acknowledgement 150 years later than the other two kingdoms, it took that much longer for Buddhist beliefs to be actually adopted by the Silla people. It may be that the very conservative Silla court gave its imprimatur only after Buddhism had already spread widely throughout the kingdom. And generally speaking, the construction of Buddhist temples in all three kingdoms can be dated to roughly the same time, the early 6th century. That the construction was most actively centered around the capitals, Pyongyang, Buyeo, and Gyeongju, means that the three kingdoms had established centralized royal government with Buddhism as the state ideology. This is attested to by large-scale national temples such as Geumgangsa Temple of Goguryeo, Neungsan-ni Temple of Baekje, and Hwangnyongsa Temple of Silla. Unfortunately, however, no large gilt-bronze or clay Buddha statues remain to show the style of Buddhist images clearly and accurately, so changes in style and beliefs can only be studied through an analysis of a very limited number of small gilt-bronze and stone Buddhist images.

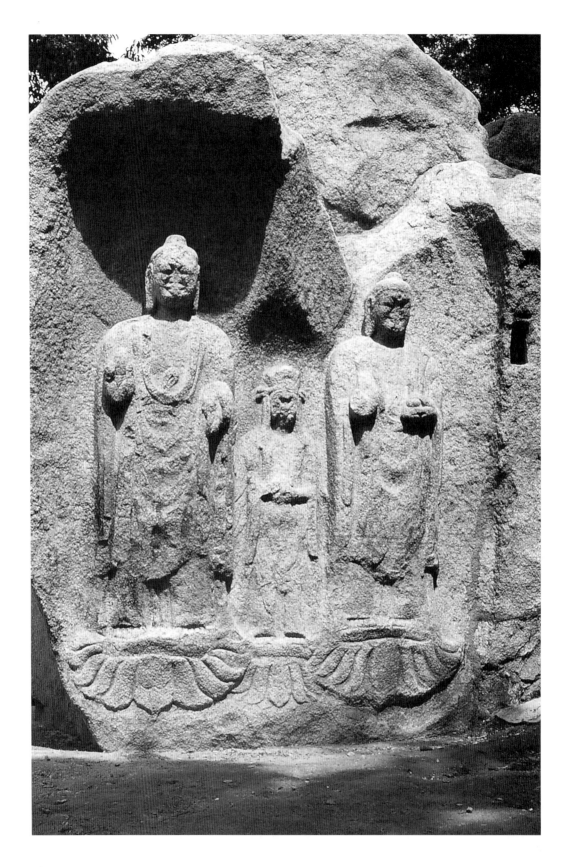

1. Variations and Changes in Style

The most important statue in studying the style of Buddhist images of the Three Kingdoms period (三國時代) is the Gilt-Bronze Yeonga Buddha, discovered in Uiryeong, Gyeongsangnam-do province. According to its inscription, this statue was one of a thousand votive images made at Dongsa Temple in Pyongyang, the capital of Goguryeo, to pray for a wide dissemination of the dharma. It was discovered, not in the capital of Silla, but far off in the southern region, indicating that Goguryeo played a pioneering role in the spread of Buddhism.

In terms of style, Goguryeo Buddhist images follow the style of the Northern Wei Dynasty in China. The Gilt-Bronze Yeonga Buddha is the earliest of the dated Korean images, and it is indicative of the quick adoption of the Northern Wei style. This suggests that the production of Buddhist images in Korea began in earnest around the beginning of the 6th century. The Three Kingdoms of Korea copied the styles of Northern Wei (北魏, 386−534), Eastern Wei (東魏, 534−550), Northern Qi (北齊, 550−577) and Sui (隋, 581−618) Dynasties in succession, and the stylistic changes in the Buddhist images of the Three Kingdoms almost paralleled such changes in China.

But shaped by its own particular context and culture, Korea started to fashion its own style, the representative examples being the Gilt-Bronze Pensive Image with Sun and Moon Crown, National Treasure No. 78 (Fig. 23), and the Gilt-Bronze Pensive Image with Lotus Crown, National Treasure No. 83 (Fig. 69). While National Treasure No. 78 does reflect the style of Eastern Wei, the profound smile, the lively movement of the body, and the perfect casting technique shows that by the late 6th century, Korea was

2. Rock-Carved Buddha Triad, Taean. Avalokiteshvara H. total 221 cm, figure 180 cm. Amitabha H. total 303 cm, figure 250 cm. Bhaisajyaguru, H. total 295 cm, figure 240 cm. Treasure No. 432. (p.14)

3. Stone Seated Buddha at Yeondongni, Iksan. Baekje. H. mandorla 448 cm, image 169 cm. Treasure No. 45. (left)

4. Seated Cave Buddha at Bulgok, Mt. Namsan, Gyeongju. H. 142 cm. Treasure No. 198. (right)

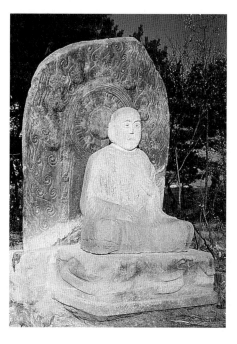
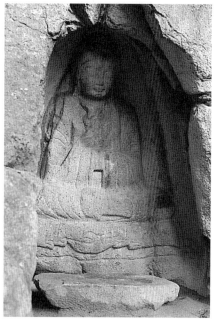

developing its own style. National Treasure No. 83 reflects the style of Northern Qi but the body is much more realistic in expression. These two statues alone show that Korea did not just adopt the styles of China but tried to expand on them. A notable point is that both statues are around one meter in height, indicating that Buddhist images had developed into large-scale objects of worship as the main image of the main hall in a Buddhist temple, a trend that was then transmitted to Japan.

A unique aspect of Korean Buddhist sculpture is the production of stone images using granite, a very coarse material that was not used in any other country in Northeast Asia. With gilt-bronze or clay figures, the details can be finely expressed, as the production method is a process of adding wax or clay. But stone figures are made by carving away parts of the stone to create the desired form, which is a completely different process. Moreover, because granite particles are coarse, fine detailing is very difficult, and so it was impossible to make small statues. Even in the case of life-size figures, the omission of finer details was unavoidable, which is why they tended to be abstract in form. Therefore, in Korea, which produced many stone Buddhist images, the tradition of realistic sculpture was quite weak.

The production of wooden Buddhist images entails a process similar to that of stone images. However, more realistic forms are possible in wooden images because they can be produced by assembling smaller parts and because wood is more amenable to fine carving. In Korea, however, there are not only no records of wooden Buddhist images, there is not one single example extant from ancient times. For this reason, it is thought that wooden Buddhist images were not produced in Korea in ancient times, and that those made in the Goryeo (高麗, 918−1392) and Joseon (朝鮮, 1392−1910) Dynasties, with their strong tendency toward abstraction, were descended from the tradition of the stone images.

So while the Japanese sought realism in making their wooden Buddhist images, the Koreans sought abstraction in making stone ones. Thus, it can be said that the material determines the style. It is highly likely that Baekje was the kingdom that first chose to use granite for Buddhist images and developed its own techniques for sculpting it, because it had early on made stone versions of wooden pagodas. The Rock-Carved Buddha Triad on the Taean Peninsula (Fig. 2), dating from the late 6th century, has a commanding sense of volume, and the Rock-Carved Buddha Triad of Seosan, dating from the early 7th century, has a sophisticated beauty and elegance. Both of these examples show that by the late 6th century, Baekje had already perfected granite sculpting techniques. Then in the mid-7th century, two figures in the round were produced, the Stone Seated Buddha of Yeondongni of Iksan (Fig. 3), and the Stone Standing Buddha of Jeongeup.

Stone Buddhist images were found throughout Baekje territory, but were few in number. In contrast, the granite images of ancient Silla were concentrated in Gyeongju and were large in number. Some examples are the Seated Cave Buddha of Bulgok, Mt. Namsan, Gyeongju (Fig. 4); the Stone Maitreya Buddha Triad of Samhwaryeong; the

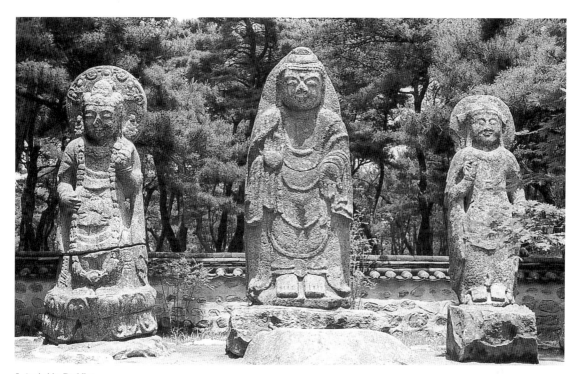

5. Amitabha Buddha
Triad at Baeri,
Gyeongju.
H. 275 cm (center),
242 cm (right), 239 cm
(left). Treasure No. 63.

Seated Buddha of Inwangdong, the Pensive Image of Mt. Songhwasan, the Amitabha Buddha Triad at Baeri (Fig. 6), the Vajrapani in the brick pagoda at Bunhwangsa Temple, and a group of sculptures featuring the Rock-Carved Maitreya Buddha Triad at Mt. Danseoksan. The Amitabha Buddha Triad at Mt. Seondosan (Fig. 6), about which there are many differing opinions, and the Stone Buddha Triad at Gunwi (Fig. 7), I would date to the mid-7th century or late Silla. These stone sculptures show that Silla was actively producing stone Buddhist images at the same time as Baekje and Goguryeo, and the concentration of these sculptures around Gyeongju shows that the centralized government system in Silla, which had proclaimed Buddhism as its ruling ideology, was much stronger than in the other two kingdoms.

Are there, then, distinct differences in style between the Buddhist images of Goguryeo, Baekje, and Silla? Generally, Japanese scholars make no distinction between the Three Kingdoms of Korea and describe an object as simply being from the "Three Kingdoms period" (三國時代), and even Korean scholars make little effort to identify the stylistic differences. But the Three Kingdoms, though basically homogeneous in character, each had distinct cultural aspects according to the nature of its people and the land. There are clear differences in style and form when it comes to the structure of their ancient tombs, stone and metal inscriptions, metal craft, roof tiles, and pagodas. Such being the case, I believe that there are clear differences in style in their Buddhist images as well. The distinguishing characteristics of the artistic style of Goguryeo are stateliness, volume, power, and vitality and liveliness. These common traits can be found in ancient

Goguryeo tomb murals, the inscription on the stele of King Gwanggaeto the Great (廣開土大王), gilt-bronze crowns, roof tiles, and the Gilt-Bronze Yeonga Buddha. It is within this context that I have identified National Treasure No. 78, the Gilt-bronze Pensive Image with Sun and Moon Crown, as a product of Goguryeo.

The art of Baekje, while heavily influenced by the Liang Dynasty (梁, 502−557) of China, has some unique aspects, as demonstrated by its brick tombs and images of Bodhisattva holding chinta-mani (wish-granting jewel) with both hands (捧持寶珠菩薩像). The Baekje people created the stone pagoda form, which is characterized by a beautiful sense of proportion and balance, and the harmonious relation between its parts. The elegant calligraphy of the inscription on the memorial stone of the Tomb of King Muryeong, the sophisticated roof tiles with lotus patterns, and clay tiles with relief landscape designs are definitely of a style that is unique to Baekje, not found in Silla or Goguryeo.

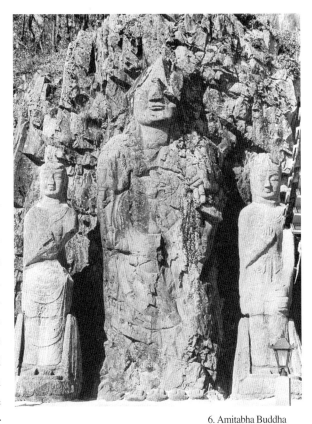

6. Amitabha Buddha Triad at Mt. Seondosan, Gyeongju. Silla, mid-7th c. Present Amitabha (center) H. 570 cm, estimated original 700 cm. Avalokiteshvara (left) H. 462 cm, Mahasthamaprapta (right) H. 455 cm. Treasure No. 62.

In comparison, the qualities of Silla art, as seen in its tomb structure, stone and metal inscriptions, roof tiles and metal crafts, include artlessness, earthiness, heaviness, massiveness, allowance for imperfection, and the coexistence of inconsistencies—characteristics which can all be found in Silla Buddhist images.

It is very important to study these stylistic differences among the Three Kingdoms because they reveal the regional variations contributing to a stylistic diversity that continued through the later Goryeo and Joseon Dynasties and up to the present.

2. Iconography and Faith

Buddhist statues are objects of worship and the changes in iconography mirror the changes in forms of faith according to period. Indeed, in the study of religious faith Buddhist art presents material much more vivid than written documents.

In the early days of Buddhism in Korea, all of the Three Kingdoms made meditating Buddha images, and these mark the beginning of the history of Korean sculpture. The iconography of the meditating Buddha dates back as early as the 5th century, to the tomb murals of Tomb No. 1 at Jangcheon-ni in Tonggu, although the images there fall under the category of Buddhist painting rather than sculpture. Of the three kingdoms, it was

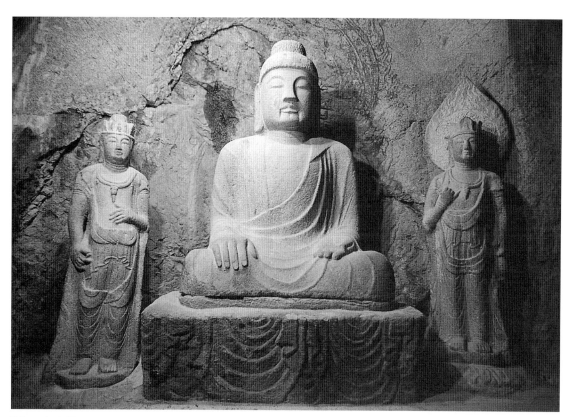

7. Stone Amitabha
Buddha Triad, Gunwi.
Silla. H. 288 cm (center),
192 cm (left), 180 cm
(right).

Goguryeo that made meditating Buddhas (禪定印像) in the greatest quantity in the early 6th century, some examples being the Agalmatolite Meditating Buddha excavated at the site known to be Hwangju, and the Clay Meditating Buddha excavated at Wonori, Pyeongannam-do province (Fig. 55). Baekje and Silla made fewer meditating images than Goguryeo. Baekje examples include the Gilt-Bronze Meditating Buddha excavated at Sin-ni in Buyeo, the oldest extant Baekje Buddhist image, and the Agalmatolite Meditating Buddha excavated at Gunsuri (Fig. 8). Silla examples include the Rock-Carved Cave Meditating Buddha in Bulgok, Mt. Namsan.

All of these were made between the 5th and 7th centuries, and the meditating Buddha emerged as the most prevalent object of worship in the early stages of the propagation of Buddhism, as it was in China before. In China, many meditating images were made during the period of the Sixteen Kingdoms by Five Clans of Barbarians (五胡十六國時代), and the small Gilt-Bronze Meditating Buddha that was discovered in Ttukseom, Seoul, was made during the same period, in the 4th century. Interestingly, there is not a single one of these meditating images among the early Buddhist sculptures of Japan. However, it is not known why Buddhist images with the *dhyana mudra* (K. *seonjeongin*, 禪定印), or meditation gesture, was produced only in the early stages of the introduction of Buddhism in both China and Korea. It is highly likely that the figure represented in the meditating images is Shakyamuni (釋迦如來), the historical Buddha.

Another kind of iconography popular in the early stages was seated or standing figures of Buddha displaying the *varada mudra* (wish-granting gesture, K. *yeowonin*, 與願印) with the right hand and *abhaya mudra* (gesture of assurance, K. *simuwoein*, 施無畏印) with the left. Such mudra were displayed not only by Shakayamuni but also Amitabha, Maitreya, and even Avalokiteshvara, and therefore is called *tongin* in Korean, meaning the "common mudra." Most Buddhist images from the Three Kingdoms period (57 B.C.–668 A.D.) display the tongin mudra, including the Gilt-Bronze Yeonga Buddha, Amitabha in the Rock-Carved Buddha Triad of Taean, and the main Buddha in the Mt. Danseoksan Rock-Carved Maitreya Triad. In many of these tongin images, the fourth and fifth fingers of the left hand showing the varada mudra are bent, and in all tongin images the identity of the figure is always revealed either by an inscription or can be deduced from the attendants to the left and right.

8. Agalmatolite Meditating Buddha. Excavated at Gunsuri, Buyeo. Baekje. H. 13.5 cm. Treasure No. 329. National Museum of Korea, Seoul.

Pensive images (思惟像), first made in the latter half of the 6th century, during the Three Kingdoms period, and prevalent till the mid-7th century, developed some specifically Korean characteristics. In China pensive images appeared first as attendants to Maitreya (彌勒菩薩) and then became the main image during the Eastern Wei and Northern Qi Dynasties, sometimes depicted in the form of a triad with pensive monks or other figures as attendants. However, in Korea, the pensive image was produced as an independent figure. It grew larger, to around one meter in height, and became an independent object of worship as the main image of the main hall. Examples resulting from this process of development include National Treasure No. 78, the Gilt-Bronze Pensive Image with Sun and Moon Crown (金銅日月飾寶冠思惟像), and National Treasure No. 83, the Gilt-Bronze Pensive Image with Lotus Crown (金銅蓮華冠思惟像).

These developments were transmitted to Japan, and some examples there include the wooden pensive images at Koryuji Temple (廣隆寺) and Chuguji Temple (中宮寺). In Japan such pensive images are identified as Maitreya, but in China and Korea the identity of the image is uncertain. In China the pensive image was commonly an attendant to Maitreya, so it is undoubtedly closely linked to Maitreya. But because it is depicted as an attendant, it cannot be construed with certainty to be the Bodhisattva Maitreya. The pensive image was originally the image of a prince and therefore should rightly be called Shakayamuni Bodhisattva (釋迦菩薩), but no such terminology has been confirmed. It is possible, however, that it is a representation of Shakayamuni reincarnated as Maitreya. In any case, the distinctiveness of Korean pensive images reached its zenith before and after the unification of the Three Kingdoms. After unification, a work such as the stone pen-

sive image excavated at Bonghwa (Figs. 89—92)—which would be about 2.5 meters in height if fully restored—was produced. It is not known why pensive images were suddenly discontinued afterwards.

The image of a bodhisattva holding chintamani with both hands, one on top and one underneath, is part of the iconography of the standing bodhisattva images of the Three Kingdoms period, and according to my research, unique to Baekje. The materials used to create such sculptures, which have been discovered throughout Baekje territory, were diverse, including gilt-bronze, agalmatolite, clay, and granite. In China such images of a standing bodhisattva holding chintamani with both hands were produced only during the Liang Dynasty. The interesting thing is, as with the pensive images in China, this kind of image appeared first as an attendant to Avalokiteshvara (觀音菩薩) and then later became an independent image of Avalokiteshvara. Such images of Avalokiteshvara, very popular in Baekje and large in scale, ultimately gave rise to the unique iconography seen, for instance, in the Taean Rock-Carved Buddha Triad, where Avalokiteshvara holding chintamani with both hands is in the center, flanked by Bhaishajyguru (the Medicine Buddha, 藥師如來) to the left and Amitabha Buddha (阿彌陀如來) to the right as attendants. This eventually led to a widespread establishment of temples for the worship of Avalokiteshvara, a trend that was passed on to Japan, where the wonderful Horyuji Wooden Avalokiteshvara was produced.

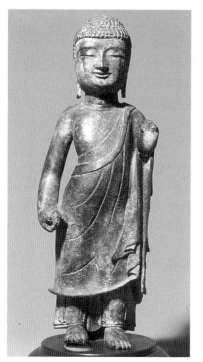

9. Gilt-Bronze Standing Buddha. Silla 7th c. H. 31 cm. National Museum of Korea, Seoul.

Such Avalokiteshvara images were prevalent only in Baekje. In ancient Silla, the popular image was of a standing Buddha holding an attribute, the right hand hanging down and holding chintamani or a lotus blossom and the left hand in the abhaya mudra. The robe is draped over the right shoulder leaving the left shoulder bare, and despite being a Buddha, the figure always holds the tribangha ("thrice-bent") pose. (Fig. 9) As many as twenty such images have been discovered throughout Silla territory, and it seems that Silla was the only kingdom in East Asia that made them, though one example has been found in Japan, apparently produced under Silla influence. The icon is commonly identified as Bhaishajyguru, the Medicine Buddha, but as yet there is no satisfactory proof of this. The origin and the identity of this Buddha remain unknown, but their discovery in large numbers in Silla territory suggest that Silla had its own particular form of Buddhist faith.

We have thus far examined various types of iconography. We have seen that the tongin Buddha images continued to be produced; that the cult of Shakayamuni was gradually succeeded by the cult of Amitabha; and that Buddha images in meditation pose were produced only for a short period whereas pensive images continued to develop, gradually becoming larger and more prevalent. As for Avalokiteshvara, images of the bodhisattva continued to be produced in various types of iconography, holding various attributes such as chintamani, a lotus blossom, or a

kundika.

It is important to arrange in chronological order the stylistic changes in Buddhist images because these changes are ultimately linked to the history of religious faith.

Finally, a particularly noteworthy point is the special relationship between Maitreya and Silla's Hwarang (花郎), or "flower of youth corps," a group of young elite soldiers. That the Hwarang as a group were also called "Yonghwahyangdo" (龍華香徒), meaning a group devoted to realizing the ideal world of the Maitreya in this world, and that they believed Maitreya would be reincarnated in this world as a Hwarang—these all indicate that there was a dynamic connection between the ideal state and the Maitreya cult, with its belief that when Maitreya descends from Tusita Heaven to the mundane world, Cakravartin, the ideal king, will appear and rule this land with the true law to realize the ideal state. Because such beliefs appear in many written accounts of Silla, it is usually thought that the Maitreya cult was particularly ascendant in Silla. However, considering that the biggest Baekje temple, Mireuksa, has a shrine featuring a Maitreya Triad, it is evident that the Maitreya Pure Land cult (彌勒淨土信仰) was quite widespread in the Three Kingdoms, and further, in East Asia, prior to the Amitabha Pure Land cult (阿彌陀淨土信仰).

3. Buddhist Images of Unified Silla

In the latter half of the 7th century, the Three Kingdoms were unified by Silla, bringing new developments in politics, society and culture overall. While absorbing the culture of Baekje and Goguryeo, Silla fully adopted the culture of High Tang of China as well to produce a wholly different style of art to the Three Kingdoms period.

After the political unification, Sacheonwangsa Temple (四天王寺, Temple of the Four Heavenly Kings) was built around 680, followed by Gameunsa Temple, Deokmangsa Temple, and Gamsansa Temple in Gyeongju. Though these did not possess the large scale of the temples of the Three Kingdoms period, they were the first to feature a unique arrangement where two pagodas were placed in front of the main hall. By the mid-8th century, Silla demonstrated originality in a variety of genres, as evidenced by the temple bells, called Joseon bells, renowned for their beautiful form, decoration, and sound; the Silla stone pagodas typified by the pagodas of Bulguksa Temple (佛國寺); the system of tomb construction with stone panels bearing the twelve zodiacal animals; and the stupas containing the sarira of monks. The tradition of Silla art continued through the Goryeo and Joseon Dynasties, and it can be said that the art tradition established in the 8th century was the seed of all later Korean culture. In these general conditions, images of Buddha in meditation displaying the *bhumisparsha mudra*, the gesture of defeating the demons and touching the earth (K. *hangmachokji-in*, 降魔觸地印), and Vairocana in Buddha form with hands in the *bodhishri mudra*, or wisdom-fist gesture (K. *jigweonin*, 智拳印, commonly called *vajra mudra* in esoteric Buddhism) which were particularly prevalent from

10–11. Fragments of high pottery panels of the Four Heavenly Kings excavated at Sacheonwangsa Temple. Dhartarastra, guardian of the east (top, left) and reconstructed drawing (bottom, left) and Virudhaka, guardian of the south (top, right) and reconstructed drawing (bottom, right). Unified Silla. Size: Dhartarastra 42 × 52 cm, H. reconstructed panel 86.2 cm, H. seated figure 59 cm. Virudhaka 50 × 69.5 cm, H. reconstructed panel 90.5 cm, H. seated figure 63.6 cm. Gyeongju National Museum, Gyeongju. (Reconstruction by Kang Woobang)

the mid-8th century onwards, are two types of Buddha images that have continued to the present day. Korea is the only country in East Asia where these two forms have survived for such a long time.

This shows that by the 8th century, Silla had gone beyond the influence of the Tang Dynasty and begun to develop its own styles, a development that was not unique to Korea but common to all Buddhist nations in China, Japan, and Southeast Asia. Consequently, from this period on Buddhist nations had to work out their own ideas in terms of style and iconography.

1. Changes in Style and the Emergence of a Central Style

Silla began Buddhist projects in earnest around 680, after it had defeated Tang forces and restored political stability. After unification, the monumental Sacheonwangsa Temple was built, and the glazed pottery panels of the Four Heavenly Kings rendered in high

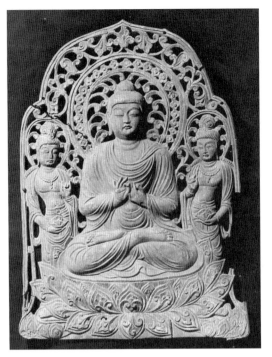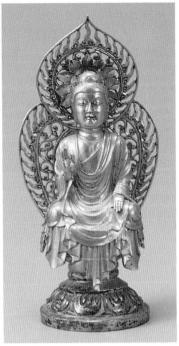

relief (Figs. 10, 11) that were enshrined in the temple's wooden pagodas stand as master-pieces representing the beginning of the history of Unified Silla Buddhist sculpture. Around the time of unification, the Venerable Yangji (良志), a famous sculptor of Buddhist images, made many clay statues, but these pottery fragments of the Four Heavenly Kings excavated at the Sacheonwangsa site are all that survive of his works. The craftsmanship here is precise and powerful, showing the influence of the Tang style but more highly advanced, achieving a perfect artistry of form. Other works from the same period—such as the Gilt-Bronze Buddha Triad Plaque excavated at Anapji (Fig. 12) and relief images, such as the Gilt-Bronze Bodhisattva, and Gilt-Bronze Four Heavenly Kings (Fig. 14) found in the stone pagoda at Gameunsa Temple—also reflect the style of High Tang (盛唐) but are precise and imbued with even greater vitality. The continuation of High Tang influence is borne out by the Gold Amitabha Buddha (Fig. 13) found at Hwangboksa Temple and dated 707.

Among the representative works of the first half of the 8th century are two stone statues from Gamsansa Temple (Figs. 15, 16). Commissioned in 719 by an aristocrat named Kim Ji-seong, the back of the mandorlas of Amitabha Buddha and Maitreya Bodhisattva are carved with long inscriptions and as such are valuable historical artifacts as well. The standing Amitabha Buddha displays the tongin gesture, and because the monastic robes are tight on the body, the contour of the body is clearly revealed and the U-shaped folds of the legs emphasize the volume of the lower body. The drapery reflects the Gupta style, and from this we can infer that Gupta strongly influenced the style of High Tang. As for the Maitreya figure, its tribangha stance, rich decoration, and the form of its dhoti repre-

sent a style that is distinctly Indian in characteristics, of a kind not found in China. Therefore, though it is apparent that Unified Silla (統一新羅, 668−935) adopted the style of High Tang in the 8th century, direct influence from India cannot be ruled out.

The Gamsansa stone statues show that in Unified Silla the techniques for working with granite, a hard, coarse-grained stone, had developed to such a degree that this material was being handled with a great deal of freedom. This development in technique and maturity of religious thought, combined with the political goal of strengthening centralized government, ultimately led to the construction of Seokbulsa Temple (Seokguram) and Bulguksa Temple. Seokbulsa (石佛寺) is the original name of Seokguram (石窟庵), but since Seokguram is the better-known designation, that is the one that will be used here.

It is believed that the construction of Seokguram, a cave temple, was started in 751 and completed around 775. However, the principal Buddha image had to be completed before the rest of the structure, including the sculptures on the walls, so it would have been made around 755. Inside Seokguram there are thirty-eight sculptures, including the principal Buddha, a seated Shakyamuni displaying the bhumisparsha mudra in the center of the grotto; and on the interior walls, Vajrapani, the Four Heavenly Kings, bodhisattvas, the Ten Great Disciples, and the Eight Classes of Dharma Protectors. Originally there were forty sculptures, but two from the upper niches have been lost.

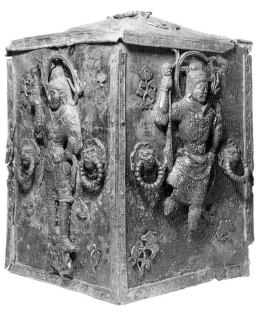

14. Gilt-Bronze sarira case featuring high relief figures of the Four Heavenly Kings. From the stone pagoda at Gameunsa Temple. Unified Silla, c. 682. H. 28 cm. Treasure No. 366. National Museum of Korea, Seoul.

Because these stone sculptures make up a full, intact set, they are very important in the study of the composition of Buddhist images in Korean temples. Technically perfect, they are beautiful and awe-inspiring. The full, stately body of the main image, draped in a close-fitting monastic robe, exemplifies an idealized style of expression. This style of seeking ideal beauty is also perfectly realized in the images of Brahma, Indra, two bodhisattvas, and Eleven-Faced Avalokiteshvara, which are all elegant and exquisite. But the images of Vajrapani, the Four Heavenly Kings, and the Ten Great Disciples are realistic, showing a completely different type of expression from the bodhisattvas. So in Seokguram, realistic and idealistic methods of expression are used together. The Seokguram sculptures represent not only the height of Korean Buddhist sculpture but the embodiment of sublime religious thought unmatched in East Asia.

In the mid-8th century a new material, iron, began to be used in Buddhist images. The iron Buddha with bhumisparsha mudra discovered at what is believed to be the site of Bowonsa Temple (Fig. 17) has a stately body and beautiful drapery that make it a work comparable to the main Buddha at Seokguram.

In the mid-8th century, works strong in Gupta stylistic elements reached their peak, resulting in a central style

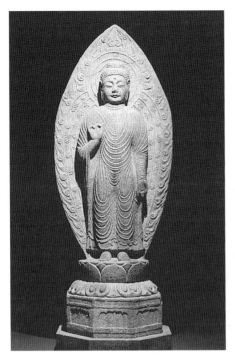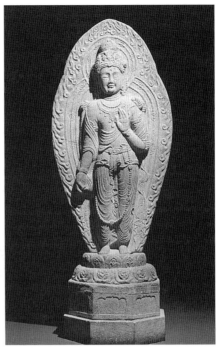

15. Stone Amitabha Buddha. From Gamsansa Temple. H. mandorla 212 cm, figure 174.5 cm, pedestal 63 cm. National Treasure No. 82. National Museum of Korea, Seoul. (left)

16. Stone Standing Maitreya Bodhisattva. From Gamsansa Temple. H. mandorla 201 cm, figure 183 cm, pedestal 51 cm. National Treasure No. 81. National Museum of Korea, Seoul. (right)

which then spread throughout the country. Many works were made in this style until around 800, but then in the 9th century this central style, along with sculptural techniques, began to wane. Therefore, after the 9th century, the stylistic development of Buddhist images in relation to foreign influences becomes difficult to discern. And as Buddhist images in a variety of regional styles begin to appear in this period, it becomes almost impossible to compile a chronology of stylistic changes in Korean Buddhist images.

Hence the monumental Seokguram sculptures created in the mid-8th century mark a watershed in the history of Korean Buddhist sculpture. In the 9th century, the confident sense of volume, and the vitality inherent in it, and the stylistic rigor were gradually lost, and Buddhist sculpture began to move in the direction of folk art.

2. Iconography and Faith

During the Unified Silla period, as in the Three Kingdoms period, images of Amitabha, Maitreya, the Medicine Buddha, and Avalokiteshvara were made. The Amitabha cult, whose followers hoped to be reborn in the Western Paradise, was prevalent and indeed the most widespread Pure Land cult in all of East Asia. In contrast to the Maitreya Pure Land, whose adherents were mainly among the aristocratic classes in the Three Kingdoms period, the Amitabha Pure Land cult in the Unified Silla period was popular with everyone from aristocrats down to the lower strata of society.

But the history of Korean sculpture in the Unified Silla period was defined by the stat-

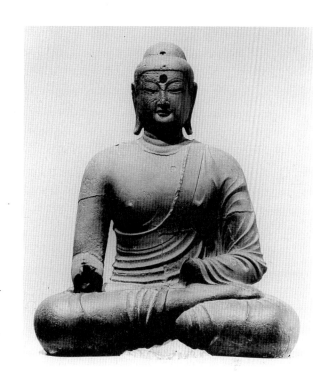

17. Iron Seated Buddha. From Unsan-myeon, Seosan. Unified Silla, mid-8th c. H. 150 cm. National Museum of Korea, Seoul.

ues of Shakyamuni Buddha displaying the bhumisparsha mudra and Vairocana Buddha displaying the *bodhishri mudra*. Although a rock-carved Shakyamuni triad with bhumisparsha mudra (Fig. 18) was made in the early 8th century at Chilburam Hermitage on Mt. Namsan, I believe that the first statue of this kind in the round was the principal Buddha at Seokguram. Since then countless images of the Buddha displaying the bhumisparsha mudra have been created throughout all periods down to the present.

What then was the doctrinal basis for this iconography? The bhumisparsha mudra, or earth-touching gesture, with one hand pointing to the ground, was the gesture made by Shakyamuni when he attained enlightenment under the Bodhi tree. In Buddhism, enlightenment is paramount; and its absolute importance to the people of Unified Silla is evidenced by the fact that they continuously produced images of Buddha at the point of enlightenment.

The Seokguram Buddha's orientation is east and its mudra, or hand gesture, is the bhumisparsha mudra. Measured in the traditional unit of *Tang cheok* (Tang foot), its sitting height is 1 *jang* 1 *cheok* 6 *chon*, the width from knee to knee 9 *cheok* 8 *chon*, and the shoulder width 6 *cheok* 6 *chon*. I was convinced that these measurements had a specific origin, and that the Buddha's dimensions had determined the architectural design of Seokguram cave temple. Amazingly, the mudra, orientation, and dimensions of the Seokguram Buddha exactly match those of the Shakyamuni statue in Mahabodhi Temple, Bodh Gaya (the very place Shakayamuni attained enlightenment), which is described in detail in *Great Tang Dynasty Record of the Western Regions* (大唐西域記), an account by the Chinese Buddhist master Xuanzang (玄奘) of his pilgrimage to

Buddhist holy places.

Therefore, the Seokguram Buddha was most likely based on this account in an attempt to suggest that Shakyamuni attained enlightenment in Silla, that is, in Seokguram, Mt. Tohamsan, Gyeongju, representing the realization of Silla's Buddha Land philosophy, which centers on the belief that Silla is indeed the Buddha Land. Shakyamuni attained enlightenment when the sun was about to rise; the Seokguram Buddha faces the rising sun over the East Sea. This is symbolically important, for it is a representation of Shakyamuni, who, having attained enlightenment, leads sentient beings out of the darkness with the light of truth, just as the sun rises over the horizon and chases away the darkness with light. When Shakyamuni attains enlightenment, he becomes the light of truth, just like the light of the sun. This means that this image represents the dharmakaya, the embodiment of truth and law. And the embodiment of light is Vairocana, who illuminates the entire universe. This dramatic symbolic transformation of Shakyamuni from Bodhisattva to the Buddha and to Vairocana at the same time is based on interpretations of *Lalita Vistara* (part of the Vaipulya Sutra) and the *Avatamska Sutra* (華嚴經).

The monumental image of enlightenment was made in Seokguram sometime between 751 and 755, and the oldest extant Vairocana Buddha, at Seoknamsa Temple (Fig. 19), was made in 766, so it is clear that the latter was made under doctrinal understanding of the Seokguram sculptures. Beginning in the 9th century in China and Japan, there appeared images of Mahavairocana in the diamond element of the universe, in the form of a bodhisattva displaying the vajra mudra, wearing robes, adorned with a crown and earrings, and with the hair drawn over the shoulders. But the Vairocana at Seoknamsa,

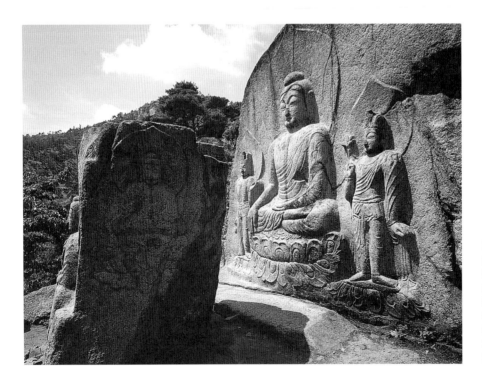

18. Rock-Carved Shakyamuni Triad. Chilburam Hermitage, Mt. Namsan, Gyeongju. Unified Silla. H. 266 cm (center), 211cm (left), 211cm (right). Treasure No. 200.

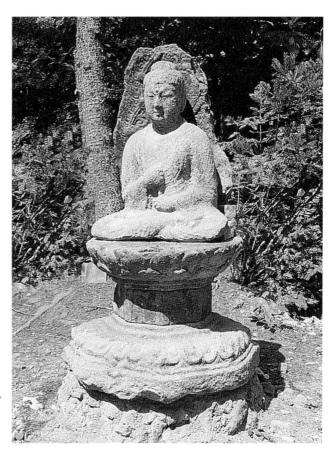

19. Stone Vairocana Buddha. Excavated from Seoknamsa Temple. Unified Silla, 766. H. figure 103.5 cm, pedestal 63 cm. Naewonsa Temple, Sancheong.

the oldest in Asia with the *bodhishri mudra*, is not in bodhisattva form but Buddha form. Though it is impossible to explain in detail how this iconography came into being, it is clear that the Korean Vairocana Buddha did not have a basis in esoteric Buddhism but in the Vairocana of the *Avatamsaka Sutra*. So, although Vairocana in Buddha form displaying the *bodhishri mudra* has been produced through the ages in Korea, the absence of any in bodhisattva form confirms that, unlike in Japan, esoteric Buddhism never became mainstream in Korea.

In other words, the above shows that in Unified Silla the two forms of faith that constituted the mainstream were easily approachable forms: one seeks to reach Nirvana through faith, or one seeks to attain enlightenment through meritorious deeds accomplished through one's own strength. From this, we can see that the people of Unified Silla did not rely on prayer but focused on enlightenment, which is the basic philosophy and goal of Buddhism.

Vairocana Buddha came to be portrayed in a triad with attendants Manjushri (文殊菩薩) and Samantabhadra (普賢菩薩) to the left and right, and later, Shakyamuni was also portrayed with the same attendants and displaying the bhumisparsha mudra. This unified image shows that Shakyamuni and Vairocana were not considered separate but one and the same. The prevalence of these two types of iconography throughout the ages is a

major characteristic of Korean Buddhism, something not seen in China or Japan. It shows that in the mid-8th century, Unified Silla did not follow the philosophy and iconography of Chinese Buddhism but systemized its own individual form of faith and created its own iconography. Here I use the word "created" because, although Vairocana in Buddha form displaying the *bodhishri mudra* was based on the *Avatamsaka Sutra*, it is highly possible that the wisdom-fist iconography was borrowed from esoteric Buddhist images.

In this way, the individuality of Korean Buddhism in terms of doctrine and faith was established, and great sculptures of Shakyamuni Buddha and Vairocana Buddha were produced in the mid-8th century. But in terms of artistry, the latter half of the 8th century was a turning point, and in the 9th century the artistry of Buddhist sculpture began to decline. There are clear changes in the history of ancient Korean Buddhism before and after Seokguram. That is, in the latter half of the 8th century, a Korean-style Buddhist iconography and Buddhist faith were established and standardized, and for half a century many Buddhist images were produced across the country. Afterwards, there was a definite decline, but the style established then has continued to the present day. In particular, the bhumisparsha mudra at the time of enlightenment even became part of the iconography of the Medicine Buddha. And in the Joseon Dynasty, this Medicine Buddha appears as the main Buddha in paintings of Buddha preaching on Vulture Peak, which is based on the *Lotus Sutra* (法華經).

The main Buddha in Seokguram is the pinnacle of Korean Buddhist sculpture in terms of style, iconography, faith and doctrine, and has served as the model of Korean Buddhist images ever since it was made. That is, it became the definitive model in Korean Buddhism in terms both of sculptural arts and Buddhist teaching and learning. It is similar to the way the Divine Bell of King Seongdeok (聖德大王神鐘), made in the latter half of the 8th century, became the model for all Korean temple bells. The desire of the Silla people to lead sentient beings to enlightenment by means of the image of Buddha at the point of enlightenment and the sound of the "divine bell" was so strong that they were able to achieve such superior artistry and symbolism. This also reflects the unique nature and cultural characteristics of the Korean people, who, having achieved something, strive to perpetuate it through the ages.

Gilt-Bronze Pensive Image with Sun and Moon Crown

Reinterpretation of Goguryeo, Baekje, and Silla Buddhist Sculptures of the 6th Century and the Japanese Tori Style

The Pensive Image with Sun and Moon Crown shows that beauty of form is achieved on the basis of perfect technique. In spite of this statue being one of the most outstanding works of sculpture in the world, it has been largely overlooked. If we look at the style of Buddhist images of the Three Kingdoms period, we can see that this statue is in the Goguryeo style and that it is a link to the Tori style of the Asuka period in Japan.

1. Introduction

The Gilt-Bronze Pensive Image with Sun and Moon Crown (金銅日月飾寶冠思惟像, National Museum of Korea, National Treasure No. 78 [Figs. 20−25]) represents the peak of ancient Korean sculpture, along with the Gilt-Bronze Pensive Image with Lotus Crown (金銅蓮華冠思惟像, formerly in the collection of Deoksugung Art Gallery, National Treasure No. 83 [Fig. 69]). Long overshadowed by the latter, the Sun and Moon Crown pensive image has not been sufficiently analyzed. One of the major reasons is the lack of research on the style of the statue, which means it has not been stylistically backed up by succeeding pensive images as in the case of the Lotus Crown image. The latter statue is compared to the pensive images of Northern Qi (北齊) of China and is acknowledged as achieving a uniquely Korean form that spread widely and developed in diverse ways. In comparison, the Gilt-Bronze Pensive Image with Sun and Moon Crown is isolated in the context of the history of sculpture.

However, the Sun and Moon Crown pensive image is as important as the Lotus Crown pensive image because it played an important role in the transmission of Buddhist culture from China to Korea to Japan, and because it has a unique style of its own.

Ultimately, this statue is the result of Korea achieving a unique style of its own after assimilating the style of Northern Wei−Eastern Wei (北魏−東魏) of the 6th century, and the nature of this statue will be newly investigated through a study of the Northern Wei−Eastern Wei style Buddhist images of Goguryeo (高句麗), Baekje (百濟), and Silla (新羅). In the latter half of the 6th century, during the Three Kingdoms period (三國時代),

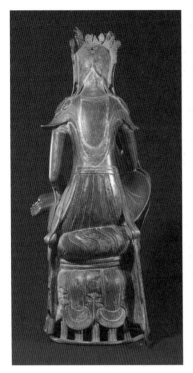 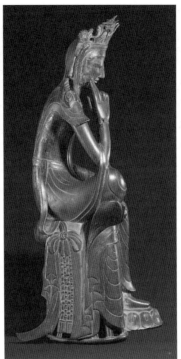 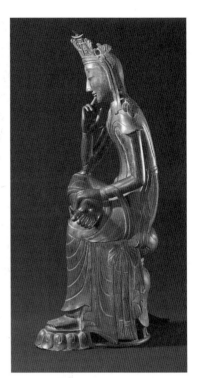

20–22. Back, right and
left side view of Gilt-
Bronze Pensive Image
with Sun and Moon
Crown.

23. Gilt-Bronze Pensive
Image with Sun and
Moon Crown. Late
7th c. H. 83.2cm.
National Treasure
No. 78. National
Museum of Korea,
Seoul. (p. 33)

Korean-style Buddhist sculpture was being established and actively transmitted to Japan, where it had a definitive influence on the Tori style of the Asuka (飛鳥) period, which in turn led to the establishment of ancient Japanese sculpture in the 7th century. In this general context, the Gilt-Bronze Pensive Image with Sun and Moon Crown represents the height of the development of Eastern Wei style in China, Korea, and Japan, which means it is possible to consider it as a product of Goguryeo.

In spite of this background, the statue has been considered a product of Silla. Because it has been tacitly identified as such without sufficient effort to show why its style is that of Silla, it has been isolated among the Buddhist sculptures of Silla also, which means it has been rather neglected in the history of ancient Korean sculpture.

Generally speaking, no Buddhist sculpture can exist on its own. Though partial creation and metamorphosis was possible, it was not possible to create something completely new in ancient Korea. By saying it was not possible to create a completely new style, I do not mean to undervalue the Sun and Moon Crown pensive image. In the midst of strong cultural exchanges between East and West, Koreans have dressed foreign forms in Korean styles, and sometimes synthesized foreign form and Korean styles to leave behind great works of art, such as the two gilt-bronze pensive images discussed here and the main Buddha of Seokguram (石窟庵) cave temple. The supple and elegant curves of the body, both overall and in the parts, the bright smile, and the flawless casting technique of the Gilt-Bronze Pensive Image with Sun and Moon Crown results in a special kind of beauty that cannot be seen even in the Gilt-Bronze Pensive Image with Lotus Crown.

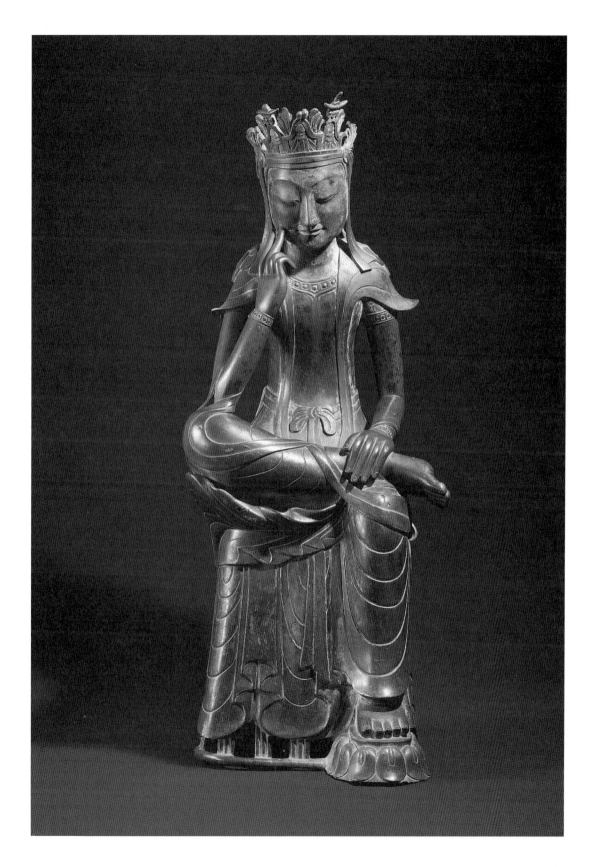

It is important to determine which of the ancient Three Kingdoms of Korea produced this statue because, without doing so, the history of ancient sculpture in Asia cannot be properly organized. To determine the origin of the statue, I studied the Eastern Wei style of China, and Buddhist statues of Eastern Wei style from the Three Kingdoms of Korea, focusing particularly on the Buddhist images of Goguryeo. In addition, I reinterpreted Tori-style statues from the Asuka period in Japan that are of the Eastern Wei style, and tried to work out the true nature of the Gilt-Bronze Pensive Image with Sun and Moon Crown in the context of stylistic developments in China, Korea, and Japan. It is my hope that such research will prove to be of some help in the study of ancient Korean Buddhist statues of the 6th century.

2. Style and Form of the Gilt-Bronze Pensive Image with Sun and Moon Crown

The most noticeable thing about the Gilt-Bronze Pensive Image with Sun and Moon Crown is the form of the finely made and elaborate crown. This form of crown used to be called a "pagoda crown," but I believe it should be renamed the "sun and moon crown." Combining the shapes of the round sun and the crescent moon, this form was commonly found in the Sassanian royal crowns of Persia, and was introduced to Korea through China and then passed on to Japan.

Though it is not desirable to determine the cultural context of the statue just by looking at the style of crown, the subject is worth addressing because, even though the crown is a rather special form in Asian art, it was nevertheless quite widespread at the same time. It is an important point in understanding this statue and therefore worth looking at in detail.

This crown is highly ornamental and finely made thanks to excellent casting technique. Of course, it is based on a variation of the so-called "three-peaked crown" (蓮華冠) and as can be seen in the drawings, the three peaks are divided into abstract and geometric sections with a second line alongside the dividing line, and the space between the lines is filled with a fine dotted line or bead chain pattern. On the left and right sides of the three peaks there are stylized lotus leaves with a fine bracken pattern carved on the tips and a bead chain pattern around the border. This kind of pattern is repeated at either end of the band of the crown, making it even more elaborate. The three peaks are each topped with a stylized and modified lotus pedestal pattern, which is then topped by a pattern combining a round sun and a crescent moon. The same fine bead chain pattern also appears along the border of the sun shape. On top of each sun pattern is placed a

24. Inside view of Gilt-Bronze Pensive Image with Sun and Moon Crown.

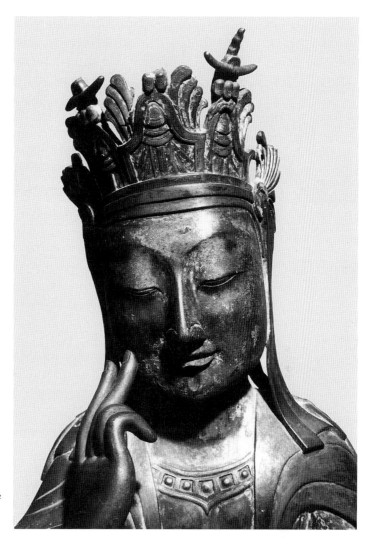

25. Head of Gilt-
Bronze Pensive Image
with Sun and Moon
Crown.

long indefinite shape, like a genie bottle. No other crown of such complex composition can be found even on the Buddhist statues of China. This crown is so stylized and abstract that it cannot be identified with any actual shape; it is also very big and for this reason a very important part of this particular statue. The focus of this crown is the sun and moon forms. They are placed on top of lotus pedestals, each made up of three petals, which suggests their great importance.[1] The bottle-shaped decoration protruding on top does not seem to be anything more than an added ornamentation intended to emphasize the harmonious upward movement of the design. The composition of various geometric and abstract shapes and geometric division of the surfaces with a bead chain pattern, or thin dotted line, all add up to a work of art that evinces great creativity (Fig. 26).

The sun-and-moon form originates in the crowns of Sassanian Persia (Fig. 27)[2] and is one of the countless examples of things that traveled the Silk Road to reach China and then eastwards to Korea and Japan, being transformed a little in each country along the

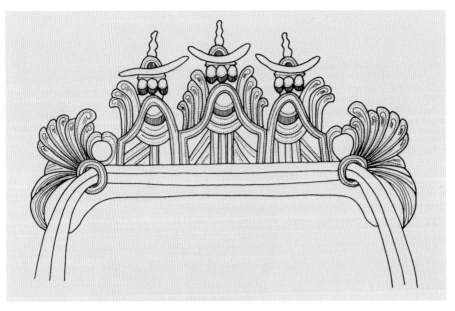

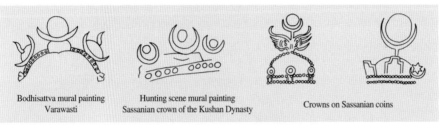

Bodhisattva mural painting
Varawasti

Hunting scene mural painting
Sassanian crown of the Kushan Dynasty

Crowns on Sassanian coins

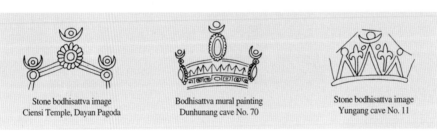

Stone bodhisattva image
Ciensi Temple, Dayan Pagoda

Bodhisattva mural painting
Dunhuang cave No. 70

Stone bodhisattva image
Yungang cave No. 11

26. Drawing of crown of
Gilt-Bronze Pensive
Image with Sun and
Moon Crown. (top)

27. Sassanian sun and
moon crowns. (center)

28. Chinese sun and
moon crowns. (bottom)

way. For example, in China, as seen in figure 28, the sun and moon crown developed in diverse ways from the Northern Wei through to the Tang Dynasty (唐), as demonstrated by examples found in the cave temples of Yungang (雲崗) and Longmen (龍門) and the frescoes of Dunhuang (敦煌).

Korean examples include the gilt-bronze pensive Buddha seen in figure 57 that is estimated to date to Goguryeo, the Seosan rock-carved attendant bodhisattvas from Baekje, and the gilt-bronze pensive image believed to have been excavated from Gongju (now belonging to the Tokyo National Museum) from Baekje, whose crown is not actually a sun and moon crown but has a similar basic form to the crown of the Gilt-Bronze Pensive Image with Sun and Moon Crown. Examples from Silla include the gilt-bronze pensive image excavated from Gaeryeong-myeon in the northern part of Silla, which has a crown

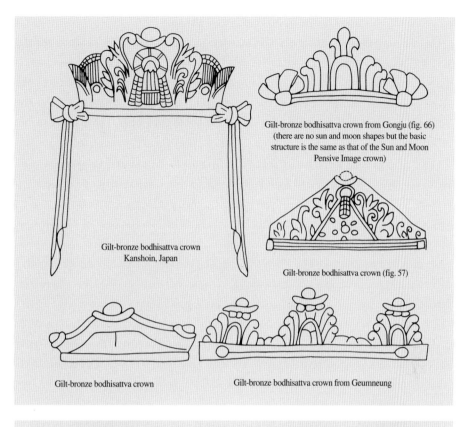

Gilt-bronze bodhisattva crown from Gongju (fig. 66) (there are no sun and moon shapes but the basic structure is the same as that of the Sun and Moon Pensive Image crown)

Gilt-bronze bodhisattva crown Kanshoin, Japan

Gilt-bronze bodhisattva crown (fig. 57)

Gilt-bronze bodhisattva crown

Gilt-bronze bodhisattva crown from Geumneung

29. Korean sun and moon crowns from the Three Kingdoms period. (top)

30. Japanese Tori style sun and moon crowns. (bottom)

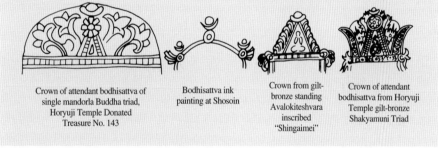

Crown of attendant bodhisattva of single mandorla Buddha triad, Horyuji Temple Donated Treasure No. 143

Bodhisattva ink painting at Shosoin

Crown from gilt-bronze standing Avalokiteshvara inscribed "Shingaimei"

Crown of attendant bodhisattva from Horyuji Temple gilt-bronze Shakyamuni Triad

similar to that of the Sun and Moon Crown pensive image.

In Japan there are the Gilt-Bronze Buddha and Bodhisattva Triad at Horyuji Temple (法隆寺), the Gilt-Bronze Avalokisteshvara (Treasure No. 165) dating from A.D. 651 at Horyuji Temple, the Gilt-Bronze Attendant Bodhisattva Triad (Treasure No. 143), and the gilt-bronze pensive image from Kannoji Temple (神野寺), and statues that are thought to have come from either Baekje or Goguryeo such as the gilt-bronze pensive image from Kanshoin in Nakano prefecture (Fig. 29). Coincidentally, the Japanese Buddhist statues with a sun and moon crown are those that are closely related to Korean Buddhist images in style (Fig. 30). As seen above, the sun and moon crown is an important form, not only in studying the Gilt-Bronze Pensive Image with Sun and Moon Crown, but also in tracing the route of its transmission to Japan. This statue is considered the major exam-

ple of the sun and moon crown, from which it gets its name.

On this statue the band of the crown is in two layers which pass through a loop at either side and hang down in two strands to the shoulders. Next, looking at the different parts of the body, the face is almost a perfect oval and reflects the characteristics of Eastern Wei style. The eyes are narrow slits with the upper and lower eyelids forming a graceful line. The nose is particularly high and each side is incised in thick lines. The eyes, nose, and mouth are sharply delineated, but the cheekbones, cheeks, and chin have soft and beautiful modeling, making the statue a masterpiece for its delicate and subtle expression of the Buddha's face. This beauty and femininity of the face can be seen even more clearly in profile. The smile on the face is different from the awkward smile—with the ends of the lips are pressed together—so commonly found in Northern Wei or Eastern Wei Buddhist images. But in this Sun and Moon Crown pensive image, there is emphasis on the cheekbone area that naturally swells when smiling, and the cheek area around the mouth is indented a little, creating a very realistic expression that distinguishes this statue from others. In this statue the whole face is depicted smiling, not simply the lips.

The hair is covered by the high crown, and at the back it is divided into two parts that each end in three strands sitting on the wing-shaped shoulder part of the robes (*pi-geon*, 被巾), which can be seen from the front. The ears have been pushed back because of the band of the crown and cannot be seen very well from the front, and have therefore been treated very simply.

In contrast to the largeness of the face, the body is very thin. The shoulders are narrow, the waist and the arms thin—an abstraction of the thin, soft lines of women—and the smooth texture of the skin has been emphasized, resulting in a wonderfully sensitive expression. This is even more so in the hands, which are large and long compared to the thin arms. The fingers are stretched out long, smooth, and supple like the fingers of women, and without joints. The right hand is raised with the middle finger lightly touching the cheek, and the fourth and fifth fingers are bent, curving softly and beautifully without artificiality. The left hand, which rests on the right foot of the crossed leg, is also large and long. The large face, hands, and feet, and their fullness (fundamentally male) in comparison to the thinness of the body, constitute an idealized expression of a young female to symbolize the compassion of Buddha, while bodhisattvas were expressed in the form of a female. The body is exquisitely decorated with bracelets at the wrists, bands on the upper arms, and a necklace.

The robes are wide at the shoulders with the ends turning up and ending sharply, and suddenly narrow at the chest into long sashes that cross over at the right knee, wrapping around both knees and looping over the arms, hanging down and disappearing beneath the thighs before reappearing again. As seen from the side, the hem sticks up at the back in a large curve. The depiction of the robes in this way is appropriate to the complex composition of the body in a pensive image, and the soft and lively modeling of the robes, growing wider here and narrower there, surely makes the attire on this statue the most

beautiful found in the Asian Buddhist world. If this element is not handled well, then it can easily obstruct the contours of the body, but in this statue it closely follows the graceful curves of the body, thus emphasizing the beautiful curves of the whole statue. Making the robes flow and wrap softly around the different parts of the body is impossible without great technical skill, and the achievement here is little short of amazing.

The wide shoulder part of the robe is called *pi-geon*,[3] and the turned-up wing-like ends seen in this statue is a form found in Chinese statues from late Northern Wei through early Eastern Wei (it disappears in Northern Qi, when naked figures became common). Another Korean example with this feature is the Clay Bodhisattva from Goguryeo found in Wonori. Also, another Korean statue with robes winding round the arms is the Gilt-Bronze Pensive Image with Rectangular Pedestal. Although it has the characteristics of Sui (隋) style, the modeling of the hands and arms show that it is closely related to the Gilt-Bronze Pensive Image with Sun and Moon Crown.

The figure in the Gilt-Bronze Pensive Image with Sun and Moon Crown is wearing a thick dhoti (skirt) which makes the legs look full, giving the image a sense of stability. The folds are depicted in deeply engraved lines, marking a series of S curves on the crossed right leg, imparting a lively sense of rhythm, and a series of U curves on the left leg. This method of expressing the folds in a series of engraved lines like a terrace, or steps, was prevalent in Eastern Wei. As stated before, this part is unrealistic in expression but is required in the form of the half cross-legged pensive image, and I have previously mentioned this as being a "great addition."[4] The upward and downward movement of the bowed head, the right arm supporting it, and the right leg supporting the arm, are ultimately supported by the hem of the skirt, and it is common to treat this part in an abstract way. However, in this statue this part is very realistic and rhythmic. Divided into two layers, the upper layer supporting the knee seems to be blown by the breeze and has been executed with excellent casting technique so that it is very three-dimensional and free of the body. The lower layer is a series of overlapping zigzags, imparting a quiet but strong sense of movement. This particular part brings a strong change in tone to the expression of this statue, which is a figure looking inwards and lost in thought, thus revealing a strong creative will. The sashes hanging from the sides of the waist go under the wrists and then appear again to hang down to the end of the pedestal, each tied in a bow. The sash on the right is decorated with a bead pattern and the one on the left with a crosshatch pattern.

The dhoti drapes quietly over the openwork pedestal, and the overlapping of U-shaped and Ω-shaped folds is typical of late Northern Wei or early Eastern Wei form. The same kind of folds can be found on the Stone Buddha Triad inscribed with the date 535 in the collection of Yurinkan Museum in Kyoto, Japan, and the principal figure of the Shakyamuni Buddha Triad in the main hall of Horyuji Temple, Japan, and is a good point of comparison between the three statues. The skirt drapes over the front and left and right sides of the pedestal, and the front has a two-tiered hem (the part that supports the right leg, and the part that drapes over the stool). This shows that the drape of the cloth has been

determined by the pose of the pensive image. On the left and right sides, the skirt of the old-style robes, the long decorative sash at each side, and the hem of the long robes that stick out toward the back are all in an orderly arrangement. The hem of the robes which turns up and sticks out toward the back in other statues usually sticks out to the left and right when seen from the front, as in the Buddhist statues of Northern Wei and Eastern Wei, and it is interesting to see that the structure of this pensive image has been oriented toward the back. The foot pedestal on which the left foot rests is composed of voluminous down-turned lotus leaves, a style that is often found in the Buddhist statues of Goguryeo.

The openwork pedestal is a very rare form. From the back, the pedestal and its cover can be seen. The upper part and lower part of the cover, separated by a band around the seat, are both in a double layer of folds, and in order to give some variation to the folds which are vertical overall, the upper part has been deliberately depicted in S-shaped folds like those at the right knee. These rhythmic and unrealistic folds in a set of folds that are stiff and formalized overall impart a sense of liveliness and compositional harmony to the whole. The back shows that this statue was very carefully designed.

The last thing to note here is that, seen from the back, the buttocks are sloped. Commonly the buttocks form a flat horizontal line, but in this statue, because the right leg is crossed over, the change in the line of the buttocks that naturally occurs is realistically expressed. So while the statue is as realistic as possible in terms of the structure of a body in pensive pose, there is a lovely harmony between these realistic parts and the parts that are unavoidably rendered abstract, and the complex ornamentation. Also, the statue has an overall flatness that was the stylistic characteristic of the time.

The above is an analysis of the form and structural characteristics of the Gilt-Bronze Pensive Image with Sun and Moon Crown through a comparison with the Buddhist images of Northern Wei and Eastern Wei of China. I have touched on the style of this statue and will now talk about the distinctiveness of the style.

Seen from the side, the body is supple and curved, and seen from the front, the thin waist serves as a supple connection between the large head and the lower body. The robes turn sharply up at the shoulders and at the hem, but overall they closely and softly follow the contours of the body. The folds at the knees are S-shaped on the right leg and U-shaped on the left leg, and variation has been given to the back of the pedestal cover with a combination of S- and U-shaped folds. The major characteristic of this statue is the use of these folds in the parts and the whole to achieve both harmony and variation. The dhoti featuring such abstract and schematized folds gives the statue a sense of flatness and adds decorativeness. The contradictory stylistic elements of realism, abstraction, flatness, decorativeness, stiffness, and suppleness do not create a conflict but achieve a beautiful and delicate harmony, and the body and the drape of the robes complement each other, producing a work of art that is unified overall.

In the end, analyzing the form and working out the style of the Gilt-Bronze Pensive Image with Sun and Moon Crown arouses a sense of delight in the beauty of the statue,

which isn't possible with the Gilt-Bronze Pensive Image with Lotus Crown.

If the Gilt-Bronze Pensive Image with Lotus Crown represents the high point of the early 600s when Korea achieved its own unique style while basically reflecting the Northern Qi style, the Gilt-Bronze Pensive Image with Sun and Moon Crown represents the high point of the latter half of the 6th century, when the style of Eastern Wei, which carried on the style of Northern Wei, is reflected. These two gilt-bronze pensive images represent the best of the styles of two different periods in the Asian Buddhist cultural sphere, and both styles had an influence on Japan, one on the Tori style of the Asuka period and the other on the non-Tori style.

3. Casting Technique

I have always had a great interest in the casting technique of gilt-bronze Buddhist images and discussed it in many essays along with the issues of style and form. The casting technique as seen from the inside is very closely related to the style and form as seen from the outside, and casting technique has changed in accordance with changes in external style.

The internal structure of the Pensive Image with Sun and Moon Crown was scientifically examined in 1963 by Koh Jong-geon and Ham In-yeong who used radio-stereography (Figs. 31–33).[5]

From the report of their findings, the section on "Analysis of Results" will be cited here. While I agree with their analysis overall, there are a few points that I would like to bring up. The casting technique used for this statue is the lost wax technique, and is basically the same as the technique used for the Pensive Image with Lotus Crown.

Based on the findings of the radio-stereography photos the following conclusions were reached.

"Overall there are very few air bubbles, with only a few small bubbles in the head and the right hand, which means the metal used is of very high quality. The thickness of the metal on the body of the statue ranges from 3mm to 8mm. Considering the size of the image, this shows very sophisticated casting technique, which is in contrast to the Pensive Image with Lotus Crown (National Treasure No. 83). ① The radio-stereography photos show that the head and the body were cast separately and attached to each other with two long nails. The neck was soldered with lead and the join burnished and smoothed down afterwards. The internal structure shows that of the nails joining the head and body, one is about 19cm long and extends from the head down to the top of the chest, and the other is about 12cm long and extends from the neck to the middle of the chest and is placed a little behind the other nail. In addition, the head part shows that the clay still remains inside the statue and that two rods, or rather nails, were used to fix the outer mold in place, one from left to right and one from front to back. ② Also it seems that the rod

that would have been used to fix the inner mold in place was removed through a square-shaped hole at the back of the head.

The thickness of the metal in the head part is roughly double that of the body and is not even, ranging from 7 to 13mm. Crossing the chest there is a square rod of about 8mm thickness that extends from the right arm to the left arm. Most of the clay in this part appears to have been removed, however in the two arms and the upper chest, there appears to be some left. ③ On the palm of the right hand, just below the middle finger, there is a hole about 9mm in diameter, which seems to have been necessary for the casting process. On the surface the hole was filled in with something like plaster and then gilded. Judging from various structural features and external decoration, this statue was made by making an inner mold out of clay, covering it with wax which was then carved and covered with an outer mold of clay. The figure was then heated so the wax would run out and molten bronze was then poured into the space left by the wax. ④ The thing to take note of here is the clear difference in the methods used to make the head and the body. For the head, the shape was roughly made with clay, then covered in thick bronze and carved, which is why the thickness is uneven and the interior is roughly finished. In contrast, the metal for the body is thin overall and even, and the surface on the inside is as smooth as the outside, which means that the method of making the mold is very different. The cause of this difference requires further study. Of the gilt-bronze statues that we have examined, no other has been made with this method, and no similar cases have been reported overseas. Therefore, the material and method of production of this pensive image are unique and are proof that the statue was made at a time when casting technique had become highly advanced. There are no faults on the inside or traces of repair, the whole figure having been preserved in excellent condition."

The above report is consistent and thorough, but there are parts that I would like to discuss.

① In this statue, the head and the body were not cast separately but as one. The reasons are first, the two nails serve the function of pins to fix the inner mold in place and therefore cannot function to join the head and the body. The other nails, or part of the rod, were taken out when the clay was removed from inside. Second, if the head and body had been made separately, then it would only make sense that the two nails at the neck would have been removed and the clay that still fills the inside would have to have been removed also. So judging from the inner structure this statue was cast all in one piece.

② The square hole at the back of the head is not the mark where one of the metal spacers was removed but the hole in which the aureole was fixed (0.7 × 1.3 cm). The stick that was inserted in the hole is now gone.

③ Though this part is not explained in detail, it is a point that has not been solved. It may be seen as the hole through which the square rod running through the two arms was removed, but the hole that can be seen in the palm of the hand is round rather than square, so this does not match.

④ This matter is related to the separate casting mentioned in ①, and as I have already stated, this statue was cast in one piece. The reason why the metal on the head part is thick is that as the undulations of the face are big, a thick layer of wax would have covered the inner mold to facilitate the carving. The face is the most important part of any Buddhist image and the undulations of the nose, eyes, and mouth are deep and important, and the thick layer of wax would have been applied to make the carving easier.

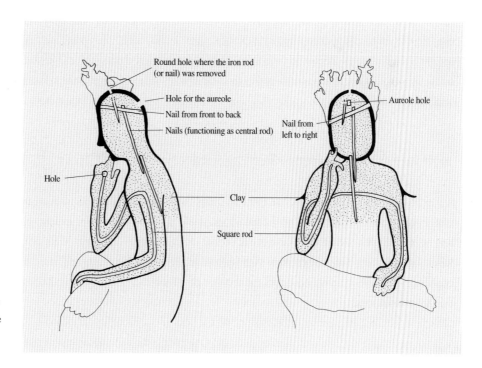

34. Internal structure of the Gilt-Bronze Pensive Image with Sun and Moon Crown.

A point that needs to be supplemented here is that as can be seen in figure 34 there is a nail of about 5 cm reaching down from the top of the head. There is no mention of this nail in the report. This nail is related to the round hole at the top of the head. That is, I believe it is part of the central core that held the inner mold in place. That central rod would have extended through the top of the head and been cut. This would have left a round hole on the top of the head. Because this hole cannot be seen from the front it was not filled in.

From an investigation of the inner structure of this statue I have made a reconstructed drawing, adding the points that were not mentioned by Koh and Ham (ex. There was no mention of the hole at the top of the head). As seen from the side, the central rod that would have extended down from the top of the head to form the core of the inner mold can be inferred.

In sum, the metal of this statue is thin overall and the figure was cast in one piece. The details of this statue such as the complex crown, the structure and composition of the robes, the solid hem that supports the right knee, show the excellence of the casting technique. Without highly advanced casting technique, such sensitive style and complex composition would not have been possible.

But the problem is the casting technique seen in the Gilt-bronze Pensive Image with Lotus Crown. As Koh and Ham mentioned, the casting technique in this statue is excellent, but that does not necessarily mean it was made later than the Pensive Image with Lotus Crown. Generally speaking, advance in style and casting technique is a good guide for dating but it is not an absolute standard.

However, the excellent casting technique of the Sun and Moon Crown Pensive Image must be connected with a nation that had a highly advanced metal craft culture. At the time, the Goguryeo Kingdom was the most advanced in this area. This point will be brought up again in the section on Goguryeo, but seen through the analysis of style and casting technique so far, it is most likely that this statue was made in Goguryeo, and is not a product of Baekje or Silla.

4. The Style of Eastern Wei Buddhist Statues of China

The style and form of the Gilt-Bronze Pensive Image with Sun and Moon Crown originated in China, but it is unclear whether the focus should be on Northern Wei, or Eastern Wei, or Northern Qi. But it seems largely to reflect intact the style and form of Eastern Wei, so the characteristics of Eastern Wei style should perhaps be examined more in detail here. Only when this is done will the stylistic developments among China, Korea, and Japan make sense.

Discussion of the pensive image form, one of the various forms of Buddhist images, must not be limited to those with one leg pendant. Only when the different forms of stat-

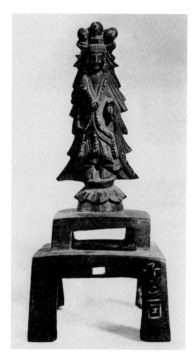

35. Gilt-Bronze Pensive
Image. Eastern Wei,
534−541. H. 7.8 cm.
(left)

36. Gilt-Bronze Pensive
Image. Northern Wei,
early 6th c. H. 7.6 cm.
(center)

37. Bronze Standing
Bodhisattva. Northern
Wei, 530. H. 14.5 cm.
(right)

ues from the same period are studied and compared across the board can the true charac-
ter of any one style be revealed, and only when the interrelationships between statues is
examined can the place of any one statue in the history of Buddhist sculpture be estab-
lished. However, it is very difficult to come up with a summary of how the Eastern Wei
style was transmitted since this process was very complex. In China alone the Eastern
Wei style developed in complex and varied ways according to region (Figs. 36, 37), and
when it was introduced to Korea, it was developed in different ways by each of the Three
Kingdoms—Goguryeo, Baekje and Silla—and in different times, complex combination
of forms were produced. The Korean developments of the Eastern Wei style was then
transmitted to Japan, where it influenced the style of the Asuka period, which effected its
own stylistic changes and development of form. However, if all these aspects are ana-
lyzed and compared in detail, the large outline can be drawn, though it may be hard to
come up with the complete picture.

First, at Xiudesi Temple in Quyang there are 247 statues bearing a date of production,
among which are 40 Eastern Wei statues. In regards to this, Yang Boda (楊伯達) divides
Eastern Wei Dynasty into three different periods—the Tianping era (天平期, 535−538),
the Xinghe era (興和期, 539−542), and the Wuding era (武定期, 543−550)—and looks
briefly at the stylistic changes in each. In the Tianping era to mid-late Xinghe, Buddhist
statues were made in the style of late Northern Wei, long and thin overall with a round
face and squarish jaw line, and the face was large compared to the whole body. The hem
of the skirt was spread out wide to the left and right. Then in the ten years between late
Xinghe and the Wuding era, great changes were made: the height shrank, the body

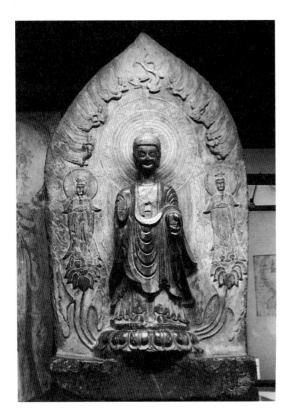

38. Stone Standing
Buddha Triad. Eastern
Wei, inscribed "2nd
year of Tianping" (535).
H. 179 cm.

became plump, and the overall proportions of the body grew childlike. These characteristics continued through the Northern Qi Dynasty, where it became the fixed form, with only a change in the expression of the robes.[6] Looking at what came before and after, it can be concluded that the style of Eastern Wei Buddhist statues was a transitional style between those of Northern Wei and of Northern Qi. Of course, even if Eastern Wei did have a unique style of its own, it is still considered transitional because, unlike Northern Wei before it or Northern Qi afterwards, Eastern Wei did not have any fixed style. That is, early Eastern Wei style was that of late Northern Wei, and late Eastern Wei can be the called the formative period of Northern Qi style, all of which indicate transitional aspects.

However, in his paper "Essay on Eastern Wei Sculpture," Matsubara Saburo (松原三郎) discussed in great detail the position occupied by Eastern Wei style in the history of ancient Chinese sculpture.[7] Though his focus was on the history of Chinese sculpture, he also had great interest in the history of ancient Korean sculpture and wrote many papers on the subject, pointing out the connection between China, Korea, and Japan from a macroscopic perspective.

He, too, saw the Eastern Wei style as a transitional style between Northern Wei and Northern Qi, and pointed out that it showed many diverse aspects in a short period, varying according to time and place, and that therefore no unified style was established.

However, Matsubara deals with the transitional Eastern Wei style by studying the collapse of the style of the Zhengguang era (正光, A.D. 520−525) of Northern Wei, a period

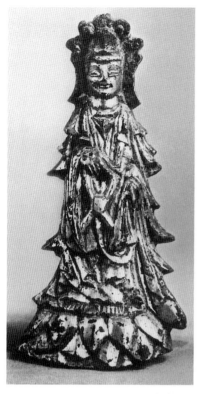

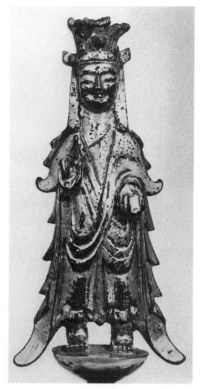

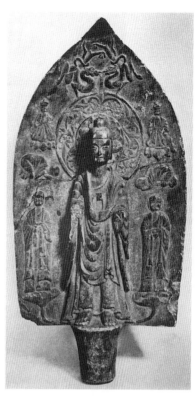

39. Gilt-Bronze Standing
Bodhisattva. Eastern Wei, 534–
542. H. 11.2 cm. (top left)

40. Gilt-Bronze Standing
Bodhisattva. Western Wei, 535–
556. H. 10.5 cm. (top center)

41. Gilt-Bronze Standing
Buddha. Eastern Wei, inscribed
"fourth year of Tianping" (537).
Excavated from Qufu, Shandong
province, China. H. 46 cm.
Tokyo University, Japan. (top
right)

42. Stone Standing Buddha.
Excavated from Chengdu,
Sichuan province, China. Liang,
537. H. 126.5 cm. (bottom left)

43. Stone Seated Buddha.
Excavated from Chengdu,
Sichuan province, China. Liang,
6th c. (bottom right)

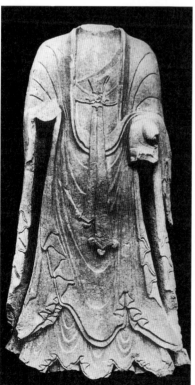

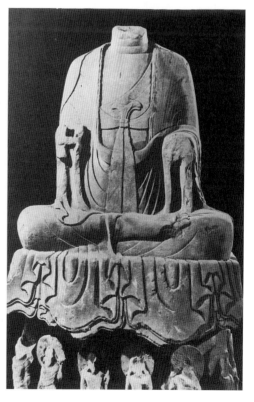

of rule over a unified territory. He said that the Zhengguang style was most strongly established in the Hebei region, which later directly came under Eastern Wei territory, and that the Northern Wei style was in evidence for a long time during Eastern Wei. In contrast, he pointed out that in the Henan region, which was a point of contact between the Northern and Southern dynasties, stylistic change had already begun in late Northern Wei. A sense of the three-dimensional had partially appeared, the drapes of the robes had begun to be engraved and the face had become larger. Buddhist statues of Henan, late Northern Wei, such as the Stone Buddha Triad in the Metropolitan Museum, or the Stone Buddha Triad in Ohara Museum in Japan, or the Stone Buddha Triad inscribed with the third year of Yongxi (543) in the Freer Gallery in the United States show the beginnings of Eastern Wei style. The partial fullness that started to appear in late Northern Wei, which is inconsistent with the overall flatness and stiffness of the Northern Wei style, continues into early Eastern Wei. The fullness grows, the attire and decoration become simpler, and the figure is made with softly curving lines. The major example is the Stone Buddha Triad from the Tianping era (534−537) in the Tokyo National Museum.

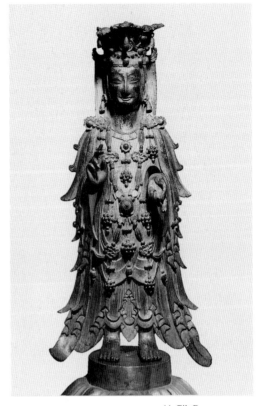

44. Gilt-Bronze Standing Bodhisattva. Northern Zhou, 557−580. H. 40 cm. Tokyo University, Japan.

The figure, with robes falling straight down and decorated simply, is full of strength, and its overall sophistication is mixed with a feminine gentleness, resulting in a quiet and yet showy grace. This kind of sensibility is a characteristic of the Henan region, and gradually became fixed as the Eastern Wei style. In the Luoyang region, however, the Northern Wei style continued right through to the Wuding era. The mixing of regional styles within China holds many clues for dealing with Eastern Wei-style sculptures from the Three Kingdoms period of Korea. Ultimately, the Eastern Wei style was not a single established style, as it was unable to rid itself of the form and symbolism of Northern Wei. But the major characteristic consistent throughout Eastern Wei was the coexistence of a sense of fullness and flatness, and a linear composition. In addition, the decorativeness of the aureole was emphasized, leading to extremely high craftsmanship. This contradictory style of Eastern Wei Buddhist statues, though reflected intact in Korea, also went through changes while being assimilated, taking on a more complex aspect. A statue that reflects the influence of Eastern Wei, as well as the changes during its introduction to Korea, thus resulting in a unique style, is the Gilt-Bronze Pensive Image with Sun and Moon Crown. Therefore, the issue of this work's style and form will be examined with references to examples from the first half of Eastern Wei.

Pensive images featuring a garment that widens and turns up at the shoulders (pi-geon)

and then suddenly narrows at the waist and crosses over at the knees was established in the early 6th century, during the late Northern Wei dynasty. This form is seen not only in many pensive images, such as the Gilt-Bronze Pensive Image inscribed the 5th year of Zhengguang (524) or the Stone Pensive Image from Huatasi Temple (花塔寺) in Xian (collection of Xichuan) (Fig. 184), it is also one of the major forms of standing bodhisattva images from the late Northern Wei Dynasty. This was followed to some extent in the first half of Eastern Wei and, though not commonly found, can be seen in the early gilt-bronze pensive images from that period (Fig. 35). The attendants in the Bodhisattva Triad inscribed the 2nd year of Tianping (〔535〕, Fig. 38) and the Stone Pensive Image inscribed the 2nd year of Xinghe (540) found at Xiudesi Temple site (修德寺址) in Quyang, China, feature the upturned pi-geon at the shoulders, but the crossed-over robes is a feature that disappeared over time.

The expression of the folds change in late Northern Wei to narrow layers and then, as seen in the Tianping Buddha Triad, there are many examples where the folds were expressed in thick engraved lines. In addition, a characteristic of Eastern Wei is the elaborate decorativeness of the mandorla. Such characteristics of Eastern Wei Buddhist images are faithfully reflected in the Gilt-Bronze Pensive Image with Sun and Moon Crown.

But the most striking change in the form of Eastern Wei Buddhist statues is the change in the dhoti, which originally stuck out to the left and right at the bottom. Considering this point to be important, I decided to study this characteristic, keeping in mind the Eastern Wei-type Buddhist statues of the Three Kingdoms in Korea and the Tori style Buddhist statues of the Asuka period in Japan.

An important stylistic change in the transition from Northern Wei to Eastern Wei can be found in the hem of the dhoti. In Northern Wei the hem is pointed and uneven and exaggerated. But in Eastern Wei, as seen in the gilt-bronze statue in figure 39, the gilt-bronze statue of Western Wei in figure 40, and the gilt-bronze statue of Northern Zhou (北周) in figure 44, the hem sticks out at the sides in a stylized, abstract, and orderly pattern. Korean examples showing Northern Wei form include only a few from Goguryeo, while there are many showing Eastern Wei style from Goguryeo, Silla, and Baekje. The Buddhist figures of the Three Kingdoms show that this form of robe was further developed and established in Korea. The hem of the skirt separates into two strands and is transformed into unrealistic shapes in both Goguryeo and Baekje, but in a more lively way in Goguryeo. And as can be seen in the Gilt-Bronze Pensive Image with Sun and Moon Crown, it reached the stage where the ends were pointed like the end of a dagger. This aspect will be mentioned again when discussing the Eastern Wei-style statues of Goguryeo and the Tori style Buddhist statues of Japan.

5. Korean Buddhist Statues of the Eastern Wei Style

In the above, the form and style of the Gilt-Bronze Pensive Image with Sun and Moon Crown has been shown to reflect faithfully the Eastern Wei style of China. It has also been shown that Korea went beyond the confines of the Eastern Wei style to produce a uniquely Korean style.

To further clarify the nature of this statue, it is necessary to sort through the Eastern Wei-style Buddhist statues from the Three Kingdoms period of Korea. I will focus on the statues of Goguryeo, an area in which research has been especially vague, and talk about the cultural exchange between Goguryeo and Northern or Eastern Wei to sort out the Goguryeo statues which are related to the Eastern Wei style, and then examine the cultural exchange between the Three Kingdoms. Such study seems a prerequisite to solving the riddle of which kingdom produced the Gilt-Bronze Pensive Image with Sun and Moon Crown.

1. Goguryeo

From the Chinese perspective, Goguryeo was basically one of the kingdoms in the era of the Sixteen Kingdoms by Five Clans of Barbarians (五胡十六國時代) of China and for

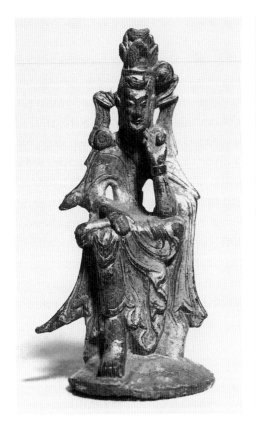 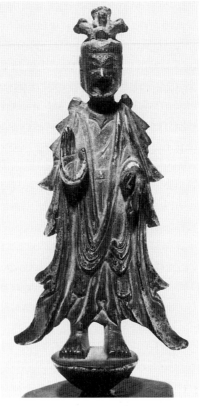

45. Gilt-Bronze Pensive Image. Northern Wei, early 6th c. H. 9.1 cm. National Museum of Korea, Seoul. (left)

46. Gilt-Bronze Standing Buddha. Goguryeo, 6th c. H. 15.1 cm. Treasure No. 333. National Museum of Korea, Seoul. (right)

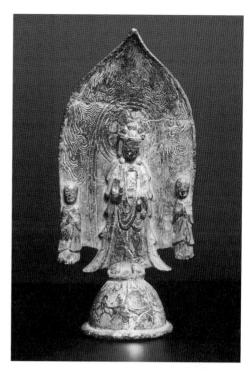

47. Gilt-Bronze Buddha Triad. Goguryeo, "inscribed 5th year of King Pyeongwon" (563). H. 17.5 cm. Kansong Art Museum, Seoul. (left)

48. Gilt-Bronze Bodhisattva Triad. Goguryeo, mid-6th c. Presumed excavated from Chuncheon. H. 8.8 cm. Ho-Am Art Museum, Yongin. (right)

this reason very different from Baekje and Silla.[8] In addition, until the early 4th century Goguryeo was very closely related with Lolang (樂浪) in China, which it occupied in 313. Goguryeo was therefore more strongly influenced by the Lolang cultural tradition than the other two kingdoms, and this resulted in their playing an important role in the spread of the Lolang culture through Baekje and Silla.

Goguryeo culture, centered in Pyongyang, developed rapidly when it adopted the excellent technology of Lolang. At the same time, Goguryeo's strong southern expansion policy swept over Baekje and Silla. Goguryeo defeated Lolang in 313, but the Lolang commandery, which had been governed by the Han Dynasty for 400 years, had had a strong influence on the politics, economics and culture of the Korean peninsula. This influence was not limited to areas directly ruled by Han but spread through the whole peninsula and also influenced Japan. The most important aspect of the Lolang commandery is its cultural influence because its highly advanced metalworking techniques became highly coveted in indigenous Korean society.

The spread of metalworking techniques across the Korean peninsula was not limited to the time the Han state continued to exist; the influence of Han would have strengthened the solid base of Goguryeo culture and thus continued. In the late 4th century King Sosurim established peaceful relations with the Former Qin Empire (前秦) and concentrated efforts on importing Buddhism and new systems and culture. King Gwanggaeto, who succeeded him, conquered vast territories in the late 4th and early 5th centuries, occupying Manchuria east of Liaohe. Although Korea and China were military adver-

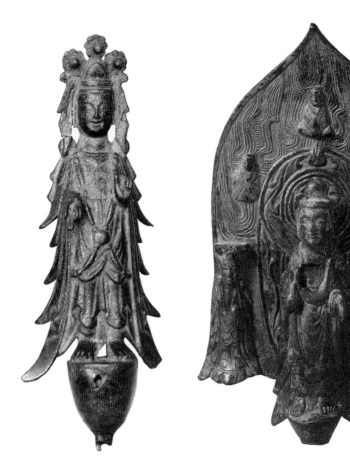

49. Gilt-Bronze Standing Bodhisattva. Goguryeo, mid-6th c. H. 19.2 cm. Mt. Funagata shrine, Japan. (left)

50. Gilt-Bronze Amitabha Buddha Triad. Excavated from Goksan. Goguryeo, inscribed "4th year of Sinmyomyeong" (571). H. 15.5 cm. National Treasure No. 85. Ho-Am Art Museum, Yongin. (right)

saries, Korea actively adopted Chinese culture along with the territories it conquered.

In the period from the late 4th and early 5th centuries, when Gwanggaeto conquered vast territories, to the time of King Jangsu (長壽王) and King Munja (文咨王) in the early 6th century, Goguryeo saw its most dazzling development. After King Gwanggaeto had conquered vast territories and King Jangsu moved the capital to Pyongyang, Goguryeo formed even closer ties with Northern Wei and sent envoys to pay tribute every year, often up to three times a year.

While continuing to pay frequent tribute to Northern Wei, Gogureyo also began, in the 21st year of King Munja, paying tribute to the Liang Dynasty (梁). During the reign of King Anjang (519−530), the Liang emperor tried to invest the Goguryeo king with a title but failed because of the interference of Northern Wei. In spite of this, Goguryeo sent more envoys to Liang than to Northern Wei. During the reign of King Anjang and King Anwon, envoys were sent to Liang seven times, and to Northern Wei three times. After Northern Wei was divided into Eastern Wei and Western Wei, Goguryeo paid tribute to Eastern Wei quite frequently but did not fail to send envoys to Liang as well.

These political and diplomatic relations show that in the first half of the 6th century Goguryeo had contacts with both the Southern and Northern dynasties of China, which means that, in addition to Northern Wei or Eastern Wei influence on the Buddhist sculp-

ture of Goguryeo, the style of the Southern dynasties should also be considered.

With the arrival of the Tang Dynasty, the Buddhist culture of Goguryeo changed greatly and rapidly declined. When Tang unified China, King Yeongnyu ascended to the throne of Goguryeo and received Taoism from Tang. In the 7th year of the reign of King Yeongnyu, the Tang ruler ordered a Taoist priest to take the statues of the immortals and the Taoist canon and preach about Lao-tzu (老子) while the king and all the people listened. Later, in the 2nd year of the reign of King Bojang (寶藏王, 643), the Tang emperor sent, at the request of General Yeon Gaesomun, a Taoist priest and eight other people to Goguryeo along with Lao-tzu's *Tao-te Ching* (道德經). The king had these people stay at Buddhist temples.[9]

There are relatively few records of Buddhist culture in Goguryeo compared to Baekje or Silla. It can be surmised, however, that when Buddhism came under the pressure of Taoism in the early 7th century, it rapidly declined. But at least until the late 6th century, Buddhism flourished, and Goguryeo not only adopted Buddhist culture earlier than Baekje or Silla, it played a role in the expansion of Buddhist culture into those other two kingdoms, a process which is reflected in ancient Korean art overall.

Though the lack of reliable written records and the paucity of remains and relics make the study of Goguryeo Buddhist art problematic, I have briefly described what the available records say about the general current of Buddhist culture in Goguryeo.[10]

Despite the scarcity of extant records and relics, the excellence of Goguryeo culture can be inferred to some extent from the existing tomb murals, the scale of the temples that are being discovered one by one, and the Goguryeo relics excavated from the tombs

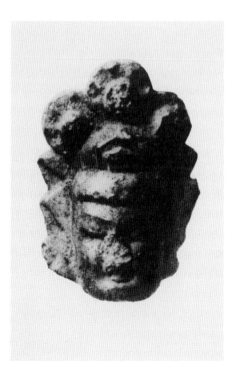
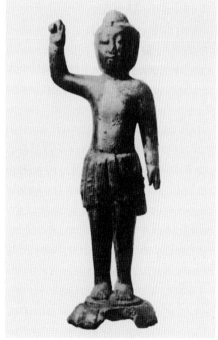

51. Head of Gilt-Bronze Bodhisattva. Goguryeo. Collection of Miakawa, Japan. (left)

52. Gilt-Bronze Infant Buddha. Presumed excavated from Sadong. Goguryeo, 7th c. H. 10 cm. Private collection (right).

53. Clay Standing Bodhisattva. Excavated from Wonori, Pyongwon. Goguryeo, mid-6th c. H. 17 cm. National Museum of Korea, Seoul. (left)

54. Clay Seated Buddha. Excavated from Wonori, Pyongyang. Goguryeo, mid-6th c. H. 17 cm. Pyongyang Museum, Pyongyang. (right)

of Silla, Gaya (伽倻), and Baekje kingdoms. Such speculation is only possible by taking into consideration the unique characteristics of the cultures of Goguryeo and Lolang, which was ruled by China.

What then was the style of Goguryeo Buddhist images? Considering the close contact Goguryeo had with Chinese culture and the overwhelming and wide-reaching influence it had on the entire Korean peninsula and Japan, Buddhist culture in Goguryeo seems to have flourished during the first half of the 6th century. This view is supported by the existence of Goguryeo Buddhist statues in the Eastern Wei style. There are Baekje and Silla statues that show the influence of the styles of Northern Qi and Sui that descended from Eastern Wei, but in Goguryeo the overwhelming stylistic influence was Northern Wei and Eastern Wei. The influence of Northern Qi and Sui was not really apparent until the 7th century, which was when Buddhism had declined in Goguryeo, and consequently there are not many statues reflecting Northern Qi and Sui styles. Against this general background, I will discuss the Buddhist statues whose place of excavation is known, which carry an inscription, and whose place of excavation is not exactly known but can be judged to fall under the category of Goguryeo style.

First, the following are statues that strongly reflect the Northern Wei style (including some that may have been produced in China).

1. Gilt-Bronze Seated Buddha, around 400, China (Sixteen Kingdoms period), excavated from Ttukseom, Seoul.

2. Gilt-Bronze Pensive Image, early 6th century, Northern Wei, collection of the National Museum of Korea (Fig. 45).

3. Agalmatolite Seated Buddha, presumed excavated near Hwangju, (private collection), Japan, height: 12 cm.

4. Gilt-Bronze Standing Buddha (inscribed 7th year of Yeonga), 7th year of King Anwon (539 A.D.), discovered in Euiryeong, Gyeongsangnam-do province (Fig. 1).

5. Gilt-Bronze Standing Buddha, mid-6th century, collection of the National Museum of Korea (Fig. 46).

6. Mandorla of Gilt-Bronze Maitreya (inscribed 7th year of Yeongang), excavated from Pyeongcheon-ni, Pyongyang, collection of Pyongyang Museum.

7. Gilt-Bronze Buddha Triad (inscribed Gyemi year), 5th year of King Pyeongwon (平原王, A.D. 563), collection of Kansong Art Museum, Korea (Fig. 47).

8. Gilt-Bronze Bodhisattva Triad, mid-6th century, presumed excavated from Chuncheon, Gangwon-do province, collection of Ho-Am Art Museum (Fig. 48).

9. Gilt-Bronze Standing Bodhisattva, mid-6th century, Japan, preserved at the Mt. Funagata shrine (Fig. 49).

10. Head of Gilt-Bronze Bodhisattva, collection of Miakawa (Fig. 51).

11. Gilt-Bronze Amitabha Buddha Triad (inscribed 4th year of Sinmyomyeong), 13th

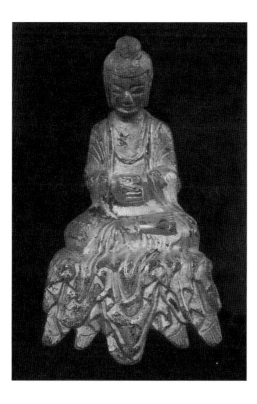

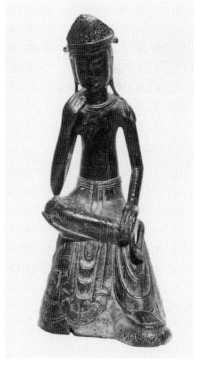

55. Gilt-Bronze Seated Buddha. Goguryeo, mid-6th c. H. 9 cm. National Museum of Korea, Seoul. (left)

56. Gilt-Bronze Pensive Image. Goguryeo, second half 6th c. H. 21 cm. National Museum of Korea, Seoul. (right)

57. Fragments of Buddhist sculpture molds. Excavated from Toseongni, Pyongyang. Goguryeo. National Museum of Korea, Seoul.

year of King Pyeongwon (571 A.D.), excavated from Goksan, Hwanghae-do province, collection of Ho-Am Art Museum (Fig. 50).

12. Gilt-Bronze Buddha Triad, presumed excavated from Gawangju, collection of Pyongyang Museum, height: 15 cm.

13. Gilt-Bronze Infant Buddha, presumed excavated from Sadong, private collection, height: 10 cm (Fig. 52).

14. Wonori Clay Standing Bodhisattva and Seated Buddha, mid-6th century, excavated from Wonori, Pyongwon-gun, Pyeongnam (Figs. 53, 54).

15. Pyongyang Buddhist sculpture molds (Fig. 57).
 ① Clay Seated Buddha (mold for Wonori Seated Buddha).
 ② Clay Seated Buddha.
 ③ Clay Seated Buddha.

16. Gilt-Bronze Seated Buddha, mid-6th century, collection of National Museum of Korea (Fig. 55).

17. Mandorla of Gilt-Bronze Shakyamuni Buddha Triad (inscribed Gapin Year), 5th year of King Yeongyang (594), collection of Tokyo National Museum, Japan (Fig. 58).

18. Gilt-Bronze Pensive Buddha, collection of National Museum of Korea (Fig. 56).

19. Mandorla of Gilt-Bronze Shakyamuni Buddha Triad (inscribed 5th Year of Geonheung), 7th year of King Yeongyang (596), excavated from Jungwon-gun, Chungcheongbuk-do province (Fig. 59).

Goguryeo Buddhist statues developed certain common characteristics in style and form. In contrast to the stillness of Baekje style and the coarseness and massiveness of Silla style, the major characteristic of Goguryeo Buddhist statues is the rhythmic depiction of movement, which can also be seen in the Gogruyeo tomb murals.

58. Mandorla of Gilt-Bronze Shakyamuni Buddha Triad. Goguryeo, inscribed "Gabin year" (594). H. 31 cm. Tokyo National Museum, Japan. (p.57 top)

59. Mandorla of Gilt-Bronze Shakyamuni Buddha Triad. Excavated from Jungwon. Goguryeo, inscribed "5th Year of Geonheung" (596). H. 12.4 cm. Buyeo National Museum, Buyeo. (p.57 bottom)

While there are a few Eastern Wei-type Buddhist statues from Baekje, the number is small and they do not reflect the Eastern Wei style as clearly as Goguryeo images. A macroscopic investigation of the Eastern Wei-style Buddhist statues from the Three Kingdoms period of Korea leads to the inevitable conclusion that the Gilt-Bronze Pensive Image with Sun and Moon Crown belongs to late 6th-century Goguryeo. This is borne out by its accurate reflection of the Eastern Wei style, the soft yet sharp treatment of the robes, the overall straightness, the stiffness, the coexistence of these characteristics with the roundness of the face and hands, the deep and stylized folds of the robe, the way the hem is finished sharply and sticks out toward the back, the extreme decorativeness of the crown, the most accomplished casting technique found in any gilt-bronze Buddhist image, the upright form of the voluminous lotus foot pedestal, and the way the sharply upturned ends of the shoulder garment resembles an outturned hat. In the Goguryeo style, all these elements are connected to each other for the first time, revealing many points in common while standing on their own. In Baekje Buddhist statues of the Eastern Wei type, the Eastern Wei style has already been transformed in Baekje fashion. However, it can be hypothesized that Goguryeo statues of the Eastern Wei type had a big influence on Baekje.

Before examining how the Goguryeo style of Buddhist sculpture, established through cultural contact with Northern Wei and Western Wei, influenced Baekje and Silla, it is necessary to give a general outline of cultural exchanges between the Three Kingdoms. So far it is known that Goguryeo produced the greatest number of Buddhist statues in the 6th century of the Three Kingdoms period, and any further research will only confirm this point. So it is necessary to re-examine the cultural relationship between the Three Kingdoms from this perspective.

King Jangsu (413−491) succeeded Gwanggaeto and inherited his plans and ambitions, and took Goguryeo to its greatest height. In 427 he moved the capital to Pyongyang and undertook reforms, ushering in the period of greatest cultural stability. Threatened by such movements, Silla and Baekje created an alliance, but in 475 Goguryeo conquered Baekje's capital, Hansan, and killed King Gaero, forcing Baekje to move its capital to Ungjin. Goguryeo now had vast territory that stretched from Manchuria and the Juknyeong region to Namyang Bay, forming a kind of empire and battling for supremacy with China.

So what exactly is "Goguryeo style"? Though it has been briefly mentioned, the stylistic characteristics of Goguryeo art and culture will be summarized once again. The artistic style of Goguryeo is closely related to that of northern China. The Goguryeo tomb murals reveal such friendly relations between the two that Goguryeo could be

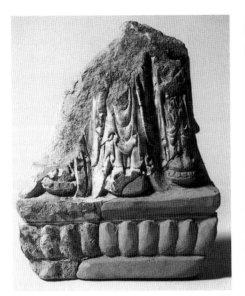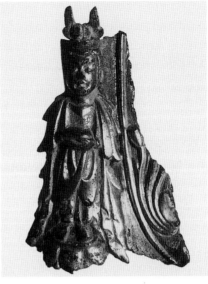

called an extension of northern Chinese culture. The grand scale of Goguryeo, on a par with northern China, can be seen in its vast territory, huge tombs, and large-scale fortresses. The stele of King Gwanggaeto the Great (a gigantic natural stone) is a symbolic artifact of such Goguryeo culture, the bold and majestic calligraphy of its inscriptions being in the Chinese calligraphic style rather than being derivative of it. Indeed, the style of calligraphy on many ancient Goguryeo tombs is that of the Northern Dynasties of China.

This is not to downplay Goguryeo culture simply as an extension of the Northern Dynasties culture. While the earlier period of Goguryeo culture should be considered as falling under that category, as Goguryeo gradually expanded over the Korean peninsula and came into contact with Baekje and Silla, it began to form its own unique cultural characteristics. In the larger picture, Goguryeo culture played a mediating role between Chinese culture and Baekje, Silla, and Japanese cultures. From the late 5th century to the early 7th century, Goguryeo developed a unique culture of its own, and its characteristics can be detected for the first time in its Buddhist statues from the early 6th century. The Gilt-Bronze Yeonga Buddha (延嘉七年銘金銅如來立像, inscribed the 7th year of Yeonga [539]) boasts a commanding sense of volume in the robes, the pedestal, and the lotus petals—a quality absent in the work of the other two kingdoms—and the free yet well-ordered sensibility can be seen in the pattern of the holy spirit emanating from Buddha on the mandorla. This sense of great freedom and strength can also be seen in the gilt-bronze Goguryeo crown excavated in Pyongyang, and the same commanding sense of volume continues to be found in later works, for example, the Gilt-Bronze Standing Buddha excavated in Yangpyeong. Even the Gilt-Bronze Standing Bodhisattva presumably excavated in Chuncheon, a small figure only 9 cm high, is finely crafted but has the same free and open character. In summary, Goguryeo art has a commanding sense of volume, liveliness, free and open character, strength, precision and meticulousness, and gentleness,

sometimes leaning toward the sensibility of the Northern Dynasties and sometimes the Southern Dynasties, and sometimes a harmonious mixture of both, which sets it apart from the art of Baekje and Silla.[11]

2. Baekje

When Silla occupied the Hangang River basin in the mid-6th century, Goguryeo and Bakeje became geographically separated. As a result, from that point on (502-557) it can be said that Baekje culture began to change in nature. It is believed that in the first half of the 6th century, Baekje actively adopted the culture of Liang, China, and received the influence of Wei or Eastern Wei, while also being heavily shaped by its contact with the more culturally advanced Goguryeo. Baekje thus entered a period of cultural maturity, developing its own sense of style. This is evident in King Muryeong's tomb, built in 525, which reveals the overwhelming influence of the Southern Dynasties (Liang) and the influence of Goguryeo; and excavations of Jeongnimsa Temple site have revealed the influence of the Southern Dynasties and Northern Wei as well. So while Baekje was geographically separated from Goguryeo in the mid-6th century—with Silla standing in between them—it would not have been able to ignore Goguryeo culture, which had already taken root in that region, as already mentioned.

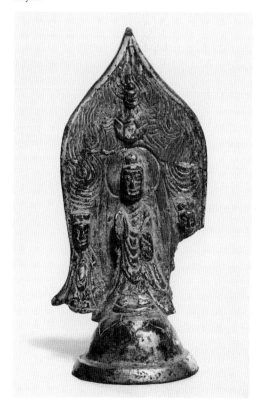

62. Gilt-Bronze Buddha Triad. Baekje, inscribed "Jeong Ji-won," 7th c. H. 8.5 cm. Treasure No. 196. Buyeo National Museum, Buyeo.

Meanwhile, Baekje also came into close contact with Silla, which had been heavily influenced by Goguryeo in the latter half of the 6th century. The cultural contact between Baekje and Silla continued into the mid-7th century, and in spite of the two kingdoms being bitter rivals, Baekje sent the master artisan Abiji to Silla to construct the nine-story wooden pagoda at the monumental Hwangnyongsa Temple (皇龍寺), designed to appease the nine neighboring barbarian states. Meanwhile, Baekje culture spread as far as Japan in the mid-6th century when it transmitted Buddhism to Japan.

The above is a brief survey of Baekje and its relations with neighboring countries, and since much research has been carried out in this area, I will concentrate my research on its Buddhist statues of the Eastern Wei style.

First, the following are statues that reflect the style of Northern Wei or Liang.

1. Gilt-Bronze Seated Buddha, excavated at Sin-ni, Buyeo, collection of Buyeo National Museum.
2. Gilt-Bronze Standing Buddha, excavated at Bowonsa Temple site, Unsan-myeon, Seosan-gun, collection of Buyeo National Museum.

 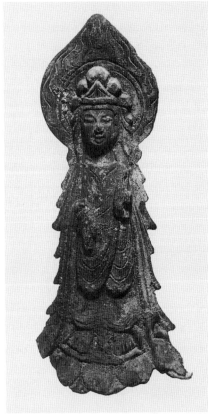

63. Gilt-Bronze
Standing Bodhisattva.
Excavated from
Gunsurisa Temple site,
Buyeo. Baekje, 6th c.
H. 11.5 cm. Treasure
No. 330. (left)

64. Gilt-Bronze
Standing Bodhisattva.
Excavated from Sin-ni,
Buyeo. Baekje, 6th c.
H. 10.2 cm. Buyeo
National Museum,
Buyeo. (right)

3. Agalmatolite Buddha Triad, excavated at Jeongnimsa Temple site, Buyeo, collection of the National Museum of Korea (Fig. 60).

The following are statues of the Eastern Wei style.
1. Agalmatolite Pensive Image, excavated at Busosan, Buyeo.
2. Fragment of Gilt-Bronze Buddha Triad, provenance unknown (Fig. 61).
3. Gilt-Bronze Buddha Triad (inscribed Jeong Ji-won), discovered at Busosan, Buyeo (Fig. 62).
4. Gilt-Bronze Standing Bodhisattva, excavated at Gunsurisa Temple site, Buyeo .
5. Agalmatolite Seated Buddha, excavated at Gunsurisa Temple site, Buyeo (Fig. 63).
6. Gilt-Bronze Standing Bodhisattva, excavated at Sin-ni, Buyeo (Fig. 64).
7. Gilt-Bronze Standing Buddha, excavated at Gatamni, Buyeo (Above statues all in the collection of the Buyeo National Museum).
8. Gilt-Bronze Pensive Image, excavated at Gongju, collection of Tokyo Museum, Japan (Fig. 65).
9. Fragment of Agalmatolite Bodhisattva, Dongnamnisa Temple site, Buyeo, collection of Buyeo National Museum.
The above are Baekje Buddhist images from the latter half of the 6th century that reflect

65. Gilt-Bronze Pensive
Image. Excavated from
Gongju. Baekje, 6th c.
H. 16.3 cm. Tokyo
National Museum,
Japan. (p. 61)

66. Gilt-Bronze Standing Buddha. Excavated from Hwangnyongsa Temple site, Gyeongju. Silla, 6th c. H. 14 cm. Dongguk University, Seoul. (left)

67. Gilt-Bronze Standing Buddha. From Suksusa Temple site, Yeongju. Silla, 6th c. H. 11.3 cm. National Museum of Korea, Seoul. (right)

the Eastern Wei style. Compared to Goguryeo's, such statues are concentrated in the latter half of the 6th century and no stone statues reflecting the Eastern Wei style were produced.

The Gilt-Bronze Buddha excavated from the site of Bowonsa Temple, the Gilt-Bronze Standing Bodhisattva excavated from Sin-ni, the Gilt-Bronze Standing Bodhisattva excavated from Gunsurisa Temple site, and the Gilt-Bronze Buddha excavated from Gatam-ni, are all triads sharing a single mandorla (一光三尊佛). It is notable that the Buddhas and Bodhisattva figures are all separately made and fixed onto the mandorla independently. As seen in the Goguryeo statues, in most cases only the principal figure is made separately while the attendants on either side are cast as one with the mandorla, so the separate casting of all three figures represents great progress. An mandorla inscribed with the year Gapin (594), however, shows that this form of three separately cast figures had already been established in Goguryeo in the latter half of the 6th century.

Much of the research in this area has thus far been carried out by Japanese scholars, and as a result only the relationship between Baekje art with that of the Southern Dynasties in this period has been emphasized, thus establishing the following scheme for the transmission of culture: Southern Dynasties culture → Baekje culture → Asuka culture. But in the context of the flow of cultural exchange at the time, this is a very biased view. At times, the comparison of Japanese culture with the culture of Goguryeo and Silla is confrontational, and at other times there seems to be an emphasis on the close

contact with Baekje, which had a more advanced culture. But as far as style is concerned, that of the Southern Dynasties has not been clearly identified, and as seen in the Baekje Buddhist statues so far, those made in the 6th century had a more direct and sustained relationship with the Northern Dynasties and Goguryeo.

In general, the examples taken to illustrate the relationship with the Southern Dynasties are Liang statues from the early half of the 6th century, such as those seen in figures 42 and 43 (excavated at Wanfosi Temple site [萬佛寺址], Sichuan Sheng province, China), but it is premature to draw any conclusions from so few examples. There are many examples of this form from the Northern Dynasties, and the geographic conditions of Sichuan Sheng province should be taken into consideration again.

3. Silla

In the 6th century during the Three Kingdoms period, Silla received overwhelming influence from Goguryeo and then in the 7th century from Baekje. Being isolated in terms of relations with China, it generally came into contact with Buddhist sculptures second-hand through Baekje and Goguryeo, which is why there are few Silla statues that accurately reflect the Chinese style. Because of this second-hand assimilation of Buddhist sculpture, many Silla statues are illogical in form and primitive in style.

Though Silla occupied the Hangang River basin under the reign of King Jinheung (眞興王) and from the mid-6th century began to receive Chinese culture directly, Goguryeo had already ruled this area for a century and established its culture there, so this cultural foundation cannot be ignored. In this light, the influence of Goguryeo culture on Silla should be emphasized more strongly. Without doing so, it is hard to explain the Eastern Wei-style Buddhist statues that were discovered in Silla territory. And although exchanges between Silla and China became frequent in the mid-6th century, by this time Eastern Wei had been succeeded by Northern Qi, during which period big changes occurred in the style of Buddhist statues.

The above explains the discovery of Goguryeo-style statues estimated to date from the latter half of the 6th century in places such as Hwanghae-do province, Gyeonggi-do province, and Gangwon-do province. Although Silla occupied the Gangwon-do and Gyeonggi-do regions in military terms, the cultural foundation remained that of Goguryeo culture, which appears to have continued and developed for quite some time. Silla culture was concentrated in the Gyeongju area at the time, and it is difficult to conclude that it had a strong influence in these other regions.

An example of an Silla statue that reflects the Northern Wei style is the Gilt-Bronze Standing Buddha (Dongguk University collection) presumed to have been excavated from the Hwangnyongsa Temple site. Its thick robes and wide U-shaped folds in the abdomen area, and the way the robes are draped over the two hands and the hem is pointed at the ends and slightly flared clearly suggest Northern Wei style, which would have

been introduced via Goguryeo (Fig. 66). Examples of Silla statues of the Eastern Wei style are as follows.

1. One of the oldest Eastern Wei-style gilt-bronze statues from Silla is that found at Suksusa Temple site (宿水寺址) in 1954 (Fig. 67).[12]
2. In addition, the Gilt-Bronze Pensive Image excavated in Okdong, Andong, and the Stone Pensive Image excavated from Yeonghwasan in Gyeongju have the stylized folds on the lower skirt, stiff and repetitive, that indicate Northern Wei or Eastern Wei style. These statues, too, would have been shaped by the influence of Goguryeo.

Considering the characteristics of Eastern Wei-style Buddhist sculptures of the Three Kingdoms period, there is little possibility of the Gilt-Bronze Pensive Image with Sun and Moon Crown being a product of Silla, while the possibility of it being from Baekje cannot be ruled out altogether. Although there has been much discussion by Japanese scholars about the Baekje Buddhist statues and the Tori style of Japan, Matsubara has argued, albeit without offering any concrete evidence, that the deep influence of Goguryeo cannot be ignored. But as discussed in the study of Goguryeo, if we combine all the various factors—that Goguryeo had an excellent culture of its own; that being close to China, it adopted the advanced culture of China most quickly, widely, and precisely; that it absorbed the high-level culture of Lolang; that it had a far-reaching influence on Baekje, Silla, and Japanese culture; and that its influence on Japan was as strong as that of Baekje—the dominant view that the Japanese Tori style was influenced by Baekje may need to be replaced by the idea that it was first influenced by Goguryeo Buddhist statues, and then by the inflow of the Baekje style. The validity of such an interpretation can be confirmed through an analysis of the Gilt-Bronze Pensive Image with Sun and Moon Crown. This statue's place in the history of sculpture can only be established in the following chain of connections: Northern Wei-Eastern Wei style—Goguryeo style—Baekje style—Japanese Tori style.

6. Tori Style of the Asuka Period of Japan

Japanese scholars tend to insist on a direct connection between the Tori style (止利樣式) of the Asuka period (飛鳥時代) with the Buddhist statues of late Northern Wei and early Eastern Wei, and mention the Buddhist statues of Goguryeo and Baekje as mere supplements in this relationship. But this argument is not persuasive, considering the time gap of almost a century, which makes it highly unlikely that Japan adopted Chinese Buddhist statues directly. Also, it is often emphasized that the sculptors who established the Tori style were the descendants of naturalized Chinese in Japan, but how could the descendants of Chinese who had arrived in Japan in the 4th century know the style of Northern

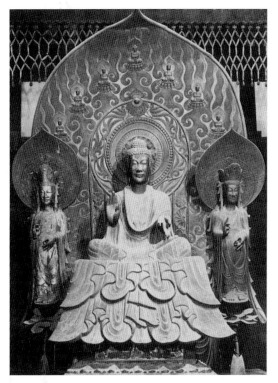

68. Gilt-bronze Shakyamuni Buddha Triad. Asuka period, 623. H. main figure 87.5 cm. Horyuji Temple, Japan.

Wei or Eastern Wei? Moreover, it was already the Tang period in China when the Tori style was established. These scholars say that the Chinese style reached Japan after simply "passing through" the Korean peninsula, but this view confuses the history of ancient Japanese sculpture. Of course, Korea was not able to make a substantial break from the Chinese form, but it did achieve stylistic changes according to the nature of the Korean people and the land, thus fashioning a Korean style of Buddhist sculpture. The sculpture of the ancient Asuka period in Japan reflects the progress of this stylistic development from China to Korea to Japan, which is an ordered set of connections that also makes chronological sense. But this insistence on the notion of Chinese influences simply "passing through" Korea can only hinder research on the Tori style. In recent times, however, Ohnishi Shuya has talked about the direct and close relationship between the Tori style and Korean ancient Buddhist statues as follows:

"There are differing opinions on the interpretation of Goguryeo style and Baekje style, and this is related to unresolved issues on the styles of the Southern and Northern dynasties of China from which they originated. Such uncertainty in the study of Korean sculpture of the Three Kingdoms period casts a dark shadow on the study of ancient Japanese sculpture centered on the Tori style Buddhist statues."[13]

We should now examine what constitutes the Tori style, and through analysis and comparison work out its connection with extant Goguryeo and Baekje Buddhist statues. Scholarly opinions vary on the proper division of Japanese historic periods, but here, those presented by Machida Koichi will be followed.[14] The Asuka period ended in 670 when Horyuji Temple (法隆寺) was burnt down, and the year 645, when the Japanese revolution took place, is often taken as the division between early and late Asuka periods. The Tori style is the style of the Tori school, founded by the sculptor Kuratsuki no Tori (鞍作止利) and his followers in the early Asuka period. The representative work of Tori style is the Shakyamuni Triad in the main hall at Horyuji Temple in Nara, Japan. (Fig. 68) Buddhist statues that belong to this school include the 16-foot Shakyamuni (about 3.5 m) at Asukaji Temple (飛鳥寺) and the Shakyamuni Triad at Horyuji Temple, which were made by Tori sculptors, as well as the Horyuji Medicine Buddha, the Shakyamuni Triad inscribed "Muja year" (568), the Standing Bodhisattva in the Daihozoden Treasure House, and the Buddhist sculptures that are designated Donated Treasures No. 145 and 155.

The stylistic characteristics of these Tori style statues are generally described as follows: "As Buddhist statues with the style of Chinese Buddhist statues from late Northern Wei through Eastern and Western Wei, they are generally oriented toward the front and composed mostly of planes and lines, not emphasizing the body, and are abstract and conceptual in form."[15] But as shown above in the sections on Goguryeo and Baekje, it would be more accurate to propose that the Japanese Tori style was the result of Japan adopting the style of ancient Korean Buddhist statues that had assimilated the influences of Eastern Wei, and then transforming it to develop a style unique to Japan.

The following is an overview of the characteristics of the Tori style:[16]

1. The robes are in the style established in the late Northern Wei dynasty. Following the policy of Emperor Xiaowen (孝文帝) to change all artistic styles to conform to Chinese tastes, the robes on Buddhist statues did not cover both shoulders in the Indian fashion but in a Sinocized fashion.
2. Detailed examination of the face indicates that the eyes are in the shape of apricot seeds, the ends of the lips are upturned and strongly curved, the nose is wide, and all the features are big. The face is longish overall. The ears are long and flat.
3. The patterns on the robes are strictly symmetrical. In bodhisattva statues there is an exaggerated fin pattern stretching out sideways, and the folds are almost completely flat and overlapping, repeated in regular parallel curved lines on the body part.
4. In terms of the casting technique used to produce a Buddhist sculpture, the bronze is thin and the statue hollow inside from the pedestal to the head.

Thus far, the introduction and development of style and form from Northern Wei to Eastern Wei, to Goguryeo, to Baekje, and to the Tori style of the Asuka period in Japan has been analyzed, with the greatest importance placed on the Goguryeo style.

Goguryeo culture was greatly advanced in all areas at the time and influenced Baekje and Silla to such an extent that these cultures took on a Goguryeo flavor. This influence spread to Japan, where Gogureyo culture had a strong impact during the early Asuka period, a view that has already been put forth by other scholars. But a study of the Gilt-Bronze Pensive Image with Sun and Moon Crown, analyzing its form and stylistic characteristics, reveals that this statue, of all ancient Korean Buddhist images, has the closest connection with the Japanese Tori style. I strongly felt the need for reinvestigation and reexamination of Goguryeo Buddhist statues overall, and as a result have dealt in some detail with Goguryeo Buddhist images and their cultural characteristics. I believed the theory that Asuka culture was established under the sole, unilateral influence of Baekje needed to be reexamined. As far as Buddhist images are concerned, the Goguryeo style influenced the Baekje style and the two were introduced to Japan together, it seems. That is, it is highly possible that the Goguryeo style entered Japan directly, and that the Baekje style, having assimilated the Goguryeo style, entered Japan at the same time. Then the

Japanese sorted through the combination of influences and established the Tori style, based on their own sense of style and artistry.

Materials that support this view include studies on the origin of ancient Japanese architecture. The floor plans of Asukaji Temple follow the pattern of the one-pagoda, three-hall layout of Goguryeo's Cheongamnisa Temple, and a very important paper has been published positing that the architectural style of the main hall at Horyuji Temple was established under the influence of Goguryeo.[17] The author of that paper, Sekiguchi Kinya, after analyzing the Goguryeo style of architecture that appeared in tomb murals and identifying its characteristics, closely compared detailed parts with the architecture of Horyuji Temple in Japan and noted the similarities—the powerful form of the *kondo* (金堂), or main hall, the strong molding of the cloud-shaped pillar top beam ends and small bearing blocks in the brackets, and the vigorous patterns on the roof tiles. He argued that the origin of the style of the main hall at Horyuji could be found in Goguryeo, allowing for the possibility that Gogureyo style entered Japan directly, while offering the cautious conclusion that "at this stage, the style of the main hall at Horyuji could be called a Baekje style of the Goguryeo type."

7. Conclusion

Though the Gilt-Bronze Pensive Image with Sun and Moon Crown and the Gilt-Bronze Pensive Image with Lotus Crown are monumental works of art produced in the late 6th and early 7th centuries, respectively, sufficient effort has not been made to analyze their form and style and to confirm which kingdoms produced them. But as these two statues represent the apogee in the transmission of Buddhist art from China to Korea to Japan, the history of Asian sculpture of that time cannot be properly organized until they have been studied thoroughly.

In another essay I have analyzed the form and style of the Gilt-Bronze Pensive Image with Lotus Crown to determine its place in the history of Asian sculpture and concluded that it is a product of Baekje. With regard to the Gilt-Bronze Pensive Image with Sun and Moon Crown, too, I had initially connected it in my mind with the Baekje style, though with some lingering doubts about the context of its form and style. In the past its origin was said to be Silla, but as it was completely cut off from the Silla style, this idea was not worth pursuing. After sorting through the Goguryeo Buddhist statues of the first half of the 6th century, I was able to assemble several important facts, and after examining Buddhist statues of the same style from Baekje and Silla, I reached the conclusion that this statue must be considered a product of Goguryeo.[18]

The determination of which kingdoms produced the statues serves as the basis for examining the artistic styles of the Three Kingdoms period, which of course is vitally important to any study of ancient Korean art. If these things are not revealed in connec-

tion with each other, then the nature of the art of Unified Silla cannot be worked out, it becomes difficult to discuss the diversity of Korean art, and further, it becomes difficult to understand the art of the Goryeo and Joseon dynasties.

The contents of this essay can be briefly summarized as follows:

1. I have analyzed the form and style of the Gilt-Bronze Pensive Image with Sun and Moon Crown, and, revealing that the form of the crown is a combination of the sun and moon, I have proposed this new name for the statue.
2. To determine which Chinese style this statue reflects, I have sorted out the Eastern Wei style and shown how it has developed in Korea.
3. To determine the origin of this statue, which reflects the style of Eastern Wei, I have sorted through all the Three Kingdoms Buddhist statues that are of the Eastern Wei style. I identified 17 from Goguryeo, 9 from Baekje, and 4 from Silla, these figures suggesting that an overwhelming number of Eastern Wei-style Buddhist statues were made in Goguryeo. Thus I was able to classify the stylistic characteristics of the Buddhist statues of the Three Kingdoms to some extent. My arguments are supported by the historical fact that, as already revealed in studies of the art of ancient Korean tombs, Goguryeo exerted heavy influence on both Baekje and Silla.
4. Because no rock-carved Buddhist images reflecting Eastern Wei style have been found from the 6th century in the Three Kingdoms period, it has to be concluded that Korean stone Buddhas were not produced till around 600. Hence, the first Korean stone Buddhist statues were in the Northern Qi style. But in the 7th century, Buddhism began to decline in Goguryeo, while it was still prospering in Baekje and Silla. As a result, not many Goguryeo gilt-bronze statues reflect the styles of Northern Qi and Sui, and rock-carved images were not made.
5. The basic structure of the Japanese Tori style can be found in Goguryeo style, or in Baekje style reflecting the Goguryeo style. Because the Gilt-Bronze Pensive Image with Sun and Moon Crown is the Korean statue most closely connected with the Tori style, I have examined it as a way to make clear the stylistic connections between the Buddhist statues of China, Korea, and Japan.
6. Without comprehensive research on Goguryeo art, the art and culture of Baekje and Silla, and by extension, the ancient culture of Japan, cannot be properly understood.
7. In art-historical research, study of the work of art itself is more important than written records or records that have been orally transmitted. In addition, the position that a work of art occupies in art history is gradually established through a sustained study of the interrelationship between the parts of an artwork and the whole.

Ultimately, this essay is a kind of summary of the form and style of Buddhist statues of the early 6th century in China, the late 6th century in Korea, and the early 7th century in Japan.

Gilt-Bronze Pensive Image with Lotus Crown

A Comparison with Pensive Images of Northern Qi, China, and Koryuji Pensive Image of Japan

The Pensive Image with Lotus Crown is undeniably one of the most beautiful works of sculpture in the world. Through stylistic comparison of the art of the kingdoms of Baekje, Silla and Goguryeo, we can determine that this pensive image was made in Baekje. At the same time, if we compare it in detail with the wooden pensive image at Koryuji Temple in Japan we can also find its place it in the history of ancient sculpture of Asia. The pensive image form, which originated in India and was transmitted to Korea through China, achieved a unique artistry in Korea.

1. Introduction

The notion that in ancient times art would have been a handmaid to religion or politics seems to be quite firmly fixed. But though the establishment of Buddhist art styles is certainly linked to religious and political events, Buddhist sculpture, architecture, and painting should not be considered subordinate to religion or politics but as independent works of art. In other words, religious works of art are not simply the tools or mediums of religion but vital works that contain artistic impulses and the creative will. As with the poetic songs called *hyangga*, which borrowed Chinese characters to express the spirit and soul of Koreans, the external form is not the entire essence. Works of art—whether or not they are the products of the politics or religion of a certain period—have always had a message of their own to convey. Sometimes in ancient works of art, astounding artistic metamorphosis that is hard to understand from a modern, rational perspective can be discovered; and in order to understand this mysterious aspect of art, the creative will or impulse that comes from deep within the psyche must be affirmed. But in periods of imitation, art does not take on this aspect.

The subject of this essay is the Gilt-Bronze Pensive Image with Lotus Crown (金銅蓮華冠思惟像, Fig. 69−74), a work of art that was produced during the emergence of a period of creativity. This piece has been generally described as a pensive image with "three-peaked crown" (三山冠), but I believe that "three-peaked" is not an appropriate description of the crown's shape. As the concept of three peaks has no significance in Buddhism, I suggest that the term "lotus crown" (蓮花冠) be used instead. In China, it is

certain that the shape of the crown on pensive images was based on three lotus petals, the pointed ends of which gradually became more rounded. The term "lotus crown" is therefore consistent with a Buddhist image.

This pensive image, whose pose is very distinctive among Buddhist sculptures, is unlike other man-made objects of worship which inevitably gaze forwards and have a direct relationship with the worshipper; it strikes the pose of one whose ego is turned inwards, lost deep in thought about the essential problems of mankind. It is not in the shape of a god but that of a human being. The model for pensive images in both China and Korea was the pensive image that appeared in India some time later than other Buddha and bodhisattva images. At first it appeared in the form of the pensive image of a prince enshrined in Buddhist temple main halls, then as an attendant bodhisattva to the cross-legged Maitreya (交脚彌勒菩薩), then as the principal figure in a Buddha triad. From the time of the Northern Wei (北魏, 386−534) Dynasty, it appeared intermittently as an independent image, and then became fully established as an independent image from the latter half of the Northern Qi−Northern Zhou (北齊−北周) period. Then in the Sui (隋) and Tang (唐) dynasties it reverted to being part of the four Buddhas of the four regions (四方佛), thus declining in importance and losing its independent status. Such changes in the pensive image would have been related to changes in faith, and in terms of modeling the pensive image was at first rendered as the image of Prince Siddhartha in low relief, then as attendant pensive images in high relief, then sculpture in the round focusing on the front (early part of Northern Qi, 550−577), and then complete sculpture in the round, going through a process of gradually becoming more and more sculptural. Almost exactly the same process took place with pensive images in Korea, and the culmination was the Gilt-Bronze Pensive Image with Lotus Crown.

Opinions vary as to what constitutes an artistically complete sculpture, but first, in terms of size, it is a sculpture that is bigger than a work of handicraft; second, it does not have heterogeneous transitional elements; and third, it transcends the ponderous treatment that comes from unskilled expression of the human body. It can be said that such works of sculpture are accomplished not simply because of religious demands but also because they embody a pure artistic impulse and the will to create, and when this is the case, the artwork transcends its historical limitations and conditions to acquire a sense of the present.

To examine how pensive images express the nature of the deity, the focus has to be placed on the unusual pose of meditation. This is because the abstract act of meditation could only be expressed through this physical pose. In half cross-legged pensive images, or pensive images with one leg pendant (半跏思惟像), the subtle changes in the body not found in other standing or seated images must be comprehended. Therefore, I believe that in making pensive images there was greater necessity to understand the human body than in making other standing and seated images.

Also, just as rock-carved images call for a kind of modeling suited to a rock-carved

69. Gilt-Bronze Pensive Image with Lotus Crown. Baekje, early 7th c. H. 93.5 cm. National Treasure No. 83. National Museum of Korea, Seoul.

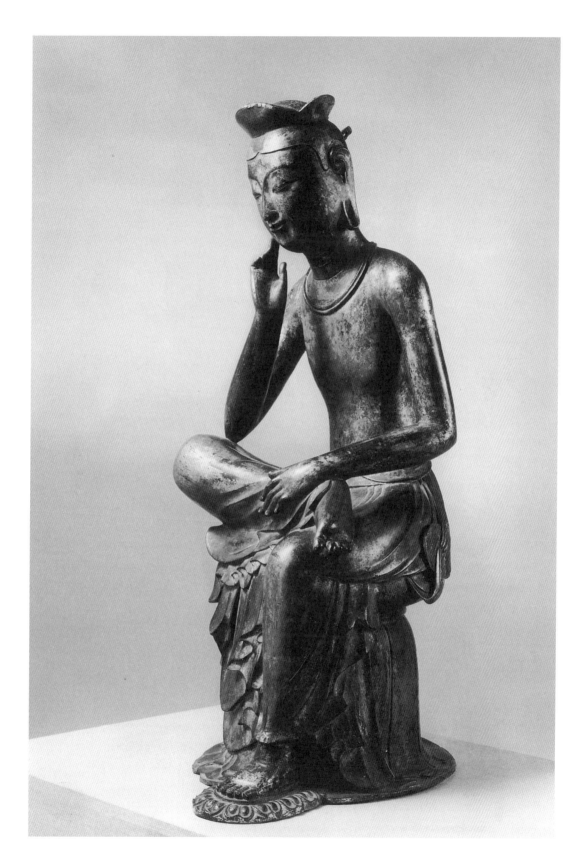

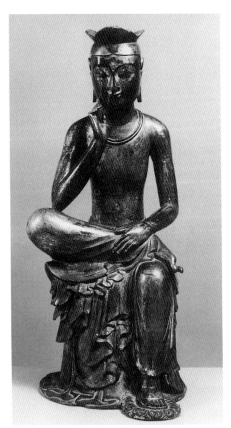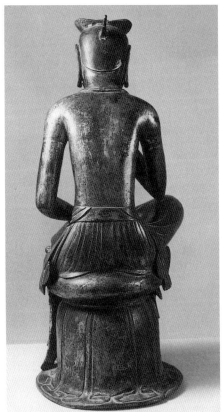

images, the method of modeling for this sculpture seems to have been possible only in gilt-bronze and in dimensions that are close to life size. In the case of rock-carved pensive images or small gilt-bronze pensive images, they are strongly imitative, or strong in local color, or easily changed according to constraints in material and size. In contrast, the method of modeling for this image seems to have been necessary and absolute. So far the article by Koh Yu-seop is the only article that has dealt with this pensive image from the viewpoint of art history.[1]

2. Form and Style

The provenance of the Gilt-Bronze Pensive Image with Lotus Crown is uncertain. Other studies[2] have dealt with this matter in depth, and I will not repeat the arguments here but rather focus on a study and analysis of the statue itself.

The main difference between this image and various other pensive images is its realistic expression. Ancient pensive images have several common characteristics: exaggeration or simplification of the pose, stylized treatment of the folds, or the folds depicted in repetition. In this statue such problems have been solved and ornaments have been elimi-

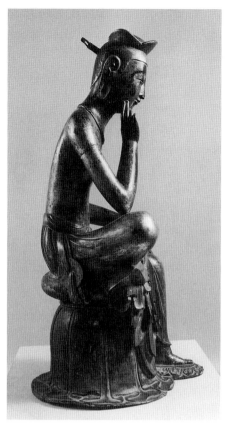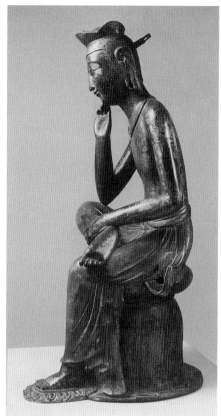

70–73. Gilt-Bronze
Pensive Image with
Lotus Crown, front,
back, right and left side
view.(pp.72–73)

nated. Because of the difficulty of sculpting the particular pose of the pensive image, the
form continually underwent changes, and the figure of the pensive image—which is
actually impossible in real life—is rather fascinating. But rather than being deliberate,
these characteristics resulted from the imitation of Chinese images or inexpert modeling.
In most cases, the torso and arms are unrealistically thin and are joined unnaturally, and
the pose of one leg resting on the other is also distorted. Such unrealistic physique and
pose are clearly apparent in pensive images discovered in the territory of the Silla
Kingdom (新羅), such as the small gilt-bronze images from the site of Samnangsa
Temple in Gyeongju and from Okdong in Andong, and the Gilt-Bronze Pensive Image
with Rectangular Pedestal.

In the pensive image, one leg is crossed and resting on the other knee, one arm is bent
and resting on the knee, the head in meditative pose rests on the hand, and the back is
slightly bent. Organic connection between these parts of the body requires modeling that
is completely different from that found in the rigid poses of the upright or seated images
from the Three Kingdoms period (三國時代, 57 B.C.–668 A.D.). But among pensive
images, many have simply borrowed the simple, rigid poses of the standing and seated
images, and the conflict between the conventional sense of modeling and the modeling
required of a pensive image results in unnatural and unrealistic elements. But in the Gilt-

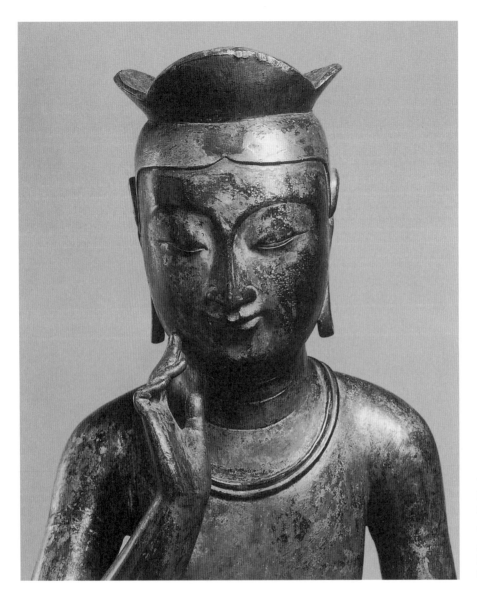

74. Head of Gilt-Bronze Pensive Image with Lotus Crown.

75–76. Left hand and right foot of Gilt-Bronze Pensive Image with Lotus Crown. (p.75)

Bronze Pensive Image with Lotus Crown, all of these shortcomings—the simple imitation, unnaturalness, unrealistic metamorphosis, inexpertness, stiffness—are completely overcome. The perfection of modeling resulting from the process of overcoming such shortcomings can be observed only in the Lotus Crown Pensive Image, and not in other Asian pensive images.

With this in mind, let us examine in detail the parts of the Gilt-Bronze Pensive Image with Lotus Crown. First the lotus crown on the head. It is made up of three quadrants rather than pointed lotus leaf ends. This form of lotus crown can also be found on the Samnangsa Temple gilt-bronze pensive image, the gilt-bronze bodhisattva head from Hwangnyongsa Temple, and the attendants from the Maitreya triad from Samhwaryeong on Mt. Namsan in Gyeongju. The rounded lotus crown form originated in Northern Wei,

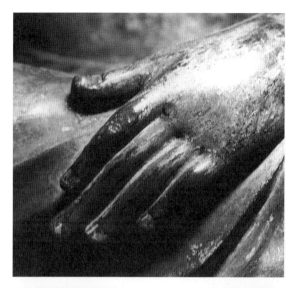

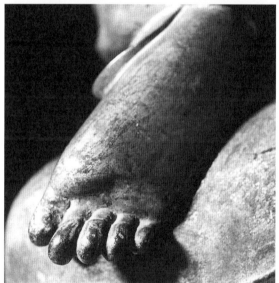

China, where it had a long tradition. A simplified version can be seen on the double stone Buddha image bearing an inscription dating it to 502 that is in the collection of the Tokyo Shodo Museum. It appears this crown was derived from the lotus crown and, as can be see in the head ornament on the statue of Vajrapani from Xiangtangshan caves (響堂山石窟) in the collection of Tokyo National Museum, by the time of the Northern Wei Dynasty the lotus crown consisting of quadrants was fully established and the pointed lotus ends had completely disappeared. But this form of crown did not appear in the Sui Dynasty (581−618) in China. Therefore, there are two forms of lotus crown: that consisting of three pointed ends, and that consisting of three rounded ends. In Korea, one did not precede the other but both existed at the same time. Judging from the trends in lotus crowns from China, it is apparent that the crown on this image follows the form of Northern Qi, and it should be noted that this is the form of crown most frequently found on Korean pensive images. In the Gilt-Bronze Pensive Image with Lotus Crown, the crown and the hair are directly joined on the forehead so that there is little distinction between the two.

The face is full and the line starting at the eyebrows, joined at the bridge of the nose and descending, is generous and sharply defined. The meditating eyes are slender open slits and the expression is sharp. The nose is rather long, and because the philtrum is short, it intensifies the impression of a bowed head when viewed from the front. The mouth is firmly closed with a typical archaic smile. But the distinguishing feature of the face is its overall fullness. The same can be said for the Northern Qi images found in the Xiangtangshan and Tianlongshan grottoes (天龍山石窟) in China. The faces continued to show this sense of power through the Sui Dynasty, but in the Tang Dynasty (618−907) the fullness was replaced by a corpulent quality. Such fullness can be seen as a realistic expression of a boyish face, and most images with this fullness give off a sense of freshness. The Chinese statue with a face most like that of the Gilt-Bronze Pensive Image with Lotus Crown is the White Marble Standing Buddha from Northern Qi, now in the collection of the Nezu Institute of Fine Arts in Tokyo, which displays a similar elegance in its mantle (Fig. 88). The Gilt-Bronze Pensive Image with Lotus Crown is deco-

rated simply with three engraved rings around the neck and two necklaces depicted in relief on the chest. The chest and arms are neither thin, like most Korean small gilt-bronze Buddhist statues, nor full like those of the latter half of Northern Qi in China. The hands are rather small and plump but finely expressed, and it is these hands that make it clear this image is of a male youth. The hands and toes are full of life in every joint, and their expression is so lifelike that a comparable example is hard to find not only in Korea but all of Asia (Figs. 75, 76). It seems the vividness of this image was achieved through these little details. In other images the emphasis tends to be on the face only, and the hands and feet are usually neglected. This is unavoidable in small images less than 20 cm high and even more so in images made of granite.

The most difficult part of making a pensive image is achieving the right proportions, especially in the right arm which rests on the right knee and supports the cheek (this arm typically bends at the knee and extends up to the cheek and therefore tends to end up too long). But in the Gilt-Bronze Pensive Image with Lotus Crown, almost everything accords with the rational. In general, the distortion of form in pensive images comes from the difficulty in getting the relationship between the parts right, the relationship between the knee, arm, and face, and between the back and waist that support them. Because the natural relationship between these parts is difficult to depict, if a mistake is made in one part it carries over into all the other parts, transforming the shape overall and creating an illogical and unrealistic pose. The knee is raised to support the elbow, and the arm has to support the face, which is turned down in thought, and the upward movement and the downward pressure endow the arm with a harmony of form; such dynamics in the relationship between the parts and their complex spatial composition cannot be seen in other standing or seated images and therefore demand a much more difficult kind of modeling. From the side, the three-dimensional composition of each body part requires great care, but most pensive images are encumbered by the limitations of ancient sculpture in that they are oriented toward the front only, as seen for instance in the Gilt-bronze Pensive Image with Rectangular Pedestal.

In contrast to the foot resting on the foot pedestal, which is not very expressive (this foot was made and attached later), the toes of the crossed leg and the right hand are full of subtle expression. The wonderful liveliness of the hand and foot accentuates the 32 great physical marks and 80 small physical characteristics (三十二吉相, 八十種好) of a Buddha which were standards in the production of Buddhist statues. And in contrast to images of deities made to differ in form from human beings, this image was made to resemble a realistic human being. This closes the distance one

77. Left foot and lotus foot pedestal of Gilt-Bronze Pensive Image with Lotus Crown.

feels between god and man, the infinite and the finite being, suggesting instead that both are one.

This same feeling continues in the flowing robes, draped from the legs and over the pedestal. Usually, the robes on Buddhist images tend to be formalized and fixed in the unrealistic style that is associated with images of deities, but here it is treated in an extremely realistic way. The sense of upward movement from the knee to the arm to the face, and the sense of downward movement from the face bent forward, to the arm, and back to the knee, have a subtle relationship in this image; and the element that sets off the upward movement and arrests the downward movement is the mystifying hem of the skirt that sticks out from beneath the crossed knee. This draping cloth supporting the knee is, I believe, necessary according to the modeling demands of the pensive image form and can be called a great addition to Asian sculpture.[3] It does not appear in the early pensive images of China but emerges in the Eastern Wei Dynasty (東魏, 534−550). It appears in most Korean pensive images, though not all. In some images this knee support has a decorative quality that does not add or detract anything from the statue and is greatly exaggerated. In this image there is minimal exaggeration, and the hem is folded back up again beneath the ankle to prop up the downward movement, once again emphasizing the sense of movement in the hem. The skirt that falls over the pedestal is commonly in two layers, the upper layer short and consisting of a repetition of close folds, and the bottom layer long in a repetition of big folds. In most cases the folds are formalized and fixed, but in this image the repetitiveness has been broken, giving a wonderful sense of liveliness and movement, and the problem of separation between the upper and lower layers of the skirt seen in other images has been completely solved in this image. The upper layer in particular, develops very naturally through exquisite and gradual changes and represents the finest drapery found on a Buddhist statue. At first glance, it may appear confused but a closer look reveals an order where the folds flow in the one direction. There is a space between the falling dhoti (skirt) and the pedestal (in most cases the skirt is carved as one with the pedestal, giving no sense of space), and the way the skirt falls suggests it is being blown by a gentle breeze. The folds over the lowered left foot are in most cases depicted in a repetition of arcs, but in this image only the folds that are absolutely necessary have been depicted, making it very natural and accentuating the volume of the knee and the leg. In most cases, the lower layer of the skirt, which is in direct contact with the body, is depicted in engraved lines, but in this image there are no flat engraved lines at all because the skirt has been expressed as raised folds.

As for the foot pedestal, which will be examined in greater detail in the next section, the front half was made separately and is a later addition. (Fig. 77) It seems that the front part of the foot and the foot pedestal was originally bigger. In the overall regular proportions of this image, this part alone conflicts with the rest of the figure. The foot is not only poor in appearance but also is flat and stiff in expression, especially when viewed from the side. In size, the sole of the right foot is 14.5 cm but the sole of the left foot is only

12.8 cm. And the toenails are double-layered on the left foot only.[4] The pedestal is bordered by a double layer of lotus petals, and while the petals on the original part are long and thin, the subsequent addition has shorter, broader petals with a strong sense of volume in the Unified Silla style, which leads me to believe that this part was made during the Unified Silla period (統一新羅, 668–935).

The pedestals of pensive images serve as a seat and are called *donja*, a kind of stool. There are many small differences in the details of the pedestals and therefore a great variety of pedestals and pensive image forms.

In the Gilt-Bronze Pensive Image with Lotus Crown, the seat is round and has no pattern, and the cloth drapes over the trunk in well-ordered folds, flaring out as it touches the bottom edge. In other statues the folds of the cloth covering the pedestal and the folds of the skirt are the same, leading to confusion, but in this image the lively moving folds of the skirt form a contrast with the quietly hanging and decorative folds of the cloth. From each side of the waist hang identical pendants that disappear beneath the seated figure.

3. Casting Technique

The casting technique is largely determined by the modeling of the exterior and the relationship between the inside and outside. So, detailed matters that cannot be solved on the surface are, in many cases, supplemented from the inside. In this statue, the Lotus Crown pensive image, the key to its realistic expression can be found in the internal structure rather than the exterior.

The internal structure was first revealed through stereo-radiography by two scientists from the Korean Atomic Energy Research Institute, Koh Jong-geon and Ham In-yeong.[5] Study of a gilt-bronze Buddhist statue using optical science was first attempted in Japan in 1953, and this method continues to be used today. The things that can be revealed through radio-stereography are as follows: the casting process used, that is, whether the intaglio clay mold method or the lost wax technique was used; the shape of the clay core; the thickness of the metal; the presence or absence of a central rod; the marks left by metal spacers or pins, and the presence or absence of bubbles.[6]

According to the findings of Ham and Koh it can be determined that:

1. This image was made with the lost wax technique.
2. Air bubbles of about 2 mm in size are found in several spots both in the upper and lower halves of the body.
3. The central rod is a square rod 12 mm in thickness extending from the head to the pedestal. Also, in each arm there is a rod of 3 mm thickness attached to the central rod so that the two rods cross over each other at the chest.
4. Parts of the clay core remain in the head, chest, and arms.

On the basis of these findings and my own studies of the interior of the statue, I have attempted to uncover the casting process used. Radio-stereography on its own is insufficient in revealing the whole picture because it does not include an investigation of the internal structure. But since investigating the inside involves many parts that are not visible, I will supplement my description of the inside with the results of the scientific investigation.

Seen with the naked eye, there is a central rod inside extending from the neck down to the thighs, bending according to the bending of the legs. It seems this rod held the central mold and the outer clay covering in place (Figs. 78–80). But radio-stereography reveals that the rod actually goes up even further, to the head. It is a square rod about 12 mm wide, and the whole rod is about 65 cm long. The bottom end splits into two branches and then stops almost immediately. It seems that it is split into two branches in the pedestal part to support the central mold of the pedestal because of its size. Also, approximately where the ornaments are located, the rods cross over at the chest. Seen with the naked eye, the rods seem to be cut off as soon as they cross, but radio-stereography photos reveal that they extend down through each of the arms. In addition, inside the pedestal part there are about 20 short nails of about 5 mm in thickness, distributed unevenly in three layers. Because of the large inner space of the pedestal, it seems the nails were used to hold the inner and outer molds together. That is, they functioned as the spacers for the pedestal part. It is not clear where the spacers were fixed on the body part, but in the middle of the hair above the forehead, there is a clear square outline measuring 2×2.4 cm, and it seems that this may be the mark of the spacers used to hold the inner and outer molds for the face. The spacers are usually symmetrically placed, back and front, or left and right, and the location for the spacer at the back that would have been the partner for the one at the front seems to have been where the aureole was attached. Also, at the line

78. Bottom of pedestal and inside view of Gilt-Bronze Pensive Image with Lotus Crown.

between the hair and the crown at the back, there are four small indentations which are perhaps the marks of subsidiary spacers. At the back inside the pedestal, there is a rough square patch (Fig. 80) that seems to be the place where the spacers were removed and the marks covered over.

In any case, in contrast to standing images or seated images, a very complex system of molds was used in making this statue, which shows a great deal of thought was given to the matter of using spacers. Therefore, aside from the main spacers, there would have been dozens of supporting spacers attached to the iron rods. The system of iron rods and spacers used to fix the inner and outer molds of the statue cannot be revealed in its entirety even through a combination of radio-stereography and naked eye exam-

ination, which leaves many questions still unanswered.

Next, based on this image, I will trace the casting process that would have been used. First, the central mold would have been shaped around the square central rod which splits into two branches at the bottom end. Radio-stereography photos and visual examination have revealed that there were several central molds, one of around 10 cm diameter at the head, one of around 7 cm diameter from the chest to the hip, and one of around 30 cm diameter at the top part of the pedestal. However, the bent leg is hollow, and the inside of the lowered leg and the folds of the skirt at the front follow the shape of the outside, which

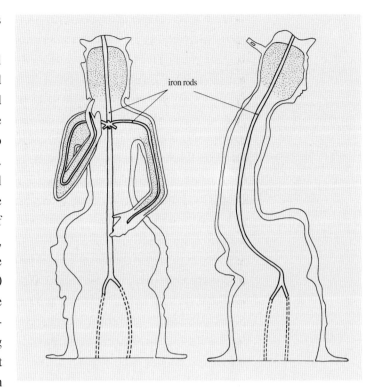

iron rods

79. Positioning of iron rods inside the Gilt-Bronze Pensive Image with Lotus Crown. This is a hypothetical diagram of the inside of the statue and iron rods, created on the basis of radio-stereography photos, observation and supposition. It is not a survey diagram. The dotted lines indicate parts filled in with clay.

indicates that a mold was made. The central mold was covered with a layer of wax more than 3 cm thick, and the figure of the resulting gilt-bronze statue was carved out of the wax. The wax figure was then covered with layers of clay slip and the outer and inner molds were fixed with a series of metal spacers and supporting spacers. Next, the wax was heated so that it would melt and run out, and molten bronze was poured into the space where the wax had been. Finally, the clay slip and central mold were removed, but because the clay inside the head and the arms was so deep and hard to remove, it was left inside. The lower parts of the iron rods that go through the top of the head and extend down the arms were cut, the ends being hard to remove. On the bronze figure that emerged, the facial details and other parts of the surface were smoothed down with a chisel and then covered in gold. The crown of the head was not covered in gold, and the place where the central rod that passed through the top of the head was cut is visible from above.

The last matter to be dealt with is the post-casting of the foot pedestal.[7] As can be seen in figure 79, the traces of later work on the foot pedestal and the bottom edge of the stool show how difficult it would have been to cast the edge of the pedestal. Because the foot pedestal and bottom edge of the stool are very thin, there was a high possibility of failure from the outset. On the foot pedestal, the original lotus pattern remains, three-layered on the left side and two-layered on the right side, indicating this part was cast as one. The front part of the foot pedestal, which failed to adhere, was later cast again and attached to the original statue, and the sides of the foot that were later cast were attached with metal

hooks (Fig. 81). From the bottom, the foot pedestal has the shape of a horse's hoof and a bronze rod seems to cut across it. It seems that this was used to reinforce the foot pedestal when it was originally cast. In the process of recasting the front part and attaching it to the statue, some differences appeared in the lotus pattern. There is also a difference in the overall proportions, the addition being rather small, which is the only blemish in this otherwise well-ordered statue. That the addition is smaller than the original is evident in the joint, showing a significant difference in width. Therefore, this front part of the foot pedestal introduces a flaw in the overall proportions. As such, the question that remains is when this part would have been made. If the attached part had been cast straight after the original casting, the form and size would not have differed. But while the original lotus pattern and that on the part later attached show a great difference in time and sensibility, the statue surely would not have been left in a damaged state for a long period of time. Though no definite conclusion can be reached, there is no doubt that the part now attached to the original was made at a significantly later time, perhaps at some point in the Unified Silla period. Also, the three parts around the edge that were also made and attached later were all made out of hammered bronze and fixed to the original with bronze nails. Thus, as Ham and Koh have revealed, the new parts were not soldered to the original with lead but attached in this primitive way.

In studying the casting technique of this statue in comparison with the excellent casting technique of another image, the Gilt-Bronze Pensive Image with Sun and Moon Crown

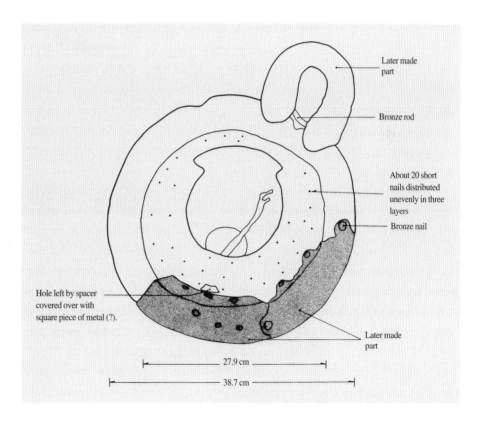

80. Internal structure of Gilt-Bronze Pensive Image with Lotus Crown.

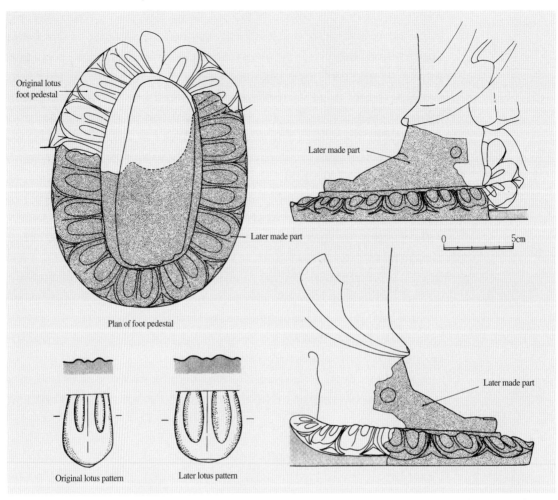

Original lotus
foot pedestal

Plan of foot pedestal

Later made part

Later made part

0 5cm

Later made part

Later made part

Original lotus pattern Later lotus pattern

81. Later made foot
pedestal of Gilt-Bronze
Pensive Image with
Lotus Crown.

(金銅日月飾寶冠思惟像), it becomes evident that there is a complementary relationship between sculpting and casting techniques. An important aspect of casting is economizing on materials, and in that respect the Gilt-Bronze Pensive Image with Lotus Crown has to be considered less advanced than the Gilt-Bronze Pensive Image with Sun and Moon Crown. The thickness of the bronze in the former ranges from 8 mm to 28 mm, whereas in the latter, it is much thinner, only 2 mm to 7 mm.[8] But it is this very aspect that gives the Lotus Crown statue its volume and makes possible its rich and diverse modeling, making the latter statue seem, by comparison, so flat. That is, the modeling was determined according to developments in casting techniques, and the more developed the casting techniques, the thinner the metal became and the more elaborate the workmanship. Therefore, as a result of focusing on sculpting techniques rather than casting techniques or metal carving techniques, the Lotus Crown figure has excellent modeling; it also has a lively expression, made possible by the volume, without the aid of overly intricate workmanship. By contrast, in the Sun and Moon Crown image, modeling technique

was forgone in favor of excellent casting and metal carving techniques, and consequently there is an overflow of fine workmanship in the complex crown and the decorations of the robes, creating a pensive image of rich decorativeness. Therefore, these two images are not only both representative of their time but also demonstrate how the casting techniques can determine the modeling.

	Gilt-bronze Pensive Image with Lotus Crown	Koryuji Temple Pensive Image
Total height	91.0	147.0
Height of statue	89.0	125.0
Seated height	59.9	82
Length of head	19.7	28.5
Length of face (minus hair)	13.5	17.3
Depth of face	14.4	18.5
Width of face	12.1	16.0
Length of ears	14.3	18.0
Height of knees	38.7	39.5
Height of pedestal	31.1	40.0
Diameter of pedestal	38.7	41.5
Aureole stick	5.5	

* Measurements of the Koryuji image are according to those in "the manual for repair of National Treasures produced by Nihonbijutsuin," the Research Institute of Japanese Art.
* Unit is cm.

Table 1. Comparison of Dimensions of the Two Statues

4. Koryuji Temple Pensive Image of Japan

Among the pensive images of Japan, there is one very similar to the Gilt-Bronze Pensive Image with Lotus Crown, but the relationship between the two remains a mystery. The statue in question is the Wooden Pensive Image of Koryuji Temple (廣隆寺 木造思惟像, hereafter Koryuji Pensive Image) in Kyoto, Japan. (Figs. 82, 83)

Because there are no records indicating where or when the Lotus Crown pensive image was made, there is no choice but to rely on studies of the form alone. In contrast, there is a relatively large amount of records about the Koryuji Pensive Image, so that although it has no inscription of its own, it reveals many clues about its provenance. Therefore, an investigation of the Koryuji Pensive Image may provide a key to studying the Lotus Crown pensive image.

According to available records, Prince Shotoku Taishi of Japan received a statue of the Maitreya (彌勒菩薩, Bodhisattva of the future) from Baekje in 603 and bestowed it upon the head of the Hata clan who built Koryuji Temple to enshrine the statue. These records

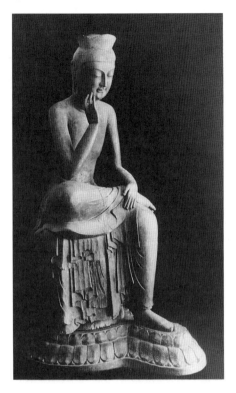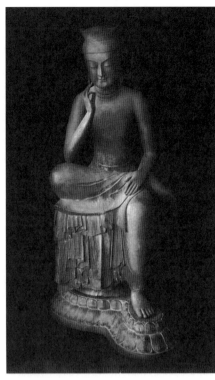

82. Koryuji Wooden Pensive Image. Asuka period, early 7th c. Japan. H. Total 147 cm, figure 125 cm (photograph from 1913). (left)

83. Koryuji Wooden Pensive Image (present appearance). (right)

have been studied from various perspectives in Japan, and the consensus is that the statue mentioned seems to be the Koryuji Pensive Image,[9] the height of the statue being almost identical to that noted in the records. However, these records are supplementary and are reliable to a limited extent only.

The Koryuji Pensive Image has been repaired in many places and now differs significantly from what it looked like originally. So, the photographs taken of it in 1913, which show the statue before repairs, will be used as a reference. The original statue as seen in figure 82 has a much softer and gentler countenance, and the damaged parts and the repairs can be clearly distinguished, making it that much easier to get an overall grasp of the image. On the original statue there is quite a large amount of gold leaf remaining, which is believed to have been applied in later times. In front of the left shoulder, part of the robes remains, and on the inside of the pedestal there is a record reading, "The pedestal was newly made and both feet have been repaired." The current lotus pedestal is the newly made one and the feet have been repaired to a large extent. In addition, a large part of or all of the ears, eyes, nose, shoulders, forehead, and fingers have been repaired.[10]

The modeling of gilt-bronze statues is different in fundamental ways from the modeling of wooden or stone statues. In the case of gilt-bronze, the details of the original shape can be sculpted in wax and partially revised in the process of carving, and even after casting the mold, the details can be fixed with a chisel. This makes gilt-bronze figures essentially different from wood and stone figures which are hard to correct. Therefore, if by chance the Koryuji Pensive Image is a copy of the gilt-bronze one that is the subject of

this essay, then partial metamorphosis would inevitably have occurred in the process of translating the gilt-bronze figure into wood. If this point is not taken into consideration when comparing the two statues, then the two can be said to be the same overall. But the perplexing fact remains that there are significant differences in some parts. In comparing the two statues below, first the similarities will be dealt with and then the differences, and in the case of the differences the reasons will also be given.

Similarities

1. Both statues have a lotus crown.
2. The bodies have the same six-sided structure.
3. The physical expression of the legs is the same.
4. The shape of the stool and the folds of the robes are the same.
5. The jade ornaments hanging down from the waist at either side are tucked under the seat of the figures, hiding the ends.
6. The way the hem of the skirt beneath the right knee protrudes and folds up in the opposite direction is the same, as is the way the hem of the skirt beneath the left hand turns in the opposite direction; the flow of the folds at both feet is the same.
7. The internal structure of the wooden statue follows that of the gilt-bronze statue.
8. Both are big statues of around 1 meter in height.

Differences (Gilt-bronze statue: A, Wooden statue: B)

1. A is a gilt-bronze statue while B is a wooden one (red pine).
2. The aureole was attached directly to the back of A (now lost), and in B the aureole was attached to a long rod that was inserted in the stool. This results in a change in the overall structure. Because the aureole rod in B has to be inserted in the stool, the figure cannot help but sit forward on the stool.
3. In B the right knee protrudes beyond the pedestal less than in A and is not raised as high, and therefore does not have the same sense of upward movement as A.
4. The folds of the skirt in A vary greatly, conveying a sense of movement, but in B there is no sense of movement, the folds falling naturally with subtle variations.
5. A has ornaments on the chest and B does not. But in B there is a hole where the ornaments might have been attached originally.
6. The expression of the hands and feet is different. In B the right hand has a subtle expression but the left hand and the feet are flat and stiff. It is hard to understand how such extremely different hand expressions can exist in the one statue.
7. The edge of the skirt below the right knee in A is depicted in raised folds, while in B they are depicted in listless engraved lines.
8. From the side, in A the line from the face to the arms and legs is a supple S shape, while the same line in B is stiff.
9. In overall feeling, A is very lively and lifelike, while B, though it does not have the

same condensed sense of power, has a soft and gentle feeling.

As seen above, the two statues have many similarities as well as many differences, and it is this fact that is baffling. However, the differences—for example, that the folds of the skirt are expressed in engraved rather than raised lines and have no sense of movement, and that the place where the aureole is attached is different in the Koryuji Pensive Image—result from the Koryuji image being a wooden image rather than a gilt-bronze one.

It is certainly rare to find two Buddhist statues with so many similarities. These similarities are of a different kind from those found in statues of identical form that are prevalent over a certain period of time. It is no coincidence that many of the distinguishing features of the original statue, including size and form, have been transmitted intact to the Koryuji statue. From a modern perspective, it is generally thought that the act of imitating alone degrades the value of the copy. Therefore, in aesthetic terms the Koryuji Pensive Image is not accorded great importance in either Japan or Korea, but the historical relationship between them is considered very important. Through a comparison of the two statues, the excellence of the original is highlighted. If the copy is better than the original, then the copy is a new creation; if it is not better, then it is nothing more than a copy. As previously noted, the Koryuji Pensive Image has the same overall appearance as the original but it has failed to express the same sense of inner power, and this is because it is a copy. In this respect, the Koryuji statue does not have any significance as an image on its own. A statue that has risen beyond such constraints and been infused with uniquely Japanese sensibilities is the pensive image of Chuguji Temple (中宮寺) in Japan, which is a masterpiece culminating Indian, Chinese, Korean, and Japanese influences.

Finally, a point must be clarified about the material of the Koryuji Pensive Image. It is commonly believed that it is made out of the wood of the red pine tree that only grows in Korea, which would mean that this statue went from Korea to Japan. But it has been revealed that red pines and black pines are distributed throughout Japan also, which means no judgments can be made about the statue based solely on its material.[11]

As for dating the Koryuji statue, despite records indicating it was made in 603, it cannot be decisively dated to that year, considering the level of sculptural technique in Japan at the time and the relationship between the statue and the presumed original. Also, according to some theories, the statue came from Baekje (百濟), while others propose that it came from Silla, though the Silla theory is basically difficult to accept.[12] In this light, a study of the statue itself should precede any study of the relevant documents.

5. White Marble Pensive Image from China

Though there are Korean Buddhist statues from the Three Kingdoms period that are in the style of Northern Wei, none have been confirmed to actually date to the time corre-

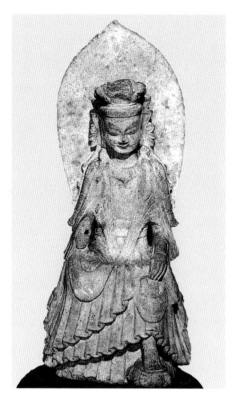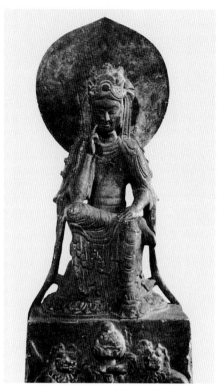

84. Stone Pensive Image. Northern Wei (512–533). H. 65 cm. Private collection, Japan. (left)

85. White Marble Pensive Image. Eastern Wei, 544. H. 54.4 cm. Tokyo Shodo Museum, Japan. (right)

sponding to the Northern Wei period. However, the influence of Northern Wei Buddhist statues—whether Northern Wei-style statues or early Eastern Wei-style statues with Northern Wei influences—cannot be disregarded. Therefore, in examining the changes in pensive images since the Northern Wei Dynasty, I will look at Chinese pensive images that have points of similarity with the Gilt-Bronze Pensive Image with Lotus Crown.

In the case of Northern Wei, although there are some works possessing the status of an autonomous image (such as the Stone Pensive Image from late in the period seen in figure 84), pensive images were usually attendants to the main Buddha or depicted in relief carvings on the back of the Buddha's aureole. In such images, the faces are long and thin as are the bodies. They were made to be viewed from the front, from which perspective they have the structure of an isosceles triangle, and the side view is flat.

In the early stages of Eastern Wei, the style of late Northern Wei was perfected but new aspects began appearing in the form, such as the nimbus and hair, and an early form of three-sided crown also emerged.[13] Yang Bo-da (楊伯達) says that the pensive image is a new form that appeared at this time, emphasizing that it was established in the Eastern Wei period. He identifies the distinguishing characteristics of Buddhist statues of this time as long and thin bodies, child-like proportions, big head and small rounded shoulders, and the friendly expression of a child, all of which can also be seen in pensive images.[14]

Yang says that the Buddhas of Eastern Wei achieved perfect form during the Wuding era (武定期, 543–549), which is when pensive images became independent figures. The

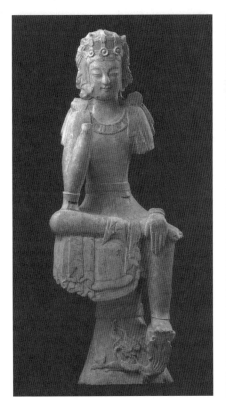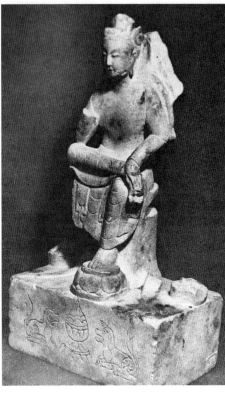

86. Stone Pensive
Image. Excavated at
Longxingsi Temple site,
Qingzhou, Shangdong
Province, China.
H. figure 75 cm,
total 90 cm. (left)

87. White Marble
Pensive Image.
Northern Qi, inscribed
"first year of Wuping"
(570). H. 35 cm. (right)

most important statue in regard to Chinese and Korean pensive images from that time is
the White Marble Pensive Image dating to 544 (Fig. 85). But at this stage, the statues are
still meant to be viewed mainly from the front and still have the isosceles triangle struc-
ture, overall stiffness, flat body, and strong overall decorativeness. From such painterly
and flat characteristics, they begin to acquire three-dimensional and sculptural character-
istics in Northern Qi, showing a new aspect of Asian sculpture and opening up new pos-
sibilities. Yang summarizes these new characteristics as plump body, round face, and
simply decorated robes, which show that in this period the human body, and with it sculp-
ture, was being newly discovered. Divine elements, such as the elaborate decoration
around the body, were gradually eliminated, and the transition toward a rediscovery of
human elements can be confirmed in the sculpture. Such triumph of the human being
reaches its zenith in the Tang Dynasty. Yang observes that the Northern Qi style was
formed around the Tiantong era (天統期, 565−569), the characteristics of which were
realistic human figures with realistic expression of the body—that is the disappearance of
the naked upper body form, overall simplicity, and long skirt with incised folds. These
aspects appear in the twin pensive image inscribed "second year of Tiantong" (566), but
reaches the peak of expression in the white marble pensive image inscribed "first year of
Wuping" (570). (This figure measures 35 cm in height.) That this exemplary Chinese
sculpture has some connection with the Gilt-Bronze Pensive Image with Lotus Crown of
Korea reveals an important aspect of Chinese culture (Fig. 87). In China, pensive images

88

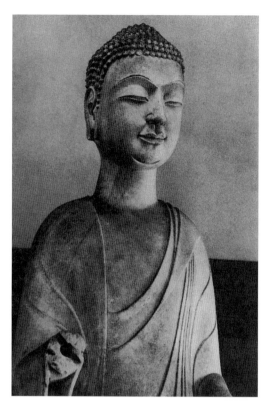

88. Stone Standing Buddha. Northern Qi, 560-577. H. 314.5 cm. Nezu Institute of Fine Arts, Tokyo, Japan.

reached their peak around 570 and then rapidly declined. The modeling of this image is completely different from that of previous images. The chest is fuller and the pedestal much more simplified; the traditional lotus flower foot pedestal appears under the lowered left foot only; the right side of the upper body is slightly thrust forward; it has a three-sided crown; the skirt is slightly hitched up; the skirt is smooth over the feet; there is space in the pedestal beneath the drawn down skirt; the robes are simplified—Matsubara emphasizes that all of these features show that the statue has a special place in Northern Qi sculpture.[15]

The various distinguishing characteristics of this statue, which represents the height of Chinese pensive images, are close to those of the Korean Gilt-Bronze Pensive Image with Lotus Crown. In China such changes and progress started in Eastern Wei and continued through to the white marble pensive images that were prevalent in the Dingxian region of Hebei, Northern Qi. (Fig. 88) Considering this, further comparison and study of Korean pensive images with white marble pensive images of the Dingxian region is needed. Just as the White Marble Wuping Pensive Image (白玉思惟像) has a special place among Chinese pensive images, the Gilt-Bronze Pensive Image with Lotus Crown has a special place among the pensive images of Korea. There are various differences between the two statues, but they also have many of the same basic characteristics, to an extent that is hard to find in any other two statues. So, though it would be difficult to claim that the Korean figure was directly modeled on the "half cross-legged" images of Northern Qi, as represented by the Wuping pensive image, the Northern Qi images certainly exerted a strong influence. The Wuping pensive image is a stone sculpture while the Korean statue is made of gilt-bronze and thus perhaps more sculptural. And though the Korean work bears some characteristics that correspond to those of the Wuping pensive image, it is a complete sculpture in the round and thus much more advanced and incomparably more realistic in its expression of the body. In size, too, it is much bigger than the small images which are craft-like in nature; it is almost life-size, which is one of the conditions of a true work of sculpture.

Recently, a large number of clay Buddhist sculptures were found at Longxingsi Temple (龍興寺) in Qingzhou city (青州), including some life size pensive images. (Fig. 86) In style and form, however, they are completely different from the Lotus Crown Pensive Image.

From the comparisons with Chinese and Japanese sculptures, it can be gathered that the Gilt-Bronze Pensive Image with Lotus Crown occupies a point somewhere between the White Marble Wuping Pensive Image (570) of China and the Koryuji Temple

Wooden Pensive Image of Japan. The connection between these three statues, as investigated through a comparison of the modeling, seems unavoidable. They have the same newly emerging characteristics, and the differences between them can be attributed to the difference in materials—white marble, gilt-bronze and red pine—and the differences in the people who made them and their sense of style. The similarities between the three, even if they did arise from a certain period and a certain style, reveal a very important aspect of Asian art history. That is, although Korea received the influence of China, in many respects it built on the Chinese example and took it to a higher level, creating something new. This aspect first appeared in Korean sculpture in the Gilt-Bronze Pensive Image with Lotus Crown, then in the twelve stone figures of zodiacal animals used around tombs (石造十二支像群),[16] and then in the main Buddha of Seokguram cave temple (石窟庵), all of which are works of substantial size.

In Japan, by contrast, there is a strong sense of imitation and preservation of the original. As seen in the Koryuji Pensive Image, although the ancient Japanese faithfully copied the Chinese and Korean examples, they failed to advance them and develop them further. The reason why Japanese statues are important in the study of Buddhist statues is because in some respects they retained the old style and techniques for a longer period of time. For example, the gilt-bronze Buddha triad at Horyuji Temple in Japan is dated to 632 and shows Northern Wei style, but the date corresponds to the Tang period in China.

Returning to the question of the dates of production, it seems the Korean Gilt-Bronze Pensive Image with Lotus Crown predates the Koryuji statue of Japan but is later than the Wuping statue of China, which means it dates to some time between 570 and 603. And as noted previously, it has the lotus crown and full face that was prevalent in Northern Qi, the sensual expression of the two legs seen through the skirt that was achieved in Northern Qi, and the lotus flower pedestal style of Eastern Wei and Northern Qi. This image, with its basis in the style of Northern Qi, seems to embody the stylistic developments in the golden age of Baekje.

6. In Relation to Other Korean Pensive Images

It has not been definitely determined when the Korean pensive image was first produced and how it developed in each of the Three Kingdoms—Goguryeo (高句麗), Baekje (百濟), and Silla (新羅). Some thirty pensive images from the Three Kingdoms have been found, but the exact provenance of many these is not known, and therefore must be deduced through an analysis of their style and form. I will leave the systematic organization of Korean pensive images to another time and for now will make a simple investigation of the Gilt-Bronze Pensive Image with Lotus Crown and related statues in order to establish its place in the history of Korean pensive images. In addition, I will examine which of the Three Kingdoms produced it.

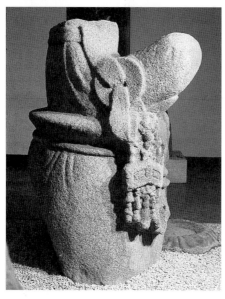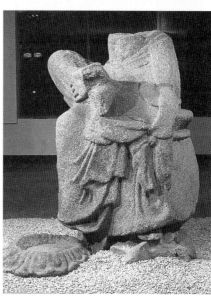

89–92. Stone Pensive Image, front, back, right, and left side view. (from top, left to right) Excavated from Bonghwa. Silla, second half of 7th c. H. 160 cm. Kyungpook National University Museum, Daegu.

First, judging by excavation sites, pensive images were more prevalent in Baekje (18 B.C.–660 A.D.) and Silla (57 B.C.–668 A.D.) than in Goguryeo (37 B.C.–660 A.D.). In terms of material, agalmatolite was the primary material used in Baekje, and bronze and granite in Silla. In Baekje, agalmatolite was used not only for pensive images but also for Buddha and Bodhisattva images, and it seems that the Baekje agalmatolite images were influenced by the white marble images that were prevalent in Eastern Wei and Northern Qi. The images that are related to the Lotus Crown pensive image in terms of modeling are the gilt-bronze pensive image believed to have been excavated near Gongju and the stone pensive image of Bukjiri, Bonghwa. These three works represent a new kind of statue reflecting the development of a uniquely Korean style and approach

toward true realistic expression—quite in contrast to other statues, which are imitative of Chinese statues and are marred by a tendency toward stereotyping, regional modeling, and mannerism.

The Gongju Gilt-Bronze Pensive Image (Fig. 66) breaks away from the modeling of Northern Qi that was a continuation of Eastern Wei, and is close to the Gilt-Bronze Pensive Image with Lotus Crown in overall structure and understanding of the human body, though it still has traces of stiffness. Though the Lotus Crown pensive image appeared suddenly and is isolated from other pensive images in terms of the site of excavation and different also in terms of modeling, I have previously presented the Gongju Pensive Image as the precursor of this statue.[17]

The Bonghwa Stone Pensive Image (奉化 石造菩薩思惟像, Figs. 89−92), whose fully restored height would reach 2.5 meters, is the largest pensive image in Asia and is important because it essentially has the same style as the Lotus Crown pensive image. The upper half is missing and only the bottom half remains, and one foot has also been lost. The folds of the skirt hanging over the pedestal fall softly in a very natural way, unlike in previous statues, where the folds are stiff and repeated in identical units because of the material, granite. The folds over the left foot are raised and have the same feeling as the folds in the Lotus Crown pensive image. Seen from the right side, the folds finish in the same way, with the hem curling up over the foot, giving the skirt a sense of movement. The Bonghwa statue also has a separate foot pedestal with a double-petal lotus pattern, similar to the part that was later attached on the Lotus Crown image but more developed and softer in feeling. There are differences, however: in the Bonghwa statue the waist is exaggeratedly thin, the right knee is raised too high, the expression of the hands is soft, and overall it is distorted in the manner peculiar to a statue of such great size. Nevertheless, the Bonghwa Pensive Image is certainly in the same vein as the Gilt-Bronze Pensive Image with Lotus Crown. However, the advanced treatment of the folds in the Bonghwa image, in comparison to the older method of expression in the Lotus Crown pensive image, is indicative of a significant time gap between the two works.

Therefore, in the chronology of art history, the Gilt-Bronze Pensive Image with Lotus Crown belongs somewhere between the Wuping White Marble Pensive Image of China and the wooden Koryuji Pensive Image of Japan; and within Korea, between the gilt-bronze Gongju Pensive Image and the stone Bonghwa Pensive Image.

This brings us to the question of which kingdom, Baekje or Silla, produced this image. Goguryeo early on accepted Taoism, so Goguryeo Buddhist images from the early half of the 7th century, when Buddhism had declined, are rare. This question must be approached through a comparison of the sense of style of Baekje and Silla. No conclusions can be drawn from unconfirmed stories, and since there is no evidence to support witness that it was discovered in Gyeongju or in Chungcheong-do province, there is no choice but to rely on an analysis of style.

First, the characteristic of Baekje sculpture, as can be seen in its handicrafts, is a sense

of elaborateness. This comes from a faithful translation of Chinese culture, though it resulted in more sophisticated modeling than the Chinese examples. The Baekje culture was the height of Korean culture at the time and had a decisive influence on Japan and Silla.

The Baekje brick tombs that are a faithful translation of the Chinese, and the beautiful proportions and harmony between the parts of the stone pagodas, a form created by Baekje, stand in contrast to the earth and stone-covered tombs of Silla, which are a simple accumulation of material, and to the massive structure of Silla stone pagodas. Also, a comparison of the Seosan Rock-Carved Buddha of Baekje and the Baeri Buddha Triad of Silla shows that the former has an open sophistication while the latter has a condensed, primitive sense of modeling. In the case of small gilt-bronze Buddhas, those of Baekje, no matter how small, were finely sculpted in every part and had beautiful form overall. This can be seen in the Buddha group of Gunsurisa Temple site in Buyeo, the Buddha group of Sin-ni, Gyuam-myeon, Buyeo, and the Gilt-Bronze Standing Buddha of Yonghyeon-ni. In contrast, the small gilt-bronze Buddhas of Silla show ponderous treatment overall and primitive modeling, and a sense of folkishness. The products of Silla have a strong tendency toward simplification and departure from severe proportions, and they are very unrestrained in composition. This kind of modeling reaches the grotesque in such statues as the big Buddha of Seondosan, and the big rock-carved Maitreya of Sinseonsa Temple, Danseoksan. Clear differences between Baekje and Silla art are apparent in examples of calligraphy as well: the elegant examples of Baekje calligraphy on the memorial stone of King Muryeong's tomb and the memorial stone of Sataek-jijeok, a state minister of Baekje, as opposed to the rather simple and natural calligraphy of Silla on the Sinseong stelae commemorating construction of the fortress on Namsan and the King Jinheung memorial stelae. The distinguishing features of Silla art are artlessness, folkishness, humor, the coexistence of inconsistencies, dullness, and heaviness, rough-hewn treatment, and an allowance for imperfection. In contrast, the characteristics of Baekje art are a perfect beauty of composition, sophistication, openness, and elaborateness. When Silla unified the Three Kingdoms (668), the Silla qualities disappeared, and suddenly a new kind of modeling characterized by unity, sharpness, and perfection was produced. This sudden change in modeling from ancient Silla to Unified Silla can be attributed to the Baekje artisans who were assimilated into Silla after the fall of Baekje.

In light of these distinctive cultural differences between Baekje and Silla, and judging from the characteris-

93. Agalmatolite Pensive Image. Baekje, second half of 6th c. H. 13.3 cm. Buyeo National Museum, Buyeo.

tics of the Gilt-Bronze Pensive Image with Lotus Crown that have been studied here—that is, realism resulting from perfect proportions, a sense of stability, vibrancy, and elaborateness—there is a persuasive argument to be made for the statue as a product of Baekje. It is only when we consider it as one of the gilt-bronze sculptures of Baekje that it has a proper place to occupy: it does not fit in among the gilt-bronze Buddhist sculptures of ancient Silla. And only then can it stand as the height not only of Baekje Buddhist sculpture but of Asian sculpture of its time. And within the Baekje period, it is impossible for the statue to have been made at any time other than during the reign of King Mu (武王, 602−641).

The wooden Koryuji Pensive Image from the Asuka Period (飛鳥時代, 538−645) in Japan, which can be called a copy of the Gilt-Bronze Pensive Image with Lotus Crown, only makes sense when considered as the result of the relationship between Baekje and Japan and the introduction of Buddhism from one to the other; it does not make any sense from the perspective of relations between Silla and Japan. Therefore, the Koryuji Pensive Image, a product of the Asuka culture that can be called an extension of Baekje culture, is a manifestation of the cultural relationship between Baekje and Japan.

Another issue here is that while the Lotus Crown pensive image is well-balanced overall, the Bonghwa statue is quite deformed. But the deformity of the Bonghwa Pensive Image is a kind of deformity that could not have been done without a great deal of confidence in the modeling and is different from the unstable deformity that comes from unskilled workmanship. In this respect, the Bonghwa statue shows much more advanced modeling than the Lotus Crown image, but the question is why such a great work was discovered in Bonghwa, so far from capital, Gyeongju (慶州). In the Bonghwa area, which is closer to Baekje, along with the Yeongju area, a number of giant rock-carved Buddhas were created including the seated Buddha image and rock carved Buddha image group in Bonghwa, Bukjiri. These relics constitute a strategic point in the southward transmission of Silla culture, before it reached Gyeongju.[18] But since a statue such as the Bonghwa Pensive Image was made, it is possible to think that the Gilt-Bronze Pensive Image with Lotus Crown was also made in Silla. But it is more reasonable to deduce that the production of such a big stone pensive image in the Bonghwa region was possible only after receiving the influence of the Lotus Crown image made in Baekje.

7. Conclusion

This essay has been a study of the form and modeling of the Gilt-Bronze Pensive Image with Lotus Crown, and an examination of the casting technique through an analysis of the surface structure and internal structure revealing the relationship between the inside and the outside. After such investigation and research centering on the statue itself, the work was then compared with the Wuping White Marble Pensive Image of China and the wood-

en Koryuji Pensive Image of Japan in order to establish its place in the history of Asian sculpture and its date of production. It was then studied in the context of the history of Korean pensive images and related images, and its provenance was determined in light of the cultural characteristics of Baekje and Silla. The conclusion thus reached is that the Gilt-Bronze Pensive Image with Lotus Crown was most likely made in Baekje and should be dated somewhere between the Gongju Pensive Image and the Bonghwa Pensive Image. These three statues show a gradual increase in height, from 16.4 cm for the Gongju statue, 91 cm for the Gilt-Bronze Pensive Image with Lotus Crown, and 2.5 m (restored height) for the Bonghwa statue. A similar increase in size can be seen in relation to statues from other countries: from 35 cm for the Wuping Pensive Image, to 91 cm for the Gilt-Bronze Pensive Image with Lotus Crown, and 125 cm for the Koryuji Pensive Image.

The three Korean statues also show a change in material, from a small gilt-bronze, to a large gilt-bronze, to a large stone image; and in the three statues of China, Korea, and Japan, the material changes from white marble, to gilt-bronze, to wood. Such changes in size and material reflect precisely a cross-section of the cultural history of Buddhism in Asia. The Lotus Crown pensive image is the largest extant gilt-bronze statue of its kind in Asia while the Bonghwa statue is the largest stone statue in Asia. That the pensive image grew to become life size means that it was being established as a distinct work of sculpture, eventually becoming an independent object enshrined in the main hall of a temple. In small images, formalized and abstract expression is unavoidable, and it is only in the big works that realistic expression becomes possible. But simple enlargement of a small work of sculpture does not translate into a successful large work. Of course, the appearance of large pensive images was impelled by religious demands. However, this essay is a study of the theory of ancient sculpture, focused on modeling, and does not deal with the Maitreya cult or the identity of the pensive image.

Research in this area has been most active in Japan[19] where the only pensive image carrying an inscription clearly identifying it as Maitreya was found—that is, the inscribed Miroku Bosatsu Pensive Image kept at Yachuji Temple (野中寺) in Japan.[20] That piece, however, has been proven to be a fake. Also, there have been a number of specialized studies into the relationship between the Maitreya cult and the Hwarang (花郎), Silla's elite "flower of youth warriors," and so the issue is not dealt with in this essay.[21] But to briefly mention the issue of identity here, it does seem that the pensive image has been confirmed as Maitreya Bodhisattva there, but not a single pensive image in China carrying an inscription saying so. There exist images of Maitreya that are not pensive images, and for this reason not all pensive images can be conclusively identified as Maitreya.[22] Therefore, the name "pensive image" (思惟像) is used in this essay as it refers to the common characteristics of all the statues discussed.

Having studied the Gilt-Bronze Pensive Image with Lotus Crown from various angles, what meaning does it hold in the context of Korea's acceptance of Buddhist culture? Korean Buddhist art cannot always be studied in relation to China. Of course, there is no

denying the influence of China in the appearance of any form of Buddhist art or the absolute influence of China in the transitional stage, but after a certain period of time it is natural that development comes from within.

The early Buddhist images of Korea show the influence of Northern Wei and the subsequent Eastern Wei styles, but after a certain period, the Buddhist images of the Three Kingdoms show a style different from that of Northern Qi, which succeeded the style of Eastern Wei. That is, Korea was establishing its own unique style at the same time as Northern Qi, and while Korea received the influence of Northern Qi it also transformed it, which is consistent with the pattern of Korea's adoption of Chinese culture. In other words, Korean art did not always develop solely according to Chinese influences; after a certain amount of time, a uniquely Korean style of modeling began to develop and then, while intermittently receiving Chinese influence, Korea broke away from the complex relationship with Chinese culture and even advanced it further. The Gilt-Bronze Pensive Image with Lotus Crown attests to this cultural phenomenon, and an earlier statue that shows original Korean developments in style include the agalmatolite pensive image excavated from Busosan in Buyeo (Fig. 93). This statue has the typical style of Northern Wei, apparent in the form of the wide, thick folds of the robe, the long thin fingers, and the overall modeling which is precise yet flat. These characteristics, which are not found in the pensive images of Eastern Wei, appear in the pensive images of Baekje, suggesting Korea was building on the influence of China in its own way. As for date of production, the Gilt-Bronze Pensive Image with Lotus Crown can be dated to around the early 7th century, while in China pensive images were no longer produced from around 600. Moreover, the basic sense of modeling has the flavor of Baekje. So while some periods can be directly compared with China, some cannot. As such, the issues of imitation and creation in Korean sculpture are basic issues that must be raised in Korean art history, and only when this is done can ancient sculpture be released from an isolated past and exist in the present as a part of tradition.

As examined above, it can be estimated that the Gilt-Bronze Pensive Image with Lotus Crown was made in the first half of the 7th century, and this suggests that Korean Buddhist art around the turn of the 7th century developed in a unique way and that this particular work was one of the finest of its kind in Asian art.[23]

It seems that at some point the Koreans faced the basic issue of what both religion and art were aspiring to achieve. One deals with ethics and the other with sensibility, and this statue shows the process of ethics being translated into sensibility. The high-handed moral code that is ethics is translated into sensibility as an overall expression of life and it must be accepted as that, the expression of all life. That is, if it is Buddhist statues that give shape to the truth of Buddhism, then sensibility is needed to bring that truth to life. When one realizes that truth has been achieved through art in the Gilt-Bronze Pensive Image with Lotus Crown, then one can recognize the truth of Keats' line "Beauty is truth, truth beauty."

The Application of *"La Porte d'Harmonie"* to Seokguram

Proportion and *Pratitya-Samutpada*, or "Dependent Origination"

When I first discovered that the iconography, size and orientation of the main Buddha of Seokguram were the same as those of the image of Shakyamuni at Mahabodhi Temple in Bodh Gaya, India, the site where Shakyamuni attained enlightenment, I could not sleep. By reconstructing the design plans and studying the principles of the geometry and proportions used in Seokguram, I discovered that the proportions were used to express the doctrine of "dependent origination," which is one of the most important philosophies of Buddhism.

1. Introduction

This essay examines the importance of Seokguram cave temple (石窟庵, Fig. 94) from another perspective. In studying Seokguram, those specializing in the history of sculpture tend to focus on the principal icon, which is the central Buddha, and the iconography and style of the devas (佛法 守護神), the bodhisattvas (菩薩) and the Ten Great Disciples (十大弟子) surrounding it. On the other hand, for those studying ancient architecture, the main interest is in the structure itself; for scientists, the scientific principles used in the architecture; and for theologians, the iconography of the sculptures as based on Buddhist doctrine. Thus various aspects of Seokguram have been studied from these diverse perspectives, but the work of art as a whole is still difficult to grasp. In such a case, can the whole be revealed by gathering together all the research on its different parts?

While studying the architecture, sculpture, religion, mathematics, and science of Seokguram, I came to the conclusion that the mathematical principles applied to its architecture and sculpture were the key to the organic relationship between all the different parts. Proportion based on mathematical principles introduces the element of compositional harmony to a work of art. But religious ideals also emphasize harmony between the individual, society and nation. Therefore, harmony in art and harmony in religion are essentially of the same order. According to Pythagoras, "Rational order, progression, and laws exist in natural phenomena, and all relations can be expressed as a quantity or number."[1] Pythagoras may have been talking only about natural phenomena in the physical world, but I came to believe that, inasmuch as Buddhism also has its starting point in the exploration

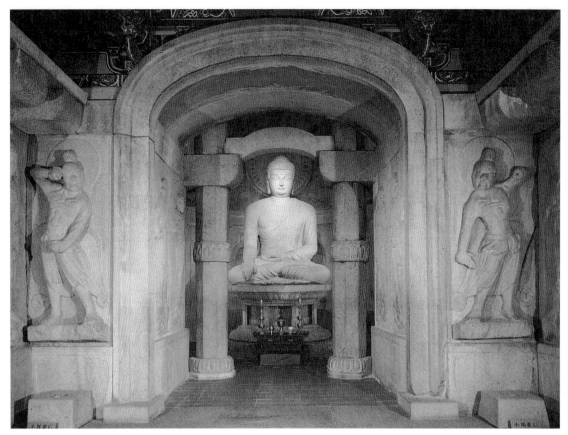

94. Interior of
Seokguram cave
temple, Gyeongju.
Unified Silla, mid-8th c.

of natural phenomena, religious truth, too, could be expressed as a quantity or number.

In my studies I was deeply influenced by the Japanese architectural historian Yoneda Miyoji (米田美代治).[2] Yoneda made great efforts to restore the original construction plans of Seokguram and to discover the mathematical principles behind the architecture. In his otherwise simple and plain text, there is, curiously enough, a philosophical sensibility. This is probably because in his investigation of the temple he did wish to uncover a philosophical principle. In my research, I tried to move beyond Yoneda's work and examine the relationship between the architecture and the principal icon (the main Buddha) of Seokguram, focusing on the question of why such meticulous mathematical relationships were applied to this work of art.

Ultimately, the religious sublimity and beauty originate from the harmonious proportions underlying the architecture and the sculpture. Of course, I do not mean to slight the extraordinary architectural beauty of the monument or the skilled workmanship of the sculpture; I am merely placing greater emphasis on the various relationships in the intricately calculated proportions of the architecture and the sculpture. My purpose here is to show Seokguram in its entirety by focusing on this question of proportions, wherein nature, art, religion, mathematics, and astronomy all come together. I will go over the work achieved by Yoneda before discussion of my own research.

2. Seokguram Construction Plans:
Yoneda Miyoji's Research

Yoneda Miyoji carried out detailed analyses of major 7th- and 8th-century structures from the Three Kingdoms period and Unified Silla, including the floor plans of major temples, the floor plans and elevations of stone pagodas, and the construction plans of Seokguram, and was wholly devoted to their study and interpretation for the purpose of restoration. He spent altogether seven years surveying the works and another three publishing his research, making a monumental contribution to Korean art history through his study of the proportions hidden in the beauty of ancient Korean architecture and their ideological interpretation.[3] Through such efforts, he raised research on ancient Korean art to an international level.

In 1940 Yoneda published a paper on the construction plans of Seokguram, the gist of which is presented here.[4] First, he stated that in the making of Seokguram the basic unit of measurement was *Tang cheok* (唐尺, Tang foot, approximately 29.7 cm), and then reconstructed the Seokguram plans as follows.

1. Cave Temple Floor Plans (Fig. 95)

The radius of the rotunda, or the circular main chamber, is 12 Tang feet. The entrance to the rotunda is 12 Tang feet wide, and this is equivalent to one side of the regular hexagon that is inscribed in the circle of the main chamber. And if an equilateral triangle is created with each side equal to the width of the entrance, the tip of the triangle would reach the middle of the front of the main Buddha's pedestal base stone. Starting with this basic construction plan, the position of the pedestal and the size of the surface planes were decided. That is, the front of the octagonal base stone of the pedestal is placed on the diameter at a right angle to the center line of the main chamber; and the diameter of the circle inscribed in the octagonal base stone is equivalent to one half of the height of the perpendicular of an equilateral triangle with each side measuring 12 Tang feet.

2. Cave Temple Elevations (Fig. 95)

The combined height of the circular main chamber wall and the upper niches which contain sculptures of the bodhisattvas and the Ten Great Disciples is 12 Tang feet. The height from the top stone of the niches to the top of the dome is also 12 Tang feet. This means that the section of the main chamber dome describes a semi-circle with a radius of 12 Tang feet.

The height from the floor to the top stone of the niches is the same as the length of the diagonal of a square measuring 12 Tang feet on each side. This length, the length of the diagonal of a 12 Tang-feet square, is the same as the total height of the main Buddha statue, including the pedestal.

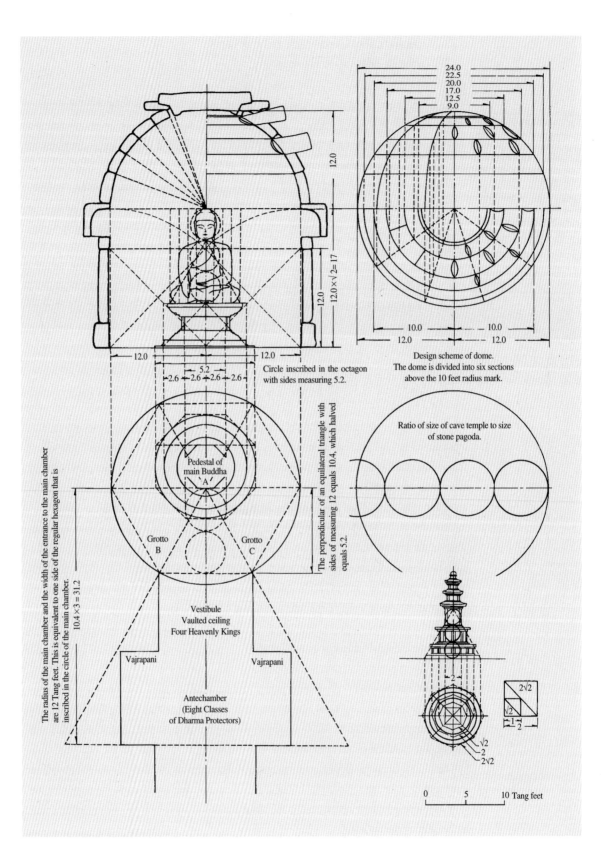

24.0
22.5
20.0
17.0
12.5
9.0

12.0

12.0×√2=17

12.0

10.0 10.0
12.0 12.0

Design scheme of dome.
The dome is divided into six sections
above the 10 feet radius mark.

12.0 12.0

5.2
2.6 2.6 2.6 2.6

Circle inscribed in the octagon
with sides measuring 5.2.

The perpendicular of an equilateral triangle with
sides of measuring 12 equals 10.4, which halved
equals 5.2.

The radius of the main chamber and the width of the entrance to the main chamber
are 12 Tang feet. This is equivalent to one side of the regular hexagon that is
inscribed in the circle of the main chamber.

10.4×3=31.2

Pedestal of
main Buddha
A

Grotto
B

Grotto
C

Ratio of size of cave temple to size
of stone pagoda.

Vestibule
Vaulted ceiling
Four Heavenly Kings

Vajrapani Vajrapani

Antechamber
(Eight Classes
of Dharma Protectors)

2

2√2

√2

½

√2
2
2√2

0 5 10 Tang feet

100

3. Pedestal Plans (Fig. 96)

The diameter of the base stone of the pedestal is equal to the length of the diagonal of a square with sides measuring 5.2 Tang feet, which is half the height of an equilateral triangle with sides measuring 12 Tang feet.

The lower pedestal stone is the same size as the circle inscribed inside the octagon with sides measuring 5.2 Tang feet.

To summarize, the floor plans and elevations of Seokguram are based on a square with sides measuring 12 Tang feet, and the diagonal of that square. And the position and composition of the pedestal of the main Buddha is based on an equilateral triangle with sides measuring 12 Tang feet and the height of its perpendicular.

4. The Composition of the Main Buddha (Fig. 96)

The total height of the main Buddha (本尊像) is equal to the diagonal of a square with sides measuring 12 Tang feet, which is the radius of the circle of the floor plan of Seokguram's main chamber.

The total height of the main statue is 11.53 Tang feet. The figure can be rounded off to 11 Tang feet and divided by ten to arrive at the unit of 1.1 Tang feet, which can be used as the basic unit for this study. Based on this unit, the width between the knees is eighth tenths, or 8.8 Tang feet, the width of the face two tenths (2.2 Tang feet), the width of the chest four tenths (4.4 Tang feet), and the width of the shoulders six tenths (6.6 Tang feet).

If an equilateral triangle is constructed using the width between the knees as the length of each side, the tip of the triangle would the Buddha's chin, and one half of the perpendicular height of this triangle would approximate the height of the face. Therefore, an equilateral triangle using the width between the knees as the measure of each side determines the position and size of the face.

Hence Yoneda Miyoji was confident that the construction plans of Seokguram were based on the following geometric principles:

The basic unit is 12 Tang feet.

The square and its diagonal are used.

The equilateral triangle and its perpendicular are used.

The circle is used.

The sphere is used.

The hexagon and octagon are used.

Division into equal lengths is used.

95. Design scheme of Seokguram cave temple and pagoda (based on diagram by Yoneda Miyoji).

Yoneda found the application of such basic techniques in the construction plans not only of Seokguram but also of Bulguksa Temple (佛國寺). He revealed that the composi-

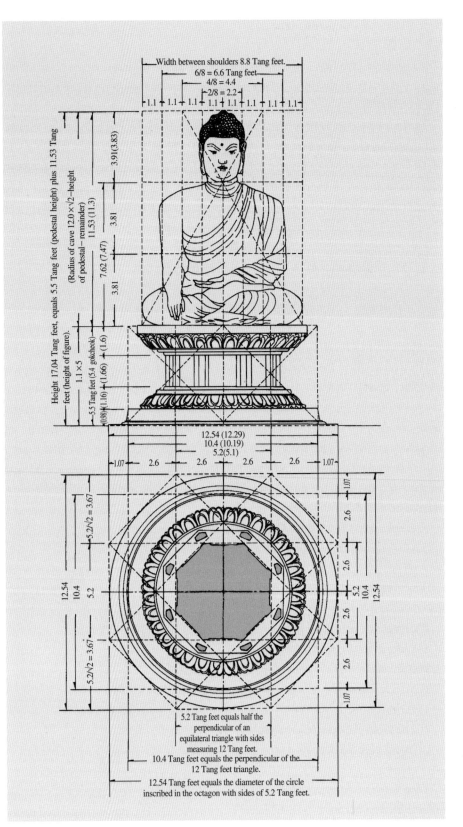

Width between shoulders 8.8 Tang feet.

6/8 = 6.6 Tang feet
4/8 = 4.4
2/8 = 2.2
1.1 · 1.1 · 1.1 · 1.1 · 1.1 · 1.1 · 1.1 · 1.1

3.91(3.83)

Height 17.04 Tang feet, equals 5.5 Tang feet (pedestal height) plus 11.53 Tang feet (height of figure).

(Radius of cave 12.0 × √2 − height of pedestal = remainder)
11.53 (11.3)

3.81

11.53 (11.3)

7.62 (7.47)

3.81

1.1 × 5

−5.5 Tang feet (5.4 gokcheok) ·(1.6)

(1.66)

(1.16)

(0.98)

12.54 (12.29)
10.4 (10.19)
5.2(5.1)

1.07 · 2.6 · 2.6 · 2.6 · 2.6 · 1.07

1.07

2.6

5.2√2 = 3.67

12.54
10.4
5.2

2.6

5.2
10.4
12.54

5.2√2 = 3.67

2.6

1.07

5.2 Tang feet equals half the perpendicular of an equilateral triangle with sides measuring 12 Tang feet.
10.4 Tang feet equals the perpendicular of the 12 Tang feet triangle.
12.54 Tang feet equals the diameter of the circle inscribed in the octagon with sides of 5.2 Tang feet.

96. Survey drawing of Seokguram main Buddha and pedestal (based on diagram by Yoneda Miyoji).

102

tion of the cave temple and the pedestal of the main Buddha are both based on one side of a square. And the technique of using the diagonal of the square as the basic measure in forming a regular octagon and circle suggests a very precise method of planning in terms of overall proportions. That the selection of such geometric techniques was behind the compositional beauty of a structure was a significant discovery.

The applied mathematics found in the art and architecture of Seokguram probably represents the height of basic mathematics in the Unified Silla period (統一新羅, 668−935), and this unified method to achieve an extremely systematic overall design makes Seokguram a unique monument in Asian sculpture and a splendid example of Korean architecture. It is evident here also that a knowledge of solid geometry based on plane geometry was used. The domed ceiling is a semi-sphere made with stones, and it is astonishing that *pi*, the ratio of the circumference of the dome to its diameter, was used in its dimensions.[5]

In his paper titled "Mathematical Consistency in Construction Plans Predating the Joseon Dynasty," Yoneda Miyoji added his opinion in a special postscript entitled "A Personal Observation on the Astronomical Expression of Seokguram":

"I reached the conclusion that the expression of quantity and shape in Seokguram has something in common with the astronomical mathematics of Mesopotamia. This may be prejudice on my part, but because there are corresponding points in terms of quantity and shape, it is worth attempting speculation. That is, the basis for the composition of the cave temple's floor plan is a circle (one year equals 360 days, corresponding to 360 degrees) with a radius of 12 Tang feet (diameter 24 Tang feet, corresponding to 12 parts of a 24-hour day). The entrance to the chamber is also 12 Tang feet wide (corresponding to the remaining 12 parts of a 24-hour day). Because the cave temple represents the Pure Land where Buddha resides, the whole monument in its entirety describes that world as seen by human beings, that is, the cosmos."[6]

With the above, Yoneda seems to arrive at an ultimate religious interpretation of the architecture of Seokguram. While studying Yoneda's essays, I was able to grasp the key to the lofty feeling experienced inside Seokguram. I realized that the secret of Seokguram had been unraveled, not by an art historian or a theologian, but by a little-known architectural historian. That is, the aesthetic and religious experience of it could be attained ultimately through geometry and astronomical mathematics.

3. The Relationship between the Architecture and the Main Buddha

Yoneda Miyoji did not reveal what determined the size of the main Buddha because, as an architectural historian, his main interest was the structural composition of Seokguram.

But it can be said that the heart of this cave temple is the main Buddha. So, before elaborating on the question of the architectural proportions as revealed by Yoneda, I will examine the relationship between the structure of the main chamber and the main Buddha, and also, in light of the recent effort to restore the façade, the relationship between the main Buddha and the façade.

While Yoneda's approach began with a study of the architecture of Seokguram and then analyzed the composition of the main Buddha, I wish to begin with the Buddha statue as the reference point and look at its relationship to the architecture. The reciprocal, inseparable nature of this relationship makes these two opposing approaches possible.

Despite its significance, Yoneda Miyoji's work remained incomplete. It was only when Professor Nam Cheon-wu (南天祐) initiated efforts to restore the façade of Seokguram that it became possible to examine the relationship between the proportions of the façade and the main Buddha,[7] and thus I was able to contribute to the study of the overall proportions of Seokguram.

When talking about the relationship between the sculpture and architecture, I am referring to the principal icon, or the main Buddha, in the center. The other sculptures, like those in the niches or carved on the walls, are actually a part of the architectural structure and can, therefore, be excluded from the floor plans of Seokguram for the time being.

Two perspectives are necessary for examining the relationship between the architectural space and the dimensions of the main Buddha in the center. One is the relationship of the main Buddha to the floor plans and the elevation, of which it occupies the center, and the other is the relationship between the main Buddha and the façade as one approaches the entrance to Seokguram. As already discussed, the former matter has been dealt with by Yoneda. But he did not say what determined the size of the main Buddha. If the architecture of Seokguram and the pedestal of the main Buddha were composed according to an exact geometric design, it follows that the size of the main Buddha would also have been determined according to a certain criterion. I have previously mentioned that the size of the main Buddha in Seokguram is exactly the same as the statue of Shakayamuni displaying the *bhumisparsha mudra* (gesture of defeating demons and touching the earth, K. *hangma chokji-in* 降魔觸地印) in Mahabodhi Temple at Bodh Gaya, the site of Siddhartha's enlightenment, as measured in Tang feet by the Chinese Buddhist master Xuanzang (玄奘, 596–664) on his pilgrimage to holy places in India.[8]

It can be concluded, then, that the main Buddha's dimensions were determined before the construction plans were drawn up. It was after the statue's size was decided upon that its relationship to the floor plan and with the elevations was determined, and the harmonious relationship between the three can be traced to various proportions based on the triangle and square with sides measuring 12 Tang feet. In view of this, the geometric and mathematical principles applied to Seokguram, as revealed by Yoneda, are even more astonishing. That is, it would have been much easier to devise the architectural plans first and then decide on the size of the main Buddha; but with the dimensions of the Buddha

acting as a constraint on the overall architectural design, the task had to have been much more difficult. However, the architectural design, which achieves harmony with the main Buddha, shows no signs of such limitations. Moreover, although the pedestal was designed after the mathematical principle underlying the main Buddha and the architectural space was decided upon, it reveals itself to be based on mathematical variations of the equilateral triangle with sides measuring 12 Tang feet. So, the relationship between the main Buddha, the pedestal, and the architecture, despite difficult conditions, are unified and harmonized in mysteriously perfect mathematical relationships. The height of the main Buddha is 11.53 Tang feet, which is very close to 12 Tang feet. Whoever designed Seokguram must have taken the height of the main Buddha, 12 Tang feet, as the module, and designed the architecture based on it. This view is reinforced by the fact that the combined height of the Buddha and the pedestal is equal to the diagonal of a square with sides measuring 12 Tang feet.

Next, the relationship between the main Buddha and the façade of the structure is no less important. Though it is difficult to visually grasp the relationship between the main Buddha and the elevations and the floor plans, it is apparent when facing the façade that the relationship between the main Buddha and the façade was very carefully planned.

The important part of the façade is the two octagonal pillars that stand where the vestibule meets the main chamber. The two pillars were designed to support a skylight to illuminate the face of the Buddha. The columns, therefore, symbolize that this is the true entrance to the sacred ground, or the Buddha land, which is the main chamber where the main Buddha is enshrined. At the same time, dynamically, they support the skylight that lights up the face of the Buddha and provides a strong structural connection between the corridor and the main chamber.

The octagonal pillars are divided into two parts with a protruding capital. The top half of the pillar supports the weight of the skylight and the lower half serves as the main part of the entrance. The two octagonal pillars, including the lotus-patterned base, brackets, and window, ornament the main Buddha, which is visible between the pillars. In the drawing of the façade that I have reconstructed (Fig. 97), the protruding capitals in the middle clearly divide the entrance into top and bottom halves. The lower half is the entrance through which the worshipper comes and goes; the middle of the upper half is where the face of the Buddha is positioned; and the midpoint, where the face of the Buddha and the pillars end, is the main part where the skylight frames the Buddha's face. In this way, the boldly protruding capitals were designed to give the effect of dividing the entrance into two parts, the upper half symbolizing the heavenly world and the lower half the earthly world. At the same time, the capitals functionally link the pillars with the lower structure of the building and the upper dome structure. Hence, the major structural parts of Seokguram are transformed into the shape of religious and philosophical symbols, and thus the Pure Land, or paradise, is ornamented both physically and symbolically.

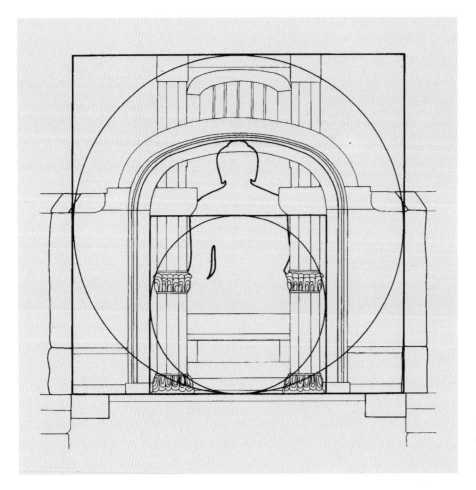

97. Elevation of
Seokguram's main
chamber façade (Kang
Woobang).

Based on the structure of the skylight as proposed by Prof. Nam Cheon-wu,[9] I have recreated the façade, and the relationship between the composition of the faade and the main Buddha is as follows.

The lower half of the entrance forms a square with sides measuring 12 Tang feet. This I call the "inner square." The total width of the front, including the relief carvings of the two Vajrapani, one on either side of the entrance, is equal to the total height of the pillars and also forms a square. This I call the "outer square." Thus the overall composition of the façade is made up of two squares of different sizes, one within the other.

The height of the arch at the entrance is roughly equal to the height of the main chamber from the floor to the top of the niches, and therefore equal to the total height of the main Buddha.

The upper line of the upper part of the pillars above the capitals is level with the Buddha's chin and orders the arrangement of the major parts of the face.

The width between the shoulders of the main Buddha is equal to the width between the two pillars.

To summarize, like the floor plans and the elevations, the composition of the façade of

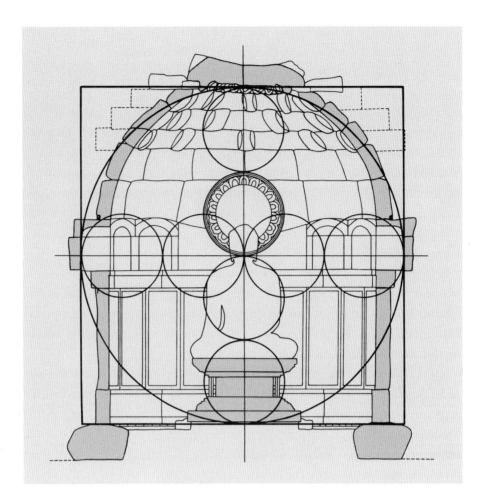

98. New interpretation
of main chamber
elevation and diameter
of nimbus
(Kang Woobang).

Seokguram is based on the basic module of 12 Tang feet, which indicates that the height of the main Buddha determined the composition of the façade.

The composition of the two squares seen in the façade is also seen in the elevation of the main chamber. That is, the height from the floor to the ceiling is equal to the width of the main chamber, forming a square. Here, an interesting point is that the diameter of the nimbus on the wall behind the main Buddha is one quarter of the height of the main chamber. In other words, the diameter of the nimbus is designed to be one half of 12 Tang feet (Fig. 98).

4. "*La Porte d'Harmonie*" Applied to the Sculptures and Architecture of Seokguram

The matter of the overall proportions of Seokguram will be examined by bringing together the composition of the floor plans and the elevations as revealed by Yoneda Miyoji, the relationship between the proportions of the elevations as newly attempted by myself, and

the reconstruction of the façade and its relationship with the main Buddha. What was the principle underlying the proportions applied to this historical monument?

Yoneda discovered that the proportions used in the floor plans of the tombs and temples of the Three Kingdoms period (三國時代, 57 B.C.−668 A.D.) were all based on a rectangle of sides with a ratio of 5:4, or an equilateral triangle, or a rectangle of sides with a ratio of 1:$\sqrt{2}$.[10] But Yoneda did not explain the relationship between the $\sqrt{2}$ rectangles used in the floor plans and elevations of Seokguram and the proportions of the pedestal based on the equilateral triangle. And although he often mentioned the diagonal of a square with sides measuring 12 Tang feet, he did not pursue the meaning of the $\sqrt{2}$ rectangle derived from the ratio of 1:$\sqrt{2}$, with 1 equal to 12 Tang feet. But the secret of the beauty of Seokguram can be discovered by uncovering the limitless proportional possibilities offered by the $\sqrt{2}$ rectangle.

In the architecture of Seokguram, the proportion applied to the elevations is $\sqrt{2}$, the basic units being the equilateral triangle in the floor plans, and the perpendicular of the equilateral triangle in the pedestal, between which a commensurable relationship must have existed. That is, these units were not used in the elevations and pedestal in isolation but with a common denominator linking them.

It is my analysis that two sets of $\sqrt{2}$ rectangles (*la porte d'harmonie*) repeat or overlap in the elevations of Seokguram. Inside the $\sqrt{2}$ rectangle there is a square and what is approximately a $\sqrt{6}$ rectangle, and this rectangle is repeated in the center (Figs. 99, 101). The arrangement of the sculptures is determined according to this design. The middle section where the two $\sqrt{2}$ rectangles overlap is where the head of the main Buddha and the niches containing the seated bodhisattvas are positioned. In the two square sections

99. Geometric scheme of main chamber elevation. (left)

100. The 1: $\sqrt{2}$ ratio in the main chamber elevation. (right)

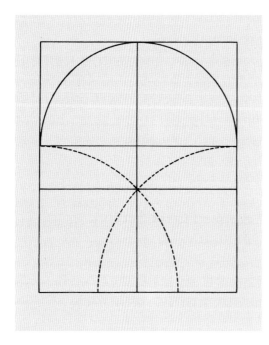

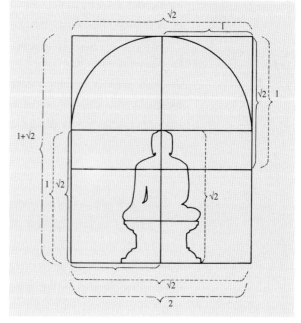

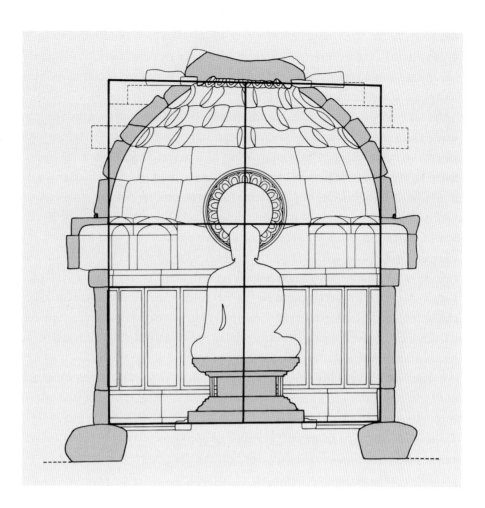

101. Elevation of main
chamber, composed of
√2 rectangles.

below, the relief figures of the standing bodhisattvas and the Ten Great Disciples are located. And in the two square sections above, the dome is installed.

More detailed analysis of the elevation of Seokguram shows that the ratio of 1:√2 has been consistently applied to its design (Fig. 100). The height of the cylindrical main chamber minus the dome section is 12 Tang feet, which is equal to the diagonal of the square. When 12 Tang feet is taken as 1, then the diagonal of the square with sides measuring 1 equals √2. That is, the height of the walls of the main chamber equals √2. At the same time, the total height of the main Buddha and the pedestal also equals √2. Therefore, the elevation of the main chamber is made up of two rectangles, each with two sides measuring 1 and two sides measuring √2. When the two overlapping rectangles are combined, they form one large rectangle with a height of √2, and when this is taken to be 1, then the width of the large rectangle is √2, which means the diameter of the dome is also √2. The dome is a semi-circle with a radius of 12 Tang feet. Similarly, when this is taken to be 1, both the total height of the main Buddha and the distance from the top of the Buddha's head to the top of the dome is also 1. Likewise, the width of the entrance is also 1.

So when 12 Tang feet, the basic unit of measure proposed by Yoneda, is taken to be 1, an examination of all the parts of Seokguram reveals that the ratio of 1:$\sqrt{2}$ has been consistently applied throughout the cave temple, and that the main Buddha and the architecture are also related in the ratio of 1:$\sqrt{2}$.[11]

The basic unit of measure in the main Buddha's pedestal is half the length of the perpendicular of an equilateral triangle with sides measuring 12 Tang feet. What relationship does this unit have with the $\sqrt{2}$ rectangle? When 12 Tang feet is taken to be 1, the equilateral triangle with sides measuring 1 has a perpendicular measuring $\sqrt{3}/2$. In other words, an equilateral triangle with sides measuring 2 has a perpendicular of $\sqrt{3}$. And thus the composition of the pedestal is based on this element of $\sqrt{3}$. But the ratio of 1:$\sqrt{3}$ is derived from the ratio of 1:$\sqrt{2}$. From the diagonal of a square with sides measuring 1, a $\sqrt{2}$ rectangle can be derived; and from the diagonal of this rectangle, a $\sqrt{3}$ rectangle with the ratio of 1:$\sqrt{3}$ can be derived. This ratio is 1:1.732, which is very close to the golden section of 1:1.618. It was thus called the "approximate golden section" and was widely applied in ancient art and architecture. Hence the composition of the pedestal, which uses $\sqrt{3}$, is in fact derived from the $\sqrt{2}$ rectangle, and one quarter of $\sqrt{3}$ is the width of the octagonal upper pedestal, and one half of $\sqrt{3}$ is the diameter of the upper pedestal stone.

It is now time to investigate the nature of the $\sqrt{2}$ rectangle. A $\sqrt{2}$ rectangle divided in half forms two smaller $\sqrt{2}$ rectangles. Continual division will always yield two smaller rectangles in the same proportion, that is, with length and width in the ratio of 1:$\sqrt{2}$. Therefore, this division of the rectangle can be repeated infinitely with the ratio between the parts and the ratio between the parts and the whole remaining constant.

Then, the $\sqrt{2}$ rectangle gives birth to the $\sqrt{3}$ rectangle (close to the golden section), and this in turn gives birth to the $\sqrt{4}$ rectangle, which in turn gives birth to the $\sqrt{5}$ rectangle, finally arriving at the golden rectangle and the golden section. Therefore, the $\sqrt{2}$ rectangle, the most basic figure and the starting point for various other figures, is called "*la porte d'harmonie*,"[12] or "the gate of harmony" (Figs. 102, 104).

Thus the compositional characteristic of the $\sqrt{2}$ rectangle is that it can be infinitely divided into two smaller $\sqrt{2}$ rectangles or infinitely expanded into a larger $\sqrt{2}$ rectangle double the size (Fig. 103). This is the same as the principle of infinite repetition of interrelationships among members of the cosmos, and such a world is called *dharma-dhatu* (dharma realm, or the world of truth) which is found in the Avatamsaka (K. Hwaeom, 華嚴) philosophy. The golden rectangle (黃金矩形) also follows the same principle of infinite repetition of the same ratio. That is, the proportion between the long side and the short side make up the golden section (黃金分割) and can repeatedly form a rectangle that is different in size but the same in proportions. So, a diagram of the systematic projection of the golden rectangle contains within it the famous spiral shape of the nautilus. That is, immanent in both la porte d'harmonie and the golden rectangle is a shape that can be infinitely repeated in the same proportions. And within that shape, the principle of natural beauty is expressed geometrically and mathematically. The beauty of these aesthetically

102. Construction of the $\sqrt{2}$ rectangle.

103. Division of the $\sqrt{2}$ rectangle and its geometry.

104. Construction of golden-section rectangle.

105. Various division of the golden-section rectangle and its geometry.

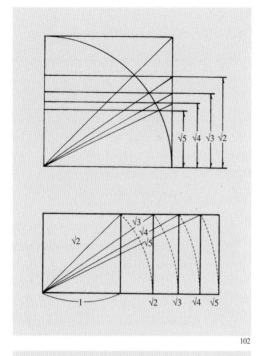

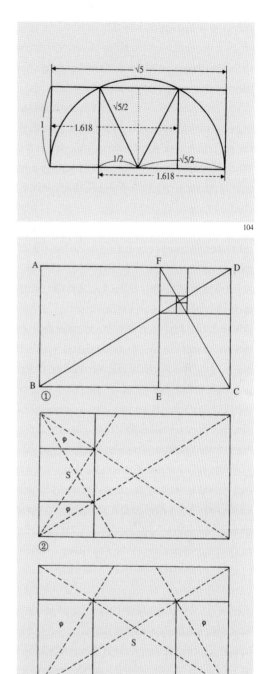

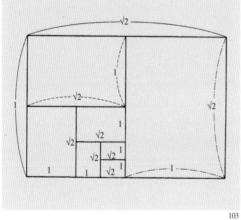

* √2r is √2 rectangle
* φ is golden rectangle
* S is square

pleasing proportions and the philosophical and religious insights contained in them were applied to the Parthenon in Greece. That these repeating, infinite mathematical relationships between the whole and the parts were used in a religious building is a very important fact. Just as the golden rectangle, or divine proportion, was used in the Parthenon in Greece, la porte d'harmonie was used in the Buddhist cave temple Seokguram in Unified Silla.

The uniqueness of the Seokguram construction plans becomes even more apparent when compared to the plans and elevations of the Parthenon. As already observed, in Seokguram the ratio of the rectangle was used in the elevation, la porte d'harmonie in the elevation of the main chamber, the circle and the hexagon inscribed within the circle in the floor plan of the corridor, and the $\sqrt{3}$ rectangle in the floor plan of the main chamber. Although a variety of proportions were used together they are all unified by a systematic set of connecting relationships. The basic module is 12 Tang feet, and when this is taken as 1, then the ratios used in the architecture, the main Buddha, and the pedestal are $1:\sqrt{2}$, $\sqrt{3}$, and $\sqrt{3}/2$, respectively. Though the actual ratios used are different, the same systematic relationship between proportions was applied to the floor plan and elevations of the Parthenon. The analysis of the Parthenon carried out by Professor Jay Hambidge shows just how systematically the proportions are related and how the golden rectangle was divided to achieve this.

To interpret the façade of the Parthenon, the nature of the golden rectangle must first be understood (Fig. 105). First, the golden rectangle contains two squares, one big and one small; two golden rectangles, big and small; and two 1.382 rectangles (square + golden rectangle), big and small. If the 1.382 rectangle inscribed within the golden rectangle is halved, then it forms two smaller rectangles that can each be divided into a square and a $\sqrt{5}$ rectangle. The façade of the Parthenon is thus based on the 1.382 rectangle and the $\sqrt{5}$ rectangle.[13]

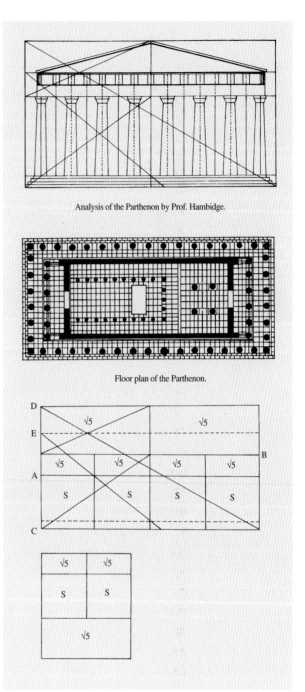

Analysis of the Parthenon by Prof. Hambidge.

Floor plan of the Parthenon.

106. Geometric composition of the floor plans and elevations of the Parthenon.

112

The following is a summary of an analysis of the Parthenon façade (Fig. 106).[14] The façade is composed of four squares adjoined side by side, and six $\sqrt{5}$ rectangles, two big and four small. The top two $\sqrt{5}$ rectangles, the big ones, form the section where the entablature (cornice and architrave) is located.

The overall shape of the elevation is formed by taking the golden rectangle and subtracting a $\sqrt{5}$ rectangle from one side, which results in a new rectangle (composed of a 1.382 rectangle and a $\sqrt{5}$ rectangle), two of which are placed side by side on their ends to form the overall shape of the façade of the Parthenon.

Further division of the rectangles and their placement are all logically arranged according to the nature of the large overall rectangle. As demonstrated by Professor Hambidge's diagram, the intrinsic proportional element here is the golden section. Though much simpler, these proportional relationships are also found in the elevation of the main chamber of Seokguram.

The floor plan of the Parthenon is as follows. Overall, it is a $\sqrt{5}$ rectangle. The inner chamber can be divided into two sections; the rear section is a 1.382 rectangle, and the front section is a golden rectangle inside which is an altar called Naos, where the statue of Athena Parthenes is enshrined. The altar is a $\sqrt{5}$ rectangle and is surrounded by a corridor formed by a series of small columns.

The floor plan is organically connected to the elevation by using the same kind of composition, maintaining perfect uniformity between the two. It is this relationship which creates the beauty of the dynamic proportions in the Parthenon. It can be said that the golden rectangle was applied to this temple because of its emphasis on exterior beauty, and la porte d'harmonie to Seokguram because of its emphasis on interior beauty. Although the actual proportions applied to the Parthenon, a temple to the gods, and Seokguram, a temple to Buddha, are different, the two temples are alike in that unified proportions are applied to the parts as well as to the whole of the structures, thus creating an organic connection. Compared to the Parthenon, which is made up of straight lines, Seokguram is a curved structure. All of its transverse sections, as well as the vertical sections of the dome, are curved, meaning that the structure is curved in all three dimensions. The rectangle, specifically the $\sqrt{2}$ rectangle, appears when a vertical section is made of the whole main chamber. So it can be said that a combination of proportions is used: the circle, the rectangle, the $\sqrt{2}$ rectangle (la porte d'harmonie) and the $\sqrt{3}$ rectangle. Among them, $\sqrt{2}$ determines the vertical section of the main chamber and the height of the main Buddha, which make up the major parts of Seokguram. This is why $\sqrt{2}$, or la porte d'harmonie, has been emphasized in the title of this essay.

5. *"La Porte d'Harmonie"* and *"Pratitya-Samutpada,"* or "Dependent Origination"

As discussed thus far, basic geometric forms such as the circle, rectangle, equilateral triangle, and regular hexagon are used in the façade, floor plan, and elevations of the main chamber of Seokguram. And in the elevation of the main chamber, the most important part of the structure along with the main Buddha, the $\sqrt{2}$ rectangle is applied in varying ways. But such a meticulously conceived geometric construction scheme was not limited to the architecture of Seokguram; it was also commonly found in the floor plans of ancient temples and in the plans and elevations of stone pagodas from the 7th to the 9th centuries. It can be said that such perfect compositional proportions inhere as an aesthetic element in all ancient Korean architecture from the late Three Kingdoms period to the mid-Unified Silla period, and the style of art of this period can be called the "ideal classical" style. Such characteristics can be found not only in architecture but are also in the sculpture of that period and therefore should be studied in relation to the philosophy, religion, astronomy, and geometry of the time.

The classical style of Korea, based on such consummate compositional proportions, cannot yet be examined in relation to that of China, but it can be compared with the Hindu art of India, for which classical theory has been established. But the idealism found in classical theory is a universal artistic phenomenon, so it would not be unreasonable to attempt a comparison between the classical style of Korea and that of ancient Greece, about which there is extensive research. The importance of ancient Greek and Roman art, as is well known, is not limited to Europe; both played a definitive role in Gandhara art and were known in ancient China, so whether we are aware of it or not, there is an indirect connection with Korean art.

What meaning, then, is held in these perfect proportions that are inherent in the classical style? Proportions are based on the forms of nature, and from the beautiful proportions of nature, various geometric figures are derived which are then applied to the composition of architecture, sculpture, and painting. Therefore, proportions can be explained according to geometric figures, and there is an inseparable relationship between geometry and art. Architectural composition in particular is determined according to geometric proportions.

Because geometry is the study of how space is ordered through the size and interrelationship of forms, it first developed as a part of astronomy. It reflected ancient cosmology and was related to philosophy and religion. And because the oscillations of sound could be expressed as a ratio, the harmonic proportions of music could be explained geometrically and poetic meter could be established. Geometric proportions extracted from natural phenomena have always been considered important in all areas of human culture including astronomy, philosophy, religion, art, and music. In this way, geometry is the

result of cosmology and a world-view obtained from observation and contemplation of dynamic natural phenomena that constantly change and grow, and so it is closely connected to human thought itself. This is why geometry encompasses all cultural activity.

Plato defined geometry as the most concise, the most basic, and therefore the most philosophical language. Geometric shapes and numbers can be mediums for philosophical thought and the language that provides the clearest descriptive model of the metaphysical world. Therefore, to enter a temple composed on the basis of geometric proportions is to enter a house of truth.[15] Such thinking is common to both the East and the West. For instance, in esoteric Buddhism (密教), which can be considered a development of Mahayana Buddhism (大乘佛教), the mandala—composed of geometric figures and inside which are arranged various Buddhas and bodhisattvas—is used as a means of communicating esoteric Buddhist philosophy. Moreover, the French mathematician, philosopher, and physicist Jules-Henri Poincare said that one could not be a true scholar of geometry without also being a poet, thus emphasizing the importance of poetic intuition and imagination in geometry.[16]

Geometric proportions are therefore the most important principle in achieving the ancient ideal of the "beauty of harmony" in the plastic arts, especially architecture and sculpture.

Proportion means the balance that is the basis of harmony. Such balance occurs when a certain quantity maintains a certain ratio with another quantity, and that relationship is felt to be beautiful. When a uniform ratio is maintained between the parts and the whole and among the parts themselves, all things are connected with each other. So harmony means there is a legitimate relationship between the parts and the whole. And in such a relationship, a common unit always exists. Though the quantities may differ, a homogeneous "commensurable relationship"[17] is maintained because of the common unit. The concept of harmony derived from proportions has been considered sacred since ancient times and thus has also taken on a religious nature.

Art and the natural sciences seek to find uniformity in diversity, and religion is no exception. For this reason, these sacred proportions have been applied to the design of religious architecture. Architecture based on the converging principles of religion and proportion is a manifestation of religious concepts transformed into art. This is why a sublime religious feeling as well as artistic beauty is felt inside such architectural spaces. The rules of proportion were derived from the study of natural phenomena, and Buddhist philosophy was established on the study of natural phenomena, which is perhaps how they arrived at a common principle. An examination of the principles of religious philosophy will show what they have in common with the principles of proportion.

The core of Buddhist philosophy is the doctrine *pratitya-samutpada* (K. *yeongi sasang*, 緣起思想) or "dependent origination," it states that all phenomena are the result of mutually dependent existence, and not being spontaneous and self-contained, have no separate and independent nature. This interdependence of all things is the truth that

Shakayamuni realized when he attained enlightenment at Mahabodhi Temple in Bodh Gaya. It is the doctrine of inner witness, and to offer salvation and make this idea of dependent origination easier for others to understand, the doctrine preached is the four dogmas, or four noble truths that are the fundamental doctrines of Shakyamuni.

After attaining Buddhahood, Shakyamuni sat quietly alone under the Bodhi tree and thought to himself, "The dharma that I have attained is so subtle and deep and difficult to understand that only the wise will readily understand it. It will be hard for sentient beings to understand this philosophy of dependent origination, and even if I do preach it, my pains will be for nothing. So I will not preach it." Sakayamuni finally preached the sermon after Mahabrahma (大梵天王), the first king of heaven, pleaded with him three times, but in the beginning it is said that he did not preach the doctrine of dependent origination.[18]

Shakayamuni's awakening to the truth is his realization of the interdependence of all things, and this is the basis for attaining deliverance and reaching Nirvana, which is emancipation from individual existence. When Shakayamuni fell into deep meditation after attaining Buddhahood, he would have been contemplating a way to preach this doctrine to sentient beings.

In the early sutras dependent origination is generally explained this way: " ... thus one thing depends on another, and because one thing lives so does another, if this does not exist then neither does that exist and if this disappears, so does that disappear." Dependent origination means that everything is causally produced and that nothing in the realm of phenomena is isolated but that all things are interdependent. One thing existing because another thing exists means that all things in the realm of phenomena spatially depend on and are related to each other, and one thing happening because another thing happens means that all things are temporally dependent and related to each other.[19] Therefore, all phenomena arise and expire because of this spatial and temporal interdependence of all things.

The theoretical system of dependent origination gradually developed and reached its peak in the Avatamsaka school (K. Hwaeomjong). The concept of dependent origination developed in the Avatamsaka school is known as *dharma-dhatu pratitya-samutpada*, the phenomenal world where everything is dependent on everything else, and in which all are one, and one is all. The six characteristics found in everything—the whole and the parts, unity and diversity, and entirety and fractions—and mutual identity (water is waves and waves are water) are all ways of explaining dharma-dhatu pratitya-samutpada. In the *Avatamsaka Sutra*, it is frequently mentioned that all realms can be seen in even a grain of dust, or that everything can be found in the tip of a hair, and that the tip of a hair can be found in all things, which all describe the principle of mutual identity that all things are the same.[20] The doctrine of dependent origination is expressed in a fantastic way by the jewel net of Indra: In the heavenly palace of the great god Indra, there hangs a wonderful net that stretches out infinitely in all directions. In every node of the net, a clever artist has

hung a glittering jewel, and since the net is infinite in dimension, there are an infinite number of jewels, glittering like stars of the first magnitude. If one of the jewels is chosen for close inspection, it can be seen that all the other jewels in the net are reflected in its shining surface. Not only that, this jewel is reflected in all the other jewels so that the process of reflection is also infinite.

This metaphor of the jewel net of Indra is often used in the *Avatamsaka Sutra* (華嚴經) to explain the infinitely repeated interdependency of all things in the universe. It is an expression of dharma-dhatu, the physical universe where all natural phenomena have mutual identity and where all are one and one is all.[21] This is the precise observation which locates all phenomena in human life and the universe in spatial, temporal, and logical relationships, with all things living, dying, and changing according to the law of dependent origination.[22]

To explain this in a concrete way, the Avatamsaka school commonly uses the interpretations of the Chinese monk Fazang (法藏), who systemized the Avatamsaka philosophy. The relationship between the whole and the parts is explained using the analogy of a building. A building as an organic whole cannot exist without its parts such as rafters and pillars. Thus, in Avatamsaka-style logic, the rafters are the building. That is, the parts are derivations of the whole. But it cannot be said that the parts—the rafters and the pillars, for example—are the same as each other. Rather, because the parts are different in shape and function, it is when they fulfill their respective functions that the building is complete, thus leading to the Avatamsaka-style logic that because the parts are different they are the same.[23] This explanation of the relationship between the whole and the parts accords with the principle of proportions—that the whole and the parts are in a commensurable relationship where the quantities may differ but are all homogeneous.

Surprisingly, this Buddhist world-view is consistent with that of modern physicists. A comparison of the ideas of Alfred Whitehead and Fritjof Capra with the Buddhist doctrine of dependent origination may help to clarify the modern meaning of this doctrine and the universal nature of Buddhist philosophy. Whitehead said that all things are dependent on each other, and because they feed off each other they cannot exist in isolation. This is what is known as organic existence. He then arrived at the following principle of the universe, that there is no isolated existence in the universe, and that all things not only depend on each other but contain each other, and that all things are the same image at the same time they are the reflections of all other things.[24] This idea corresponds to the universal causality of the universe, illustrated by the jewel net of Indra, where things are infinitely repeated.

Whitehead also said that all events are an element of all other events, and all previous actions lead to an event; that the true meaning of human relations can be found in the true meaning of immanence; that we exist in this world and the world exists inside us, we are our bodies and our body is us and we act inside our bodies. While he said such observations may seem vague, he argued that they are ineluctable and form the basis of the inter-

relatedness of the world.[25]

Meanwhile, Capra presented a new vision of reality in which all phenomena—physical, biological, psychological, social, and cultural—are interrelated and interdependent. He derived the principle of life from a comprehensive study of the structure and workings of all life forms. "The systems view looks at the world in terms of relationships and integration. Systems are integrated wholes whose properties cannot be reduced to those of smaller units ... Examples of systems abound in nature. Every organism—from the smallest bacterium through the wide range of plants and animals to humans—is an integrated whole and thus a living system ... What is preserved in a wilderness area is not individual trees or organisms but the complex web of relationships between them.

"All these natural systems are wholes whose specific structures arise from the interactions and interdependence of their parts. The activity of systems involves a process known as transaction—the simultaneous and mutually dependent interaction between multiple components. Systematic properties are destroyed when a system is dissected, either physically or theoretically, into isolated elements. Although we can discern individual parts in any system, the nature of the whole is always different from the mere sum of its parts."[26]

In this way Capra compared the relations between the whole and the parts to a net, the relationships being intrinsically dynamic in nature. That is, Capra suggests matter is not imperishable but a form of continually perishing energy. "Living organisms, being open systems, keep themselves alive and functioning through intense transactions with their environment, which itself consists partially of organisms. Thus the whole biosphere—our planetary ecosystem—is a dynamic and highly integrated web of living and nonliving forms. Although this web is multileveled, transactions and interdependencies exist among all its levels."[27]

Capra said that the smallest of these living components show an amazing level of uniformity and pointed out that that they resemble one another quite closely throughout the living world. To illustrate his point he quoted the words of Louis Thomas: "There they are, moving about in my cytoplasm ... They are much less closely related to me than to each other and to the free-living bacteria out under the hill. They feel like strangers, but the thought comes that the same creatures, precisely the same, are out there in the cells of seagulls, and whales, and dune grass, and seaweed, and hermit crabs, and further inland in the leaves of the beech in my backyard, and in the family of skunks beneath the back fence, and even in that fly on the window. Through them I am connected: I have close relatives, once removed, all over the place."[28]

"We do not have solitary beings. Every creature is, in some sense, connected to and dependent on the rest. Larger networks of organisms form ecosystems, together with various inanimate components linked to the animals, plants, and microorganisms through an intricate web of relations involving the exchange of matter and energy in continual cycles."[29]

The world-view presented by Capra is astoundingly similar to the Buddhist world-view. The web of relations that he talks about is no different from the infinite jewel net of Indra. Likewise, the symbolic meaning that proportions have in art is no different from these world-views. That is, it can be said that art has attempted an expression of a world-view through the principles of proportions. So in the end, the jewel net of Indra of the Avatamsaka school, the web of relations presented by Capra, and the web of proportions where uniform quantities are infinitely immanent in an orderly manner, are all saying the same thing. The theories of Whitehead and Capra and the principle of dependent origination are the philosophy and religion of immanence. The whole contains the parts and the parts contain the whole, and the parts and the whole are immanent in each other.

Hence the doctrine of dependent origination is not merely a Buddhist truth but something universal, which is why Shakayamuni said, "I have realized that I am not the first but that many Buddhas attained enlightenment before me, as many as the grains of sand in the Ganges River, and many more will follow in the future. I am no more than the messenger of that truth." This helps to explain why the principles of proportions have been applied to religious temples both in the East and the West. If architecture is a miniature of the cosmos, then the cosmology of each period in history is reflected in the architecture of the time, with the architectural structures designed according to geometric principles reflecting that cosmology. And thus the architecture of Seokguram is the infinitely repeating world of dependent origination expressed through infinitely repeating proportions.

Though there are several ways to express the concept of dependent origination, the most common model is the chain of causation known as the twelve nidanas (links), where each factor gives rise to the next. But since the original meaning of dependent origination is the interrelatedness of all things in the universe, the form of expression does not matter so long as the meaning is fully conveyed. This is a very important point. In Buddhism there are countless different ways of expressing the truth according to the levels of sentient beings. This means the doctrine of dependent origination can also be expressed through the plastic arts. Because the principle of proportions and the principle of dependent origination are in accord with each other, the architecture of Seokguram was designed according to the principle of proportions, and the beauty of the temple expresses the sacredness of the truth.[30]

The proportions of Seokguram can be understood as an artistic expression of dharma-dhatu as the environmental cause of all phenomena, everything being dependent on everything else, and one is all and all is one. The ratio of $1:\sqrt{2}$ that is the basic proportional unit used in Seokguram can be found in the smaller parts, the larger parts, and ultimately in the whole. If the $\sqrt{2}$ rectangle is divided in half, then it produces two smaller $\sqrt{2}$ rectangles, and if each of these is divided in half, they each produce two smaller $\sqrt{2}$ rectangles, and so on, creating an infinite series of rectangles in the ratio of $1:\sqrt{2}$. The large $\sqrt{2}$ rectangle contains within it a countless number of smaller $\sqrt{2}$ rectangles, and the small

$\sqrt{2}$ rectangles can be projected into an infinite number of larger $\sqrt{2}$ rectangles. Because the ratio of 1:$\sqrt{3}$ is a transformation derived from the ratio 1:$\sqrt{2}$, each ratio is immanent in the other. In other words, the combination of proportions in Seokguram is a physical representation of the symbolism of the jewel net of Indra. The relations between the whole and the parts in the proportions of the "golden section" or of "la porte d'harmonie" are the same as the relations between the whole and the parts and the infinite repetition in the doctrine of dependent origination.

6. Conclusion

La porte d'harmonie, which was applied to Seokguram, is exactly that: the entrance to the universe of harmony. The principles of proportion may have changed with the times, representing man's continuous search for harmony. But all those principles of proportion have as their starting point in la porte d'harmonie, embodied in the $\sqrt{2}$ rectangle. La porte d'harmonie—with 12 Tang feet as the basic unit of length and the proportions of the $\sqrt{2}$ rectangle—has been applied to all parts of Seokguram, creating complete harmony among all the parts of the architecture. This common unit and proportions can also be found in the floor plans and elevations of the three-story stone pagoda at Seokguram, which further confirms the very deliberate nature of the design used.

The symphony of grandeur, sublimity, and beauty that can be felt inside Seokguram comes from the harmony of proportions immanent in the architecture. The core of the temple is the architecture and the main Buddha in the center. Although the relief sculptures of the bodhisattvas, the Ten Great Disciples, and the Four Heavenly Kings (四天王) on the surrounding walls are masterpieces of their time, their function is to make sublime the architecture and the main Buddha. But because one's eyes are drawn to the main Buddha in the center and the relief figures on the surrounding walls, it is easy to overlook the architecture as simply a setting for the sculptures. However, the symbolism of the architecture is strong enough to overpower the sculptural reliefs. Only when one comes to understand the grandeur, sublimity, and beauty of the architecture, can one realize the meaning of the figures sculpted in high relief on the architecture. The sculptures are an integral part of, and immanent in, the architectural space, and the two cannot be considered separate as they form parts of the organic whole.

In this way, the art of Seokguram serves as a realization of the ultimate religious ideal. Through the aesthetic language of form, it serves to embody religious ideals that are based on an understanding of the principle of the cosmos. Shakayamuni's attainment of enlightenment, his realization of the doctrine of dependent origination, finds grand expression through the proportions of la porte d'harmonie. And this philosophy of the absolute, which says that all things are interdependent, finds correspondence in the spatial order of architectural composition based on geometric proportions. Thus Seokguram

represents the realization of a unified whole, comprising mathematics, geometry, physics, astronomy, architecture, religion, and art.

As I undertook my research, I often had doubts about whether Buddhist art could be considered something more than a mere instrument or method of expressing Buddhist philosophy and historical facts. But I came to realize that art does not stand as an isolated, independent entity. And so a mere stylistic study of art cannot be considered the ultimate purpose of the study of art history. Through study of the architecture of Seokguram, I came to understand that art has its own statement to make in connection with geometry and religion. As such, art and religion are not in a hierarchical relationship but a commensurable relationship. They are mirrors that reflect each other. Art is different from other academic fields or activities but it includes them all. Art cannot exist in isolation. Only when art has a true relationship with other endeavors can it reach self-fulfillment. Only then can art express through its own formative language the ultimate purposes of geometry, astronomy, religion, and physics. Seokguram, a Buddhist work of art, is a great work of art because it reveals such fundamental truth. And for this reason, Seokguram can continue to be examined and interpreted from various perspectives according to the times and the people inhabiting those times.

This study would have been impossible without the groundwork laid by Yoneda Miyoji. However, my findings on the correspondences between the principle of proportions and the Buddhist doctrine of dependent origination were the result of a great amount of time spent examining the architecture and thinking on the matter. In this essay I have not actually dealt with the architecture itself but the proportions inherent in its composition. And through the principle of proportions, I have attempted a philosophical and religious interpretation of Seokguram. If the architecture of Seokguram is the manifestation of the macrocosmos, then the Buddha in the center of it is the manifestation of the microcosmos.

The Iconography of the Main Buddha of Seokguram

The importance of the Seokguram monument (originally called Seokbulsa Temple 〔石佛寺〕, meaning "Stone Buddha Temple")[31] in world art has not been clearly uncovered. This monument from Unified Silla definitely has a special place among the great cave temples and stone edifices of the world such as the Ajanta cave temples and Bamiyan cave temples of India; the Dunhuang (燉煌) grottoes, the Yungang (雲崗) grottoes and Longmen (龍門) grottoes of China; and Borobudur Temple in Indonesia. But Seokguram is like an orphan, lost in the stream of art history. Academic research on Seokguram began only in the early 20th century, and a few papers were published on the subject by Japanese and German art historians, but most of these did not have a clear purpose or direction and are gradually losing significance. More recently, some investigative studies

on Seokguram have been published in Korea and some progress has been made in establishing the cave temple's place in the context of Korean art history.

Seokguram has attracted the attention of foreign scholars because of its distinctly international characteristics. As can be seen in its dome structure, mature style and exquisite technique, and systematic arrangement of Buddhist sculptures, it achieves a perfect harmony of architecture, sculpture, and philosophical expression in a way that is unmatched by any other single structure of its kind except perhaps Horyuji Temple (法隆寺) in Japan. While the international characteristics of Seokguram will have to be left to future researchers, there is still much to do in establishing Seokguram's place in the context of Korea's history of architecture, sculpture, and religion.

One decisive reason why studies on Seokguram have been tentative and problematic is the lack of written records. The only clear fact that can be gleaned from *Samguk Yusa* (三 國遺事, *Memorabilia of the Three Kingdoms*) or *Bulguksa Sajeokgi* (佛國寺 事蹟記, *Record of the Construction of Bulguksa*) is that it was commissioned by Kim Dae-seong, a state minister of Unified Silla during the reign of King Gyeongdeok. There is not a single line definitely stating the name of the sculptor, the date of completion, or explaining the religious meaning of the structure. As time passed Seokguram was increasingly considered ancillary to Bulguksa Temple, and records from the Joseon Dynasty mention Seokguram only in relation to Bulguksa.

Any study of Seokguram calls for a very careful and well-established methodology. Without a thorough analysis of the monument itself and its sculptures, and a logical methodology, it is easy to distort the meaning of Seokguram.

In discussing the iconography of the main Buddha of Seokguram, I have dealt mainly with its size and dimensions in an attempt to provide a starting point for research on this subject. Of the many artistic achievements of Seokguram, one of them is the harmony between the architectural space and the size of the main Buddha. While reexamining the studies of Professor Nam Cheon-wu and Yoneda Miyoji,[32] I tried to find the relationship between the mathematical values of the architecture and the size of the main Buddha, but this did not come easily. If every part of the interior structure of Seokguram is so geometrical and mathematical in its relationship with other parts, creating such unity and harmony, and if the position of the main Buddha was determined according to the architectural design, then what determined the size of the main Buddha? Was the size of the main Buddha determined by the architectural space, or was the scale of the architecture determined by the size of the main Buddha? The research by Yoneda gives the impression that the size of the main Buddha was determined by the meticulously conceived architectural design. On the other hand, because the core of Seokguram is the main Buddha, it is plausible that the scale of the architecture and the structure of the interior were determined by the statue.

The parts of the interior are based on the unit Tang cheok, or Tang feet, the diagonal of a square with sides measured in Tang feet, and the perpendicular of an equilateral triangle

measured in Tang feet. But the dimensions of the different parts of the main Buddha did not accord with any of these. After examining the dimensions of the main Buddha from many angles, I assumed that the figure was a seated sixteen-foot Buddha.[33] Generally speaking, such a figure measures about nine feet, but the Seokguram main Buddha is larger than this. Any Buddha larger than nine feet is considered to be a *daebul*, or "great Buddha," and so the main Buddha of Seokguram should also be considered a "great Buddha."

What is remarkable is that the size of each part of this Buddha accords with figures found in the *Great Tang Dynasty Record of the Western Regions* (大唐西域記), an account by the Chinese Buddhist master Xuanzang of his pilgrimage to Buddhist holy places. Here, Xuanzang is speaking about the statute of the main seated Buddha displaying the earth-touching mudra at Mahabodhi Temple in Bodh Gaya,[34] a complex constructed around the Bodhi tree where Shakayamuni attained enlightenment: "Looking inside the temple, the Buddha definitely exists with legs crossed, the right leg over the left leg, the left hand below the belly and the right hand hanging below the knee, solemnly facing east." What is of interest here is the measurement of each part of the body. As noted before, Yoneda Miyoji carefully measured each part of the body of the Seokguram Buddha and converted the measurements into Tang feet, thus reconstructing the original dimensions. They can be compared with the measurements of the Mahabodhi Temple Buddha recorded by Xuanzang as shown below:

	Total height	Width between knees	Width between shoulders	Pedestal height	Pedestal width
Mahabodhi Buddha	1 jang, 1 cheok, 5 chon	8 cheok, 8 chon	6 cheok, 2 chon	4 cheok, 2 chon	1 jang, 2 cheok, 5 chon
Seokguram Buddha	1 jang, 1 cheok, 3 chon	8 cheok, 8 chon	6 cheok, 6 chon	5 cheok, 5 chon	9 cheok, 5 chon

∗ 1 jang = 10 cheok, 1 cheok = ten chon

The comparison shows that the size of the two Buddhas is the same, but there is a difference in the size of the pedestals. When surveying a Buddhist statue, it is possible to accurately measure the total height and the width between the knees, but the width of the shoulders is difficult because of the curve of the shoulders, which may account for the difference in the shoulder width of the two statues. But what I want to emphasize here is that the size of the main Buddha at Seokguram seems to be based on the statue of Buddha reaching enlightenment enshrined at Mahabodhi. This match in size cannot be overlooked as a coincidence, especially considering that there are features that are exactly the same, most significantly the earth-touching mudra and eastern orientation.

After Xuanzang visited Mahabodhi and left precise records of what he saw, others followed, including the Chinese envoy to India, Wang Xuance (王玄策), who recorded the same measurements of the Mahabodhi Buddha as Xuanzang and had those accompanying him make drawings of the statue. It is said that afterwards many monks and ordinary people from China went to draw a likeness of the statue.[35] The original statue made in India became very popular in China from the mid-7th century, and right after Silla unified the Three Kingdoms in 668, it is certain that it became popular in Korea as well. Also, there are records showing that many Silla monks, braving death, traveled with Chinese monks to places of pilgrimage in India. From this it is clear that Mahabodhi Temple in Bodh Gaya, where Shakayamuni attained enlightenment, was a place of pilgrimage for monks from both Korea and China.[36]

In this light, it can be said that the main Buddha of Seokguram was made to recreate Shakayamuni at the moment of enlightenment, so it is no longer Shakayamuni but the Buddha, the enlightened one, who is being portrayed. But this does not fully explain the nature of Seokguram, and it is not my intention to reach any such conclusion in this essay. Buddhism went through many changes from that moment, and it is certain that Silla's own interpretation of Buddhist doctrines would have been reflected in the architecture and sculpture of Seokguram. But while people from the world may marvel at Seokguram, the lack of ancient records hinders proper research on the topic. At the very least, the fact that the model for the main Buddha of Seokguram is the Mahabodhi Buddha, and that the measurements of the Buddha, the mudra, and its eastern orientation are the same as its counterpart in India, provide a very important starting point for academic research on the cave temple.

The Iconography of the Buddhist Sculptures in Seokguram

In the center of Seokguram there is the main image of Buddha sculpted in the round and on the walls surrounding it are thirty-seven Buddhist images. These Buddhist images can be taken to represent the audience listening to the preaching of the dharma, and in this essay I proceeded to take the symbols of the various images as various characteristics of the seated image of Shakyamuni displaying the mudra of defeating the demons and touching the earth (*bhumisparsha mudra*), which is an image of Shakyamuni's attainment of enlightenment. Of these images some have mudras and attributes that do not follow the standard prescriptions, for which reason they cannot be clearly identified. In addition, further consideration is required to determine when the images of the Eight Classes of Deva Protectors were made.

1. Introduction

In Seokguram, thirty-seven statues carved in relief (thirty-nine counting the two bodhisattva images now lost in the niches) are evenly arranged in pairs on the walls to the left and right of the entrance of the main chamber, centered on the image of the Tathagata Shakyamuni carved in the round in the center of the main chamber. Thus, including the main image in the center of the main chamber, it is a structure comprised of forty Buddhist images. In India and China there are many cave temples, but the only example of one where Buddhist images are arranged systematically according to hierarchy in this fashion may be found only in Seokguram in Gyeongju.[1]

In Seokguram (石窟庵), with the exception of the images of the Vajrapani, the Four Heavenly Kings, Brahma, Indra, and the Eleven-faced Avalokiteshvara, the iconographies of the Eight Classes of Dharma Protectors, the Ten Great Disciples, and the bodhisattvas in the niches are extremely difficult to clarify, and each scholar offers a different opinion concerning them. However, to avoid confusion, in this essay I have not introduced and offered comparisons with the opinions of other scholars.

Research on these iconographies is extremely important for the clarification of not only the cultic systems of the mid-eighth century, but also the cultic character of Seokguram. Here I have attempted to treat not only the iconography of Seokguram, but at certain times stylistic comparison has been unavoidable, and I have made brief references to other examples from the same period. Further, although in my iconographic research I have chiefly treated the form of the Buddhist images—in other words, only their pos-

tures, attributes, mudras, etc.—and I have emphasized the identification of the images, at times I have also attempted partial interpretations of their iconographies.[2]

The objects of worship in Buddhism can be broken up into three general types: Tathagatas (Buddhas), bodhisattvas, and devas. Among these, the devas are the gods of ancient Indian Brahmanism, who were imported into Buddhism and became the tutelary deities who protect the Buddha-dharma. In order of rank, Brahma and Indra, who are the highest among the gods, became the retainers adopted at the sides of Shakyamuni when Buddhist images were first created; next are the Four Heavenly Kings, and the Vajrapani; and at the lowest rank are the Eight Classes of Dharma Protectors. They chiefly appear as the crowd listening at the place where Shakyamuni preaches the dharma. From the fact that they inevitably appear as the audience listening to the preaching of the dharma, we can learn that Buddhism widely embraced the gods of other religions, that having mediated their original roles they were given a new, Buddhist character, and that in terms of rank they were placed in an intermediate position connecting the celestial and earthly realms; thus, they carried out a very important role in the popularization of Buddhism.

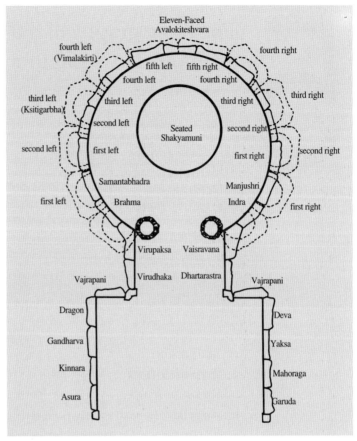

107. Arrangement of images inside Seokguram cave temple.

In ancient India, natural phenomena, the constituent parts of nature, and the power latent in their causes were deified, and the epic poems that are the holy books of Brahmanism, such as the *Vedas*, the *Mahabharata*, and the *Ramayana*, describe each god's realm and its formation.

Originally, thought about heaven began under the configuration of a utopian afterlife, but after it was introduced into Buddhism, heaven (K. *cheon*, 天) became something not expressing a concrete space but an absolute state in which a person arrives after accumulating meritorious works. However, the notion again developed from its original, ideal and concrete image into a heavenly realm divided into various levels in which the gods reside. Thus, these gods too came to be called *cheon*, or heaven.

In Buddhism, the universe is divided into three realms; in ascending order they are: the

realm of desire (the human world) the realm of form, and the realm of non-form. The realm of desire is divided into, in ascending order: hell, the realm of hungry spirits, the realm of beasts, the realm of battling titans, the human world, and the realm of the gods; these are called the six paths or the six destinations. It is the realm of samsara into which one is reborn on account of the good karma accumulated while one is alive. In the heavenly realm, which corresponds to the highest level of the six paths, there are six heavens of desire: the heaven of the Four Heavenly Kings, the heaven of the thirty-three gods (Trayastrima heaven), the heaven of Yama, the Tusita heaven, the heaven of creating enjoyment (Nirmanarati heaven), and the heaven of free enjoyment of the creation of others (Paranirmitavasavartin heaven). Apart from the sixth heaven, unique to Buddhism, these are all the products of Brahmanism and the Vedas.

The realm of desire is the realm of those who have desires, the realm of form is the pure realm in which those who have transcended the various desires of the six paths reside, and the realm of non-form is the realm of transcendence of material things—in other words, the world of those who abide in meditation. As expressions of the process of practice by which a person reaches a state of enlightenment, attained after the actual accumulation of meritorious works, with the development of Buddhism these were assigned positions as real places in physical space, and gods came to preside over the various heavens. However, when viewed from the standpoint of the three vehicles (三乘), these are divided into the three realms, but when viewed from the standpoint of the one vehicle (一乘), these are nothing other than the single dharma-realm.[3]

Let's take a look at the way in which this conception of the universe as the three realms is expressed in Seokguram.

The plan of Seokguram appears to have been composed in an effort to express the unfolding of the three realms from the entrance through the main chamber. Seen from the entrance, the space through the corridor leading to the antechamber and the main chamber is the realm of desire, with the first heaven of the realm of desire, the heaven of the first meditation. Indra is said to be in the realm of desire, but as he makes a pair with Brahma as the supreme gods, his placement in a realm apart from Brahma is baffling. But in Seokguram, he is inserted in the same category with Brahma and positioned in the realm of form. In sum, we can view the antechamber and the corridor as symbolizing the realm of form inhabited by the Eight Classes of Dharma Protectors, the Vajrapani, the Four Heavenly Kings, etc.; the walls of the main chamber as symbolizing the realm of form with Brahma and Indra, together with the bodhisattvas and the arhats, and the center of the main chamber as symbolizing the realm of non-form, taken as the seat of the Buddha who has achieved supreme and perfect enlightenment. Thus we may infer that, by arranging the devas in a systematic order, Seokguram has clearly expressed a Buddhist conception of the universe using an arrangement of icons that follows an architectural structure (Fig. 107).

2. The Devas

1. The Images of the Vajrapani

The Vajrapani (金剛力士) carved in high relief on each wall of the entrance to the corridor feature forms and styles typical of the eighth century. Their torsos are nude, they wear short skirts, and their hair is tied in topknots. They wear expressions of rage with wide-open eyes, and on their bodies with exposed faces, chests, bellies, arms, and legs, muscles represent power with tension.

The image of the Vajrapani facing the entrance on the right (Fig. 109) has its mouth closed to signify *hum*, while the image on the left (Fig. 108) has its mouth open to signify *a*. On account of the Vajrapani' powerful postures, their skirts and heavenly garments that rise up from below beneath their halos, and those that descend on the right and left forcefully whirl their ends into circular knots. In contrast with the fact that their bodies' modeling, postures, and clothing are all realistically depicted, only the ends of their heavenly garments are treated abstractly, as if the entire energy of the Vajrapani were condensed into their garments.

The image on the right faces the entrance, its right hand lowered and its left hand raised high in a fist. Scrutiny of the arm, discovered during the period of Japanese rule, shows that the arm is raised with its hand in a fist touching the head of the image. The right hand of the image on the left, powerfully drawn into a fist, reaches the face of the image, and its left hand descends and projects forward. In the image on the left, the right fist was sculpted together with the face, which it touches, and would be difficult to break, but in the image on the right, the left hand would have been somewhat detached from the face and therefore easy to break.[4] Both images of the Vajrapani are executed in high relief, but the arms raised high in both images were not made and attached separately; rather they were treated in the round and give a sense of verisimilitude. Relief sculptures which treat both arms in the round in this fashion are hard to find in East Asia, but are a style that may be seen in Greek and Roman reliefs.

The pedestals have been made to project on the sides on account of the high relief, but because it has not been finished the natural surface of the rock has been left to show to its best effect. What is notable here is that the details of the legs held in tension have been left uncarved. The toes have not been sculpted, so the feet may seem incomplete, but this is not so. Rather, by treating the feet as though they were incomplete, the sculptor has naturally connected, and thus harmonized, the interval between the rough pedestal and the realistic image. This gives us a sense that the image might have sprung from the very rock itself.

From the plastic sculpting of the arms, the schematic and abstract treatment of the ends of the heavenly garments, and the bold presentation of the pedestal and the feet, we may infer that the master who sculpted the two Vajrapani had extraordinary intentions. I

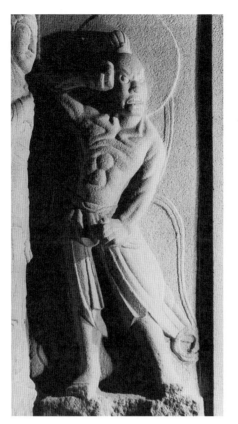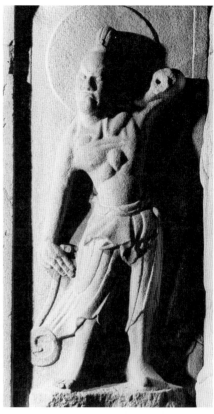

108–109. Vajrapani.

believe that the artist's presentation of the Vajrapani with this sense of verisimilitude, as if they were springing from the wall, stems from a religious intention to personify and deify the Buddha's power to smash all delusions in the form of the Vajrapani.

In the Gandhara region, images of the Vajrapani hold vajras and follow Shakyamuni in attendance, but they generally are clothed and have placid expressions. Perhaps because of the effect of the cult of Herakles, they were metamorphosed into nudes with emphatic muscles, and as they crossed Central Asia they came to wear expressions of rage. After it came to China, the single image split into two shapes to appear on the two sides of a gate, and these took root as the guardian gods for temple gates. This is the form that was transmitted to Korea and Japan.[5]

During the period of Japanese rule, when Seokguram was dismantled for repairs, portions of the face and the right arm of the image on the right, as well as the left hand of the image on the left were discovered. On this basis, it appears that unsuccessful trial works were broken up and the present images of the Vajrapani were produced. Considering that this process of trial and error was required, we can tell that it was extremely difficult effectively to sculpt the Vajrapani in high relief like sculpture in the round, and to produce the dynamic force that relied on this. Unlike menacing Chinese or Japanese images of the Vajrapani, these do not imbue a sense of fear, but are merely expressions of the Buddha's great power, which is to say the power of his compassion, through images that display his

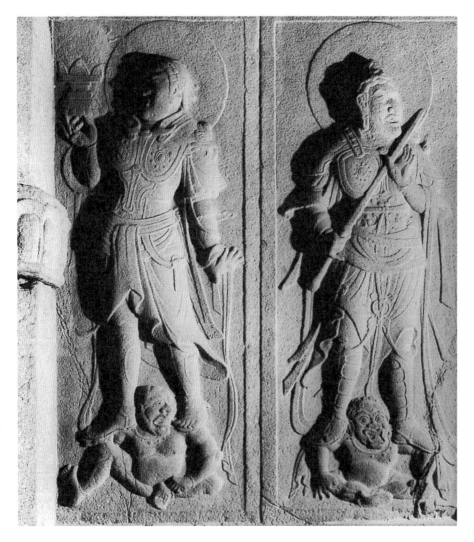

110. Vaisravana (left)
and Dhartarastra (right).

skillful means as a mild anger. Therefore, it appears that the planners and artists who worked on Seokguram considered the Vajrapani not as mere temple gate guardian divinities who appear to protect Shakyamuni, but rather as images of the Buddha's power to shatter all delusions. Pilgrims who come to worship at this cave temple take heart from the majestic power of the Vajrapani, who are incarnations of this dynamic power (the supernatural power of the Buddha).

Like these, most Korean images of the Vajrapani—especially those from the Joseon Dynasty (朝鮮時代, 1392–1910)—do not have a menacing appearance that would impart a sense of fear, but rather comic expressions that give a sense of affinity.

2. The Four Heavenly Kings

Between the antechamber and the main chamber at Seokguram there runs a corridor,

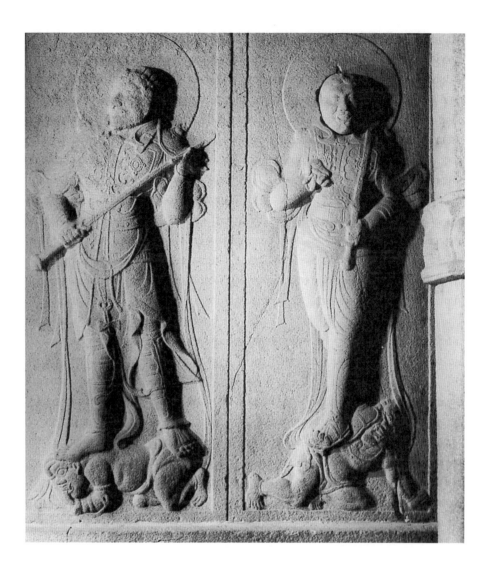

111. Virudhaka (left)
and Virupaksa (right).

on both sides of whose walls two images of each of the Four Heavenly Kings (四天王) are positioned. In the case of Seokguram, they are positioned to the left and right of the entrance corridor, but the heads of the Four Heavenly Kings face the four directions, thus giving the effect of having transplanted intact the orientations of the four corners of a platform for enshrining a Buddhist image. Thus there is no difficulty in determining the identities of the images. The first image facing the entrance on the right side is Dhartarastra (K. Jigukcheon, 持國天), and the second is Vaisravana (K. Damuncheon, 多聞天) (Fig. 110); the first on the left side is Virudhaka (K. Jeungjangcheon, 增長天), and the second on the right is Virupaksa (K. Gwangmokcheon, 廣目天) (Fig. 111). At the time of the construction of Seokguram, arranging images in this way on both walls of a corridor was a unique technique that did not appear anywhere else in East Asia, and may be called the oldest extant precedent for the placement of the Four Heavenly Kings on both sides inside the Heavenly Kings Gate at the entrances of Joseon Dynasty temples.

First, as for points in common of all four images, they are all in the form of armed generals with halos, bare heads with no helmets, gorgeous jeweled sashes, and armor; however, to show that they are gods, heavenly garments flow out rhythmically on both sides of their legs. Their faces are not the threatening display of rage with wide-open eyes and open mouths as in images from China, Japan, and the early Unified Silla period (統一新羅, 668−935); further, the demons on which they trample with both feet do not have expressions filled with pain but rather wear humorous expressions.

I believe that such softening of the displays of rage in the Vajrapani and the Four Heavenly Kings into a human expression is a style particular to Korea. In the end, considering the heavenly garments of the Four Heavenly Kings, which extend to both sides in rhythmic long and short sections, and the rhythmic fluttering of the skirts of the Vajrapani and the folds which follow from it, the details of enraged images of the Four Heavenly Kings, such as the pigmented clay images unearthed from the site of Sacheonwangsa Temple (四天王寺, Figs. 10, 11) or the gilt-bronze images of the Four Heavenly Kings on the reliquary discovered in the western three-level pagoda at Gameunsa Temple (感恩寺), have transformed to become more rhythmic and peaceful. The details of the Four Heavenly Kings' head decorations, chest armor, shin guards, and skirts, the particulars of their designs, and the forms of the demons have all changed to display diverse variations. Their hands and feet are abbreviated and give us a sense of visual verisimilitude. Further, here by not sculpting any of the fearsome mouths that almost necessarily adorn the shoulders of the armor and the front of the belts of the Four Heavenly Kings, the sculptors seem to have deliberately tried to soften the threatening elements of the images. We could say that the forms for the Four Heavenly Kings that have this peaceful atmosphere are modeled on images from the Unified Silla period that began to be extremely popular on stone pagodas roughly 800 years ago.

In China, the assembly of the Four Heavenly Kings into a group of four images that defends each of the four directions first appears in the Sui Dynasty cave from the Mogao Cave at Dunhuang, and may also be seen in the tiled pagoda from Xiangjisi Temple (whose stone images of the Four Heavenly Kings are now held by the Museum of Fine Arts, Boston). However, in Tang Dynasty cave temples such as Longmen, the images of Vaisravana on the north and Virudhaka on the south have been paired together with the Vajrapani and have the status of mere temple guardian gods. In contrast, in Korea during the Unified Silla period, carving the images of the Four Heavenly Kings on each face of the lowest level of a stone pagoda was greatly popular, with the pigmented images of the Four Heavenly Kings enshrined in the wooden pagoda at Sacheonwangsa Temple as the primary example. This popular style likely has its roots in the "Chapter on the Four Heavenly Kings' Defense of the Nation" in the *Sutra of the Golden Light*.[6]

The image of Dhartarastra at Seokguram is often compared with the mid-seventh century image of the Heavenly King on the northern wall in the Jingshansi cavern in the Longmen cave temple. However, although it may have partial similarities, there are great

differences in their overall iconography and style.

The Four Heavenly Kings were guardian divinities from the age of myth in India, but after they were accepted into Buddhism they became the masters of the first heaven in the realm of desires. This corresponds to the four directions halfway up Mt. Sumeru, which stands at the center of the world. Thus the Four Heavenly Kings took up the role of guarding the four directions and the four rivers and of serving Indra in his palace at the summit of the mountain. Images of the Four Heavenly Kings in India originally had the appearance of aristocrats, but as they crossed Central Asia they started to wear armor and gradually were transformed into warriors, and their expressions also turned fierce; but after they came to Korea they were again transformed into simple forms that were not warriors and did not have expressions of rage.

If we take a quick look at the characteristics of the images of the Four Heavenly Kings at Seokguram, they are as follows.

Dhartarastra holds a sword in his two hands. His left hand is drawn in an abbreviated fashion, and his two feet stand on the shoulders of the demon whom he tramples.

Vaisravana holds up a pagoda in his right hand, and his left hand descends and is rendered in an abbreviated fashion. His two feet stand on the shoulders of the demon whom he tramples.

Virudhaka grasps a sword in his left hand, while his right hand is rendered in an abbreviated fashion. His left hand is drawn in an abbreviated fashion, and his two feet stand on the shoulders of the demon whom he tramples.

Virupaksa grasps a sword in his left hand, while his right hand is rendered in an abbreviated fashion. His left foot is also drawn in an abbreviated manner and this image gives the overall impression that it is stepping forward. In other words, the image is as a whole treated in an abbreviated fashion, and represents a bold attempt to use the abbreviation technique in a way that is difficult to imagine in a relief.

The details on the demons are also rendered in diverse ways. The two demons on the right wall sit facing the front, and the two demons on the left are lying on their sides. Their facial expressions, arms, and the orientations of their legs all differ. They are all rendered comically, as are the demons in Sui Dynasty images of the Four Heavenly Kings, for instance those beneath the Four Heavenly Kings in cave 427 at the Magao Cave at Dunhuang. Since the comical appearance of the demons may also be seen as early as images of Yakshi made in Mathura during the Kushan dynasty in India, we can determine that in Chinese images of the Four Heavenly Kings were synthesized Gandharan, Mathuran, Central Asian and other elements.

3. The Eight Classes of Dharma Protectors

Among the devas, the Eight Classes of Dharma Protectors (八部衆) have a special position. They are miscellaneous ancient Indian gods who, after being enlightened by the

Buddha's preaching the dharma, converted and came to embrace Buddhism; they were transformed into tutelary divinities who protect the Buddha-dharma, and appear as the audience whenever Shakyamuni preaches the dharma. The mystical Garuda bird, king of the birds; the naga, who is the god of wealth and possessor of supernatural powers; the kinnara king, the non-human god of music, whose body is human but who has the head of a horse; and the gandharvas, who are gods who feed on fragrance and music, may be called good gods, as followers of Vishnu, Kubera, and Indra. However, such deities as the asuras, who always start fights with the gods as their rivals, and who especially battle Indra as titanic deities, or the yaksas, evil and violent gods who take charge of food, may be said to belong to the category of evil gods.

The devas are less any particular gods than a general designation for the various gods of Brahmanism who live in the heavenly realm. Therefore, the Eight Classes of Dharma Protectors may be considered a general and representative term for all the good and evil gods of Brahmanism, excluding its chief gods, Brahma and Indra.

At the time of the rise of Mahayana Buddhism, Brahma and Indra had already been accepted into Buddhism to appear as attendants at the side of Shakyamuni, but the Eight Classes of Dharma Protectors were reorganized much later and arose in China; however, the definite establishment of their members and their popularization were carried out in Korea.

In the development of Buddhist images in East Asia, the Eight Classes of Dharma Protectors may be cited as one group of images that was especially popular in Korea. They are often enumerated as the audience when Shakyamuni preaches the dharma, and although they are first given form through dialogue in Central Asia and China, until the Tang Dynasty their iconography was not definitely established and they never appeared as a set.

In the case of Japan the dry hollow lacquer standing images of the Eight Classes of Dharma Protectors enshrined in the 734 Western Golden Hall of Kofukuji Temple (興福寺) are today considered the oldest complete set of these images, but strangely enough, after that sculpted images of these devas were almost never made in Japan. In contrast, in Korea, on the base levels of pagodas at post mid-eighth century temples such as the now defunct Jeongnimsa and Sungboksa, both in Gyeongju, from the time that the images of the Eight Classes of Dharma Protectors were carved through the mid-Goryeo period, these images were greatly popular.

In the case of China, to date the only known cases of sculpted images of the Eight Classes of Dharma Protectors are several wall carvings in the rock caverns at Dunhuang. In the transformation tableau of the Buddha's Nirvana on the western wall of the mid-Tang cave 159, they have been depicted with gorgeous colors and flowing brushwork. In the *Mahayana Nirvana Sutras* (K. *Yeolban-gyeongjeon*, 涅槃經) it is recorded that when Shakyamuni entered Nirvana, there gathered fifty-two types of beings, such as the bhiksus, the various bodhisattvas, the believers, the various devas, and the kings of the ani-

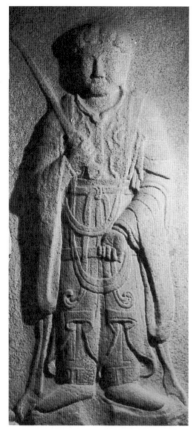
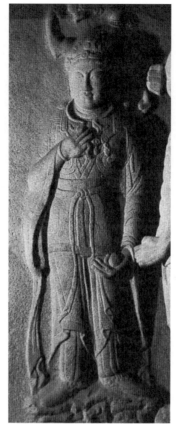
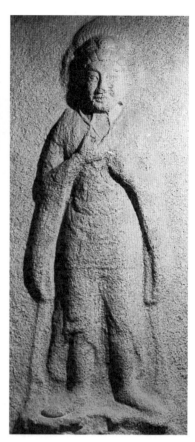

112. Deva. (left)

113. Dragon. (center)

114. Yaksa. (right)

mals. In the case of cave 158, facing the western wall on the right, images of the Four Heavenly Kings and the Eight Classes of Dharma Protectors are depicted together. The audience is made up of the dragon king wearing a dragon head crown, a mahoraga wearing a dragon head crown, an unidentifiable deva wearing a magadha crown, three devas of unorthodox form wearing animal crowns, and garuda wearing a garuda crown. Continuing in the scene on the right are also depicted garuda wearing an animal crown, a deva wearing a goose crown, etc.[7] Even considering all of these together, only four can be confirmed as members of the Eight Classes of Dharma Protectors, and to date among the published wall paintings of the Dunhuang rock caves which have been introduced to the general public, there are no other examples from the Tang period. As for examples from the Five Dynasties period, in the transformation tableau of Manjushri on the western side of the southern wall in cave 36, there is a gandharva wearing a lion's crown, a dragon king wearing a dragon head crown, etc.[8]; finally, in the northern and southern sides within the niche on the western wall, there are positioned four images of each of the Eight Classes of Dharma Protectors.[9] In their inscriptions, only the names of Kinnara King, Garuda King, and Asura King are clearly specified. Although not clearly identified, a gandharva wearing a lion's crown, a mahoraga wearing a naga head crown, and a dragon king with a dragon wrapped around its head are also depicted, though apart from these

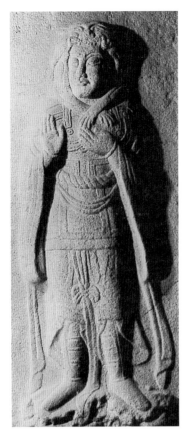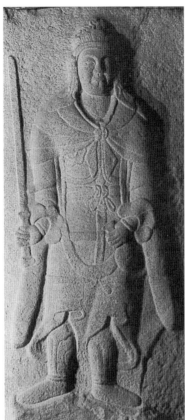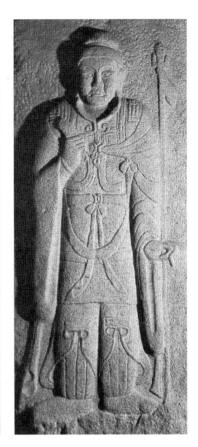

the figures are unidentifiable. Judging by their positions, they are unmistakably the Eight Classes of Dharma Protectors, but the yaksas and the devas cannot be confirmed. Aside from this, the fact that the Eight Classes of Dharma Protectors were established as a set of eight images is confirmed by the example depicted in the Anxiyulin cave 16, in the northern and southern walls of whose antechamber are four images apiece. The four examples above are the best depicted examples of the Eight Classes of Dharma Protectors in China, and apart from these the majority depict one or two of them in a fragmented manner. Looking through these, there are no confirmed sculptures of the Divine Generals wearing animal crowns or the Eight Classes of Dharma Protectors in China, but rather all are depicted in wall paintings; and although unstable sets and the earliest of these have been found from the early mid-Tang period dating from 780 to 850, at the earliest it was the tenth century during the Five Dynasties period that a set of eight images was completed. However, if we exclude the exceptional images of the Eight Classes of Dharma Protectors from Kofukuji in Japan, then Korea is the only country in which this set of eight icons was created in sculptural form and continued to be popular. This being the case, what is the origin for the outstanding images of the Eight Classes of Dharma Protectors at Kofukuji and the pagodas of the Unified Silla period? Also, in the eighth and ninth centuries in Tang China and Nara and Heian Japan, no images of the Eight

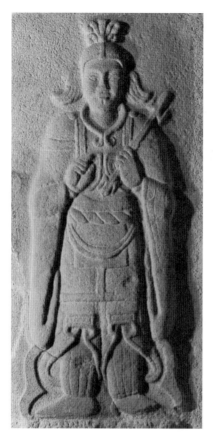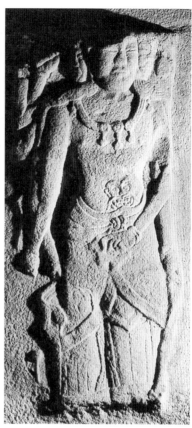

115. Gandharva.
(p.136 left)

116. Mahoraga.
(p.136 center)

117. Kinnara.
(p.136 right)

118. Garuda. (left)

119. Asura. (right)

Classes of Dharma Protectors were produced, but only in Unified Silla in Korea were they greatly popular; why this was the case and other problems are also suggested, but no satisfactory answer has yet been found.

The images of the Eight Classes of Dharma Protectors in Seokguram are the single example of standing sculpture of this group in the Unified Silla period, but iconographically they are the closest to the icons in Dunhuang cave 158. Therefore, they can be considered in terms of the connection with China, since the images of the Eight Classes of Dharma Protectors began to be popular in China in the mid-Tang period. In Seokguram, which was built between 750 and 775, these images appear to have been added sometime in the end of the eighth century, after Seokguram's initial construction. In fact, aside from the Eight Classes of Dharma Protectors, all the sculptures in Seokguram are clearly the work of the same group of sculptors working in the same period, but as the technique for the dharma protectors is completely different, it is difficult to see them as products of the same period, or even to consider them as having been made at the same time. Among the icons of the Eight Classes of Dharma Protectors, in particular the image of the dragon king resembles that in Dunhuang cave 158. This means there is great possibility that these images, which were not originally planned when Seokguram was initially built around 775, were added later. If this is the case, then together with the relationship with

China, the Eight Classes of Dharma Protectors began to be added to Seokguram around the end of the eighth century, and the images of Asura and Garuda, whose technique is the most inferior, appear to have been created even later. Considering the many Korean and Chinese examples, it appears that the common thesis which holds that the images of the Eight Classes of Dharma Protectors at Kofukuji were created in 734 places them at too early a date. Further, images of these devas were never created in Japan after that point. In addition, the mutual relationships among the images of the Eight Classes of Dharma Protectors in Dunhuang cave 158, the images at Seokguram, and the images at Kofukuji are unclear, and as there are insufficient images apart from these, it is difficult to establish their chronological arrangement. However, since the mid-Tang period wall paintings in Dunhuang cave 158, the Unified Silla period relief sculptures in Seokguram, and the Nara period dry lacquer sculptures in the round at Kofukuji are all standing images, it would not be impossible to date all these works to the late eighth century. These images were fixed as seated icons after the Unified Silla period entered the ninth century, and as their appearance as adornment in relief on the base levels of stone stupas cannot be found in any other country, we may consider this the original creation of Unified Silla.

Before explicating the images of the Eight Classes of Dharma Protectors in Seokguram, from close inspection of the technique of their carving we may observe the following.

The relief images are lined up, four to each side, on the right and left walls of the antechamber. As they are all stiff, forward facing images who stand straight upright, they differ greatly from the free and natural detailing of all the other images. The two images on the left facing the entrance, in other words the images of the dragon (Fig. 113) and the gandharva (Fig. 115) have a technique that is three-dimensional and superior, the images facing the entrance on the right, in other words the images of the deva (Fig. 112) and the yaksa (Fig. 114), are next in technique, while the third images on the right and left (Figs. 116, 117) correspond to each other and show a similarly flat technique, while the outer-most two images, in other words the asura (Fig. 119) and the Garuda (Fig. 118) are, while flat, much lower in height than the other images and have a technical correspondence. The reason why these last two images are lower than the other images is unclear. Overall, going from the inner to outer, the technique shows a noticeable difference, which could be considered less a difference in period than in the technique of the stonecutters. In sum, at this stage no definitive judgments can be made.

However, when we attempt to compare these images with not the other images within Seokguram but rather the other sculptures of the period, while it is not impossible to see them as works of the late eighth century, it would be hard to imagine that they were planned at the time of the creation of Seokguram. In the event that Seokguram was creat-ed over a period of twenty-five plus years, those masters who participated in its construc-tion would have been aged at the time of its completion, and we cannot exclude the possi-

bility that the images of the Eight Classes of Dharma Protectors would have been made by the assistants or disciples who followed after the masters. If this were the case, then we could hypothesize that, even though these images could not be said to be contemporaneous with the creation of Seokguram, the Seokguram that included these images was finally finished by around 800 after its initial completion around 775.

Deva (天, first image facing the right) (Fig. 112)

This image stands straight up and faces forward, its hair curled up as though it were permed, and its right hand raised to its chest grasping a sword. Iconographically, it is not clear what kind of image it is. Judging from the fact that when the Eight Classes of Dharma Protectors are enumerated, the deva and the dragon are often mentioned first of all, and from the fact that this group is also known as the Eight Classes of Deva and Dragon Protectors, we can infer that the deva was seen as important. Thus, as this image forms a pair with the dragon and occupies the most important place in the antechamber, it would not be implausible to guess that it is a deva. Like the other members of the Eight Classes of Dharma Protectors, it stands on a rocky ledge.

Dragon (龍, first image facing the right) (Fig. 113)

This is the most superior image among the Eight Classes of Dharma Protectors. It wears armor, a simplified form of that worn by the Four Heavenly Kings. It seems that the chest armor has been simplified, the shoulder guards abbreviated, the leg gaiters left undone, exposing the pants as they are (the image of the gandharva to the side has its gaiters bound, and those with and those without are mixed together without unity), the belly armor and hip armor simplified, and the image wears a short frontal skirt. Its heavenly garments drop off flaccidly to the right. A point of contrast with the dress and adornments of the Four Heavenly Kings is that this image has extremely long sleeves. In this way, the dress of the Eight Classes of Dharma Protectors present the appearance of mixing military and civilian wear, and they are not depicted strictly as divine guardian generals. Among the Eight Classes of Dharma Protectors, only the dragon has a tribangha posture, and its belt and the hems of its skirt, sleeves, and heavenly garments all have a sense of movement.

The face is well-rounded and wears a faint smile; the right hand is raised to the chest with its thumb and forefinger linked and expressed very clumsily. The left hand is lowered and holds a wish-granting jewel (chintamani). On its head, it wears a jeweled crown, whose dragon head filled with power and two legs suggest that behind this image is the personification of the dragon. One of the dragon's legs is raised above, and the other is lowered in a threatening posture, and its throat is adorned with flaming wish-granting jewels. Only the mudra is expressed clumsily; with its skillfully rendered semi-relief, dynamic posture and dress, full face, and powerful dragon crown, this image may be called a sculpture that shows late eighth-century style to its best.

Yaksa (夜叉, second image facing the right) (Fig. 114)

As this image wears an expression of rage, with its hair standing on end, it would be safe to say that it is a yaksa. Its hair rises up like flames and from its mouth is suspended a long chain of linked jewels, whose end is supported by the two hands of the image. This unique style is not to be seen in China or Japan but appears only in Korea, and all images of yaksas from the seated images of the Eight Classes of Dharma Protectors on the base level of stone pagodas from the Unified Silla period uniformly follow this style. The meaning of the chain of linked jewels held in the mouth is unclear.

Gandharva (乾闥婆, second image facing the left) (Fig. 115)

This image wears a lion's crown on its head. The crown is surmounted by a lion mask and its two legs encompass the front of the neck like a scarf. The gandharvas were originally followers of Indra and gods of music. The image faces the entrance and its head is slightly turned, and as it wears the most martial dress of any of the Eight Classes of Dharma Protectors, its clothing and adornments resemble those of the Four Heavenly Kings.

Images of gandharvas carved on the base levels of pagodas such as the three-story stone pagoda at the site of Jinjeonsa Temple in Yangyang County, Gangwon-do province (Unified Silla period, late ninth century) or the five-story pagoda at the site of Boweonsa Temple in Sosan, Chungcheongnam-do province (Goryeo Dynasty 935-1392) wear lion crowns and perform on the *gonghu* (Baekje harp), but the image here does not hold an instrument.

Mahoraga (摩睺羅伽, third image facing the right) (Fig. 116)

The jeweled crown of this image is unique. It is encircled by lotus leaves, and at its top is an unidentifiable object sinuously wound around it. Also uniquely, the sash of its deva crown extends long to cover the shoulders of the image. This shawl covers both shoulders and is bound at the chest of the image. Its right hand is lowered to support a long sword, and as we might expect its left hand is lowered to hold a bottle of water. Iconographically it is not clear which image this is, but seeing that mahoragas wear naga crowns, the complicated and snarled shape of the image's jeweled crown suggests the effort to represent a snake, so we will presume that this is a mahoraga. The skill of the carving is, compared with the previous four images, much more stiff, flat and unrealistic, and represents a simplified abstraction.

Kinnara (緊那羅, third image facing the left) (Fig. 117)

The image's right hand is raised to its chest and holds a short object, while its left hand is lowered to grasp a long spear. The technique for depicting the shawl draped around both its shoulders is precisely the same as that used for the presumed mahoraga image facing it directly opposite. This too is a forward-facing linear image, whose carving is

stiff and flat. The kinnara are followers of Kubera, musicians and semi-human with the head of a horse and the body of a human. They are also said to be the musicians for either Indra or Vaisravana. However, as this image does not have horses' heads on either side of its face as kinnara images from the Unified Silla period often do, it is difficult to state conclusively that it is a kinnara.

Garuda (迦樓羅, fourth image facing the right) (Fig. 118)

Garuda is also known as the king of the birds. Often Garuda is depicted in the form of a bird, with a bird's beak and eyes but the body of a human, but at Seokguram it is through the depiction of two wings on either side of the image's face that its identity as a bird is suggested. This image is roughly two meters in height, making it about 20cm smaller than the other members of the Eight Classes of Dharma Protectors, and for this reason the rocky ledge on which it stands has been raised relatively. Why it was planned to be so small that it could not achieve a balance with the other images is unclear.

Asura (阿修羅, fourth image facing the left) (Fig. 119)

Asura wears an expression of rage, with its upper torso exposed, having three faces and eight arms. Its left arm, and the parts of its body below the knees were not carved. However, it is difficult to see this image as incomplete, and neither has it been damaged. We could almost say that this depiction was intentionally carried out, but we cannot determine why.

4. Brahma and Indra

The deva images that we have treated so far are all outside the main chamber. Unlike their orderly arrangement in the antechamber and the connecting corridor, Brahma and Indra enjoy positions as higher deities and are therefore positioned at the sides of the very entrance to the main chamber, where they are able to stand on a par with the bodhisattvas. Also, their expressions are not masculine as in Chinese or Japanese examples, but rather have a feminine character.

Brahma (K. Beomcheon, 梵天) (Fig. 120)

Brahma and Indra are furnished with elliptical halos and round, cushion-like, flat pedestals which are not inscribed with lotus flower patterns, which indicates there was an effort to create a depiction distinct from the circular halo and lotus flower pedestal of the bodhisattvas. However, perhaps these merely suggest that Brahma and Indra have a different status in the Buddhist hierarchy than the bodhisattvas, since overall, the iconography of these images has many points in common with the bodhisattvas.

The gorgeous three-faced jeweled crowns that adorn the heads of the images, as well as their earrings, rings, bracelets and anklets are all strong in decorative quality as in images

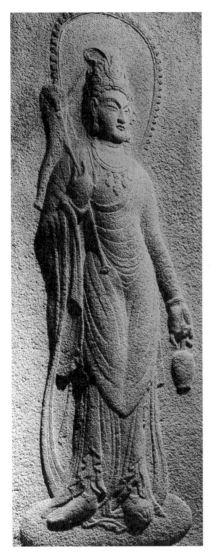 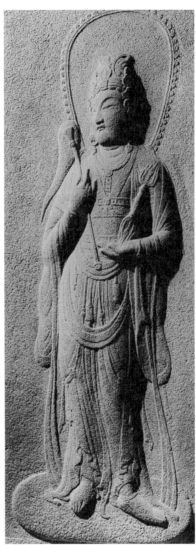

120. Brahma. (left)

121. Indra. (right)

of the bodhisattvas.

However, the difference from the technique for depicting the bodhisattva's clothing is in their upper body garments, which resemble a shortened version of monk's robes. They remind us of the monk's robe open at one shoulder worn by the Tathagata. The ends of the heavenly garments do not cut across the belly, but rather descend straight from the arms to reach the pedestal. In the upper garment, the undulations of the clothing which follows the curves of the body are just expressed as in the Tathagata image, and show a contrast with the complex and intricate image of Indra, in which two strands of the heavenly garments cut across the belly.

In its right hand, the image holds up a whisk, and its left hand is lowered and holds a water bottle.

The head is slightly turned to face the main image in the inner part of the chamber. We

142

could say that a characteristic of all the images around the entrance to the main chamber, such as Brahma, Indra, Manjushri, and Samantabhadra, is that they all face inward, that is toward the main image. In these images, physical modeling such as the beauty of the softly rendered curved lines and the sense of movement in the sensitive toes harmonizes with the gorgeous adornment to display the acme of feminine beauty. This style is common to the images of Brahma, Indra, Manjushri, Samantabadhra, and the Eleven-Faced Avalokiteshvara, and the bodhisattvas in the niches.

Indra (K. Jeseokcheon, 帝釋天) (Fig. 121)

Here I will indicate only those points which distinguish Indra from Brahma.

The design of the elliptical halo is different from Brahma's, and from the fine sections as well we can tell that a contrastive design was planned. Although the right hand holds up a whisk in almost the same form as Brahma's, its left hand supports a vajra. Careful inspection of this vajra reveals that it has five points. From both sides of its jeweled crown, the sash of its deva crown flows down to silhouette the shoulders and reach the ankles. It resembles the style of the bodhisattvas in such stylistic points as the two parallel U-shaped strands of heavenly garments that are visible on the belly, the heavenly garments that descend in long sweeps from both arms, and the several strands of adornments that descend from the waist. However, what merits attention here is the form of the upper garment that peeks out from between the heavenly garments. Generally, Chinese and Japanese images of Brahma and Indra wear Chinese style military dress, but at Seokguram they are draped in clothing in the style of the monk's robes as worn by a Tathagata. Originally, Indra was famous as the most powerful god who battled asuras, and on account of the martial character usually wears leather armor under his dress. While the upper garment of the image of Indra at Seokguram displays these martial elements, the display of the armor has been reduced.

The two devas resemble the bodhisattvas in style, but closer analysis shows that their halos, attributes, clothing, and pedestals are completely different from those of the usual bodhisattva. These two devas, which had generally been rendered in a masculine fashion, were feminized at Seokguram, and having passed through a process resembling the idealization of the bodhisattva, they were raised to a status commensurate with the bodhisattvas Manjushri and Samantabhadra. When Buddhist images first emerged in the Mathura region, Brahma holding a whisk and Indra holding a vajra appeared as the attendants of Shakyamuni. At Seokguram, they are attendants of the main image, and as their original significance and position have been recovered we can have insight into the new interpretation of the devas by the people of Silla.

Originally, Brahma was the creator god of the universe and a deification of Brahman, the highest god and origin of all things; Indra had a complex character as on the one hand the strongest god of Brahmanism who caused the rain to fall and made the earth fertile, and on the other as the victor in the battle against the asuras. Gods who were the central

deities of ancient Indian myth were at an early stage absorbed into Buddhism, and Brahma came to reside in the first heaven of the realm of form, which is the heaven of the first dhyana, and Indra came to reside in the Heaven of the Thirty-three Gods, at the summit of Mt. Sumeru. On the other hand, in the biographies of the Buddha, it is said that when Shakyamuni descended from preaching the dharma to his mother the Lady Maya in the Tusita Heaven, Brahma stood on his right side holding a white whisk and Indra on his left holding up a jeweled casket. In this way, when they emerged in the Mathura region these two gods appeared as the Buddha's attendants and became the predecessor iconography for the later Buddhism iconic triads. In general, icons of these gods all hold whisks, and images of Indra sometimes hold vajras. In particular, there are many cases in which lone images of Indra wielding a vajra appear in depictions of the Buddha's life. These devas, who served the Tathagata, gradually grew distant from the Tathagata and merged with the Four Heavenly Kings and others to become members of a sculptural group.

A Chinese example is the early eighth century group of Buddha images at Baoqingsi temple (which were originally images in the seven-treasure platform of Guangzhesi). In all there are four examples, and in general only the image in attendance to the Buddha on the right or the left invariably holds a whisk and a bottle of water in each of its hands, while the other attendant holds up a lotus flower in one hand and grasps a strand of its heavenly garments in the other. Hence, the whisk and bottle of water indicate that the figure is Brahma, while the other image signifies merely a bodhisattva or Avalokiteshvara. In other words, the chances are great that Brahma, a representative member of the devas, and Avalokiteshvara, a representative bodhisattva, were seen as attendants to the Tathagata. Incidentally, Brahma has as its only attribute the whisk and is depicted completely as a bodhisattva.

Representative examples from Japan include the Tempyo-era mid eighth-century clay images from the dining hall at Horyuji Temple or the dry-lacquer images from the Lotus Hall (Hokkedo or Sangatsudo) at Todaiji Temple. In all of these groups, the images face the entrance, with Brahma positioned on the right and Indra on the left; there is no difference in iconography between the two images. The images at Horyuji accentuate their role as gods who protect the Buddha-dharma by wearing monk's robes over their military armor, and in this respect differ from the bodhisattvas. As for the images at Todaiji, only Brahma wears armor beneath his clothes, but both the images wear monk's robes like the Tathagata.

In any event, when they are compared with images from China and Japan, the images of Brahma and Indra at Seokguram are clearly differentiated by the objects they hold and therefore they have the role of serving the main image at Seokguram; and that in terms of style or form they have a status higher than the bodhisattvas, and their original roles have been restored.

3. Images of the Bodhisattvas

When one circumabulates (K. *uyo* 右繞; to make three turns around a main image walking counterclockwise or chanting a sutra while walking in file around an image of the Buddha) the main image at Seokguram, one first encounters the image of Brahma, and next the image of the bodhisattva Samantabhadra (K. Bohyeon bosal, 普賢菩薩) (Fig. 122). This image of Samantabhadra also has a posture directed inward. Its three-faced jeweled crown, earrings, necklace, bracelets, anklets, and the jewels that hang down from its chest to its knees are all highly decorative. The sash of the deva crown on its jeweled crown hangs down to reach the waist, and the strands that flow down on both sides of the necklace extend long to reach the knees. Its heavenly garments also extend long to reach the lotus pedestal, and between the belly and the knees four strands of heavenly garments cut across describing identical curves. It is in this very section that the jeweled strands and sash descend vertically and overlap with the horizontal heavenly garments. In this way, one has the feeling that this image carries the decorative character of the bodhisattva to the acme of perfection. As the various strands of heavenly garments, deva crown sashes, jeweled ornaments, and sleeves cascade down with matchless variation, to achieve harmony with these there are as many as four strands of heavenly garments hung horizontally. It is conventional to have only two, and it is difficult to find other examples with four. It is as if, so to speak, through the mystery of the structure four strands of heavenly garments have been adopted. The left hand holds up a sutra, while the right hand is lowered. The beautiful movement of the fingers and toes, the sense of rhythm in the dynamic yet fluid heavenly garments, the elegant feminine style of the figure, and its gorgeous adornments all harmonize so that there is not the least feeling of disorder.

The partner of Samantabhadra, Manjushri (K. Munsu bosal, 文殊菩薩) (Fig. 123), has a posture facing into the main chamber. The particulars of the design for its three-faced jeweled crown, necklace, chest ornament, bracelets and anklets all differ from those of Samantabhadra. Manjushri has no earrings and wears sandals on its feet. The heavenly garments and deva crown are comparatively simple, and there are two strands of heavenly garments which flow down in an orderly fashion to cut across the belly. The pedestal is also different from Samantabhadra's; it has compound petals instead of single ones. Thus it is clear that there was an intentional effort to present Manjushri in contrast with Samantabhadra. In spite of the overall complex quality of decoration in these two images, what is stressed are the outlines of their beautiful bodies. In this sense we could call this a masterpiece which embodies the most ideal beauty of the bodhisattva at that time. Its right hand upholds an alms bowl, while its left hand is lowered; the depiction of the fingers on the lowered hand is extremely sensitive and its beauty is a cause for wonder.

This being the case, on what basis can we presume that the two bodhisattvas of the main chamber are Samantabhadra and Manjushri? For convenience of exposition, I have provisionally assumed that these are their identities but it is still difficult to make a defini-

tive conclusion. First, there are grounds for considering the alms bowl to be the attribute held by Manjushri in the Tang Dynasty *A Record of Famous Historical Paintings* by Zhang Yanyuan. By this I mean that there was an image of Manjushri carrying an alms bowl drawn by Weichi on the wall of Ciensi Temple.[10] Although that image is no longer extant, there does still exist an esoteric "thousand-arm, thousand-bowl" wall painting of Manjushri from the mid-Tang period on the eastern wall of cave 361 in the Dunhuang Magao caves.[11] Although this icon is derived from the Mahayana *Yoga Vajra-Nature Ocean Sutra of Manjushri with a Thousand Arms and Thousand Bowls, for the Great Instruction of the King*, I think that Weichi's painting at Ciensi probably did not differ greatly from it. Even though the icon is esoteric, seeing that Manjushri is holding up a thousand alms bowls, the possibility is great that the bodhisattva holding a bowl in Seokguram is also Manjushri. In addition, this would conform to the method of arrangement in a Shakyamuni triad, since Shakyamuni's attendant on the right would be Samantabhadra and his attendant on the left Manjushri. On the other hand, to give a Japanese example, the bodhisattva who is said to place a box over a lotus flower held in the hand or to hold up a sutra is Manjushri,[12] but as time passes it is more appropriate to employ comparisons with Chinese examples than Japanese iconography.

If this is so, then what kind of relationship do the two bodhisattvas have with regard to the main image? Although Manjushri and Samantabhadra are said to attend Shakyamuni to form a triad, this configuration was not yet known in the Unified Silla period. However, as is represented by the Vairocana triad from the mid ninth-century site of Beopsusa Temple in Gyeongsangbuk-do province, the style of Vairocana triad in which Samantabhadra riding an elephant and Manjushri riding a lion was popular from its establishment in the ninth century until the Joseon Dynasty. However, in the Joseon Dynasty, there were standing images of the bodhisattvas in attendance without the beasts to ride.

In sutras such as the *Vimalakirti-nirdesa Sutra* (K. *Yumagyeong*, 維摩經) the *Lotus Sutra* (K. *Beophwagyeong*) and the *Avatamsaka Sutra* (K. *Hwaeomgyeong*) which show the cult of the bodhisattva Manjushri; or the *Lotus Sutra, the Sutra on the Practice for Contemplating the Bodhisattva Samantabhadra* (K. *Gwan bohyeon bosal haengbeop-gyeong*, 觀普賢菩薩行法經), and the *Avatamsaka Sutra*, which show the cult of Samantabhadra, despite the fact that the cults of these bodhisattvas appear clearly, it is odd that in Korea they were not depicted as either as attendants in a Shakyamuni triad or individually. There is merely one confirmed record of the creation of a clay figure of Manjushri at Sangwonsa Temple during the Unified Silla period in connection with the cult of Manjushri on Mt. Wutaishan as presented in the *Avatamsaka Sutra*.[13] In Japan, too, the bodhisattva does not appear individually at all in the wall paintings of the Golden Hall at Horyuji Temple, and it is not until after the mid-Heian period that sculptures appear.

In general, Manjushri symbolizes wisdom, and Samantabhadra its practice; there seem to be no special attributes which would identify them, and we can tell them apart only by

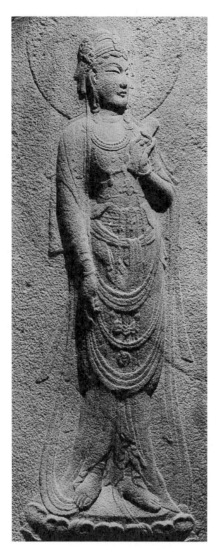

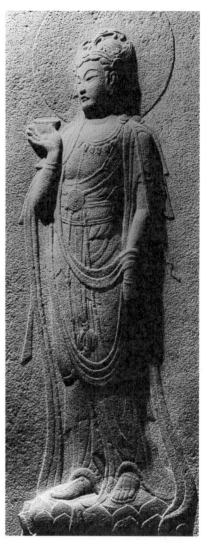

122. Samantabhadra.
(left)

123. Manjushri. (right)

the animals that they ride. Therefore the attributes are merely secondary. Bodhisattvas atop these kinds of animals are found first in the early esoteric scripture the *Dharani-Collection Sutra* (K. *Daranijipgyeong*, 陀羅尼集經). In India, too, images of Manjushri riding a lion and Samantabhadra riding an elephant originated during the late eighth century in the Pala Dynasty, when esoteric Buddhism began to gain popularity. So to speak, it is likely that before the advent of esotericism the prescriptions concerning these two bodhisattvas were not fixed. There is therefore a great possibility that Shakyamuni triads with Manjushri and Samantabhadra as attendants originated after the rise of Vairocana triads from the cult of the *Avatamsaka Sutra*, which appropriated its iconography from esotericism.[14]

In terms of examples preceding the effect of esotericism, the sculptures visible in Horyuji's five-story pagoda which depict the dialogue between Vimalakirti (K. *Yumageosa*, 維摩居士) and Manjushri according to the *Vimalakirti-nirdesa Sutra* are the

oldest example, and as for the images following the iconography similar to this we could adduce the image of Manjushri alone on the eighth wall of the Golden Hall at Horyuji, or the image of Samantabhadra riding an elephant on the eleventh wall. This type of icon appears in great numbers in the Yungang rock caves after the Northern Wei period, and was also greatly popular in Buddhist stelae.

If in fact these initial images of Manjushri and Samantabhadra were not fixed as attendants in a Shakyamuni triad, and only after a substantial length of time had elapsed and through the effects of the establishment of the Vairocana triad following the prescriptions of esotericism were Manjushri and Samantabhadra remade as attendants in a Shakyamuni triad, then why from the seventh century through the late eighth century were no Shakyamuni triads created with the two bodhisattvas as attendants? In the case of Korea, at the beginning of the Unified Silla period seated images making the mudra of defeating demons and touching the earth began to be popular, but for the most part they are single images. However, in the case of the stone Buddha images at Chiburam on Mt. Namsan in Gyeongju, the images are in a triad with merely attendants at each side holding respectively a lotus flower and a bottle of water, so there is no way to confirm that they are Manjushri and Samantabhadra. However, as the two icons were not yet fixed at the time, it is impossible to exclude completely the possibility.

4. The Ten Great Disciples

At Seokguram, the Ten Great Disciples (十大弟子) are rendered vividly with the character of real people, presenting a strong stylistic contrast with the Buddha, the bodhisattvas, the devas and others. If the Ten Great Disciples were absent or were rendered in a trifling manner, then the sense of realism and dynamism in Seokguram would diminish by half.

Just as the devas Brahma and Indra were in Seokguram elevated to the status of bodhisattvas, so too have the Ten Great Disciples been positioned at the same size as the bodhisattvas, and on account of the effort spent to present each of them in a distinct manner, we may consider that they have been treated on a level equal to that of the bodhisattvas. Judging from the fact that the arhats are positioned on ten of the fifteen stone slabs in the main chamber, they had great importance for the planners of Seokguram.

At present it is difficult to establish the identities of each of the Ten Great Disciples. In general, among them Kasyapa and Ananda are treated as representative disciples and when they are presented as Shakyamuni's attendants, they are presented contrastively, with Kasyapa presented as an extremely aged man and Ananda as a young man, even a youth. Apart from these, there are no iconographic prescriptions that would enable identification of the Ten Great Disciples.

Among the Ten Great Disciples, only Kasyapa and Ananda ought to have fixed icono-

graphies. These are the only two who always stand right by the sides of the Tathagata in his attendance. Facing the entrance to the right, his forehead and throat full of wrinkles, his wizened cheekbones and Adam's apple sticking out, his figure gaunt and with deep anxiety showing in his facial expression, stands Kasyapa. On the left, his nearly spherical head giving the viewer a clean feeling as though it were freshly shaven, with a faint smile on his face, is positioned the cheerful-looking Ananda. These mutually contrastive forms for Kasyapa and Ananda are considered as representative for the Buddha's disciples, but what could be the reason for depicting them in the extreme forms of an old man and of a young man? Is it because the oldest figure, Kasyapa, and the youngest figure, Ananda, have been the only ones treated here? Or have they been treated as the first and second patriarchs? The answers to questions of this sort cannot be found.

At Seokguram, the disciple who seems to be the oldest faces the entrance as the first disciple on the right, and the youngest disciple faces the entrance and is the fifth disciple on the left. In this way, at Seokguram the two most contrastive and important images are not positioned to contrast with one another. In other words, here the images have made a great departure from the most usual arrangement of the Ten Great Disciples. Further, none of the images has a halo. We may conclude that the images of the disciples at Seokguram have been freed from all fixed forms to be arranged freely and depicted with individuality.

Among the Chinese rock caves, the oldest [extant] example in which are positioned images of the Ten Great Disciples is the images in relief on the eastern and western walls of cave 18 in Yungang. Their faces are carved in the round, the upper halves of their bodies are carved in a high relief that gradually transforms into a semi-relief for the lower halves of their bodies.[15] The next example is in the early Tang Dunhuang Magao cave number 328, in which Kasyapa and Ananda are sculpted in the round and positioned as attendants on each side, and the remaining disciples are treated individually in four wall paintings behind them.[16]

However, because depicting all of the Ten Great Disciples is difficult and troublesome, it appears that from an early period Kasyapa and Ananda were positioned to represent them. This examination of Tang-dynasty wall paintings at Dunhuang shows the popularity of quintets with Kasyapa, Ananda, and then two bodhisattvas in attendance. Kasyapa and Ananda, who represent the disciples, do not merely have upper bodies that peep through amidst the triad (the main image plus the two bodhisattvas), but are positioned so that their bodies are fully visible, suggesting that the disciples gradually were emphasized more strongly. Also, although it is extremely unusual, in the Sui Dynasty Mogao cave number 427, on the southern face of the rectangular pillar at the rear of the cave is a triad in which Kasyapa and Ananda are positioned to the right and left of the main image.[17] However, in quintets and septets, two images of the disciples are positioned among the bodhisattvas and devas and through their odd numbered structure the numerical balance is maintained.

However, at Seokguram, a large portion of the wall amounting to two-thirds of the total wall space in the circular main chamber is given over to the sculptures of the Ten Great Disciples. What could be the reason?

As I mentioned in my reflections on the iconography of the main image, as Buddhist thought underwent historical development, and gradually grew distant from its original essence, Buddhist images came to diverge from their original intent. In the case of Buddhist triads, Mahayana bodhisattvas alone came to serve as attendants. However, it may be considered that the Ten Great Disciples, living contemporaries of Shakyamuni, have made their appearance for the restoration of the seated image of Shakyamuni Defeating Demons and Touching the Earth, which displays the most important moment in the Buddha's attainment of the Way. In other words, in order to achieve a harmony between Mahayana Buddhism, filled with ideals and transcendence, and primitive (Hinayana) Buddhism, which is realistic and immanent, the Buddhism of Seokguram dared to give prominent position to the Ten Great Disciples.

So to speak, it may be considered that by positioning the Ten Great Disciples around the Buddha, the historical character of the Tathagata, which had gradually grown faint, was re-emphasized. Therefore, we many find in that period an intent to manifest in one place the development of the Buddha, according to the historical development of Buddhist religious thought. We may ascertain a comprehensive intent not merely to depict in one image of the Buddha defeating demons and touching the earth the characters of the three Buddhas, that is, Shakyamuni, Amitabha, and Vairocana; but also to gather together those figures who had through historical shifts developed as attendants to the Buddha, in other words Brahma, Indra, Manjushri, Samantabhadra, and the Ten Great Disciples.

Are these disciples the same as the Ten Great Disciples enumerated in the "Disciples" chapter of the *Sutra of Grouped Records*? In other words, are they the disciples from the time of Shakyamuni's life or if this is not the case, are they the images of the Zen patriarchs from the *Transmission of the Entrusted Dharma-Treasury* (K. *Bubeopjang inyeonjeon* 付法藏因緣傳), as are depicted in the reliefs on the walls of the caverns at Kanjingsi Temple and Leigutaizhong?[18]

As a manner of speaking, could not it be that by positioning the Ten Great Disciples at Seokguram, there was an effort to represent the 25 Zen patriarchs? This thought occurs when we see that at Seokguram Kasyapa and Ananda, as important as they are, are not presented contrastively.

While the countless images of Kasyapa and Ananda that appear in the rock caves at Dunhuang and Longmen could of course be representatives of the Ten Great Disciples, they could also represent images of the First Patriarch Kasyapa and the Second Patriarch Ananda. When was the conception of the Ten Great Disciples formed? Did it not perhaps begin with Avatamsaka philosophy, which considered ten to be a complete number and used it profusely? In any case, we can see these images to be carrying both meanings. This is to say, it would be proper to view them as expressing both the ten disciples follow-

ing the accounts of Shakyamuni's life, and the Zen patriarchs as the historical accumulation of the transmission and receipt of Shakyamuni's dharma through the time of Bodhidharma. Further, the main images of the caverns at Kanjingsi (690–704) and Leigutaizhong (690–704), in which sculptures of the Zen patriarchs are packed in lines against the walls, are all triads of three Buddhas in these unique stone caverns. The former has as its central image a seated Buddha with a jeweled crown making the mudra of defeating demons and touching the earth (*bhumisparsha mudra*, hereafter "earth touching mudra") and in the latter, facing the entrance on the left there is also a decorated seated image making the same mudra; thus there is a deep connection between images of the Zen patriarchs and images making the earth touching mudra. Therefore, there is a high probability that the images of the disciples at Seokguram have their origins in the caverns at Kanjingsi or Leigutaizhong in the Longmen caves. This is because, even though the number of disciples differs, the basic plan of their arrangement surrounded by the walls, the form and size of the sculpted images, the particular details, and the styles all closely resemble each other. Also, there was a similar intention in positioning and dividing all the images of the Zen patriarchs around the walls.

Therefore, although I cannot help thinking that just as the seated image making the earth touching mudra has all the temporally changing aspects of the Buddha Shakyamuni in one body, at Seokguram are simultaneously depicted the Ten Great Disciples, stressing the moment of the Buddha's attainment of the Way, or the historical patriarchs who occasionally transmitted the dharma. In the end it seems correct that the key to Seokguram is in the Ten Great Disciples.

These ten individuals are called Shakyamuni's Ten Great Disciples, or the Ten Shakyamuni Sages, and all appear to have been given characters as protective deities in later generations. In the eighth chapter of the *Abhiseka Sutra* the Buddha tells Ananda that each of the Ten Great Disciples has a unique talent: Sariputra excelled in wisdom, Maudgalyayana in supernatural powers, Mahakasyapa in asceticism, Subhuti in his understanding of emptiness, Purna in his exposition of the Dharma, Anaruddha in supernatural perception, Katyayana in debate, Upali in upholding the Vinaya, Ragora in esoteric practices, and Ananda in wide knowledge; and he also tells Ananda that all people who have eliminated the Four Evils and call their names will no longer have to worry about disease, will see all obstacles eliminated, and will have all things be auspicious.[19] In this way, the Ten Great Disciples took on the status of protective gods for the Buddha-dharma and were worshipped starting from the Qi-Liang period. The dry-lacquer sculptures of the Ten Great Disciples in the Western Golden Hall at Kofukuji in Japan and the reliefs depicting them at Seokguram in Gyeongju may be adduced as the examples in which the most personal depictions have the most clearly independent character.

The Ten Great Disciples at Seokguram have neither a subservient posture of service to the main image as in the Longmen caves, nor do they face forward as in the images at Kofukuji in Japan. Rather, they show a delicate and deep expression of the whole spec-

trum of emotions, and as their postures are varied, each of them has a distinct character. They fuse harmoniously the character of the idealized Ten Great Disciples, who share among themselves the various talents of Shakyamuni, and who could be called the personification of those abilities, with the character of the real Ten Great Disciples who lived at the time of Shakyamuni. At Seokguram, the Ten Great Disciples are not depicted as a group, but through their diverse expressions and postures gain independent existence. Just as Brahma, Indra, Manjushri, Samantabhadra, and Avalokiteshvara all have independent existences, so too do the ten disciples, and here lies the grandeur of Seokguram. Through this mode of depiction, the Ten Great Disciples strengthen the sense of realism at Seokguram.

Below I will examine and describe first the five images facing the entrance on the left, and then the five images on the right, in the order of their appearance.

Overall, on first glance there seems to be no fixed standard for the placement of the Ten Great Disciples. However, closer inspection reveals that there is an order to their arrangement. On the left, the first, second, fourth and fifth images face the entrance, while only the third faces the opposite direction. On the right, the first, second, third and fourth images also all face the entrance, in other words toward the supplicant, or toward the space before the main image. On each side, one lone image apiece faces in a different direction, and through the differing orientation of these two figures, the overall order is significantly altered. Therefore, the monotony of the postures of the images of the disciples is broken, and the relationships among the images are imbued with an exceptional sense of tension and vivacity.

The great variety of postures displayed by the Ten Great Disciples shows the meticulousness of their planning. They vary from a frontal-facing perspective to a three-fourths perspective to a one-quarter perspective to a side view. If we examine the degree to which the size of the posture varies, then the results are as in Table 1.

Ten Great Disciples	Face	Body
facing the left#1	left, side view	three-quarters view
facing the left#2	left, one-quarter view	three-quarters view
facing the left#3	right, one-quarter view	frontal view
facing the left#4	left, one-quarter view	frontal view
facing the left#5	left, three-quarters view	three-quarters view
facing the right#1	right, one-quarter view	three-quarters view
facing the right#2	right, side view	one-quarter view
facing the right#3	riight, one-quarter view	three-quarters view
facing the right#4	right, three-quarters view	three-quarters view
facing the right#5	frontal view	frontal view

Table 1. Various Postures of the Ten Great Disciples.

In cases in which the degrees to which the head and body are twisted differ, I have indicated them individually.

The slight variations in the postures of each of the Ten Great Disciples produce an atmosphere with a sense of realism.

First image facing the left (Fig. 124)

The disciple's narrowish face and aquiline nose along with his pointed chin give him an exotic appearance, and the lowered corners of his mouth and eyes make him appear serious and grave. His small eyes stare forward. This image, with its head bent forward, its neck projecting and its back highly arched, depicts a figure of advanced age. Its left hand holds up an incense burner to its breast, and its right hand, with its thumb, index and third finger linked, is shown in the instant of placing something (incense?) into the burner. Its feet are lined up in one direction and it wears sandals. Only this image and the second image facing the right wear sandals; the others all wear shoes with raised toes.

Second image facing the left (Fig. 125)

The eyes seem to be half-closed, but as the upper eyelids are large the eyes appear extremely small. In contrast to this, the nose is very large and prominent, crooked at a high ankle. The ears are very long. The comparatively thin face and the healthy body inside the monk's robes depict a man in the prime of his life. The appearance of the face sunk in meditation and the posture with the two hands joined near the chin and the hunched shoulders are those of a meditation monk deeply absorbed in inner concerns. In particular, the two hands joined in one place are a form often adopted when the figure is sunk in meditation. It is as if the standing form in which the face, hands, and back have all been focused on one point is as a whole the posture of absorption in deep meditation. The pedestal, which resembles a round floor cushion, is encircled by a lotus jewel design.

Third image facing the left (Fig. 126)

This image has a very long face. Its eyes, while small, are wide open, and its nose, while short, is prominent. Its mouth is slightly open, as if it were about to say something, and the chin is longer than ordinary, jutting forward to form a pointed chin. Its left hand is concealed inside its monk's robes, and only its right hand is exposed, with the thumb and middle finger joined in a ring. The meaning of this particular mudra cannot be determined. Along with the previous image, this image is unique because its entire body is swathed in robes, with only its hand exposed. Among the five images on the left, these are the only images whose faces are turned to the left, and who adopt an orientation opposite to that of the other images. This image's pedestal is outlined by two simple lines.

Fourth image facing the left (Fig. 127)

The corners of the eyes are long, giving an impression of sharpness, and the brow juts

124−128. Ten Great
Disciples.
First left, second left,
third left, fourth left,
and fifth left. (from top,
left to right)

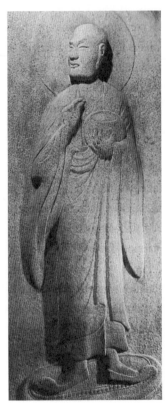
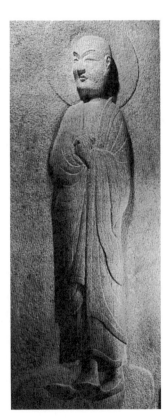

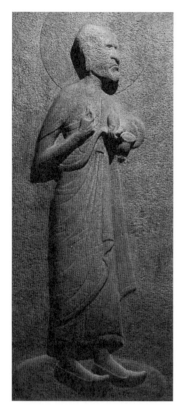
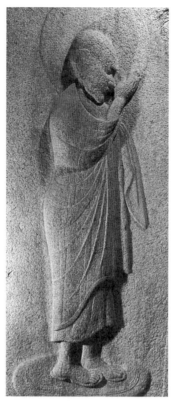
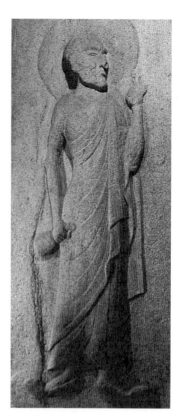

129–133. Ten Great
Disciples.
first right, second right,
third right, fourth right,
and fifth right. (from
top, left to right)

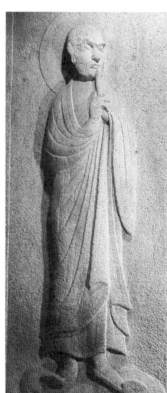
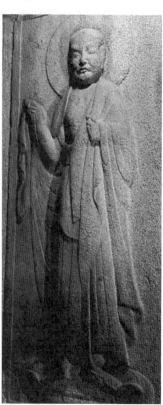

forward, suggesting toughness. The forehead is raised, and the image wears an expression of emotional transport, implying that it is gazing into the distance. Its nose is round, and its lips are on the thick side. The fingers on its left hand are spread wide to hold up a large, round alms bowl to the chest of the image, and with the two fingers of the right hand the image is making the gesture of holding something to put inside the alms bowl; this is the posture of making an alms offering to the central image. Its face is lifted in a stately manner, and the sleeves that hang down from both its arms are also portrayed with vigor. The facial expression and the dignified pose are those of a man in the prime of his life. The pedestal is outlined by a lotus jewel pattern.

Fifth image facing the left (Fig. 128)

The face is similar to that of the previous image. However, the eyebrows are treated with raised lines and the ears are smallish; the lips are thickish but drawn to appear small, and the outlines of the cheeks on its long face are those of a gentle youth. Its narrow shoulders and thin form are swathed in monk's robes, and its delicately folded hands are put forward in a subdued manner. As this appears to be the youngest among the Ten Great Disciples, it might be Ananda.

Interestingly, the five images facing the left seem to have been arranged in order of age from the entrance. Clearly, the further back one goes, the younger the images become; this phenomenon also occurs in the figures facing the right, and while it was seemingly done for a reason, that reason is unfathomable.

First image facing the right (Fig. 129)

In general, if the head and face are rounded then the figure is young, and if the head or the cheekbones and chin are pointed then the figure is aged. This, the first figure facing the right, also has the frame of an old man. The eyes are extremely small, and the upper eyelids are thick. The nose is prominent, the mouth is tightly closed to show a firm resolution, and the chin is pointed. The shoulders are thin, and with the thinness of the arms and hands the figure gives a sense of being tall. As opposed to most of the other images of old men, which face downward, this image has a neck raised straight, and its face is slightly turned to gaze forward. Only the outlines of the ears are depicted, with the details wholly omitted. With its left hand, the figure grasps the handle of an incense burner at the same time as it holds upright a lemon-shaped object in the palm of its hand, and with two fingers of the right hand it holds up something resembling a seed. With its uniquely long and thin arms and the bones that are depicted on the back of its hand, this image is shown as an

134. Seven-strip middle robe.

extremely wizened disciple of the Buddha.

Incidentally, the first image facing the right and the first image facing the left both take the form of aged old men holding incense burners. It is as if these two images of the disciples are depicted facing the main image and making incense offerings to it. Seeing that in this way, the five images on each side are arranged in order of age, and the first images on each side hold incense burners, we may determine that the style for the Ten Great Disciples was largely planned to be contrastive on both sides.

Second image facing the right (Fig. 130)

The face is slightly lowered and the eyes are shut. The chin is slightly long and pointed. The ears are depicted only in outline with the details omitted. The monastic robes envelop the entire body, and the two hands raised to the chest are in *gassho* as they touch the face. The deeply shut eyes and the hands in *gassho* show that this image is in deep meditation at the same time as expressing deep reverence for the Tathagata.

Because its hands are in *gassho*, among all the images of the Ten Great Disciples, this image is the closest to being depicted in a side view. When we consider the postures such as holding up an incense burner or the postures of worship, we may conclude that these various postures are those of worship toward the Tathagata. Therefore, these individual postures must all be considered in terms of their relationship with the main image. The pedestal of this imaged is ringed with a lotus jewel design.

Third image facing the right (Fig. 131)

The face is on the long side, and the chin is pointed. The tip of the nose has been broken, but it seems to have been slightly prominent. The eyes are comparatively long, and with both eyebrows furrowed and its mouth tightly closed, this image projects an expression of sternness and confidence. The left hand has its thumb and forefinger joined in a mudra that is the same as that of the third image facing the left. This is the only image with its right shoulder exposed, and its right hand is lowered to grasp firmly a water bottle. The expression on the sturdy, slightly upturned face, the outstretched shoulders, and the hand that firmly grasps the water bottle reveal a strong and tough character.

Fourth image facing the right (Fig. 132)

As we go further back among the five images on the right side of the chamber, little by little the faces become younger. In general, the younger the appearance, the less small the eyes, the less prominent the nose, and the less pointed the chin, But the eyes of this image are neither open nor shut. The two hands that emerge from the monk's robes reverently hold up a long and thin object which reaches close to the mouth of the image. Seeing that it is rounded and folded with elasticity, it seems not to be a hard object, but what it is cannot be determined.

Fifth image facing the right (Fig. 133)

This is the only forward-facing image among the Ten Great Disciples. It has a slightly thin shape, and the cast of its eyes and its mouth show a firm faith. Its left hand is bent to hold up the collar of its robes from the chest, and its right hand holds up the hem of its robes. This unconventional posture, in which half of the chest is exposed and the hands are raised, makes it appear that the monk is about to stride majestically forward toward the worshippers. With its collar refreshingly wide open, this image has absolutely no sense of stuffiness like the others. It is neither stooped forward nor are its hands joined, and therefore has a very liberated character. Its pedestal is encircled by a lotus jewel design.

Here I will make an overview of these images of the Ten Great Disciples.

In general, no images showing such perfect stylistic variation in the simple styles of monastic images may be found in other countries. It is also difficult to find a depiction with so much verisimilitude in the individual personalities of the monks. The depiction of the details of their faces, the orientations of those faces, the slimness and orientations of their bodies, the delicate shapes of their hands, the various attributes they hold, the various expressions that depict the inner world of the arhat, the various ways of wearing the monastic robes, the individually unique appearances of the legs and feet, the varieties of decoration on the pedestals, the relationships among all the disciples, and the relationship between all the disciples and the main image—because of this depiction, the artists who sculpted and arranged these images were able to realize flawlessly these harmonious relationships in one place, achieving variation without disorder.

Without a doubt this can be called the epitome of realism in Korean sculptural history. The Ten Great Disciples, who occupy two-thirds of the main chamber, are extremely significant both doctrinally and as artistic depictions. In fact, it may be possible to evaluate the character of the artifacts at Seokguram on the basis of the existence of these images. In other words, along with the main image's earth touching mudra, they could strongly suggest a return to primitive Buddhism (K. *wonsi bulgyo*, 原始佛敎) or fundamental Buddhism (K. *geunbon bulgyo*, 根本佛敎).

In sum, the Ten Great Disciples depict various postures of offering to the Buddha while circumambulating the central image, either by offering incense or offering alms.

Finally, I would like to touch on the issue of the images' codified dress. These images wear their robes in an Indian manner, in which each image has three robes. These are the five strip under-robe, the seven-strip middle robe (Fig. 134) and the nine or twenty-five strip outer robe.

However, among the Ten Great Disciples at Seokguram the fourth image facing the left and the fifth image facing the right alone do have depictions of the strips and leaves. Robes that are woven and worn are called *kesas*, and those that are not woven and that do not depict strips and leaves are called robes. In sum, only two of the images are wearing

manui and the rest all ought to be wearing *kesas*. However, here I am referring to two different types of garment by the general name *kesa*. In any event, there should be a reason why these depictions differ, but that can not be determined at the present time.

Each of the Ten Great Disciples wears its garments differently, showing great variety. In their details, too, they are all unique, but in general they may be divided into those who wear their robes over both shoulders and those who wear their robes over only one. The first image facing the right, the third image facing the right, and the fifth image facing the right all wear their robes over one shoulder, while the rest all wear their robes over both.

Incidentally, this Indian style of wearing three robes underwent changes in a cold region such as China. We cannot know about the under-robe and middle robes, but on the outside was worn an over-garment above which the great robe was worn. The hollow-dry statues of the Ten Great Disciples at Kofukuji depict this change, showing that in the mid-eighth century Japan, monks followed the Chinese style, while Korean monks followed the Indian.

At Seokguram, not only the Ten Great Disciples but also the devas and the bodhisattvas all have a variety of adornments and modes of wearing their garments depicted with great accuracy, and they therefore provide valuable information for the study of the history of ancient religious vestments.[20]

5. Eleven-Faced Avalokiteshvara

With only ten examples in China[21] and three in Korea,[22] images of the Eleven-Faced Avalokiteshvara (K. Sibilmyeon Gwaneum bosal, 十一面觀音菩薩) carved in stone are not so numerous. This is likely because the complicated iconography of the eleven heads made carving this style of image difficult. In the case of Japan, all the extant images are wooden carvings and there are many examples remaining from the post-Tempyo period. And in the case of China, with limestone or sandstone as the material, or with wood, as in the case of Japan, a fine depiction of the eleven heads is possible. However, in the case of Korea, the available granite is so rough that a fine depiction of the details is nearly impossible. In spite of this, the image of the Eleven-Faced Avalokiteshvara at Seokguram (Fig. 135) has succeeded in faithfully reproducing iconographic prescription.

At the front center of the head is a single petal of a flower, within which is carved a standing image of a Tathagata, which has a halo for its head, a halo for its body, and a lotus leaf pedestal. The image is so small that the features of the face and its clothing have been abbreviated, but the mudra, the mudra which grants the absence of fear (K. *simuwoein*), is clear. Above and to the right and left sides of this transformation buddha are arranged three heads of the bodhisattva, and nine of the jeweled crowns of the bodhisattva depict a standing image of the transformation buddha. In the explanation in Seokguram and Bulguksa Temple, published during the colonial period by the Korean

Governor-General, it is written that the face at the very top and one of the faces on the left side were missing and the gaps where they were inserted remain. Thus we may deduce that the very top face and one of the faces on the left side are later replacements.[23]

The arrangement of this Eleven-Faced Avalokiteshvara faithfully follows the iconographic arrangement of eleven heads that appears in such sutras as *The Sutra of the Buddha Preaching the Dharani of the Eleven-Faced Avalokiteshvara*, or Xuanzang's translation of *The Dharani Heart Sutra of the Eleven-Faced Avalokiteshvara*.[24] Because of the standing image of the Tathagata in the center of the flower crown, the three forward facing heads have merely been shifted upwards; otherwise, the image faithfully follows the sutra's directions for "three heads with the aspect of mercy at the front, three heads with the aspect of rage on the left side, and three heads with white fangs directed upward on the right side." The top of the head of the image is level, and although the seated image of a buddha with a mandorla there now was placed during the period of Japanese rule, there is a strong chance that, following the ritual prescriptions and the Chinese examples, originally a Buddha-head was placed there. Because of the difficulty in depicting even the facial expressions described in the ritual prescriptions, they were not followed to the letter. The facial expressions largely do not appear; only three of the faces wear smiles.

The primary face of the Eleven-Faced Avalokiteshvara is executed in high relief. The upper half of the image is also treated in high relief, but its lower half is treated in semi-relief, like the other bodhisattvas. In this way, the head is treated closer to sculpture in the round than the images of the other bodhisattvas or the Ten Great Disciples; therefore, the clear emphasis on the Eleven-Faced Avalokiteshvara suggests the importance of this image of Avalokiteshvara at Seokguram.

Further, as is clearly directed in the sutra, the image's necklace of beaded jewels adorns the whole image of Avalokiteshvara more resplendently than any of the other images of bodhisattvas. Its earrings and necklaces piled on necklaces begin from both the shoulders and hang down resplendently; from this point the complex and splendid necklace develops into segments and decorates the whole body. The thumb and forefinger of the right hand lightly grasp the very end of the necklace, and divide it into two opposite segments. Its anklets are resplendent and clearly depicted, unlike those of the other bodhisattvas. The left hand grasps a raised water bottle by its neck, from which emerges a single lotus flower in full bloom. The mudras of both these hands and the resplendent beaded ornamentation faithfully follow the ritual prescriptions of the sutras.

The solemn expression of the face, with just a hint of a smile; the form more harmonious than that of other bodhisattvas; the forward-facing posture; the beaded strands that decorate the whole image gorgeously; the heavenly garments that cascade down to encircle and cover the whole image in an elegant manner; the delicate movements of the fingers and toes; the well developed and high lotus pedestal—these things all show the deep interest and effort the sculptors of Seokguram devoted to Avalokiteshvara, strongly suggesting that the Eleven-Faced Avalokiteshvara was the object of an independent cult.

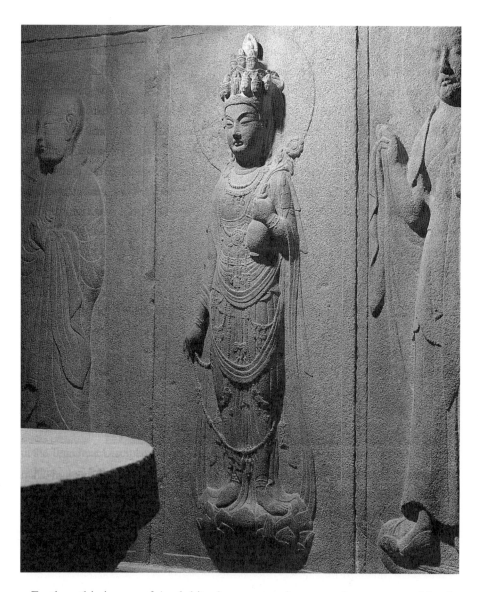

135. Eleven-Faced
Avalokiteshvara.

Further, this image of Avalokiteshvara occupies a very important position in Seokguram. Inspection of the plan of the main chamber shows that it sits in the center of the wall surrounding the oval of the chamber's interior. However, when we look up at the image of Shakyamuni from the entrance, the image of Avalokiteshvara is blocked from view. In other words, Shakyamuni and Avalokiteshvara completely overlap. I believe that this type of arrangement was planned based on an important doctrine of Buddhism. Shakyamuni's mind—in other words the mind of a Buddha—is none other than the great mercy and great compassion which is embodied in the Eleven-Faced Avalokiteshvara. Through the union of these two, the non-duality of the main image of Shakyamuni and the Eleven-Faced Avalokiteshvara is expressed. I believe that when the rite of circumambulation is carried out in the main chamber, the beautiful form of the image of Avalokiteshvara, until that point hidden and invisible behind Shakyamuni, emerges to

arouse admiration from the participant, bringing the ritual to a fixed point.[25]

If this is the case, then why was a standard image of Arya-Avalokiteshvara not positioned there, but rather an esoteric Eleven-Faced Avalokiteshvara? The placement of the eleven heads on the image's jeweled crown is to be considered the expression of the eleven faces as the expedient means of Avalokiteshvara, and result from Avalokiteshvara's intent to save all sentient beings according to their differing capacities for understanding. Therefore, it appears that the two-armed, eleven-faced images of Avalokiteshvara are the maximized version of the esoteric image of Avalokiteshvara and also the origin from which are derived the esoteric, transformed versions, such as the thousand-armed, thousand-eyed Avalokiteshvara.

In these realistic and symbolic aspects, this image of the Eleven-Faced Avalokiteshvara may be considered the culmination in both design and belief of Eastern Buddhist sculpture.

6. The Images of Bodhisattvas in the Niches

In the many Chinese cave temples, such as the Yungang rock cave and the Longmen rock cave, small niches are scattered on the inner perimeter walls of the temples, and images of Buddhas and bodhisattvas are enshrined within them. Within one cavern there may be various forms and sizes of niches, arranged with no uniformity. However, the niches at Seokguram are further abbreviated forms of the rounded Chinese niches, and they are positioned in pairs in an extremely ordered fashion. Thus, while the planners of Seokguram followed the system for Chinese cave temples, they were extremely thoroughgoing in terms of the forms and positions of the niches.

At Seokguram, the ten small niches are positioned directly under the point at which the dome of the outer wall begins. As they are the same height as the main image, they are distributed so that there ought to be five images on each side of the main image's mandorla. The first niche above the alcove facing the entrance is empty. It has been said that the Japanese moved the images, but this rumor cannot be verified. Therefore, today only eight Buddhist images are left, four to each side.

The most central among these bodhisattva images are likely the images of the layman Vimalakirti and the bodhisattva Manjushri, which form a pair to the sides of the halo behind the main image. The two images represent the main characters from the representative Mahayana sutra, the *Vimalakirti-nirdesa Sutra*, and in particular Vimalakirti has been revered as representing the Mahayana bodhisattva ideal. As in Chinese sculpture and painting, these two images at Seokguram are facing each other in conversation. As the head of the main image is positioned between them, the two images seem remarkably to be facing Shakyamuni, and to carry out the role of attendants.

We cannot determine on what basis the other six images were positioned, nor can we

easily draw conclusions concerning the identity of any except Ksitigarbha (Jijang bosal, 地藏菩薩). This is because identification of Buddhist images is relative to an extent. Following the identity of the central main image, bodhisattva pairs such as Manjushri-Samantabhadra, Avalokiteshvara-Mahasthamaprapta, or Avalokiteshvara-Ksitigarbha, or Avalokiteshvara-Maitreya may be established; alternatively, based on the identity of the two bodhisattvas, the identity of the main image may also be established.

The pairing of Vimalakirti and Manjushri at Seokguram to the sides of the main image is a curious decision, and as the other bodhisattvas cannot be identified it is hard to determine whether they too are in paired relationships. Therefore, with the exception of these two images, I will designate and discuss the bodhisattvas on each side as follows, from the entrance facing the interior: first, second, and third on the left; first, second and third on the right.

The second image facing the left, the third image facing the left, and the third image facing the right all face forward; the first image facing the left faces the entrance, and the first and second images facing the right face one another. The three images that face forward are seated in full lotus position, and therefore have postures which show them to be objects of worship. However, the other three images have postures that vary slightly from and are more comfortable than the full lotus position; their mudras too are irregular, and the positions of their heads are also depicted freely.

Further, as all of these are enshrined in the niches like sculptures in the round, each has an independent character. However, in spite of this independent enshrinement, three of these images have postures that are so irregular as to diminish their independent character, and with the addition of Vimalakirti and Manjushri, the postures of the bodhisattva images in the shrines truly encompass matchless variation, with their perfectly free postures in the midst of the rigid arrangement. As with the relief images on the walls of the grotto, the iconography of the bodhisattva images in the niches follows no specific precedent and are arranged creatively, so no hasty identification of the icons should be attempted, apart from those which can be determined for certain.

The height of the space within the niches averages 1.2 meters (3.7 *cheok*) and the height of the images averages around 1.06 meters (3.5 *cheok*). Therefore, the gap between the upper walls of the shrines and the tops of the images did not exceed 15 centimeters. This is because, as the structure of Seokguram is more than a thousand years old, the upper section of these niches (the long stones that make up the upper sections of the niches) has pressed down on the images inside. The section touched by the pressure was the center top of the halo. The top of the haloes of the bodhisattvas on the right as seen from the entrance were distorted through this kind of process, whether through steady pressure or sudden shock. With the exception of the image of Ksitigarbha, which has sustained slight damage to its halo, all the bodhisattvas on the left are in complete condition. This tells us that the structure of the right side is slightly more distorted than the left. If these images had fallen to the floor of the main chamber, then they would have

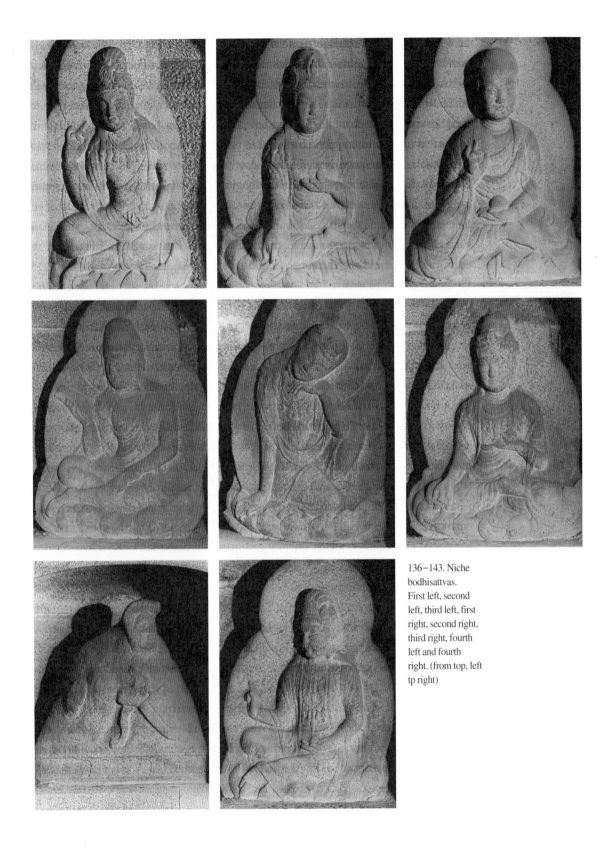

136–143. Niche bodhisattvas. First left, second left, third left, first right, second right, third right, fourth left and fourth right. (from top, left tp right)

sustained more damage in different places, and it would not have been merely the very top of each image that was damaged in a regular fashion. Therefore I attempt to see the images of bodhisattvas inside these small niches in their original positions. The earliest photographs taken of Seokguram show that a considerable portion of the arched ceiling over the entrance had collapsed, meaning that it is highly possibility that the niches in that area had been severely damaged; therefore, it is also possible that the first and second bodhisattva images to either side fell to the ground and were shattered, or were moved to another location.

Inside the niches, whose tops are elliptical in shape, are enshrined bodhisattva images whose bodies, haloes, mandorlas, and pedestals are all carved from a single piece of stone. Although the lotus pedestals are basically in the same style as those of the standing bodhisattvas on the walls, because they support both the images and their haloes together, the back has been abbreviated into a semi-elliptical section, and the further back one goes, the higher up the lotus leaves rise, so that they appear to encircle the back of the halo. This is a style that is not easy to produce in sculpture in the round, but is rather an illustratory technique often employed in painting and relief.

The styles of the bodhisattvas may be divided into two: the bodhisattva images with a strict forward-facing orientation, and those who have largely shattered this strict posture to take a more comfortable and free position. It is unknown why these two contrastive postures have been placed opposite each other, but it is certain that through the admixture of some free postures, the sculptors have created an atmosphere that is generally diverse and overflowing with a sense of vivacity. This type of unorthodox posture may also be found in the relief images of a group of bodhisattvas on the southern wall of the Jingxi cavern (mid seventh-century) in the Longmen rock caves, or in the wall paintings of Horyuji Temple.

In the modeling of their faces and bodies, the orientations of their bodies which vary by image, and the elegant heavenly clothing, the minute planning for variation and the sensitive sculptural technique of these images resembles that of the standing images on the walls of the chamber. Even though these look like sculptures carved in the round and capable of movement, because of the halos these bodhisattvas must be seen as sculptures in high relief.

First image facing the left (Fig. 136)

The face of this image is oriented to the right, and its left arm and knee are executed in a high relief close sculpture in the round. Its head and upper body slightly jut forward, and its posture is such that its hand, with the thumb and middle finger linked, nearly touches its cheek. Its legs are unfolded from the lotus position and hang over the lotus pedestal. The palm of its left hand holds upright a vajra-like object, and rests lightly on its knee. The decoration for its high topknot is not the usual three-faced jeweled crown, but rather a crown with a complex arabesque design. The heavenly garments that descend

from both shoulders crisscross over the abdomen, are entwined over the legs, and then descend again from the lap to disappear within the lotus pedestal. Its face is expressionless but seems to be sunk in thought.

On the whole, judging from the depiction of the right hand, which is reaching toward the lowered face, this is an expression of contemplation. The delicate movements of its fingers and the elegant flow of its heavenly garments appear to be expressions of this bodhisattva's inner motions. As it is a seated image in relief, there is probably no other way to express a posture of contemplation. Its right breast is emphasized so as to stand out, and the waist beneath it is drawn in, which emphasizes the posture of contemplation. The image is basically in relief, but the pose in which it sits naturally must be in high relief, giving the impression of an image carved in the round. As this image, overflowing with vitality, does not face the front, it is uniquely emphasized to stand out. The complex design of its hair, the necklace, bracelets, and anklets, the heavenly garments that cascade elegantly over the body, the sensitive depictions of the feet and arms, and the posture that expresses one certain moment—these all achieve a magnificent harmony with the simple and plain halo and lotus pedestal. In its entirety, this image embodies splendid adornment. All the bodhisattvas in the niches give the same feeling, and it is as if the bodhisattvas are adorning the Buddha and the Dharma-realm.

Second image facing the left (Fig. 137)

This is an image in a severe forward-facing position. On the mandorla of the center of its three-faced jeweled crown is depicted a standing image of a transformation-buddha. Its right hand descends over its right knee, folded in full lotus position, and its left hand is raised to its chest and holds up a small water bottle, so there is a large chance that this is an image of Avalokiteshvara. Compared to the first image facing the left, the sculptural technique is slightly rougher, and the posture is more rigid. Its face is uniquely full-fleshed, if expressionless.

Third image facing the left (Fig. 138)

With its shaven head, wish-granting jewel upheld in its left hand, and forward-facing posture in monastic robes, this is an image of the bodhisattva Ksitigarbha. Its right hand is upheld and its thumb and third finger are joined. The folds of its monastic robes are executed in layers, like all the other images, and like the second image its posture is rigid. As the oldest extant image of Ksitigarbha in Korea, this is an extremely important work of art.

First image facing the right (Fig. 139)

With a posture similar to that of the first image facing the left, these two images make a complete pair, indicating that they are in their original positions. Its high topknot is adorned with flower petals and is partially abraded. From its earrings flow long strands

which match the heavenly garments. The heavenly garments crisscross at the stomach and flow down over both arms. As the right hand of the image holds up a sutra container, we may assume that this is an image of the bodhisattva Samantabhadra, but this attribute does not necessarily confirm its identity. The uppermost center part of the halo has been damaged.

Second image facing the right (Fig. 140)

For a bodhisattva, this image has an irregular posture. The palm of its hand supports its lowered head, which in turn is supported by the knee which is held upright; its right hand grasps the foot on the leg whose knee is bent. This is less the form of a bodhisattva than that of a beautiful woman who appears to be asleep. The fingers and toes are slim, long and delicate. The uppermost center part of the halo has been damaged.

Third image facing then right (Fig. 141)

This is a rigid, forward-facing image seated in full lotus position. Long strands flow down from its three-faced jeweled crown and earrings. As in the first image facing the right, in order to avoid difficulty in the depiction of the strands flowing down from the earrings, the heavenly garments have been treated so that they simply adhere to the body. The right hand, whose thumb and middle finger are linked, is lowered to the right knee, and the palm is visible. It is raised to the chest and holds an attribute which cannot be identified. About one-third of the top of the halo has been damaged.

Fourth image facing the right and fourth image facing the left: The pair of the layman Vimalakirti and the bodhisattva Manjushri in dialogue

First, the fourth image facing the right (Fig. 143) represents the bodhisattva Manjushri. Its posture is similar to that of the first bodhisattva facing the right and left. he jeweled necklaces on its body are made up of three different levels and are the most splendid of the bodhisattvas. The ring and little fingers of its left hand are inflected and sit on the left knee, while the right hand, its ring and little fingers also inflected, forms the mudra which grants the absence of fear. The face is expressionless. Because of the jeweled necklaces adorning the chest and stomach, the heavenly garments do not crisscross but rather just descend straight down to wrap around the two arms.

The fourth image facing the left (Fig. 142) is an incomplete image of the layman Vimalakirti. In Seokguram, where the forms of all the images were planned in careful detail, why was Vimalakirti left unfinished? The image holds a whisk and sits on a cushion. And while the other bodhisattvas were all given halos, Vimalakirti does not have one. This might in fact be the only image of Vimalakirti in Korea. The head, which wears a velvet cap, is slightly lifted and seems to be staring off into the distance; the gaze, with its eyes slightly downcast and seemingly filled with pity, the forehead with its many wrinkles, the round and flat nose, and the mouth slightly open as if to say something—

this is a profound treatment of an individual human being's character, in a dimension wholly different from the idealized images of the bodhisattvas. The whole body is wrapped in a coat made of crane feathers and holds a whisk in its right hand. On the low level platform are depicted three eye shapes.

There are two Chinese examples similar to this icon, found in the didactic depiction of the *Vimalakirti-nirdesa Sutra* on the southern side of the eastern wall in Dunhuang Magao cavern 220 (early Tang), and on the southern side of the eastern wall in cavern 103.[26] While this image has a different facial expression, the overall flow of its crane feather coat, the form of the whisk, and the rectangular platform indicate that there is a strong chance that the basic structure follows that of Tang painting models.

However, at Seokguram this iconography was made abstract and its overall structure was made triangular, with a wide base, and only the most important elements, such as the facial expression—that of a sick old man—and the whisk which is unique to Vimalakirti, and the legs of the rest against which he leans, were depicted in detail. It was treated as elementary solid shapes, such as the left leg lying on the platform, or left hand covered by the crane-feather coat. The delicate depiction of the face, and the bold and abstract treatment of the body and its clothes, is unique for that period. This is an incomplete work, but one so completely planned that we cannot consider it to be the end of an incomplete process, especially when examining the platform on which the eye shapes were carved. Perhaps it was because Vimalakirti was treated with such bold technique because his uniquely Mahayana character could not be expressed in the same way as the other bodhisattvas. This image is positioned directly to the left of the face of the main image, at the very nearest point, so it is not possible that it could have been enshrined while still unfinished. It is an image that calls to mind Rodin's Balzac.

There is a strong chance that the fourth image facing the left, which corresponds to this image of Vimalakirti, represents the bodhisattva Manjushri. The insertion into Seokguram of the dramatic scene in the *Vimalakirti-nirdesa Sutra*, a representative Mahayana sutra which expresses the philosophy of lay belief, in which Vimalakirti and Manjushri debate, should be considered in conjunction with the precise enumeration of the Ten Great Disciples in the "Disciples" chapter of this sutra. This is because the personalities of the Ten Great Disciples are described in detail in that sutra. The image of Manjushri sits across from Vimalakirti, and with its ring and little fingers of its right hand inflected is forming a unique mudra. This unique mudra resembles that of the aforementioned images of Manjushri sitting across from the images of Vimalakirti in Dunhuang caves 220 and 103. There, compared with the comfortably seated Vimalakirti, depicted as a lay believer, Manjushri is always seated in a formal lotus position, and displays his right palm to Vimalakirti with the ring and little fingers inflected.

The bodhisattva Manjushri paid a get-well call to the layman Vimalakirti, suffering from a symbolic sickness; after a long debate, at the moment when Manjushri asked Vimalakirti about the dharma-gate of non-duality, or the most profound truth, Vimalakirti

was silent. Manjushri was amazed by this and said: "How marvelous. There are no words or letters. This very thing is the demonstration of the state of absolute non-duality." This is the famous "silence of Vimalakirti."

It is clear that the posture in which Vimalakirti and Manjushri sit across from one another is modeled on one that often appears in conversation. But when Vimalakirti and Manjushri are depicted individually, they cannot adopt this type of posture.

The dramatic debate between Vimalakirti and Manjushri as it appeared in the *Vimalakirti-nirdesa Sutra*, a proverbial best-seller in China, was from Northern Wei through Song a popular topic represented in a variety of genres, including stone sculptures, images engraved on tablets, wall paintings, and other paintings. Although there is a record of the painting of an image of Vimalakirti by Solgo, an important painter of the Unified Silla period, this image at Seokguram is the only example and no examples from periods after it remain.

It is noteworthy that these sculptures of Vimalakirti and Manjushri at Seokguram face each other on either side of the face of the main image.

7. The Main Image: The Seated Shakyamuni

Because the architecture and the 37 Buddhist images (two of which are missing) of Seokguram on the outer walls actually serve to adorn magnificently the enormous seated image of Shakyamuni (Fig. 144), this great seated Buddha must be considered to be the very core of the architecture and sculpture of Seokguram.

Seated images making the earth touching mudra were greatly popular in East Asia, and especially in Korea. In China, there are only a few images like this, such as the seated one with the jeweled crown in the southern cavern in Leigutaizhong cavern in the Longmen rock caves, the classical Tang-dynasty seated image in the eighteenth cavern in the fourth cave in the Tianlongshan complex, or the image at Huarasi Temple in Zhengding prefecture, Hebei Province, and these images were not especially popular. However, in Korea, with the Seokguram image as a base, this type of image became the mainstream of objects of worship in Buddhist sculpture through the Goryeo and Joseon dynasties.

The main image in Seokguram reached a height of 3.5 meters; for a great Buddha image, it is the most stately and most beautiful in the world, its sublime beauty perfectly realized through a masterful technique. It is frequently conjectured that because the main image is so splendid that there is no piece of sculpture from the same period to which it may be compared, or that artists must have come from another country to make it. However, by the middle of the eighth century, because Korea was no longer accepting outside influences and had reached a level high enough to permit it to treat artistic styles and doctrines by itself, we must look for the possibilities concerning the creation of this image within Unified Silla itself. For a piece of sculpture that may be compared with the

main image of Seokguram, we may cite the standing stone image which has been moved from the site of Cheongamnisa Temple and now stands in the Gyeongju National Museum. Even though this standing stone image of a Tathagata is badly damaged, through its masterful technique sublime beauty has been so perfectly expressed that it might have been created by the same sculptor. Or again, the seated Buddhist image in Angyeri is splendid enough to allow comparison with the main image at Seokguram.

Further, the technology for working with granite was developed and advanced in Korea. Of course, in China the technologies for working with limestone and sandstone developed, but because the Chinese could not acquire the technology for working with granite, we cannot regard this image as having been produced by foreign sculptors who came to Korea. This is because the quality of sandstone and limestone, and the sculptural techniques for dealing with them are completely different from those of granite.

The pedestal of the image is circular. Between the circular base stone and the ground is molding, and the top of the round foundation stone is surrounded by thirty-two single lotus leaf petals, and is considered the lower base stone. The central base stone is hexagonal; surrounding it are five pillars, making a unique structure. The upper foundation stone, like the lower foundation stone, is surrounded by thirty-two single lotus leaf petals, and above that is placed a round covering stone. This enormous lotus leaf pedestal, with a foundation stone composed of two semi-circular sections, and upper and lower base stones made of a single stone each. It is usual for the foundation stone to be treated as a hexagon, but here its circular form recapitulates the roundness of the main chamber and emphasizes the circular structure.

The main image, seated above the pedestal, sits upright, and its halo is affixed to the wall of the round main chamber behind it. The halo is unsophisticated and is surrounded by 20 simple lotus petals on its circumference. The halo's placement on the wall in this manner gives the viewer the sense that the best possible use has been made of the space between the chamber wall and the main image. The upper and lower base stones of the pedestal, and the design for the halo are all in the same simple lotus leaf design, giving a sense of unity.

The hair of the main image is in the conch-shell style, the hair on each cone spiraling in a counterclockwise direction. On the forehead is an urna. The two eyebrows which are linked to the line of the nose rise up in a refreshing manner, and the corners of the two eyes rise to each side in the elegantly inflected curved lines that are the classic form of the Unified Silla period. The eyes are slightly open and express deep meditation. On each side the lips are powerfully drawn apart to form a faint smile. The ears are not so large, the reason for which is linked to the broad-shouldered, tall body. In order to connect harmoniously the plump face with the body, the neck is necessarily short. The shoulder, chest and arm which are exposed by the robes going over the right shoulder only, are plump and elastic, and the simple folds in the heavenly garments that cling to the body emerge clearly. Only on the lower part of the right breast and the left arm are wide graded

144. Seated
Shakyamuni. Unified
Silla, mid-8th c.
H. figure 345 cm.
National Treasure
No. 24.

170

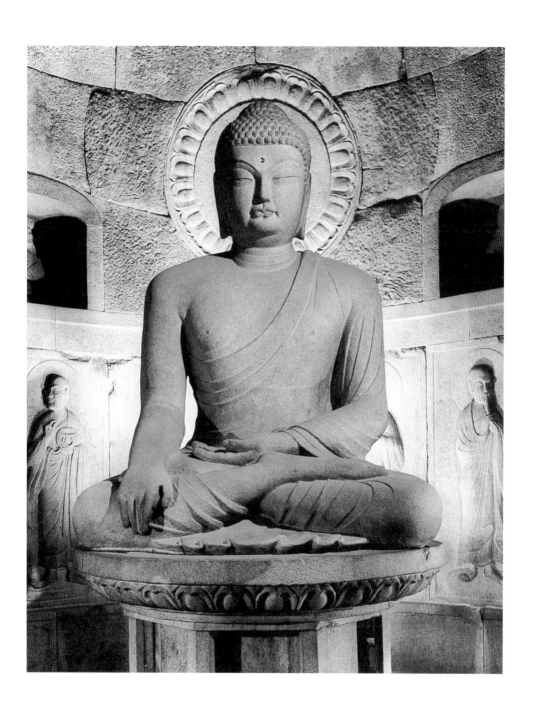

folds depicted elegantly. The folds of the clothing on the legs, folded in lotus position, form grades and are bulky, and between the two legs the hems are gathered in a fan shape. The space between the legs is wide to support the wide body solidly. The left hand is in the mudra of meditation (K. *seonjeongin*), and the right hand rests on the right knee, and the index finger is slightly extended downwards to point to the ground and form the mudra of defeating demons and touching the earth. Further, between the fingers of the image's hand the skin is webbed like a duck's foot, one of the thirty-two signs of a Buddha; this is the only example of this portrayal in Korean Buddhist sculpture. The subtle motion of the lifelike fingers that indicate the earth give a sense of vivacity, and are the epitome of the realistic expression of liveliness in this image. In this very hand is crystallized all the superhuman power that forced the demons to submit.

The main image is so perfect that it brings about a deep religious experience in the viewer who encounters its sublime beauty, which is difficult to express in words. This is truly the shape of the Absolute. It is absolute and without compare. It is a perfect form, from which nothing is to be removed or added. It could be called a work unparalleled among Buddhist images throughout the world for its sublime and beautiful shape. Who could have been the genius who depicted the life force and sublime beauty with no regrets and such perfect skill?

For that matter, what could be the identity of this main image? It is called either the Buddha Amitabha, or Shakyamuni, or Vairocana. Also, efforts have been made to work out the particular sutra on which it was based. These various theories will be treated in my essay on the iconographic interpretation of Seokguram.

However, we must not attempt to identify the main image at Seokguram through special exceptional examples, of which there are few, or through the sutras, but instead to discover its identity from Seokguram itself. In other words, we must attempt to investigate starting from its relationship with the various images carved in relief on the outer walls of the main chamber.

First we must look at the images of Bhrama and Indra, which are not often found in Korean Buddhist sculpture. The fact that these were given an important position inside the main chamber, and not placed outside the main chamber as deva images, shows that they rank with the bodhisattvas and the Ten Great Disciples and have a deep relationship with the main image. When Brahma and Indra made their early appearance in Indian Buddhist sculpture, they were important deities who appeared as attendants to images of Shakyamuni produced in the Mathura region. Therefore, the existence of these two images inside the main chamber strongly suggests that the main image is of the Buddha Shakyamuni. This is because these two images are never combined with Amitabha or other Buddhas.

Second we may adduce the images of the Ten Great Disciples, which stand on par with the bodhisattvas. Further, these occupy fully two thirds of the space on the walls surrounding the main chamber. Of course, Kasyapa and Ananda from this group are some-

times combined with the Buddha Amitabha as in the Dunhuang Magao caves, and as in Joseon-era Buddhist painting they are sometimes combined with Vairocana, but to the very end when they are seen as combined with bodhisattvas, only the upper halves of their bodies are given secondary expression.

Third, there is the problem of the identity of the two bodhisattva images. The two images may be regarded as Manjushri and Samantabhadra, but there is no definite evidence for this. In contemporary China the iconography for these bodhisattvas was not yet fixed, and even in Unified Silla there were no definite examples from before or after the construction of Seokguram. Again, there are no definite examples of Manjushri or Samantabhadra as attendants in a Shakyamuni triad from the Unified Silla period. Although there are no examples of Shakyamuni triads, even in the Buddhist triad in which the central figure makes the earth touching mudra at Chiburam on Mt. Namsan in Gyeongju, which very probably is such a triad, the bodhisattvas on each side respectively hold up a water bottle and a lotus blossom, and their iconography is not close to that of the two bodhisattvas in Seokguram, who hold up a sutra and an alms bowl. Further, in Korea most images making the earth touching mudra appear independently and triads including Tathagatas of this type are quite unfamiliar. In the instance of the stone Buddha images at the Tang-dynasty Baoqingsi Temple, although there are bodhisattvas as attendants making the earth touching mudra, they are the only ones with no identifying inscriptions and are therefore difficult to identify. In Korean scholarly circles, declaring this image to be Shakyamuni or, interpreting Seokguram as having been created based on the *Avatamsaka Sutra*, we have come to regard the two bodhisattvas as Manjushri and Samantabhadra. It is, so to speak, the reliance in art history not on inference based on important empirical methods but rather on theoretical inference.

As there is still not a single definite instance of Manjushri and Samantabhadra as attendants in a Unified Silla-era work of art, it would be premature to decide that these are the identities of the two bodhisattvas in the main chamber of Seokguram. In the Unified Silla period, these bodhisattvas were instead depicted as the attendants to the Buddha Vairocana, and references to Shakyamuni triads in which they are attendants do not appear until the Goryeo Dynasty (高麗時代, 935−1392). Thus, we must consider that Shakyamuni triads made up of Shakyamuni, Manjushri and Samantabhadra were not yet established in the mid eighth-century.

In early India, Indra and Brahma, as well as Avalokiteshvara and Maitreya, appeared as attendants to Shakyamuni. However, there are iconographic problems in seeing Seokguram's two bodhisattvas as Avalokiteshvara and Maitreya. Therefore, all that is certain is that the difficulty in identifying these two bodhisattvas reflects the circumstances in the mid eighth-century, in which triads including Shakyamuni making the earth touching mudra had not yet been established. Even if the main image were considered to be the Amitabha Buddha, then these two bodhisattvas would have to fit the iconography of the time for Avalokiteshvara and Mahasthamaprapta, but this is not the

case.

Fourth, is the importance of the Eleven-Faced Avalokiteshvara. This image represents a maximization of the concept of Avalokiteshvara, and is the prototype for the various transformed versions of Avalokiteshvara popular in esotericism. It must be seen as the first effort to express in an extreme way the compassion of the Buddha, who tries to save all sentient beings through the various expedient means which are the eleven faces of the image. When we consider this, we can see that this image, which has the most eye-catching carving and which is the most resplendent, has been emphasized as the most important among the images on the walls of the main chamber. Further, this image is placed in the center, behind the main image, where it is blocked from view when one stands at the entrance to this structure, and is positioned so that it overlaps with the main image. In other words, as these two image are positioned to overlap, they are in a relationship of non-duality. I consider this structure's designer to have had ideas of a high order in placing the Eleven-Faced Avalokiteshvara, the incarnation of the Buddha's highly important compassion, directly behind the image of the Tathagata Shakyamuni. Further, we must recall that there are no examples whatsoever of images of the Eleven-Faced Avalokiteshvara appearing as attendants to other Tathagatas and that it has always been an independent object of worship. I believe that by placing the Eleven-Faced Avalokiteshvara, with its independent character, on the center rear wall of Seokguram, the Buddha's compassion—the most important concept in the Mahayana—was emphasized, giving concrete form to this compassion, which is a turning point at which the Tathagata Shakyamuni did not stop at a Hinayana stance after achieving perfect enlightenment but came to take a Mahayana posture, in which he attained the compassion to attempt to save others. As images of Avalokiteshvara without eleven faces usually exist as attendants to Amitabha, by positioning in Seokguram an Eleven-Faced Avalokiteshvara which has an independent character, it is linked in a natural way to the Tathagata Shakyamuni.

Fifth, the main Buddha-image's orientation to the east, its earth touching mudra, and such measurements as its seated height, the breadth of its shoulders, and the distance between its knees all seem to correspond precisely with those recorded for the main image of Shakyamuni at Mahabodhi Temple, which was created at the place of the Buddha's enlightenment in Bodh Gaya, as recorded in Xuanzang's *Great Tang Dynasty Record of the Western Regions* (大唐西域記). Therefore, we can see that the people of Silla attempted to realize the Mahabodhi image, in other words the position of the instant when after long practice Shakyamuni finally achieved perfect enlightenment, on Mt. Tohamsan in Gyeongju.[27] From its relationship with the various images sculpted on the walls inside the main chamber at Seokguram, we may infer that the main image is the Tathagata Shakyamuni; decisively, if we compare this image with Xuanzang's record in the *Great Tang Dynasty Record of the Western Regions*, then we find the main image at Mahabodhi is an image making the earth touching mudra and illustrating the Buddha's

attainment of the Way.

The instant of perfect enlightenment is the grandest victory for a person. It is one of the most deeply moving and impressive instants in human history. This is in fact also the instant of transition between the Hinayana and Mahayana, and it is the instant from which Buddhism was established as a religion in the conviction that all of humanity could be saved. It is as if at that instant, through Shakyamuni's perfect enlightenment, all sentient beings also reached enlightenment. By depicting in an extremely flawless and magnificent way the moment of this grand victory, which transcended evil, Seokguram remains as a grand work of art.

Therefore, all things Buddhist converge in the instant of perfect enlightenment, and in sculpture and architecture that expresses that instant, all things converge and all grand things have a comprehensive aspect. Because of this, art historians have followed their individual inclinations and seized upon just one aspect of the diversity of Seokguram. Therefore, for those who look through the lens of the *Amitabha Sutra*, the main image is the Buddha Amitabha; for those who look through the lens of the *Lotus Sutra*, the chamber represents the assembly on Vulture Peak; and for those who look through the lens of the *Avatamsaka Sutra*, the main image is the Buddha Vairocana. Because all things begin and are transformed at the moment of perfect enlightenment, none of those interpretations is incorrect. But because they are only one aspect of the whole, they cannot be called correct either. Any of these interpretations is possible because the remains at Seokguram have a comprehensive character that expressed what is most primordial and fundamental, and this is what makes Seokguram great. Therefore, there is no way to express everything about Seokguram through any single sectarian lineage or scripture. Even when I interpreted the architecture and sculpture of Seokguram using the theory of dependent origination, I never depended exclusively on any single sutra, such as the *Avatamsaka Sutra*.[28]

Above we have analyzed in detail the style of the Buddhist images at Seokguram. To conclude, I would like to touch on the issue of their coloring. The Buddhist images in such places as the Mogao caves, the Yungang rock caves, and the Longmen rock caves are colored and enliven the atmosphere for those places.

However, with the exception of their lips, the Buddhist images at Seokguram were not colored at all. It is as if rather than depending on pictorial elements, there has been a consistent emphasis on the pure sculpture itself. On the lips of the images, there is merely a red pigment, whose constituents have not been analyzed, which gives the milky white rock a sense of life and movement.

On the lips of the main image of the Tathagata Shakyamuni, the red pigment is faint, which gives the milky-white granite body a mysterious sense of realism. The red pigment remains on the lips of the two standing images of bodhisattvas on the walls surrounding the chamber, and the lips of the Brahma are red as well. Originally, there must have been red pigment on the lips of all of the Ten Great Disciples, but now it remains only on the

lips of the first and fifth images facing the right, and the second and third images facing the left. The pigment is also vivid on the image of the Eleven-Faced Avalokiteshvara. Apart from this, it is now unclear whether the images of the devas or the bodhisattvas in the niches were also painted, but their lips likely were.

In sum, the sense of liveliness endowed upon the whole atmosphere at Seokguram by coloring only the lips of the Buddhist images elevated the artistic value of Seokguram to a new plane.

I would like to draw attention to a few points concerning the size of the images in relief at Seokguram.

When we measure the size of sculptures in Korea—for instance, in the case of an image of a bodhisattva—we speak of the image's height including the crown it wears. However, as I have disclosed in this piece, in the East the height is measured up to the forehead of the image. Were the area with the hair and the jeweled crown above that to be included, then on account of the varying heights of the jeweled crowns we could not consider that as the absolute standard.

In case of the sculpted images at Seokguram, the details are not consistent and it is difficult to estimate the actual height of the images. However, when treating problems of proportion, I have as much as possible considered the height until the forehead as the height of the image, since the actual height of the image is important, and have clearly indicated the height of the hair and jeweled crown separately. Apart from that, I have placed the parts that have no relationship to the hair and the jeweled crown in parentheses for reference. And in the case of the feet, I have taken the heel as the standard for measurement, and therefore excluded the part extending to the ends of the toes from the height of the image. As the total height of the image, including both its pedestal and its jeweled crown is meaningless in problems of proportion, I have not treated it in the chart of measurements. (Table 2)

8. The Origins and Development of the Composition of Buddhist Sculpture

As the Buddhist images at Seokguram appear to be a condensation of the images in all Buddhist structures, if we are to consider the case of their being worshipped individually in wooden structures, then although it is inadequate we may adduce the Hwangnyongsa Temple. The contemporary Hwangnyongsa, by showing the shape of the temple at the time of its reconstruction in 584, preserves in good order the pedestals for the Buddhist images at the Central Gate and Golden Hall. Large rectangular pedestals, which suggest images of the Vajrapani, are on both sides of the Central Gate site. At the site of the Golden Hall, there is an enormous pedestal made of natural rock where once stood the six-foot Shakyamuni triad, and to its side are five rectangular shaped pedestals apiece.

These ten pedestals are thought to have been where the images of the Ten Great Disciples once stood. Further, there is a possibility that the images of Brahma and Indra were enshrined on the two other stones to the left and right. At Hwangnyongsa there are no pedestals where the Eight Classes of Dharma Protectors and the Eleven-Faced Avalokiteshvara would have stood, but at that time the iconography for these images had not yet been fixed, so this is not an issue. In this way, although it is insufficient, if we make an overview of how the Buddhist images were distributed within the arrangement of temple buildings, then we may gain insight into the mutual relationship between these images and those at Seokguram.

One set of Buddhist images with iconographies extremely similar to those at Seokguram may, interestingly, be found in the Western Golden Hall of Kofukuji Temple in Nara, Japan. While only some of the images remain today, according to records in the Western Golden Hall of Kofukuji most of the Buddhist images in the Seokguram iconography were worshipped individually.

The Western Golden Hall of Kofukuji, built to the west of the Central Golden Hall, was built in Tempyo 5 (733) on the first anniversary of the death of the mother of Empress Komyo, the Lady Tachibana Michio; in it were enshrined the main image, a six-foot image of the Buddha Shakyamuni; two attendant bodhisattvas on its side; ten images of arhats; Brahma; Indra; the Four Heavenly Kings; the Eight Classes of Dharma Protectors; and two images with lion heads.[29] Relying on the *Notebook of Manufacturing Buddhist Implements*, Fukuyama Toshio has made detailed considerations of the objects remaining at Kofukuji, and has stated that what burned to the ground in 1046 (the Buddhist images were saved) was rebuilt in 1978, when all the Buddhist images were recovered with gold leaf and repainted.[30] He says that apart from the images mentioned above, one image of the Eleven-Faced Avalokiteshvara and an image of a Vajrapani, among others, were painted in gold. He says that although it is impossible to tell just how the images of the two bodhisattvas, ten arhats, Brahma, Indra, Four Heavenly Kings, Vajrapani and Eight Classes of Dharma Protectors were arranged around the six-foot image of the Buddha Shakyamuni, the Ten Great Disciples surrounded it in a circle.[31]

While there are varying opinions concerning the date of manufacture and identities of the images in the Western Golden Hall, it is fascinating that all the iconographies that appear at Seokguram are touched upon there, and that the arrangement of the Ten Great Disciples in each place is identical. The images of the Ten Great Disciples and the Eight Classes of Dharma Protectors that are now on display in the National Treasures Hall at Kofukuji were made in 733 and repainted in 1078. With reference to the religious background of this Western Golden Hall, there are also various theories, but these remain today as unsolved problems. Because there are no images making the earth touching mudra in Japan, the main image of the Western Golden Hall naturally could not have been an image with this mudra. Therefore, it is still more impossible to adduce the religious background of Seokguram for that of the Western Golden Hall or to compare the

Name of image	Height of figure	Height of crown	Remarks
Main Buddha, Seated Shakyamuni (釋迦如來坐像)	345		Pedestal height 164 cm
Vajrapani (金剛力士像), right	197	17	
Vajrapani (金剛力士像), left	202	14	
Four Heavenly Kings			
Dhartarastra (Jigukcheon, 持國天), first right	180	15	Excluding evil spirits underfoot
Vaisravana (Damuncheon, 多聞天), second right	177	9	
Virudhaka (Jeungjangcheon, 增長天), first left	187	10	
Virupaksa (Gwangmokcheon, 廣目天), second left	177	8	
Indra (Jeseokcheon, 帝釋天)	188	17	
Brahma (Beomcheon, 梵天)	189	18	
Manjushri (Munsu bosal, 文殊菩薩)	185–186	15	
Samantabhadra (Bohyeon bosal, 普賢菩薩)	183	12	
Ten Great Disciples (十大弟子)			
First right	198		There is no clear line indication
Second right	203		of where the forehead end the
Third right	205		height of the figure indicates the
Fourth right	208		height to the top of the head.
Fifth right	212		
First left	202		
Second left	208		
Third left	204		
Fourth left	212		
Fifth left	210		
Eleven-Faced Avalokiteshvara (Sipilmyeon gwaneum bosal, 十一面觀音菩薩)	181	31	
Niches			
First right	86		The image in the niches are seat-
Second right	76		ed figures. They are not sitting
Third right	81		upright so the height of the figure
Fourth right (Manjushri)	81		includes the height of the crown
First left	84		as well.
Second left	86		The order indicated is starting
Third left	89		from the entrance.
Fourth left (Vimalakirti, 維摩居士)	81		
Eight Classes of Dharma Protectors			
Deva (Cheonsang, 天象), first right	188	10	Height of dragon crown 40cm
Dragon (Yongsang, 龍象), first left	190	16	Excluding flame pattern
Yaksa (Yacha, 夜叉), second right	189	15	
Gandharva (Geondalpa, 乾闥婆), second left	195	13	
Mahoraga (Mahuraga, 摩睺羅伽), third right	192	15	
Kinnara (Ginara, 緊那羅), third left	191	16	
Garuda (Garura, 迦樓羅), fourth right	178	20	Missing below the knees
Asura (Asura, 阿修羅), fourth left	(163)	-	

∗ Unit is cm.

Table 2. Size of Buddhist Images in Seokguram Cave Temple.

two. In any event, putting aside the issue of the religious background, we can simply indicate the mutual similarity in the structure of the Buddhist images.

In order to depict the Tathagata Shakyamuni surrounded by all the images in this way, it would be even easier to employ a pictorial technique. What comes to mind here are none other than the paintings of the assembly on Vulture Peak, which were popular during the Joseon Dynasty.[32] Paintings of this genre which were produced during the Joseon Dynasty invariably have a seated image making the earth touching mudra surrounded by two bodhisattvas, the Four Heavenly Kings, the disciples, and the Eight Classes of Dharma Protectors. However, Brahma and Indra are absent. In spite of this, images of the assembly on Vulture Peak strongly depict the pictorial depiction of the assembly at Seokguram. Further, in the hangings behind Buddhist images which depict the Buddha Vairocana, only the main Buddha image differs from this assembly's structure, meaning that all pictorial representations of the Buddhist assembly have a sculptural arrangement and a structure similar to that of Seokguram. However, we cannot declare definitively that the iconography of Seokguram was based on the *Lotus Sutra*.

9. Conclusion

Through now we have considered the iconography of the thirty-eight Buddhist images at Seokguram, focusing on the mudras, attributes, and postures and the identity of the images. However, we still cannot determine the identities of the two standing bodhisattva images, which do not bear comparison with the iconography of the mid-eighth century Unified Silla period, or several of the seated bodhisattva images in the niches; and the date of the establishment of the Eight Classes of Dharma Protectors is also unclear. I will treat some of these points in the essay on iconographic interpretation.

As a consideration of the iconography of Seokguram is fundamental for an inquiry into the contemporary cultic modes encompassed there, it is extremely important. As the Buddhist images in Seokguram are carved in relief across the entirety of the inner walls of the cave, I have made a comparative inquiry with the iconography of several Chinese cave temples, but there is also a need to keep in mind the contemporary arrangement of Buddhist images carved in the round and worshipped independently in wooden structures. This is why I have attempted a comparison with the pedestals for images extant at the site of Hwangnyongsa and the Western Golden Hall at Kofukuji in Japan. In the end, the iconography of Seokguram is a systematic ordering, collection and condensation of the iconographic arrangement of the many complex Chinese cave temples, which means that Seokguram is positioned at the end point of the development of cave temples in East Asia.

However, as the arrangement of the many Buddhist images at Seokguram is a unique example which does not bear comparison with anything in China or Korea, in the end we

can do no other than to search for its cultic modes within Seokguram itself.

What I would like to re-emphasize is the importance of the main image. The main image, which sits upright in the center of the main chamber, is the core of Seokguram. In fact, it was for this image that the structure was designed, and the many images of the bodhisattvas, devas, arhats, etc. were sculpted in relief on the walls that make up this structure. This is why the only sculpture treated in the round is the main image. Therefore, the identification of the main image is the key that can unlock the cultic mode displayed in Seokguram. And to re-emphasize, it is less important to try to fit the iconography of Seokguram into the framework of any particular sect than to make inquiries from the functional relationships realized among the images within Seokguram itself. The frequent efforts to inquire into the cultic character of Seokguram through didactic tales or records such as *Memorabilia of the Three Kingdoms* (*Samguk Yusa*, 三國遺事), or the individual achievements of Kim Dae-seong, who was primarily in charge of the construction of the temple, cannot in the end be of any help. What is more important than this kind of unconfirmed evidence is Seokguram itself. Therefore, before an iconographic interpretation that inquires into the cultic character of Seokguram or its symbolism, the most fundamental and basic work is to describe the individual icons and to identify the relationships in arrangement among the icons and the main image, which show that at Seokguram the architecture and sculpture are in an inextricably close relationship. By calling attention to the architecture of Seokguram and pursuing the strict principle of proportion that inheres within the structure, I have clarified that the structure is a concrete rendering of the Buddhist view of the universe at the time, and shown that the Avatamsaka philosophy of dependent origination is homogenous with the principle of proportion that was applied to the architecture.[33] Also, through an exploratory essay, I have offered ideas about how the Indian systems of proportion were applied to the proportions of the main image, taking the main image as the basis for this comparison.[34] All of these efforts were undertaken with the proportions of the architecture at Seokguram and the proportions of the main sculpture as the starting points. Thus, my basic position and methodological stress have been placed in the idea that the iconographic interpretation of Seokguram must start from an accurate description and identification of the icons within Seokguram.

* This essay was translated some years ago by Mikah Auerback,
 a Ph. D. candidate at the department of religion, Princeton University.

Iconology of the Buddhist Sculptures of Seokguram

The heart of Seokguram cave temple is the main Buddha image, the seated Shakyamuni displaying the mudra of defeating the demons and touching the earth (*bhumisparsha mudra*). This statue, one of the most beautiful and sublime in East Asian Buddhist sculpture, what religious symbolism does it hold? Since this sculpture in the round was produced, the image of seated Shakyamuni displaying the bhumisparsha mudra has been the major object of worship to the present day in Korea, and for this reason should be studied in detail. To find the origin of this iconography I studied *Banggwang-daejangeom-gyeong (Lalita Vistara)*, and based on my findings and my own interpretations of the thoughts of Mircea Elidae, I have attempted an iconographic interpretation of this statue.

1. Introduction

In examining the iconography of the Buddhist sculptures of Seokguram (石窟庵), I have previously interpreted the symbolism of the monument on the premise that the sculptures are arranged to make the spatial structure represent the Buddhist Triloka (the three realms): Kamadhatu (the realm of sensuous desire), Rupaadhatu (the realm of form), and Arupadhatu (the realm of formlessness). I have also considered the arrangement of the Seokguram sculptures to be a gathering in one place of all the sculptures that would ordinarily be distributed throughout several buildings in most temples. The arrangement of sculptures in the main hall of Hwangnyongsa Temple (皇龍寺) is the most similar to that found in Seokguram.

However, I became increasingly convinced that the relief sculptures on the walls of the main chamber represent the assembly gathered to hear the teachings of Shakyamuni (釋迦如來). This is because every Buddhist sutra begins with a list of the assembly gathered to hear the teachings of the Buddha. At the same time, the assembly represents worship of the Buddha by circumabulating the image of the Buddha three times counter clockwise. So it seems most plausible that the arrangement of Buddhist sculptures in Seokguram is a representation of the devas, the bodhisattvas, and the disciples gathered to hear the teachings of Buddha and offer worship. The symbolism of each of these relief sculptures is very important and there is certainly room for interpretation from various aspects. But for the purposes of this essay the relief sculptures on the walls of the main chamber of Seokguram will be treated as the assembly, and their symbolism will be inter-

preted from this point of view.

But as I have emphasized many times before, the heart of the Seokguram monument is the principal icon, the sculpture of the main Buddha in the center of the main chamber. Then what is the symbolic structure of this statue displaying the *bhumisparsha mudra* (K. *hangmachokji-in*, 降魔觸地印, gesture of defeating the demons and touching the earth) with the right hand and the *dhyana mudra* (K. *seonjeongin*, 禪定印, gesture of meditation) with the left? What meaning and what significance does this iconography have among the countless Buddhist sculptural iconographies? This essay will show why this iconography in particular has been so actively produced in Korea through the ages.

2. Interpretation of the Iconography of the Main Buddha

1. Basis in the Sutras

(1) The Starting Point — *Great Tang Dynasty Record of the Western Regions*

The heart of the Seokguram monument is the main Buddha, the seated statue of Shakyamuni, in the center of the main chamber. Having discovered that it is exactly the same, especially in size, as the main Buddha that was enshrined at Mahabodhi Temple in Bodh Gaya, which was mentioned in Xuanzang's *Great Tang Dynasty Record of the Western Regions* (大唐西域記), I set out to examine the relationship between the two statues. The main Buddha in Seokguram is essentially a Silla (新羅) recreation of the statue of Buddha at the moment of enlightenment that was made and enshrined at Mahabodhi Temple, which marks the sacred spot where Shakyamuni attained enlightenment under the Bodhi tree. So while countless statues with the bhumisparsha mudra were produced during Unified Silla (統一新羅, 668–935), the Seokguram statue is especially significant because it has the same dimensions, mudra, and orientation as the Mahabodhi Buddha. The importance of the relationship between the two statues cannot be overemphasized, because the fact that one is modeled on the other reveals the essence and symbolism of the whole Seokguram monument.

Realizing this, I strongly felt that the iconography of the main Buddha of Seokguram had to be reinterpreted in detail starting with this fact. Unfortunately, the Mahabodhi statue no longer exists. But as the main Buddha of Seokguram, which was a faithful Silla recreation based on written records, and the architecture that houses it remain perfectly intact, Seokguram can be said to occupy a very important place in the history of Asian Buddhist art. That is, the eastern slope of Mt. Tohamsan in Gyeongju, a little way from the peak, represents the very spot where Shakyamuni attained enlightenment, and by making this the people of Silla sought to create the ideal Buddha Land in Silla. This aspiration of the Silla people was earlier seen in the construction of Hwangnyongsa Temple.

In *Samguk Sagi* (三國史記, *History of the Three Kingdoms*), the chapter on the "Sixteen-Foot Buddha of Hwangnyongsa Temple" says that a gilt-bronze 16-foot Buddha statue was made exactly in the shape of the small Buddha triad statue sent by King Ashoka from India along with copper and gold, and that on the site of Hwangnyongsa Temple, the rock on which Shakyamuni and Kasyapa Buddha (K. Gaseopbul, 迦葉佛) sat and preached still remains. There are more details about the site of Hwangnyonsa Temple in the chapter on "Kasyapa's Rock," which says that the temple site, which dates back to the time of Kasyapa, the Buddha prior to Shakyamuni, still has the rock on which Kasyapa sat. Among the seven Buddhas of the past, Kasyapa is the sixth and Shakyamuni the seventh, so the people of Silla connected Hwangnyongsa back to the time of the Buddhas of the past. These facts give us a glimpse of the Silla people's tenacity of purpose in creating the Buddha Land in their kingdom. The culmination of their efforts is the construction of Seokguram, and for this reason, the clues to interpreting the iconography of the main Buddha of Seokguram can be found in *Great Tang Dynasty Record of the Western Regions*.

The passages from fascicle eight relevant to the Seokguram main Buddha are as follows.[1]

The Bodhi Tree

"Going southwest from Pragbodhi Mountain for fourteen or fifteen *li*, I reached the Bodhi Tree. The surrounding walls are built high and strong with bricks ... The main gate opens east toward the Nairanjana River ... while the northern gate leads to a big monastery."

That the main gate in the walls around the Bodhi tree opens to the east is related to the fact that the statue of Buddha in enlightenment in Mahabodhi Temple faced east.

The Diamond Seat

"At the center of the enclosure of the Bodhi Tree is the Diamond Seat ... As the one thousand Buddhas of the Bhadrakalpa all sit on it to enter the Diamond Samadhi, it is called the Diamond Seat, and because it is the place for realizing the Sacred Way, it is also called the Bodhimanda (the seat for realizing Buddhahood). After the Buddha's Nirvana, the monarchs of various countries set up two sitting statues of Avalokiteshvara facing the east at the southern and northern limits of the enclosure according to the Buddha's description as they had heard from the tradition ... and now the statue at the south corner has already sunk down up to the chest."

That this place is called Bodhimanda (the bodhi site, or the place where Shakyamuni attained Buddhahood) is very important in relation to the *Avatamsaka Sutra* (K. *Hwaeomgyeong*, 華嚴經). The *Avatamsaka Sutra* is the first sermon that Shakyamuni

preached after attaining enlightenment, and it is emphasized at the beginning of the sutra that he is preaching from the Bodhimanda. In addition, it is possible that the east-facing Avalokiteshvara Bodhisattvas mentioned here are related in some way to the Eleven-Faced Avalokiteshvara (十一面觀音菩薩) in Seokguram. Of all the figures carved in relief on the walls of the main chamber of Seokguram, the Eleven-Faced Avalokiteshvara is the most three-dimensional and the only one that is facing directly east.

The Shrine

"To the east of the Bodhi Tree is a shrine ... The innermost chamber of the shrine has three doors connected to other parts of the structure. On either side of the outer door, there is a niche containing an image of Avalokiteshvara Bodhisattva on the left side and that of Maitreya Bodhisattva on the right side, both cast in silver and more than ten feet in height. Formerly King Ashoka had built a small shrine at the site of the present shrine, and later a Brahman extended it ... When the shrine was completed, artists were invited to make an image of the Tathagata as he was at the time of attaining Buddhahood. But for a long time nobody answered the call for the job. At last a Brahman came and said to the monks, 'I am good at making fine images of the Tathagata.' The monks said, 'What do you need to make the image?' The Brahman said, 'I only need some scented clay and a lamp to be placed inside the shrine. When I have entered the shrine, the door should be tightly closed and opened after six months.' The monks did as they were told. But four days short of six months, they opened the door out of curiosity. They saw that the image inside the shrine was in the posture of sitting cross-legged and facing east, with the right foot upon the left thigh; the left hand was drawn back, and the right one pointed downward. It was just as if it were alive. The pedestal was four feet two inches high and twelve feet five inches wide, while the image was eleven feet five inches tall, the two knees eight feet eight inches apart, and the breadth from one shoulder to the other measured six feet two inches ... As they saw nobody in the shrine, they realized there was a divine hand at work, and all the monks were filled with amazement and eagerly wished to know about the affair. One of the Sramanas, a man of simple and honest mind, had a dream in which he saw the Brahman, who said to him, 'I am Maitreya Bodhisattava, and fearing that artists could not imagine the holy features of the Buddha, I came to make the image. It is made with the right hand pointing downward, because when the Tathagata was about to attain Buddhahood, Mara came to disturb him, and the earth gods informed him of Mara's arrival. One of the earth gods came out first to assist the Buddha in subjugating Mara, but the Tathagata said to the god, 'Do not worry. I can surely subjugate him with my power of forbearance.' Mara said, 'Who will bear you witness?' The Tathagata then pointed his hand to the earth while saying, 'This one here will bear me witness!' At that moment the second earth god emerged to bear witness. Therefore the image is made with the right hand pointing downward."

This part is very important. It is here that I found the key to my study of Seokguram, in the fact that the main Buddha in Seokguram has exactly the same dimensions, orientation, and mudra as the main Buddha at Mahabodhi Temple. In particular, the correspondence in size means that the Seokguram Buddha was modeled after the Mahabodhi Buddha.

At the beginning of the passage it says that there is a niche at the left and right of the door to the chamber, with an image of Avalokiteshvara Bodhisattva on the left and of Maitreya bodhisattva on the right. This is important, too, because it means that the attendant bodhisattvas to the image of Buddha in enlightenment displaying the bhumisparsha mudra are Avalokiteshvara (who stands for compassion) and Maitreya, the future Buddha, thus forming the iconographical archetype of the Buddha triad featuring the Buddha attaining enlightenment.

After attaining Buddhahood, Shakyamuni, out of compassion, sets out to enlighten all sentient beings. Compassion presents important momentum for the transformation of Buddhism from the Lesser Vehicle (小乘, Hinayana Buddhism) to the Greater Vehicle (大乘, Mahayana Buddhism). The Buddha's compassion is given form in Maitreya (彌勒菩薩) and Avalokiteshvara (觀音菩薩), thus giving rise to the Shakyamuni Buddha Triad form. If this is the case, then the standing bodhisattvas to the left and right of the entrance to the main chamber of Seokguram, which are very hard to identify but have the nature of attendants, can be conjectured to be Maitreya and Avalokiteshvara. Indeed, the iconography that makes most sense here is the Shakyamuni Buddha Triad with Maitreya and Avalokiteshvara as attendant bodhisattvas. However, iconography changes with people and place and thus is not constant. I have studied the problem of identifying these two bodhisattvas in Seokguram from various angles. And because they are difficult to identify, I have tended to treat the iconography as Shakyamuni with Manjushri (文殊菩薩) and Samantabhadra Bodhisattvas (普賢菩薩), which was a popular Buddha triad in the Goryeo Dynasty.[2]

The next issue is the material that the Mahabodhi Buddha was made of. According to the records, it was made of "scented clay," meaning it was a clay Buddha. It was thus quite fragile, which explains why it did not remain preserved to the present day. The statue existed at least until the early 7th century, when Xuanzang (玄奘) visited the place, but it is not known when it was first made.

In the above, I have examined the relationship between the Seokguram main Buddha and the main Buddha at Mahabodhi Temple at Bodh Gaya in India, according to the records of Xuanzang. The moment caught in the image, the attaining of enlightenment, is not only the most important incident in the life of Shakyamuni but also in Buddhism, and it is significant that this particular iconography was more prevalent in Korea than in all the other countries of East Asia. It is in this very point that the greatness of Korean Buddhist philosophy and faith can be found.

But the records of Xuanzang are insufficient to work out the true symbolism of

Seokguram and its sculptures, which were made as a monument to the moment of Shakyamuni's enlightenment and attaining of Buddhahood. So, what is the foundation for the records of Xuanzang?

(2) The *Lalita Vistara*

That the size, orientation, and mudra of the main Buddha at Seokguram are identical to those of the main Buddha in Mahabodhi Temple at Bodh Gaya is eloquent proof that the Seokguram main Buddha represents the moment that Shakyamuni attained enlightenment under the Bodhi tree. If this is so, on which sutra is the iconography of the Mahabodhi main Buddha based? I have studied Buddhist statues for a long time and, considering the life of Shakyamuni to be very important, made a comparative study of many sutras. I studied them closely once again in regard to the Seokguram main Buddha but found in the early sutras no evidence or basis for the iconography of the Mahabodhi main Buddha or the Seokguram Buddha—facing east and displaying the bhumisparsha mudra, calling the earth to witness his subjugation of Mara. Only in the sutras of Mahayana Buddhism, in fact only in the *Lalita Vistara* (K. *Banggwang-daejangeom-gyeong*, 方廣大莊嚴經) is there any detailed description of the enlightenment posture. The early sutras dealing with the life of the Buddha do not mention that Shakyamuni was sitting cross-legged and facing east when he attained enlightenment. Only the *Lalita Vistara* mentions these details. Although countless statues showing the bhumisparsha mudra have been made, the only statues that clearly represent Shakyamuni attaining enlightenment while sitting cross-legged and facing east are the principal images of Buddha at Mahabodhi Temple and at Seokguram. But since the Mahabodhi statue no longer exists, the Seokguram main Buddha is the only statue left in Asia that clearly shows Shakyamuni at the moment of enlightenment facing east and sitting cross-legged. Therefore, the *Lalita Vistara*, a Mahayana sutra, serving as the foundation for this iconography, is very important. Therefore, in the next section I will analyze the contents of the sutra and describe the iconography of the Seokguram main Buddha and its symbolic meaning.

Dealing with the life of Shakyamuni from birth to the attainment of Buddhahood, the *Lalita Vistara* is based on the Mahayana philosophy and written in the form of a teaching of the Buddha. According to my own research, the early sutras were very simple and realistic. In contrast, the Mahayana sutras were endowed with mystic elements so that the contents became superhuman and unrealistic. The introduction states that the sutra describes the transformation from bodhisattva to Buddha through meritorious deeds, supernatural powers, and enlightenment. Here supernatural power means the unhindered and "wonderful use" of power of the Buddhas and bodhisattvas that comes from meditation and wisdom. "Wonderful use" means the power to transform through clever and miraculous action. I believe that Shakyamuni's attainment of enlightenment under the

Bodhi tree and transformation from the highest Bodhisattva to the Buddha is a demonstration of supernatural power, as is the transformation of the impure mundane world into the Pure Land, or paradise. Hence, the Buddha's supernatural power is the power to understand and transform all things.

Banggwang-daejangeom-gyeong, the Korean name for the *Lalita Vistara*, is composed of twenty-seven chapters and is similar in many parts to *Boyogyeong* (普曜經), or the *Universal Shining Sutra*, which can be said to be the prototype of this sutra. *Boyogyeong* is a translation of the same Sanskrit sutra (*Lalita Vistara*) and was translated in the Western Jin Dynasty (西晋) by Dharmaraksa (竺法護, A.D. 309), a great translator of Mahayana Buddhist scriptures into Chinese, while *Banggwang-daejangeom-gyeong* is the version translated in the Tang Dynasty (唐) by Divakara (地婆訶羅) in A.D. 683. This means there was a long time gap of some 370 years between the two translations. Consequently, there are some basic differences though many parts are the same. *Boyogyeong* is a rather abstract translation while *Banggwang-daejangeom-gyeong* is a fairly literal translation, more faithful to the original. Moreover, in the 370 years separating the two, there were major developments in the Mahayana philosophy which is strongly reflected in the translation, especially the concept of Buddhakaya (threefold embodiment of Buddha).

The major work of Buddhist scripture dealing with the Buddha as a human being is said to be the *Buddhacarita-kavya Sutra* (佛所行讚), a poetic narrative of the life of Shakyamuni, while the *Lalita Vistara* is the major work on the Buddha as Nirmanakaya (an incarnation). The view of Buddhakaya is basically different in each, the *Buddhacarita-kavya Sutra* being oriented toward the principle of seeking enlightenment and the *Lalita Vistara* being oriented toward teaching the truth to sentient beings by showing the way, which is the nature of the Buddha incarnation. Ultimately, the *Lalita Vistara* was written according to the demands of the Mahayana view of Buddhakaya and for this reason significant in the study of the Buddhakaya concept.

In the Mahayana sutras, there is emphasis on the Tathagata as Dharmakaya, the embodiment of truth and law. The Dharmakaya originally has no material existence and therefore does not appear or disappear; it does not come and does not go; and as it has no body is ubiquitous and ever present. This Buddha, answering to the motive power of sentient beings, transforms into a human being and walks the path of a bodhisattva before attaining enlightenment and Buddhahood. At this point, the meaning of teaching truth to sentient beings is emphasized greatly. So, if the *Avatamsaka Sutra* and the *Lotus Sutra* are the scriptures establishing the concept of Dharamakaya, then the *Lalita Vistara* is the one establishing the concept of Nirmanakaya, the Buddha incarnation. That is, it establishes the Mahayana view of enlightenment, that the Bodhisattva as Nirmanakaya attains enlightenment by means of doing many meritorious deeds.

To summarize, the development of the Mahayana view of Buddhakaya began from the Dharmakaya philosophy, which developed into the Nirmanakaya philosophy of teaching

the truth to sentient beings. This led to the appearance of the Mahayana scriptures which are based on the Buddha incarnation, focusing on and reinterpreting the life of Shakyamuni as a real example.

The *Lalita Vistara* is partially related to other sutras such as the *Avatamsaka Sutra*, the *Prajnaparamita Sutra*, the *Vimalakirti-nirdesa Sutra*, and the *Nirvana Sutra*, and has an important place among the Mahayana sutras, and is known to have been written in northern India in the 2nd century, when Mahayana sutras were being actively produced. It had a great influence on Buddhist art as evidenced by the Buddhist sculptures in a wide-ranging area, including the sculptures and paintings of Ghandhara and Mathura in India, the paintings and sculptures in Borobudur in Indonesia, and the sculptures on the foundation stone of the octagonal stone pagoda at Qixiasi Temple (棲霞寺) in Nanking, China (Southern Tang Dynasty, A.D. 932−935). The next section delves into the connection between this sutra and the artwork of Seokguram; and since the main Buddhas of Seokguram and Mahabodhi were both based on this sutra, it must be said that the bhumisparsha mudra, which became prevalent both in India and Korea afterwards, is inseparable from this sutra.

(3) Seokguram Main Buddha and the *Lalita Vistara*

A close analysis of the *Lalita Vistara* reveals that the bhumisparsha mudra, the gesture of defeating the demons and touching the earth, was established on the basis of its contents. The records about the main Buddha at Mahabodhi Temple in the *Great Tang Dynasty Record of the Western Regions* are based on the *Lalita Vistara*, which naturally means this sutra is also the basis for the Seokguram main Buddha, which is modeled on the Mahabodhi Buddha.

If this is the case, and with the Seokguram main Buddha in mind, I will reference parts of the *Lalita Vistara* relevant to the iconography and its symbolism, adding my opinions along the way. There are four chapters that deal in detail with Shakyamuni's attainment of enlightenment, so I will examine only those four.

Chapter 19 "Going to the Seat of Enlightenment"
"Bodhisattva, having bathed in the river Nairanjana, and having restored his physical strength and vigor by eating, departed towards the spot under the lordly Bodhi (tree), in the spot on the earth with sixteen forms, with the victorious gait of a great man ... a gait that destroyed the forces of Mara ... 'He is the King of the Trisahasra, he is the supreme Lord, the Lord of Dharma, the Lord of the earth. There is none in the abodes of Sakra and Brahma, the moon and the sun, equal to him. He who makes the six *koti nayuta* earths tremble, is going to the Great Tree today, to vanquish Mara's forces ... Seeing this Lokadhatu thus adorned, Sakra, Brahma and the Lokapalas adorned a hundred thousand Buddhaksetras in all ten directions for the worship of Bodhisattva ... Also, all the

Bodhisattvas of the various Lokadhatus in the ten directions, who adorned the seat of enlightenment with illimitable virtue, knowledge and prosperity, were seen at this seat of enlightenment. Thus, O Bhiksus, the Devaputras, the guardians at the seat of enlightenment, created such wonderful pavilions at the seat of enlightenment, that seeing these, the gods, Nagas, Yaksas, Gandharvas and Asuras thought of their own houses as cremation grounds. Seeing these pavilions they engendered miracles. And they uttered this speech: 'O well done this wonderful creation, emanating from virtues.' "[3]

Putting an end to six years of hardships and trial and error, Shakyamuni resolved anew to attain enlightenment. But before doing so, he realized that he had to first expel the demons from Kamadhatu, the realm of desire. At this time, Brahma, Sakrodevandra, the Four Lokapalas (or heavenly kings), all the bodhisattvas, and the Eight Devas surrounded Shakyamuni and praised his piety. The relief sculptures of these same figures on the walls of the main chamber of Seokguram, and the bodhisattvas in the niches, can be considered a recreation of this scene.

"It (the seat of enlightenment) was hardened with the adamant of the world, and of the Trisahasra Mahasahasra Lokadhatu, unpierceable, adamantine and firmly established, where Bodhisattva seated himself, desirous of Sambodhi."[4]

It is especially important to note that the place where Shakyamuni attained *samyagbodhi*, the perfect universal wisdom of a Buddha, or perfect enlightenment, means the very center of the universe. This emphasizes and attests to the absolute state of samyagbodhi. The place where Shakyamuni attained enlightenment and became the Buddha becomes the center of the universe, and therefore the temple that enshrines that Buddha becomes the center of the universe.

It follows then that Mahabodhi Temple in India and Seokguram in Silla, which recreate the moment that Shakyamuni attained enlightenment and Buddhahood, or the first moment that the Buddha appeared, also become the center of the universe. The Silla people's philosophy and aspiration to create the Buddha Land in their kingdom was thus realized in Seokguram.

" ... the ray emanating from the Bodhisattva's body illuminated the abode of Kalika, the King of Nagas, (the ray that was) pure, clear, arousing joy and bliss, removing all pain, engendering happiness, delight, pleasure and enjoyment of all creatures ... 'Today you will destroy Mara's forces and acquire your desired state.' ... As this beautiful golden ray passes over a hundred fields, as (all) evils are alleged and all beings are saved from sorrow, as there is rain in the abodes of the moon and the sun, the gentle breeze blows the Sarthavaha will today become the Liberator from birth and old age in the three worlds."[5]

Shakyamuni Bodhisattva attains enlightenment and becomes the Buddha after subjugating and expelling demons. For the first time, a bodhisattva becomes the Buddha. Then the Buddha shines his light on the whole world and takes away the pains and carnal desires of all sentient beings. As the truth appears, the darkness of sentient beings disappears. Hence, Buddha becomes the sun of the truth. That is, soon after attaining enlightenment, Buddha becomes Vairocana (毘盧舍那佛), the light that shines everywhere. The Buddha's enlightenment is compared with the light of truth, and this determines the orientation of the Seokguram main Buddha, which faces east, in the direction of the sunrise.

" ... it occurred to Bodhisattva: 'Sitting where had the previous Tathagatas attained Supreme Proper Sambodhi?' Then it occurred to him: 'Sitting on grass mats.' Bodhisattva saw on the right of the path, a grass-mower (named) Svastika, cutting grass that was blue, tender, soft, beautiful, curling to the right, the color of a peacock's neck ... Bodhisattva addressed the grass mower Svastika in these gathas: 'Give me grass at once, O Svastika, today I have great need of grass. Destroying Namuci along with his forces, I will touch supreme tranquil Bodhi. That for which I have practised for a thousand kalpas charity, control, restraint, renunciation, (good) conduct and austerities, that I will accomplish today' ... facing east, his body straight, his mind firm of purpose, depending on memory. He made this resolve: 'Let my body wither on this seat, let my skin, bones and flesh decay; without attaining Bodhi difficult to in many kalpas, (my) body will not budge from this seat.' "[6]

Finally, the Bodhisattva sits on a seat of kusa grass facing east and builds a big temple to attain enlightenment. Here the grass stands for samyagbodhi, perfect enlightenment, and the swastika (卍) is a lucky symbol that is ultimately a symbol of perfect enlightenment. It is very important that the Bodhisattva sat facing east. He attained enlightenment as he sat toward the direction of the sunrise and became the light of truth itself, which means two suns came face to face with each other. The sun that rises in the east shines its light on the whole world and drives away the darkness, while the Buddha facing the sun becomes Vairocana, who takes away the desires and suffering of sentient beings with the light of truth.

Chapter 20 "Marvels of the Seat of Enlightenment"
In this chapter on Bodhimanda, the bodhi site, Shakyamuni Bodhisattva sits on the bodhi site and shines the light on the world in all directions, and the bodhisattvas residing there all come down to the bodhi site and offer tribute to him.

Chapter 21 "Defeat of Mara"
" ... this occurred to Bodhisattva, seated on the seat of enlightenment: in this Khamadhatu, the wicked Mara is the lord and master. It will not be possible for me to

attain Supreme Proper Sambodhi, unknown to him. Then I will exhort the wicked Mara. When he is defeated, all the Kamavacara gods etc. will be vanquished ... the wicked Mara, not heeding the words of Sarthavaha, engaged a great fourfold army, powerful, eager for battle, terrible, thrilling, never seen or heard of before ... rushed towards Bodhisattva, vomiting poison, spewing iron balls, emitting comets, showering blazing copper and iron, throwing lightning, releasing thunder, raining hot sand, creating dark clouds, giving rise to rain, casting showers of arrows from clouds, showing a dark night, raising a clamor ... 'All the mountains may tremble, the great ocean dry up , the moon and the sun may fall down on earth, and the earth dissolve, but the Being who has begun his attempt for the good of the world, his resolve firm, will not rise from the great tree without attaining supreme Bodhi.' "[7]

Mara (魔王, the king of evil) sent down three daughters who tried to seduce Shakyamuni with beautiful words and thirty-two beautiful postures, but the Bodhisattva enlightened them all with praises for the virtuous deeds of the Buddha. And in the darkest dead of night, he repelled with his mercy all the soldiers of the devil who had gathered, this in contrast to his attainment of enlightenment by the light of dawn.

"The Bodhisattva said to the wicked Mara: 'You, O Wicked One have attained the state of the Lord of desires by a single Nigada sacrifice. I have performed many koti niyuta hundred thousand Nigada sacrifices. I have cut off my hands, feet, eyes and head, and offered them to suitors, desiring salvation for centuries.' Then the wicked Mara replied to the Bodhisattva: 'You are a witness that I have performed the faultless Nigada sacrifice previously. But you have no witness. You are defeated by your own nonsensical speech.' Bodhisattva said: 'Wicked One, the earth is my witness ... This earth is the home of all the creatures, impartial, equal to the moving and the inanimate; she is my witness; there is no untruth in me, let her bear witness to me.' Then on that Trisahasra Mahasahasra Lokadhatu, there was a goddess of the Great Earth named Sthavara, who made the entire Great Earth, surrounded by the koti hundred earth-gods tremble, and piercing the earth near Bodhisattva, (she) arose with half her body showing, adorned with all ornaments, bowed to the Bodhisattva with folded hands, and said to Bodhisattva: 'That is so, Great Man, what you have said is so. We are witnesses ... ' Hearing the voice of the Earth, that sly one, terrified, his heart broken, fled along with this army ... Sweating, his spirit dead, his face pale, Mara, saw himself overcome by old age. Beating his breast, he went in fear and helplessness, Namuci's deluded heart and mind swooned."[8]

Of all the Buddhist scriptures dealing with the scene of Shakyamuni forcing Mara to surrender, the *Lalita Vistara* is the most detailed. The seated Buddha displaying the bhumisparsha mudra is a recreation of the scene where Shakyamuni points to the earth with his right hand to call up the earth god to witness his attainment of Buddhahood through

meritorious deeds. It is the moment when the Bodhisattva finally becomes the Buddha. The Buddha statues at Mahabodhi and at Seokguram represent this very moment, the moment of becoming Buddha.

To portray that moment dramatically on the main Buddha in Seokguram, great care was taken in sculpting the right hand in the bhumisparsha mudra. The second finger is brought forward a little and, seemingly alive and moving, points to the ground. Such subtle movement in the bhumisparsha mudra cannot be found in any statues of India, China, or Korea, except in this piece. The genius who sculpted the main Buddha in Seokguram put all his skill and devotion into dramatically bringing to life the great moment when Shakyamuni subjugated Mara and attained enlightenment.

The place where he attained enlightenment was called "the navel of the diamond," and an interpretation of this symbolism will be in the next section.

Chapter 22 "Perfect Enlightenment"

" ... Bodhisattva, having destroyed Mara's opposition, crushed the thorn, won a victory in the height of battle, standard and banner raised, sojourned detached from sins and evil religions, attaining the first meditation ... the second meditation ... the third meditation ... the fourth meditation ... Thus he saw with purified, divine, superhuman vision the creatures falling (from one birth), being reborn, of good and bad class, in good and bad condition, inferior and superior, following their works. Thus, O Bhiksus, Bodhisattva realized knowledge, destroyed darkness and produced light in the first yana of the night ... This occurred to him: 'Alas, this world is indeed miserable, that which is born, grows old, dies, falls and is reborn. It does not know the way out from this terrible and unalloyed mass of pain, old age, disease and death.' Then this occurred to the Bodhisattva: 'Due to the existence of what do old age and death occur? What is the cause of old age and death?' This occurred to him: 'Old age and death occur if there is birth, birth is the cause of old age and death. ...' 'Due to the existence of what does birth occur? What is the cause of birth? ... Birth occurs if there is existence ... Existence is the cause of birth ... What is the cause of existence? ... Existence occurs if there is attachment, attachment is the cause of existence ... What is the cause of attachment? ... Attachment occurs due to the existence of desire, desire is the cause of attachment ... What is the cause of desire? ... Desire occurs due to the existence of sensation, sensation is the cause of desire ... What is the cause of sensation? ... Sensation occurs due to the existence of touch, touch is the cause of sensation ... What is the cause of touch? ... Touch occurs due to the existence of the six senses, the six senses are the cause of touch ... What is the cause of the six senses? ... The six senses occur due to the existence of the name and the form, the name and the form are the causes of the six senses ... What is the cause of name and form? The name and form occur due to the existence of knowledge, knowledge is the cause of name and form ... What is the cause of knowledge? Knowledge occurs due to the existence of condition, condition is the cause of knowledge ... What is the cause of conditions? Conditions occur

due to the existence of ignorance, ignorance is the cause of conditions.

'Due to the non-existence of what do old age and death not occur, the prevention of what leads to the prevention of old age and death?' This occurred to him: 'If there is no birth, there is no old age or death, the prevention of birth leads to the prevention of old age and death. ...' 'If there is no ignorance, there are no conditions, the prevention of ignorance leads to the prevention of conditions. The prevention of conditions leads to the prevention of knowledge, the prevention of knowledge leads to the prevention of name and form, the prevention of name and form leads to the prevention of the six senses, the prevention of the six senses leads to the prevention of sensation, the prevention of sensation leads to the prevention of touch, the prevention of touch leads to the prevention of desire, the prevention of desire leads to the prevention of attachment, the prevention of attachment leads to the prevention of existence, the prevention of existence leads to the prevention of birth, and the prevention of birth leads to the prevention of old age, death, sorrow, lamentation, pain, dejection and perturbation. In this way, the great unalloyed mass of pain is prevented.' "[9]

This passage is about how Shakyamuni, after driving away Mara, fell into meditation and realized the twelve nidanas (十二因緣) of sentient beings, which are the twelve links in the chain of existence. That is, he realized the principle of dependent origination (the interrelatedness and interdependency of all things in the universe), and after examining the twelve links in reverse order, he presented the eight correct ways (八正道) to Nirvana and the four noble truths (四聖諦). Ultimately, getting rid of the darkness (or ignorance) is the road to salvation and the way to solve the problems of life. Therefore, the four noble truths that are the four axioms—pain, accumulation, the extinguishing of pain and reincarnation, and the way to such extinction—are the core of Buddhist philosophy, and Shakyamuni teaches the eight correct ways, which are practical rules of conduct, for reaching Nirvana.

The four noble truths (four axioms) are a summary of the twelve links in the chain of existence, and their presentation in reverse order is a way to help sentient beings understand in a simple way the principle of dependent arising that Shakyamuni realized so deep in his heart. In other words, the doctrine of inner witness is changed into the doctrine of salvation of others. Looking at the real world, Shakyamuni realized that life is full of suffering and sought the cause of the suffering. He realized that the cause was desire, that human beings lead painful lives because of their desires. If the cause is removed then life is not about suffering but joy. But how can the cause of suffering be removed? This is where the eight correct ways are introduced. These are the things that sentient beings are required to do on their own. By following the eight correct ways, their suffering can be removed and they can be saved.

This is how Shakyamuni arrived at the four noble truths. Therefore, the symbol of Buddha in enlightenment with the bhumisparsha mudra is a condensation of the dramatic

and rapid process encompassing the subjugation of Mara, the attainment of enlighten-ment, and the preaching of scriptures. And it is here that we see the ultimate message of Buddha's teaching, that sentient beings are saved by practicing the eight correct ways for themselves.

"Thus, O Bhiksus, at the final *yama* of the night, at the moment of daybreak, at the moment of the morning drumbeat, Bodhisattva ... with this kind of noble knowledge, combining in a single mind and vision all that is to be known, understood, attained, seen and experienced, with intellect, attained the Supreme Proper Sambodhi and acquired the three sciences."[10]

Finally, the Bodhisattva becomes the Buddha at the moment that night turns into day.

So, to recreate this moment when Shakyamuni attained enlightenment, the main Buddha at Mahabodhi and Seokguram are made to face east. At Seokguram the sunrise is spectacular; when the sun rises over the horizon of the East Sea, the statue of Shakyamuni, as stately as Mt. Sumeru (須彌山), facing the sun is the very image of truth itself. The statue is the image of Shakyamuni realizing the principle of dependent origina-tion as the sun rises in the east, his transformation from the Bodhisattva to the Buddha. Only when we have fully understood this process of Shakyamuni's enlightenment can we grasp the reason for the existence of the main Buddha at Seokguram.

"Thus, O Bhiksus, when Tathagata attained Perfect Enlightenment, obscurity and dark-ness departed, desires were refined, the vision was altered, pains were upset, dents were removed, knots were untied, the banner of pride was thrown down, the banner of the Dharma was raised, the evil propensities laid open, the truth of the Dharma was known ... the disease of beings was known, the use of the immortal medicine on the rising beings was successful, the Lord of Physicians was arisen, the Liberator from all pains and the Establisher in the happiness of Nirvana was seated in the midst of the Tathagatas, on the royal throne of the great religion of the Tathagatas, the entire totality of salvation was bound, he entered the city of omniscience, where all the Buddhas were assembled, unconfused in the comprehension of the spread of Dharmadhatu ... All Buddhas uttered praise of Tathagata for Perfect Enlightenment."[11]

Now Siddhartha is no longer the Bodhisattva but the Buddha. Since the subjugation of Mara and the attainment of enlightenment are not two separate acts but one, the Buddha displaying the bhumisparsha mudra contains both acts. The Seokguram main Buddha is the image of Shakyamuni as a grand Buddha in the moment immediately after enlighten-ment. Having succeeded in attaining enlightenment himself, his task now is to lead sen-tient beings to enlightenment and salvation.

In the above the Seokguram main Buddha has been examined with the understanding that it was modeled after the main Buddha at Mahabodhi Temple in terms of iconography and size, and within the context of the *Lalita Vistara* as the sutra that shows the process of subjugating Mara and attaining enlightenment in the most concrete way. From this, the doctrinal meaning of the iconography is confirmed as well as the fact that the natural setting around Seokguram corresponds to the story found in the *Lalita Vistara*. As noted before, subjugating Mara and attaining enlightenment are not separate acts but one and therefore inseparable. So the correct name for the main Buddha in Seokguram should be Shakyamuni Overcoming Mara and Attaining Enlightenment. In terms of iconography, it is correct to call it Shakyamuni displaying the bhumisparsha mudra, but this name seems to place too much emphasis on the iconography alone, detracting from the importance of attaining enlightenment after subjugating Mara. So perhaps the most appropriate name is the statue of enlightenment with bhumisparsha mudra. Also, because Shakyamuni is the only one to attain enlightenment after first subjugating Mara, as described in the *Lalita Vistara* in detail, it is not necessary to specify that the Bodhisattva is Shakyamuni. But a clear distinction should be made when discussing Shakyamuni with other Buddhas such as Amitabha or Vairocana.

2. Interpretation of the Symbolism of the Main Buddha

It seems evident that the creation of the main Buddha in Seokguram was based on the *Lalita Vistara*, and the various interpretations attempted in this section are interpretations of that sutra accompanied by interpretations of the iconography of the main Buddha. Basically, interpretation of the iconography is an exploration of Buddhist doctrine and faith, which is why the interpretations presented in this essay may contribute to the history of Buddhist philosophy in Korea.

Shakyamuni goes to the Bodhimanda under the Bodhi tree on the bank of the Nairanjana River, and the question is why he chooses that particular spot to attain enlightenment and become the Buddha. It is said that that the site of enlightenment is the "center of the universe" and a "diamond seat." What does this mean? Why does Shakyamuni spread grass on the spot in order to attain enlightenment? It is said that all the Buddhas of the past attained enlightenment sitting on kusa grass, so what connection is there between enlightenment and the grass? And at every incident Shakyamuni says, "It was the same with the Buddhas of the past." What does this mean? Why did he choose to face east? And the moment he sat down, why did he call up Mara and do battle with the demons? Why was he sure that he would become the Buddha after accumulating virtuous deeds over an endless eon, and why did he call the earth god to witness him as he forced Mara to surrender? Would Shakyamuni have been the first to observe the twelve nidanas and their adversatives? All past Buddhas are said to have attained enlightenment on the same

spot, so Shakyamuni would not have been the first to recognize this truth. Then why is the process of enlightenment described with such emphasis on Shakyamuni only? What is the meaning of Shakyamuni's existence? And why does he attain enlightenment at dawn?

The countless incidents described in the *Lalita Vistara* are not actual historical incidents, so what symbolic meaning do these incidents accompanying Shakyamuni's process of enlightenment hold? This series of incidents seems to be related in some way with the archetypes of religious phenomena. In studying this area, the books of Mircea Eliade were very helpful, including *Cosmos and History* and *Patterns in Comparative Religion*, which deal with the interpretation of a wide range of symbols.[12] In the books of Eliade, I found answers to the endless questions that came to mind while examining the iconography of the Buddhist sculptures of Seokguram. With Eliade's insights as the basis, I will attempt an interpretation of the symbolism of the various incidents accompanying the process of Shakaymuni's enlightenment. These interpretations will be applicable to the *Lalita Vistara* and also to the iconography of the Seokguram main Buddha.

I have no hesitation in relying on the ideas of Eliade because, in contrast to other Western scholars of religion, he studies the religious phenomena of Asia, Africa and other parts of the world, which makes his theories more universal than those of anyone else.

(1) Sacred Places—Center of the Universe: Bodhi Tree, Diamond Seat, Grass

The conditions of a sacred place are a combination of trees and rocks. This has been a universal phenomenon around the world since primitive times. As seen in the *Lalita Vistara*, after bathing in the Nairanjana River, Shakyamuni headed for the Bodhi tree. The ground beneath that tree is a made of diamond. According to this description, Shakyamuni attained enlightenment in the center of the universe, a sacred place with trees and rocks.

"The Buddhist *caitya* was sometimes simply a tree, without any altar; but at other times it was the rudimentary construction erected beside the tree. Neither Buddhism nor Hinduism could weaken the significance of the ancient sacred places." [13]

"The 'sacred place' is a microcosm because it *reproduces* the natural landscape; because it is a reflection of the Whole. The altar and the temple (or funeral monument, or palace), which are later developments of the ancient 'sacred place' are also microcosms because they are *centers of the word*, because they stand at the very heart of the Universe and constitute an *imago mundi*. The idea of 'center,' of absolute reality—absolute because it is a repository of the sacred—is implied in even the most primitive concep-

tions of the 'sacred place,' and, as we have already seen, such conceptions always include a sacred tree. Stone stood supremely for reality: indestructibility and lastingness; the tree, with its periodic regeneration, manifested the power of the sacred in the order of life. And when water came to complete this landscape, it signified latencies, seeds, and purification. The 'microcosmic landscape' gradually became reduced in time to but one of its constituents, to the most important: the tree, or sacred pillar. The tree came to express the cosmos fully in itself, by embodying, apparently in static form, its 'force,' its life and its quality of periodic regeneration."[14]

So the tree in itself, by embodying the force of the cosmos, its life, and its periodic regeneration, expresses the cosmos. When Shakyamuni headed for the *asvattha* tree, he was walking toward a sacred place, or the center of the world.

"The Indians, for instance, venerate a certain tree called *asvattha*; the manifestation of the sacred in that particular plant species has meaning only for them, for only to them is the *asvattha* anything more than just a tree···But note that the *asvattha* is venerated because it symbolizes the sacred significance of the universe in constant renewal of life; it is venerated, in fact, because it embodies, is part of, or symbolizes the universe as represented by all the Cosmic Trees in all mythologies."[15]

The stone, because of its hardness, its indestructibility, and lasting nature, is regarded as an absolute entity, which is why people in ancient times considered it to be sacred. It is not the stone itself that is venerated but the holy being that it symbolizes. In Buddhism, it is believed that a stone becomes a diamond. The diamond becomes a symbol of wisdom and power that is so hard, so solid, and immovable that it can destroy delusion and demons but cannot be destroyed by anything. When Shakyamuni attains enlightenment the asvattha tree becomes the Bodhi tree.

Hence Shakyamuni enters the symbolic system of the center of the world, containing the tree and the stone that were the subject of ancient faiths, and when he attains enlightenment, the ultimate goal of high religion, the tree and the stone become the Bodhi tree and vajrasana (literally "diamond seat"), which is the seat of enlightenment. Behind that transformation is the archetype of ancient faith in the symbol of the eternal, represented by the constant renewal of life, hardness and immutability of the tree and the stone.

Hence, in the *Lalita Vistara* the sacred place containing the asvattha tree (Bodhi tree) and the stone (diamond seat), the center of the universe, is expressed in Buddhist terminology as the "center of the chiliocosm (Buddha-world)." The *Lalita Vistara* calls that sacred place "the navel of the diamond," the navel being the center of the universe. In ancient times the navel was considered the "navel of the earth," which also means the "center of the universe".

" ... man was fashioned at the navel of the earth ... Paradise, where Adam was formed from the slime, was, of course, at the center of the cosmos. Paradise was the 'navel of the earth' ... "[16]

The symbol of the navel, or omphalos, has great religious meaning in Hinduism as well. According to the classical Sanskrit epic poem *Mahabharata*, when heaven and earth opened, a lotus flower grew from the navel of Vishnu, and Brahma (梵天) was born from that lotus and created all things in existence.

Hence, Shakyamuni, by attaining enlightenment at the center of the universe, a symbolic system that has existed since ancient times, reinforces the symbolic system of high religion with the symbolic system of primitive religion, thus becoming an eternal being. Such phenomenon appears early on in the life of Shakyamuni.

"As soon as he was born, the Bodhisattva planted his feet firmly on the ground and, turning to the north, took seven strides, reached the pole and cried, 'It is I who am at the top of the world ... it is I who am the firstborn of the world.' "[17]

By reaching the top of the cosmos, Buddha became contemporaneous with the beginning of the world.

"Buddha (by the very fact of entering the 'center' from which the whole universe grew) magically abolished time and creation and placed himself in the timeless moment which was before the world was created."[18]

So, at the center of the beginning of time, sitting on the stone (the navel of the diamond) under the tree representing constant renewal of life and immutability, Shakyamuni is finally transformed from the Bodhisattva into the Buddha. The situation anticipates the birth of the Buddha. Shakyamuni attains enlightenment sitting on the grass that he has laid down because the grass is a symbol of life and renewal. The symbolism of the grass is in the same category as the symbolism of the tree. As Shakyamuni attains enlightenment, the grass becomes auspicious grass, which in turn becomes a symbol of enlightenment. And Shakyamuni chose such a site because it represented sacredness.

"What matters is that a hierophany implies a choice, a clear-cut separation of this thing which manifests the sacred from everything else around it ... The thing that becomes sacred is still separated in regard to itself, for it only becomes a hierophany at the moment of stopping to be a mere profane something, at the moment of acquiring a new 'dimension' of sacredness."[19]

(2) Mara

As soon as he sits at the center of the world, Shakyamuni sets out to solve the problem of Mara, the devil. What does the demon symbolize?

From the beginning of time, human beings have felt fear and horror of something which we will call the devil for now. At first it was something external, but as human intelligence developed, it came to be regarded as something internal. The ancient Korean bronze ritual implements are all geometrically shaped shamanic implements designed to fight external demons. They were divine implements created by human beings to resist that invisible and unnamable object of fear and terror. Copying the weapons that they had devised to fight enemy forces, they made geometric and symmetric shamanic implements to conquer the devil.

"God did not exist at the beginning of time, but shaking with fear and driven to the edge of despair, human beings created god for the first time. God is a phantom created by human beings to conquer the devil, which had such a hold on their souls, with its almighty strength and mysterious powers. It goes without saying that God had the power to conquer the devil. For many centuries, from ancient times to the present, the spiritual history of humankind has been the history of confrontation between the devil, which exists in the cosmos, and the God created by human beings; on the other hand, it could also be said that it has been the history of turning a virtual image into reality."[20]

To fight the devil, people first invented magic and then God and the accompanying rituals. In the development of religion, there has never been a time when magic and ritual were ignored or diminished. Though Shakyamuni rejected magic and ritual, as Buddhism developed into a religious system, magic and ritual ironically came to take on great importance. However, in Buddhism the devil is not an external thing but internal. This is indicated in Chapter 18 of the *Lalita Vistara* titled "The Nairanjana":

" ... The wicked Mara followed after Bodhisattva who had been practicing difficult tasks for six years, looking for a weak spot, searching for a weak spot. But he could find no weak spot anywhere. Not finding a weak spot, he roamed about, sadly and in doubt ... To Mara who spoke thus, Bodhisattva then said, 'Friend of the deluded! Wicked One! You have come with your own ends (in view).' ... 'Death, the despoiler of life, is better; fie on this vulgar non-life. It is better to die in battle, rather than live on defeated.'

'A man who is not valiant, does not win over an army, (but) he does not think of it when he wins. A valiant man wins over an army. Mara! I will defeat you easily.

'Your first army is desire; the second, disfavor; the third, hunger and thirst; the fourth army is craving; the fifth is sloth; the sixth is said to be fear; the seventh is doubt; the eighth is anger and covetousness.

'Greed and fame which are conditioned, that renown which is falsely won, he who praises himself and he who destroys the good, this is the army of Namuci Krsnabandhu, where Sramanas and Brahmanas are seen to be submerged.

'This army of yours that vanquishes this world along with the gods, I will smash with intellect, as a vessel of unbaked clay with water.

'I will attain proper knowledge by making memory well-established and intellect well-reasoned. What can you do, evil one?' "[21]

Therefore, in the chapter dealing with the subjugation of Mara, Shakyamuni calls the devil out and attains enlightenment after making him surrender. In general, in all religious phenomena there is a confrontation between the sacred and the mundane. Just before Shakyamuni attains enlightenment there is extreme confrontation between the sacred and the mundane, between the holy and the devil, or good and evil. The devil was not external but internal, the desires, anger, and folly in the hearts of human beings. The holy means wisdom and light, the devil means ignorance and darkness.

So Shakyamuni does not remain passive but actively invokes Mara. He brings out the devil that is the adversary in the ego's search for truth. This means the struggle with the devil is not without but within. When Mara finally surrenders, Shakyamuni calls the earth goddess to witness the fact. Therefore, conquering Mara and attaining enlightenment are not two things but one. Though it is generally established that the subjugation of Mara preceded the enlightenment, Shakyamuni was in fact able to overcome Mara because he had already attained enlightenment. Ignorance, made up of desire, anger, and folly, disappears with enlightenment.

(3) The Symbolism of Mother Earth

In Shakyamuni's battle with Mara the most dramatic scene is the appearance of Mother Earth. When Mara asks Shakyamuni who will witness his achievement, Shakyamuni points to the ground and the earth goddess appears.

The earth goddess is rarely depicted in sculpture. Some enlightenment images of Gandhara depict the god of the earth as a goddess, the upper half of the body rising aboveground as if offering tribute to the Buddha who has attained enlightenment. Why is the god of the earth depicted as a goddess and why is she called up at this most important moment?

" ... it is the earth that gives birth to all beings, feeds them and receives back from them the fertile seed."[22]

"One of the first theophanies of the earth as such, and particularly of the earth as soil, was its 'motherhood,' its inexhaustible power of fruitfulness. Before becoming a mother god-

dess, or divinity of fertility, the earth presented itself to men as a Mother, *Tellus Mater*."[23]

"A great many beliefs, myths and rituals have come down to us which deal with the earth, with its divinities, with the Great Mother. As the foundation, in a sense, of the universe, the earth is endowed with manifold religious significance. It was adored because of its permanence, because all things came from it and all things returned to it."[24]

"The earth, to the primitive religious consciousness, was something immediately experienced and accepted; its size, its solidity, its variety of landscape and of vegetation, formed a live and active cosmic unity. The first realization of the religious significance of the earth was 'indistinct'; in other words, it did not localize sacredness in the earth as such, but jumbled together as a whole all the hierophanies in nature as it lay around—earth, stones, trees, water, shadows, everything. The primary intuition of the earth as a religious 'form' might be formularized thus: The cosmos—repository of a wealth of sacred forces.' We saw the notion of seeds, latencies and rebirth in the various meanings—religious, magical or mythological—given to water, but the primal intuition of the Earth shows it as the *foundation* of every expression of existence. All that is on earth, is united with everything else, and all make up one great whole."[25]

"What is significant about these superstitions is the cosmic form the earth takes; it can be identified with the whole surrounding area, with the microcosm, not merely with the earth as such. 'The earth' here, means all that surrounds man, the whole 'place' ... "[26]

As seen in the passages above, the earth goddess has an all-embracing nature. And perhaps Shakyamuni called the earth goddess to witness his achievement because the earth goddess includes all the hierophanies in nature.

However, in the *Lalita Vistara* the earth as the beginning of all things is perceived as the "basis of equality."[27] The earth contains this meaning perhaps because it gives birth to and embraces all beings. In this sutra the shape of the god of the earth is subtle, the body decorated with pearls and beads, rising from the earth in front of the Bodhisattva to serve as witness. That is, the god of the earth appears as a goddess whose body is brilliantly adorned. Hence, the earth goddess whom Shakyamuni calls at the decisive moment is a very important symbolic element, one that is not commonly depicted in either paintings or sculpture. A statue in the collection of Sherrier in London is the only Demon Conquering and Earth Touching image where this divinity is portrayed, and she is portrayed as a woman. The god of the earth is a goddess, none other than Mother Earth (Figs. 145, 146).

The feminization of the appearance of bodhisattvas has always been a subject of great interest. In the Mathura region of India, Nagaraja (the dragon king), Maitreya, and Avalokiteshvara, were depicted as having female bodies (albeit with male genitals), modeled on the figure of Yakshi, the female spirit of fertility. In the Sarnath region during the

Gupta period, even Buddha was depicted in a feminine way. However, seeking an explanation for such feminine transformation in Yakshi is not completely satisfactory. As a tree spirit, Yakshi is the product of agricultural society. So while trees and water, which signify renewal, creation, and fertility, have usually been expressed as goddesses, the origin goes back to the mother of the earth who encompasses all these things. Eliade defines the Great Goddess as follows:

"The Great Goddess personifies the inexhaustible source of creation, the ultimate basis of all reality. She is simply the expression, in myth, of this primeval intuition that sacredness, life and immortality are situated in a 'center.'"[28]

Though Eliade did not actually call the mother of the earth the "Great Goddess," surely the archetype of all goddesses is the earth goddess, or the Great Goddess. Therefore, the earth goddess is not just a goddess but the mother goddess. Of course, Yakshi's presence beside the tree in ancient iconography and mythology corroborates the significance of the tree as a source of fertility and an inexhaustible source of creation. But the tree puts its roots down into the earth, so the earth is a stronger and more basic symbol of fertility and creation. As the earth is the most basic entity, no symbol can be more fundamental.

"One of the salient features in all agricultural societies is the solidarity they see between the fertility of the land and that of their women. For a very long time the Greeks and Romans identified the land with the womb, and agricultural labor with the act of generation. We find this same identification elsewhere, in a great many civilizations ... "[29]

Erich Neumann came up with the following equation on the symbolism of the feminine: woman = body = vessel = world.[30] Rather than in the Western world, where the patriarchal element was dominant, Neumann sought the original matriarchal structure in the East, in Guanyin (Avalokiteshvara, 觀音菩薩), the goddess of mercy. Guanyin is the bodhisattva who hears "the cry of the world" and sacrifices her Buddhahood to save the suffering sentient beings. She is the Great Mother representing love. Such feminization reaches its peak in the Bodhisattva Tara. Tara symbolizes the highest form of spiritual transformation through womanhood. In Tantric Buddhism, Tara rises to the peak of the Buddhist pantheon. She is Prajnaparamita (般若波羅蜜), who represents salvation through illumination, and because illumination and Buddhahood is the ultimate goal, Tara can be called the mother of all Buddhas. Tara guides sentient beings across the river of samsara to the far shore that is Nirvana.[31] So Tara is the wisdom of illumination. Wisdom is the Great Mother, and the Great Mother is the earth goddess.[32] Therefore, the archetype of all goddesses is the earth goddess and the Great Earth Mother.

While enlightenment is very spiritual, the womb that enables the truth of enlightenment to appear is wisdom and compassion, and the fact that the Great Earth Mother takes the

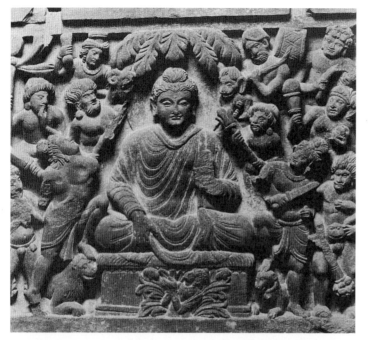

145–146. Stone relief of Shakyamuni displaying the bhumisparsha mudra (top) and detail (bottom). From Gandhara, India, 3rd c. H. 52 cm. Private collection, England.

form of Yakshi, the oldest and most important goddess of fertility and creation in India, shows that Buddhism was a complex amalgamation of the sacred and the mundane. The goddess has the nature of the mundane but, considering that this is a hierophany, or a manifestation of the sacred in the mundane world, high religion and primitive religion come together with no conflict. The Buddha triad form—with the Buddha depicted as a male and the bodhisattvas as females—can be seen as highly developed religious allegory. By having the goddess of fertility and creation, the basis of secular forms of faith, present in the process of enlightenment, the conceptual is transformed into the actual.

That Shakyamuni invoked the earth goddess just before attaining enlightenment is the most important key to understanding the process of feminization of the bodhisattvas.

"Avalokiteshvara (Kwan-yin) is depicted holding a kundika with a lotus in it. What the symbol of the lotus (or rhizome) emerging from water (or an emblem of water) expresses is the cosmic process itself. The water represents the unmanifest, seeds, hidden powers; the floral symbol represents manifestation, the creation of the universe."[33]

The figure of Avalokiteshvara directly behind the main Buddha in Seokguram appears as the spiritual transformation of the goddess which has its roots in the Great Earth Mother. And for this reason, Avalokiteshvara is one with the main Buddha in the center. When seen from the front, the main Buddha and Avalokiteshvara overlap completely. Also, Avalokiteshvara is in the center of the main chamber walls, which can be seen as deriving from what Neumann calls feminine symbolism.

In the development of the pantheon of high religions, no matter what complex doctrinal content they embody historically, the roots can be found in the most primitive sym-

bolism. Even so, the content of high religion is not distorted, nor is the symbolism weakened. Rather, by tracing the roots, the content of high religion becomes richer and more vital and enables understanding of the meaning of eternal existence. For this reason, all of Eliade's work should be credited for contributing to the search for the essence of high religion.

(4) Buddha's Transformation into the Sun: The Sun —Enlightenment Image—Vairocana

When Shakyamuni proceeded to the center of the world, resolved to attain enlightenment, he sat facing east, facing the sunrise.

"As Cakravartin, or universal sovereign, Buddha was very early identified with the sun. So much so that E. Senart wrote a startling book in which he attempted to reduce the life story of Shakyamuni to a series of solar allegories. He undoubtedly overstated his point but it is true none the less that the solar element dominates both the legend and the mystical apotheosis of Buddha."[34]

Lalta Prasad Pandy says in his book *Sun Worship in Ancient India* that the sun rises over the horizon to bring day and sinks below the horizon to bring night. The sun is the source of light and, by giving heat to the earth, the creator of life. And he says this is why all over the world the sun has been worshiped from early times. In India during the Gupta period in particular, sun worship was widespread and there are many architectural, sculptural, and literary records, as well as inscriptions on stone monuments, attesting to this.[35]

Perhaps because of this religious background, Shakayamuni sat facing east, toward the sunrise, when he resolved to attain enlightenment. The gem in the middle of Buddha's forehead is the symbol of the sun, and from this he sends out a ray of light that reveals all worlds. Upon attaining enlightenment Shakyamuni eliminates ignorance with the light of wisdom. As a Buddhist hierophany, the sun represents truth, and the Buddha who has become enlightened to the truth becomes the sun. This is where the concept of Vairocana (毘盧遮那) as a Buddha comes in. When the Bodhisattva attains Buddhahood at dawn and becomes the sun, the sun as a natural deity spreading light over the earth from the east and the light of truth (Buddha = the dharma) come face to face. Thus the two suns reflect each other. At the moment of enlightenment, Shakyamuni becomes truth itself and ceases to exist as an historical being. In discussing the iconography of Korean Buddhist images, I have mentioned that the enlightenment images and Vairocana images are not separate but one and the same. At the moment of enlightenment Shakyamuni becomes the Buddha and at the same time the formless Vairocana.[36] The formless Vairocana of the *Avatamsaka Sutra* is the brilliant light that shines everywhere.

The Seokguram main Buddha would have been the first enlightenment sculpture in the round to be produced in the Unified Silla period. The earliest enlightenment image is the Rock-Carved Shakyamuni Triad with bhumisparsha mudra at Chiburam, Mt. Namsan, Gyeongju, but as indicated by its name, it is a rock-carved image. It was astonishing to discover that the Seokguram Buddha was the first of its kind made in the round, which means that the countless Unified Silla sculptures in the round of Buddha in the enlightenment pose all date after Seokguram. In the construction of Seokguram, the main Buddha was made first and the architecture was then built around it. The building of Seokguram began in A.D. 751 and the sculpture would have been completed not long afterwards. At almost the same time, in 766, the oldest confirmed Vairocana in Buddha form (Fig. 19) was made at Seoknamsa Temple on Mt. Jirisan in Gyeongsangnam-do province. This means that the seated Buddha displaying the bhumisparsha mudra and the Vairocana in Buddha form, a creation of Unified Silla, both appeared at around the same time in the mid-8th century. Both iconographies became popular and continued to be produced through to the Joseon Dynasty, and the origin of this phenomenon can be traced to the construction of Seokguram.

Hence it is possible to attempt an interpretation of the iconography of the Buddha in enlightenment and the Vairocana in Buddha form through the symbolism of the sun. Upon attaining enlightenment, the Bodhisattava became the Budhha, and Seokguram shows that a very important metamorphosis follows—that Buddha becomes Vairocana. Herein lies the greatness of the artwork of Seokguram.

The light of the sun, which rises in the east and takes away the darkness, and the light of truth, which takes away ignorance (darkness), face each other and become one; they become Vairocana. That the sun, the image of enlightenment, and Vairocana merge into each other and become one can be deduced from studying the sculpture and architecture of Seokguram. And this shows that the development of Korean Buddhist art and philosophy from the mid-8th century were all rooted in the art of Seokguram and its philosophical symbolism.

(5) Mythicizing an Historical Figure: Shakyamuni's Transformation from Small Vehicle to Great Vehicle

When Shakyamuni heads for the Bodhimanda he searches for some clean grass. Because all Buddhas of the past attained enlightenment sitting on clean grass, he repeats the same actions. This means Shakyamuni is not the first to attain enlightenment. All through the sutras there is evidence that Shakyamuni, in all the important events of his life, is repeating the acts of the countless Buddhas who came before him.

Eliade says the meaning and value of human acts are not connected with their physical datum but with their property of reproducing a primordial act, of repeating a mythical example.[37]

"In the particulars of his conscious behavior, the 'primitive,' the archaic man, acknowledges no act which has not been previously posited and lived by someone else, some other being who was not a man. What he does has been done before. His life is the ceaseless repetition of gestures initiated by others. This conscious repetition of given paradigmatic gestures reveals an original ontology."[38]

" ... an object or an act becomes real only insofar as it imitates or repeats an archetype. Thus, reality is acquired solely through repetition or participation; everything which lacks an exemplary model is 'meaningless,' i.e. it lacks reality. Men would thus have a tendency to become archetypal and paradigmatic." [39]

" ... he sees himself as real, i.e., as 'truly himself,' only, and precisely, insofar as he ceases to be so."[40]

Eliade then mentions the greatness of Plato.

"Hence it could be said that this 'primitive' ontology has a Platonic structure; and in that case Plato could be regarded as the outstanding philosopher of 'primitive mentality,' that is, as the thinker who succeeded in giving philosophic currency and validity to the modes of life and behavior of archaic humanity."[41]

Following this, Eliade arrives at a very important symbolic principle.

"···the abolition of time through the imitation of archetypes and the repetition of paradigmatic gestures." [42]

In Buddhism there is the very unique concept of the seven Buddhas of the past who represent all the countless past Buddhas. Each attained enlightenment under a different kind of tree, while Maitreya, the future Buddha, attains enlightenment under puspanaga, the dragon flower tree. By repeating the original pattern of behavior, Shakyamuni returns to original space and time.

As an example, Eliade says that a sacrificial rite is the recreation of the first sacrificial rite dating back to when time began through the offices of God. So, the temporal dimension of a rite is always the primitive, mythological time. Eliade says that this applies not only to sacrificial rites but any rite, because, through imitation, human beings are projected back in time to the mythological age when the archetype appeared.In Buddhism, therefore, according to this principle, Dipamkara (K. Jeonggwangbul, 定光佛) appears. Dipamkara is "he who lights the lamp," the original predecessor of all Buddhas. Through his appearance, Shakyamuni is taken back to the beginning of time. Dipamkara predicts that Shakyamuni will attain Buddhahood, but the time between the prediction and the

realization is inestimably long.

" ... insofar as an act (or an object) acquires a certain reality through the repetition of certain paradigmatic gestures, and acquires it through that alone, there is an implicit abolition of profane time, of duration, of 'history'; and he who reproduces the exemplary gesture thus finds himself transported into the mythical epoch in which its revelation took place."[43]

This principle also appears in the temple, which symbolizes the center. By projecting the temple onto a space that is the same as the center of mythological space, profane space is eliminated. For example, there are passages in *Samguk Yusa* (三國遺事, *Memorabilia of the Three Kingdoms*) stating that the site of Hwangnyongsa Temple is where the past Buddha Kasyapa preached, thus transforming the site into a mythological one.

The mythicizing of an historical person occurs the moment the historical being, Shakyamuni, lays grass under the Bodhi tree like the Buddhas of the past and attains enlightenment. And the *Lalita Vistara*, which describes this process in detail, extinguishes Shakyamuni's nature as an historical person by adding such incidents as his heroic battle against Mara, thus recreating his life story within the norms of myth. This is in stark contrast to the very simple and human life story of Shakyamuni told in the early sutras, which make no mention of the battle with Mara.

The moment he attains enlightenment, Shakyamuni becomes the absolute being, Buddha, and his life story is the metamorphosis of an historical figure to a mythical hero.

"The historical personage is assimilated to his mythical model (hero, etc.), while the event is identified with the category of mythical actions (fight with a monster, enemy brothers, etc.)."[44]

The fact that incidents revert to a type and the individual to an original form, or archetype, is typical of the framework of ancient ontology. This process of going back to the beginning is condensed in the image of Shakyamuni's enlightenment. Koreans took the main Buddha at Mahabodhi Temple as their model and recreated it on Silla territory, confirming in a monumental way Shakyamuni's ontological metamorphosis. Ultimately Shakyamuni is assimilated into the beginning of the world, or original space and time, and his historical nature completely disappears. Thereby the Mahayana theory is established—that since the Bodhisattva Shakyamuni attained Buddhahood, all sentient beings can do the same. Mahayana Buddhism mythicizes the human being Shakyamuni as an historical figure. The appearance of infinite Buddhas and the appearance of infinite Buddha Lands are due to this basic religious phenomenon of repetition of the original pattern or archetype. The extraordinarily long periods of time and vast spaces spoken of

in Buddhism indicate the disappearance and transformation of profane space and time into mythological space and time.

Therefore, Seokguram, the space where Shakyamuni attained enlightenment (Mt. Tohamsan) and the time (mid-8th century) are transported to time and space at the beginning of the world. That is, eternal time and eternal space. After making the Seokguram main Buddha, the people of Silla, or rather Korea, took that image of enlightenment as an archetype and have endlessly repeated it into the present. This aspect of Korean behavior serves to abolish time, or render it meaningless. Koreans have since continuously made images of Shakyamuni in the enlightenment posture and have produced more of them than anyone else. By infinitely repeating the state of enlightenment that is the most important moment in Korean Buddhist philosophy and faith, the Silla people wanted to realize the original mythical Buddha Land in Korea. Herein lies the greatness of Korean Buddhism and Buddhist art, as shown by the archetype, the main Buddha of Seokguram.

The meaning of the infinite Buddhas, who are emphasized through their endless repetition, is as follows. Of all the Buddhas, the only one that really existed is Shakyamuni. All the others have become known through the teachings of Shakyamuni, which paradoxically means that anyone can become Buddha through his teachings. However, when Shakyamuni entered Nirvana, he stressed the importance of the dharma (the truth), saying, "Do not rely on me but on yourself and the dharma." Though he was pointing not to the Buddha but to the dharma, the two are not separate things. The truth to which Shakyamuni became enlightened existed before Shakyamuni, and whether or not Buddha exists in this world, the truth is something that always exists. For this reason, the existence of infinite Buddhas lies of at the core of Buddhist philosophy and faith: that historically many human beings have become enlightened to the truth, and are being enlightened to the truth, and will be enlightened to the truth. The image of enlightenment with the bhumisparsha mudra that gives form to the moment Shakyamuni, of all the infinite Buddhas, was enlightened and attained Buddhahood is clearly alluding to the dharma (the truth). Therefore, the enlightenment image becomes Vairocana.

I have always believed that the uniqueness, beauty, and sacred atmosphere emanating from Seokguram's architecture and sculptures had to be based in a profound corresponding philosophy and faith. It took fifteen years to arrive at it, but without the wonderful achievements of Eliade, I would never have been able to confirm the substance of my theories.

(6) The Realization of Silla's Buddha Land

Compared to Goguryeo and Baekje, Silla had a very strong Buddha Land philosophy, the realization of an ideal world. This is underscored by the fact that records on Goguryeo and Baekje in this respect are very sketchy. But it is also possible that in regard to records on Silla, such contents were added in posterity, therefore embellishing and reinforcing the

significance of Silla's Buddha Land philosophy. But whatever the case, according to existing historical records, the development of Buddha Land philosophy continued in Silla for an astoundingly long time.

First, the signs are clearly seen in the names of the kings of Silla. From the mid-5th century, Buddhist terms began to appear in kings' names, for example, King Jabi (慈悲 王, compassion), and King Jijeung (智證王, the wisdom of knowledge). The will to realize an ideal state through the mythical Indian being Cakravartin, the universal ruler, became evident from the time of King Jinheung. Jingheung's son Jinji was named Geumnyun (金輪, gold wheel, a type of Cakravartin), King Jinpyeong (眞平王) was named Baekjeong (白淨, Suddhodana, the name of Shakyamuni's father), and his father was named Dongnyun (銅輪, bronze wheel, a type of Cakravartin), and the first queen was called Queen Maya (麻倻, the name of Shakyamuni's mother), the second queen was called Seungman (勝鬘, Srimala, daughter of King Prasenajit, king of Kosala during Shakyamuni's time, after whom the *Srimala Sutra* is named), thus identifying the Silla royal line with Shakyamuni and Cakravartin. These names show just how active and passionate Silla kings were about realizing an ideal Buddhist state.

Second, the sites of major national temples of Silla and Unified Silla are endowed with close associations to the Buddhas before Shakyamuni. The seven major temples of Silla, all located in the central part of Gyeongju, are on sites associated with the seven Buddhas of the past.[45] Among them the Hwangnyongsa Temple site is considered particularly important for its connection with Kasyapa, the Buddha just before Shakyamuni. It is said that the rock on which Kasyapa, the sixth of the seven past Buddhas, sat and preached is located behind the main hall at Hwangnyongsa temple site.[46] It is also said that the gilt-bronze 16-foot Buddha (around 4.8 meters) at Hwangnyongsa was made with bronze and gold sent by ship by King Ashoka from India, who had tried to make a 16-foot statue of Shakyamuni and failed and prayed that it would be made in another land. Ashoka also sent a model of a Buddha Triad, and to enshrine the triad, Dongchuksa Temple (東竺寺) was built at the place where the ship came in.[47] In these records, India is called Seochuk (西竺), a name for western India, and Silla is called Dongchuk (東竺), which makes it eastern India and consequently on an equal footing with India.

Third, advancing further the legend that Silla is connected with the Buddhas of the past, there is also the legend that the true Buddhas (as opposed to manifested Buddhas) appeared in Silla. There are others, such as those that claim Manjushri resides permanently on Mt. Odaesan (Ch. Wutaishan, 五臺山),[48] that the temple site from the time of Kasyapa Buddha on Mt. Grdhrakuta (K. Mt. Yeongchwisan, 靈鷲山) is in Silla,[49] and that the place where Avalokiteshvara is said to have appeared is on Mt. Naksan (洛山, name derived from "lak" in Mt. Potalaka),[50] and that Dharmogata Bodhisattva resides on Mt. Geumgangsan. In this way, the effort to turn Silla into the land of the Buddha continued.

Judging from these developments, my conclusion is that Silla's Buddha Land philosophy culminated in the Seokguram main statue. The statue of Buddha in the posture of

enlightenment displaying the bhumis-
parsha mudra that was made at
Mahabodhi Temple in Bodh Gaya—
the actual site where Shakyamuni
attained enlightenment—was recreat-
ed on the slopes of Mt. Tohamsan in
the kingdom of Silla with exactly the
same size, mudra and orientation. By
recreating that statue on Silla territory,
the Silla people were in effect claim-
ing that Shakyamuni attained enlight-
enment in their land. And by so faith-
fully recreating the moment of
enlightenment, the most important
and definitive moment not only in the
life of Shakyamuni but also in
Buddhist philosophy, Silla made this
sublime and unique work of art to
proclaim to the world that it was the
center of the universe. Because the
Silla people aspired to see the fulfill-
ment of the Buddha Land philosophy,
they made it a project on a national
scale to construct the incomparable
monument, Seokguram. Being so
accomplished artistically and philo-

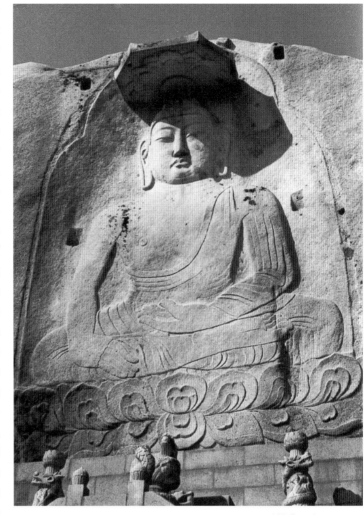

147. Seated
Shakyamuni displaying
the bhumisparsha
mudra. Seunggasa
Temple. Goryeo, late
10th−early 11th c.
H. 594 cm.

sophically, the main Buddha was taken as an archetype, and countless statues with the
same iconography were produced through to the Joseon Dynasty (朝鮮時代, 1392−
1910). As a result, Korea has the largest number of enlightenment images in East Asia.

 The basic framework of the architecture, sculptures, and setting of Seokguram were
succeeded in the Goryeo Dynasty (高麗時代, 935−1392) cave temple Boanam in
Sacheon, Gyeongsangnam-do province. Though it is a small-scale temple featuring
regional style and poor architectural and sculptural technique, the main Buddha is a seat-
ed figure of Shakyamuni in enlightenment showing the bhumisparsha mudra and facing
east to the southern sea.[51] The major enlightenment image from the Goryeo Dynasty is
the large Rock-Carved Buddha at Seunggasa Temple on Mt. Bukhansan in Seoul, which
was made between the late 10th and early 11th century (Fig. 147). The 6-meter-high seat-
ed image of Buddha covers a large rock facing east. Though this colossal Buddha is in
the form of a Unified Silla enlightenment image, its style is typically Goryeo. The face is
sculpted in low relief, and the lower down the body the flatter the carving gets till it

reaches the knees, which are depicted in carved lines. There is a subtle hint of red remaining on the lips, like the Seokguram main Buddha. In terms of scale and sculptural technique, this big Buddha that is lit up by the rising sun from the east is one of the finest Buddhist statues of the Goryeo Dynasty. Over the head there is an octagonal roof, and there are square holes around the upper body where the pillars for a wooden canopy would have been. Overlooking the whole of Seoul, the image is flanked to the left by Bohyeonbong (Samantabhadra) peak and to the back by Munsubong (Manjushri) peak. So in effect these two peaks serve as the attendant bodhisattvas for this sculpture, which is a monumental enlightenment statue from Goryeo that revives the symbolism of the Seokguram main Buddha.

(7) "Interpenetrated Buddhism" Iconography

The first person to characterize Korean Buddhism as Tongbulgyo (通佛敎), or "interpenetrated Buddhism," was Choe Nam-seon (1890–1957) a writer, historian, and cultural activist. He highly praised the theory of bringing conflicting ideas into agreement put forward by the great Silla priest Wonhyo (元曉, 617–686), which is based in the Avatamsaka philosophy, saying that Korean Buddhism reached its peak with Wonhyo, whom he credited as the founder of Tongbulgyo.[52] In the modern period, the historian Cho Myeong-gi (1905–1988) emphasized the doctrine of synthesis and resolution of confrontational elements, and stated that the characteristic of Korean Buddhism was "interpenetrated harmony." He took as his starting point Wonhyo's *Reconciliation of Disputes in Ten Aspects* (*Simmun-hwajaeng-non*, 十門和諍論), which stressed the synthesis of Buddhist teachings, a line of thought that was carried on by other renowned Buddhist priests such as Woncheok (圓測), Daehyeon, Uicheon, and Samyeong. In the end he found the core of the doctrine of synthesis in the principle of "mutual identity" and "all is one, one is all," which is the core of the Avatamsaka philosophy.

In modern times, Prof. Lee Gi-young made a systematic discussion of Tongbulgyo as the identifying characteristic of Korean Buddhism, that is, "interpenetrated harmony" as the Korean way of thinking and a religion that that forms the Korean thought tradition. He shows that this way of thinking has continued from the time of Wonhyo during Silla through the following Goryeo and Joseon dynasties, and in modern times influenced the Donghak philosophy and worship of Dangun, the mythical founding father of Korea.

In the Buddhist sculptures of Korea, as previously stated, Shakyamuni is conceptually the same as Vairocana, as expressed in the iconography of Shakyamuni showing the bhumisparsha mudra and Vairocana showing the *bodhishri mudra*, or wisdom fist gesture (K. *jigweonin*, 智拳印), which have been the primary objects of worship from the mid-8th century to the present. I have argued that these two Buddhist iconographies have synthesized all others.[53] This underlying direction in my research became clearer through this particular study and reached the point where I was able to reconfirm that the currents of

Korean Buddhist sculpture converge in the elements of "Shakyamuni and enlightenment." Tongbulgyo, a version of Buddhist faith specific to Korea based on the Avatamsaka philosophy, and the two major types of iconography, the Buddha in enlightenment with the bhumisparsha mudra and the Vairocana in Buddha form, also based on the Avatamsaka philosophy, have developed in parallel through the ages. This shows the Korean people's tendency to search for the root of all things, and demonstrates also that Korean Buddhism was not skewed toward being only a votive faith, or a faith for the protection of the country, or a Pure Land faith (centered on worship of Amitabha, the Buddha of infinite light and ruler of the western paradise). Ultimately, my own research supports, from the perspective of art history, research in Buddhist philosophy that identifies Tongbulgyo as the defining characteristic of Korean Buddhism. Indeed, it does not just support this point but rather demonstrates it in a concrete way through the study of the iconography of Buddhist statues that are objects of worship.

3. Conclusion

Seokguram currently has 38 Buddhist sculptures (originally 40), the most important one being the main Buddha in the pose of enlightenment displaying the bhumisparsha mudra in the center of the main chamber. Therefore, in this essay every effort has been made to interpret its iconography, and the following is a summary of the contents.

At first, I attempted to interpret the iconography based on the Avatamsaka Sutra. That is, my interpretation was based on the Avatamsaka view that when Shakyamuni Bodhisattva attained enlightenment and became the Buddha he also became Vairocana at the same time, which means Buddha and Vairocana are not two but one and the same. Therefore, I perceived the world that was being portrayed in Seokguram as the lotus world, or the universe of each Buddha for his apparitional body. I concluded that, ultimately, the element that Seokguram emphasizes is enlightenment. Against this background, the first enlightenment image in the round was made in the mid-8th century at Seokguram, and around the same time the first image of Vairocana in Buddha form was made at Seoknamsa Temple. These two iconographies were continually produced through the Goryeo and Joseon dynasties, constituting the mainstream of Korean Buddhist sculpture.

However, my basic approach in art history methodology is to prove my point with concrete evidence, and so I searched for a clue with which to start. As there are almost no records about Seokguram, I had long been convinced that the key lay in Seokguram itself.

I found the lead to my research in the fact that the size, mudra, and orientation of the Seokguram main Buddha exactly match those of the main Buddha at Mahabodhi Temple in Bodh Gaya, India, which stands at the very spot where Shakyamuni attained enlighten-

ment. I discovered this fact in Xuanzang's *Great Tang Dynasty Record of the Western Regions* and also learned that the record was based on the *Lalita Vistara*. Therefore, I set about analyzing this sutra and interpreting the iconography of the Seokguram main Buddha, and as expected, "enlightenment" was the focus. That is, whether the interpretation is based on the *Avatamsaka Sutra* or the *Lalita Vistara*, it leads to "enlightenment," and the two approaches are thus complementary.

I extracted various symbols from the process of Shakyamuni's enlightenment—the site of enlightenment as the center of the world, the true nature of Mara and the dialectic of enlightenment, the Great Earth Goddess, Buddha's transformation into the sun and into myth, the fulfillment of Silla's Buddha Land philosophy, and the expression of Tongbulgyo in iconography—and in interpreting these symbols, I received great help from the works of Mircea Eliade.

In the end it became clear that the theme of Seokguram's art and philosophy is enlightenment. Enlightenment is the highest and ultimate mode of existence that Buddhism aspires to. At the moment of enlightenment, man becomes Buddha and the mundane world becomes the Pure Land, or paradise. At that moment Buddhism rises above itself and its conceptual limitations disappear. Enlightenment is not the ultimate goal of Buddhism only; it is related with concepts such as the golden mean, do-nothingness, and virtue, which are the goals of all religions and ideologies, and also the goal of all people seeking to achieve something in the humanities, including philosophy, politics, literature, art, and science. Therefore, it is only after attaining enlightenment that a person can realize true love, exercise true rule, engage in true learning, write a poem that touches the heart, or create a beautiful work of art.

Hence, enlightenment is an absolute state that is the goal of all sects of Buddhism, though different sects present different ways of attaining it. Therefore, the sects are not in confrontation with each other but are complementary. It is in the absolute state of enlightenment that all the sects such as, the Avatamsaka (華嚴) sect, the Tien-tai (天台) sect, and the Zen (禪) sect converge.

From the Unified Silla period when they began to take the image of the human being Shakyamuni in the pose of enlightenment as an object of worship, Koreans have strongly maintained the original core of their faith, seeking the state of enlightenment in the context of the Mahayana tradition. Korea is the only East Asian country that has maintained this attitude. Indeed, it is perhaps the most dominant characteristic of Korean Buddhism. This is why Korean Buddhism is called Tongbulgyo, or interpenetrated Buddhism, despite there being various sects. And it is in this context that Koreans have stubbornly maintained the iconography of Vairocana in Buddha form, which comes under the category of an enlightenment image.

In conclusion, Tongbulgyo is also reflected in Korean Buddhist art, in the fact that the two images of enlightenment, Shakyamuni displaying the bhumisparsha mudra and Vairocana in Buddha form, which are based on the *Avatamsaka Sutra* and the *Lalita*

Vistara, have been popular throughout the ages. Indeed, this characteristic of Korean Buddhism, the reconciling of all sects, is borne out by the long-continued production of these two enlightenment images that reconcile all other Buddhist images. So it can be said that the history of Korean Buddhist philosophy is verified and consummated through the study of the history of Buddhist art.

The distinctive quality of Korean Buddhist philosophy and art was first perfected in Seokguram, and this then determined later developments. It is commonly said that Seokguram represents the height of Korean Buddhist sculpture, which started to decline from that point on. This may be so from the perspective of sculptural technique, but in terms of Buddhist philosophy, faith, and iconography, Seokguram proved to be a catalyst for future development.

The Art and Philosophy of the Divine Bell of King Seongdeok

Though bells made for religious purposes can be found all over the world, only Korean religious bells achieved such a high level of artistry that they are studied as a subject of art history. Korean bells exhibit not only beautiful shape and ornamentation, they also produce a clear and beautiful sound thanks to the sound flue, a device unprecedented in the world. In this essay I have traced the religious background of the Divine Bell of King Seongdeok which embodies the religious wish to lead sentient beings to enlightenment through the "perfect sound of the one vehicle." At the same time I have attempted to uncover the symbolic meaning of the ornamentation on the bell and the significance of the bell in the history of art.

1. Introduction

Few works of art in this world can truly be called great. This is because behind a great work of art there must be a great philosophy. Something that is beautiful and something that is great exist on different planes, and so it's rare to find something that is both beautiful and great. But the Divine Bell of King Seongdeok is just such an example, a monumental work that is both beautiful and great, harmonizing art and philosophy.

The Divine Bell of King Seongdeok (聖德大王神鐘) has a beautiful silhouette and elegant, intricate decorations, including upper and lower bands of floral scroll patterns, lotus bud protrusions called nipples, apsaras (heavenly maidens) flanking the inscription, a lotus blossom for the striking point, an eight-lobed mouth, a powerful and majestic hook, and a sound flue decorated with lotus and flowers. Befitting the grand and beautiful body of the Buddhist bell, the sound too is rich and sonorous with a long reverberation, and thus the bell is not simply a work of art but a musical instrument, peerless not only in Korea but throughout the world. Though it is huge—3.66 meters in total height, 2.7 meters in diameter at the mouth, and weighing 18.9 tons—it possesses perfectly those artistic elements that can easily be lost in works of this size (Fig. 148).

The Buddhist bell originally belonged to Bongdeoksa Temple (奉德寺), which was founded in 738 by King Hyoseong (孝成王) to pray for the peaceful afterlife of his father, King Seongdeok (聖德王). For the same purpose, King Gyeongdeok (景德王), Hyoseong's younger brother and successor, launched a project to produce a grand bell using 120,000 *geun* (1 *guen* roughly equals 600 grams) of bronze but did not live to see it

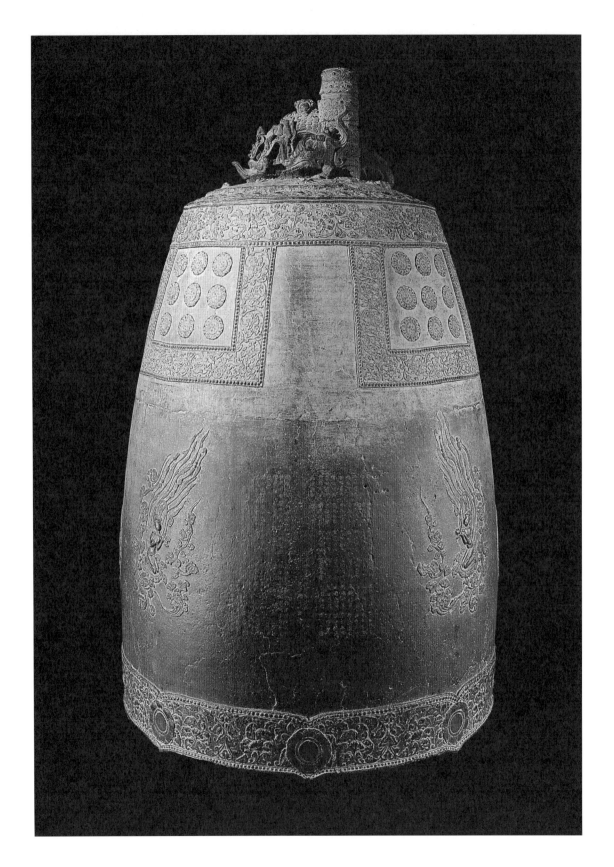

completed. The bell was completed by his son King Hyegong (惠恭王) in 771, thirty-four years after the death of King Seongdeok and twenty years after the project was initiated.[1] The inscription on the bell was composed by Kim Pil-hae during the reign of Hyegong.

The bell was cast primarily for political reasons. King Gyeongdeok instituted governmental reforms in order to strengthen the central authority of the throne, which was being threatened by the rise of a new group of aristocrats. Those leading the reforms were Gyeongdeok himself and the court's chief administrator. As part of these efforts, Gyeongdeok decided to create a divine bell to honor King Seongdeok for achieving political stability by strengthening the power of the throne and thereby establishing the framework that enabled Silla culture to flourish. Further details of this political background I shall leave to historians.

The bell, however, was made not only for political reasons but, as can be seen from the inscription on it, for religious purposes as well. The first line of the inscription reads, "This bell is made for the purpose of enlightening sentient beings with its sound, which is the perfect sound of the one vehicle." This line reveals the ambitious purpose of the Silla people to express with the sound of the bell the "perfect sound of the one vehicle" (一乘 의 圓音), which is the sound of absolute truth. Various other passages from the inscription confirm the grand religious purpose behind the bell's creation. These include the explanation that the bell is called a "divine bell" because it was made through the joint effort of gods and human beings. And there are references to the bell as a "divine vessel," "celestial bell," and "divine body."

At the time that the Divine Bell of King Seongdeok was being cast at Bongdeoksa Temple, the construction of Seokbulsa Temple (Seokguram) and Bulguksa on Mt. Tohamsan was also underway, and the grand bell of Hwangnyongsa and the grand Buddha of Bunhwangsa had already been completed. Thus, the reign of King Gyeongdeok and King Hyegong was a brilliant age representing the height of creative drive in Unified Silla (統一新羅, 668−935), a period when originality was demonstrated in many artistic fields and paradigms established for all forms and systems of cultural production.

First, Seokguram cave temple (石窟庵), like the Divine Bell, was begun by King Gyeongdeok and finished around the same time as the Divine Bell, during the reign of King Hyegong. The main Buddha at Seokguram was probably the first sculpture in the round of Shakyamuni displaying *bhumisparsha mudra* (K. *hangmachokji-in*, 降魔觸地印, gesture of defeating the demons and touching the earth) at the moment of enlightenment. Throughout the subsequent Goryeo (高麗) and Joseon (朝鮮) Dynasties and to the present, this figure has served as the primary archetype of devotional Buddhist statues in Korea.

Second, during the reign of King Gyeongdeok, the invisible dharmakaya (法身), or Buddha body—referred to as Vairocana in the *Avatamsaka Sutra*—was given visible form. An image of Vairocana in Buddha form was produced for the first time in East Asia

148. The Divine Bell of King Seongdeok. Unified Silla, 771. Total H. 366 cm, Mouth D. 227 cm. National Treasure No. 29. Gyeongju National Museum, Gyeongju.

at Seoknamsa Temple in Gyeongsangnam-do province. This Vairocana, along with Shakyamuni displaying bhumisparsha mudra, has remained the most prevalent Buddhist image in Korea.

Third, with the construction of Bulguksa Temple (佛國寺), an inseparable relationship developed between the Avatamsaka school (K. Hwaeomjong, 華嚴宗) and the Amitabha cult, and the unique configuration of various buildings in a temple—such as Daeungjeon (Main Hall), Geungnakjeon (Hall of Paradise), Birojeon (Hall of Vairocana), and Gwaneumjeon (Hall of Avalokiteshvara)—was established for the first time, becoming the model for temple layouts from then on.

Fourth, when Seokgatap (釋迦塔, Pagoda of Shakyamuni) was built at Bulguksa, it was considered to be the stone pagoda with the most beautiful proportions, and it became the model for stone pagodas which then began to be built in great numbers.

Fifth, the system of constructing royal tombs with stone figures of the twelve zodiacal animals (十二支), stone railings, and stone figures of warriors and scholars, was established, a practice that was continued in Goryeo and then Joseon.

Sixth, in this period, grand bells like those at Hwangnyongsa Temple (皇龍寺) and Bongdeoksa Temple started to be cast, a tradition that continued through later periods, as evidenced by the Cheonheungsa Temple bell of the Goryeo Dynasty (935−1392) and the Wongaksa Temple bell of the Joseon Dynasty (1392−1910).

Seventh, the stupa at Manghaesa Temple inspired the development of beautiful stupas in various forms combined with intricate sculpture.

Eighth, the form of *beopdang* (法幢, Buddhist temple structure comprising a bannerpole, bannerpole supports, and banner) was established, and it remained an important component of temple architecture up to the Joseon period, equal to the stone pagoda in terms of money and time spent on its construction.

Pushed forward by such active production of creative and monumental works of art during this period, the Divine Bell of King Seongdeok, a great work of art and musical instrument, was brought forth.

A brilliant age does not come about through developments in just one or two fields. Only when all the fields, including science, literature, philosophy, religion, art, and politics, have reached a state of maturity can a society produce great works of art. The Divine Bell, as an implement of Buddhist ritual, is first placed in the category of craft. But it is, secondly, a work with strong sculptural qualities. The relief designs of *bosanghwa* (imaginary flower, Ch. *baoxianghua*, 寶相華) and lotus blossoms are richly textured, and the powerful movement of the dragon-shaped hook makes it not just a functional element but the finest dragon sculpture produced in Korea. That is, the bell represents a new genre where the elements of craft and sculpture exist in equal proportion. Third, the bell is deeply imbued with the religious wish to enlighten sentient beings by having them hear the sound of absolute truth. Fourth, in order to produce the beautiful and sublime sound of absolute truth, the sound flue, which had no precedent in the world, was devised. Such

a creative idea would have been impossible without great advances in music. And fifth, a bell of such great size would have been impossible without the development of extremely sophisticated casting techniques.

The Divine Bell is thus a composite work of art, a synthesis of sculpture, religion, music, science, and technology, all of which had developed to a high level as a result of the political will to strengthen the authority of the throne; and the same can be said of Seokguram and Bulguksa Temple.

2. The Development of Silla Bells

The Divine Bell of King Seongdeok is the second oldest bell extant in Korea, after the Sangwonsa Temple bell dating from 725. Therefore, it's worth looking into the development of bells during the Silla period. The Japanese scholar Tsuboi Ryohei was the first to write about the origins of Korean bells in a short but clear study. Based on his research I wish to re-examine this issue of origins. Commonly the Japanese speak of "Joseon bells," whereas we use the term "Korean bells" (韓國鐘), but here, depending on the desired nuance, I will use both the terms "Korean bells" and "Silla bells" (新羅鐘).

We consider Korean bells to be unique. The form of Korean bells was established in the Unified Silla period, and compared to Chinese and Japanese bells of that time, Korean bells are incomparably gentle in form, sophisticated in decoration, and beautiful and rich in sound.

But strictly speaking, the form of Korean bells is derived, surprisingly, from the bells of Yin and Zhou periods in China. Silla artisans copied and ultimately recreated the Chinese examples, achieving a metamorphosis in the bell form and establishing a whole new genre of beauty. Similar metamorphosis was achieved in other kinds of work, with results that were completely new and even better than the Chinese originals. They include roof tiles, stupas, stone figures of the twelve zodiacal animals for tombs, beopdang, images of the eight classes of devas, and inlaid celadon. Korean bells should be understood in this broader context of Korean artistic development.

According to Tsuboi Ryohei, the origins of Korean bells can be traced to an ancient Chinese musical instrument, bell chimes called *pyeonjong* (編鐘) in Korean.[2] A long, handle-like cylindrical shaft called *yong* was a significant part of this instrument, so it was called *yongzhong* (甬鐘) in Chinese (Figs. 149, 150). Interestingly, the distinguishing features of the yongzhong, which had been around since the 9th century B.C., did not appear at all in Chinese temple bells of later periods, but then in the 8th century, they appeared very distinctly in Silla temple bells.

Korean bells have four bordered sections called *yugwak* (乳廓), and in each section there are nine nipple-like ornaments called *yudu* (乳頭), for a total of thirty-six. The Chinese yongzhong has exactly the same arrangement of four *yugwak* with nine nipple

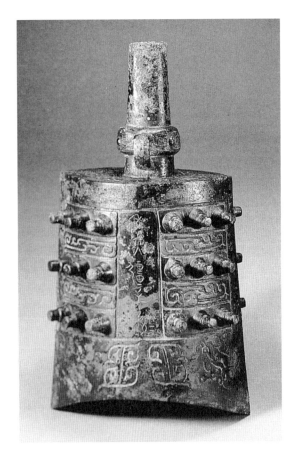

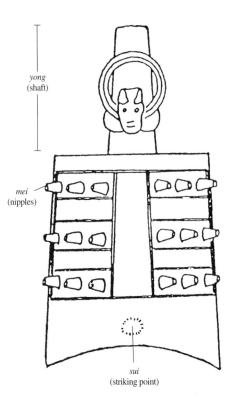

yong
(shaft)

mei
(nipples)

sui
(striking point)

ornaments in each. Therefore, the basic form of the yongzhong and Silla temple bells is the same. The only difference is that in the yongzhong, the yugwak sections constitute a very large proportion of the bell.

Tsuboi Ryohei focused on the animal head decorating the shaft of the yongzhong and surmised that this developed into the single dragon hook of Korean bells. Without exception, the temple bells of China and Japan feature a twin dragon for the hook.

All Korean bells have two striking points, one at the front and another at the back. Ryohei observed this and said that the striking point, *dangjwa* (撞座), corresponded to the *sui* (隧), distinct regions on the bell face of yongzhong.[3]

An overall comparison of the Chinese yongzhong and Silla temple bells reveals the following: the sui on yongzhong are located on either side of the bell face in the center of the bottom half, above the bell mouth, and the animal head in the center of the shaft faces forward with the shaft behind, an arrangement that is the same as the relationship between the dragon head, shaft, and striking point of Korean bells. If we take the animal head of the Chinese bell or the dragon head of the Korean bell as the reference point, the striking point on the side with the dragon head facing forward is where the bell is actually struck, and the striking point on the back exists for formal symmetry. By contrast, many Japanese bells have striking points on the sides rather than the front and the back.

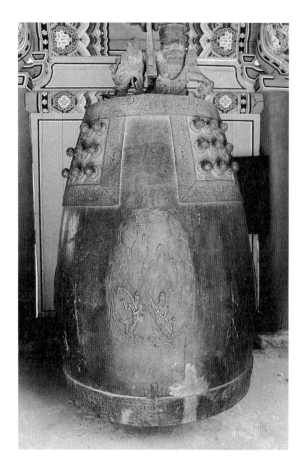

151. Sangwonsa Temple
Bell, Wonju. Unified
Silla, 725. H. 167 cm.
Mouth D. 91 cm.
National Treasure
No. 36.

In Silla bells, the shaft and nipples, which are related to the sound, are greatly empha-
sized. On the Divine Bell, the nipples are flat and decorated with a lotus design and thus
do not have the same function as the nipples called *mei* (枚) on Chinese bells. But the
Sangwonsa Temple bell that predates the Divine Bell has highly protruding nipples, in
faithful adherence to the Chinese yongzhong model (Fig. 151). The shaft, like the nip-
ples, is likely related to sound. In bells of the ancient Bronze Age in China, the shaft was
not hollow, but like the nipples, I believe it had something to do with the sound. The shaft
did not function as a handle since the bells were hung; so, unless the shaft had something
to do with the sound there was no reason for it to be so long. The people of Silla took this
shaft and turned it into the sound flue, called *eumgwan* (音管), in order to achieve their
desired goals. Because the yongzhong consisted of bells of different sizes hung up in
order and struck from the outside to play, it was called *pyeonjong* in Korean (meaning
"hanging bells"). When discussing the origin of temple bells, Chinese and Korean com-
monly compare temple bells with the Buddhist hand bells called *tak* (鐸) or pellet bells
called *ryeong* (鈴), and though the form may be similar these bells have a clapper inside
and are shaken in order to produce sound, making them fundamentally different from
bells that are struck from the outside. Also, tak and ryeong do not have a shaft or nipples

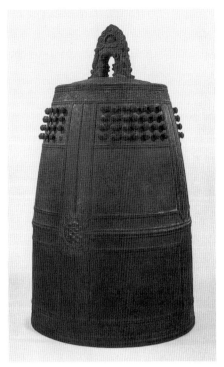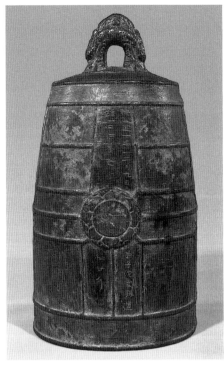

152. Myoshinji Temple Bell, Japan. 698. (left)

153. Bell inscribed "7th year of Taijian," China. Chen, 575. (right)

and so can't be considered precursors of temple bells.

The bell was originally a musical instrument. The oldest bell in China is from the Bronze Age during the Zhou Dynasty (周朝, 11th c. B.C.−256 A.D.). Since the Spring and Autumn Period and Warring States Period (春秋戰國時代), bells were used as the standard for tuning, and along with stone chimes, bell chimes were used in Confucian ritual music. It is from this Confucian ritual bell that temple bells originated. Acoustically, the nipples were placed to regulate the pitch and tone of the bell.[4]

Although Silla bells followed the general rounded form of Tang bells, they emphasized the details of the yongzhong of the Zhou period, such as the shaft and the nipples, thereby strengthening the sound-producing function. The inside of the sound flue in the Divine Bell is tapered like a trumpet, with a diameter of 8.2 cm at the bottom and 14.8 cm at the top, and there must have been an acoustical reason for this shape. The curve of the inside of the body of the bell would have had a relationship with the resonance, and the striking points would have been placed on the most convex part of the body for a special reason. Though it's unclear through what process or how, the people of Silla must have studied the shaft and nipples of the yongzhong and their function in relation to sound, and on this basis created the unique work of art that we call the Silla bell.

While preserving the musical features of the bell, the Silla people turned them into works of beauty by highlighting the curved silhouette and decorating the surface with lively and brilliant floral patterns, heavenly maidens and musicians. The hook was not just a functional device but a splendid sculpture of a dragon. Achieving magnificent visu-

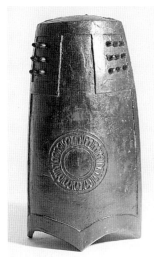

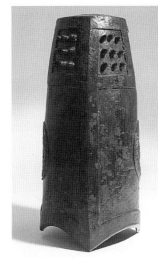

154. Gilt-bronze bell.
Excavated from Mireuksa
Temple site. Baekje, 7th c.
H. 14 cm. Mireuksa
Temple Gallery. (top left)

155. Bronze Bell.
Excavated from
Hwangnyongsa Temple
site. Silla, 7th c.
Remaining H. 24 cm.
Gyeongju National
Museum, Gyeongju.
(top right)

156−157. Bronze bell,
front (bottom left) and side
view (bottom right).
Excavated from Gameunsa
Temple site. Unified Silla,
late 7th c. H. 27.5 cm.
Gyeongju National
Museum, Gyeongju.

al effect through such relief designs and sculptural elements, Silla bells went beyond being merely musical instruments and became works of art occupying an important place in Korean art history. In fact, Korea is probably the only country where Buddhist temple bells are considered an integral part of art. Furthermore, the Silla people considered the body of the bell to be the body of Buddha, or the dharmakaya, and the sound of the bell as the sound of Buddha, or the sound of absolute truth, which is why they elevated bells to the status of religious objects of worship.

Given that Silla bells retained and emphasized distinctive aspects of the Chinese yongzhong, their creation would not have been possible if the Silla people hadn't seen and studied the yongzhong. Nonetheless, while they preserved the essence of the yongzhong, the Silla people managed to go far beyond imitation to create a totally new style.

The cross pattern dividing the body of Chinese bells (Fig. 153) was not adopted by the Silla people at all. While Japanese bells appear to have adopted the Chinese cross pattern as is (Fig. 152), they are otherwise eclectic in style with elements taken from Chinese bells and Korean bells: they have upper and lower pattern bands, nine nipple border sections with twenty-eight nipples in each, and a lotus striking point at the intersection of the cross. This lotus striking point is a feature that seems to have been first created in Korea because it appears, for instance, on the gilt-bronze bell (*tak*) dating from the earlier Baekje Kingdom (18 B.C.−660 A.D.) excavated at the Mireuksa (Maitreya) Temple site in Iksan.

The Divine Bell is the only Korean bell with an eight-lobed mouth, a feature copied from Tang bells of China, many of which have such bell mouths.

Though it appears that Silla bells did originate from the chime bells of Zhou, it has been difficult to posit a direct influence, given the vast time difference separating Silla and the two Chinese dynasties. However, in the past two decades, important materials have turned up that convincingly fill the historical gap in the development of Silla bells. Relics representing transitional forms predating Silla bells have been discovered at the

Baekje-era Mireuksa Temple site and Silla-era Hwangnyongsa Temple and Gameunsa Temple sites.

The gilt-bronze bell from the Mireuksa Temple site (彌勒寺址) is estimated to date from the early 7th century and is partly in the style of Chinese yongzhong, but at same time it represents a prototype of Silla bells (Fig. 154). It appears to have had a clapper on the inside, so it was probably a wind chime hung from the roof of a pagoda. The bell has four nipple borders with five semispherical bosses in each. Most importantly, it has at the front and back an eight-petal lotus medallion that forms a sort of striking point, though not exactly such in function. The mouth is a four-lobed one. Closer to a Silla bell than a Chinese yongzhong, it can be considered a prototype of Silla bells.

An artifact similar to this Baekje (百済) wind chime was discovered at the Gameunsa Temple site (感恩寺址), but at 28 cm in height it is bigger and more like a bell than a chime (Figs. 156, 157). This bell has four nipple borders with nine nipples, each protruding about 5 mm, and striking points at the front and back, each in the form of an eight-petal lotus medallion 7.6 cm in diameter. The mouth is four-lobed and oval with the longer axis measuring 14.7 cm and the shorter 13.2 cm. The body is softly curved, and despite its small size, the bell is beautifully decorated and very impressive. At the top there is a circular 1.2 cm-wide opening, and it is difficult to tell whether a hook was attached there or the hole had something to do with the sound flue. From its size and weight (3.9 kg), it should be identified as a small bell rather than a wind chime. If by chance it was made at the time Gameunsa Temple was built, in 682, it is a true prototype of Silla bells in the same vein as the Sangwonsa Temple bell. It is particularly interesting to see that the lotus medallions marking the Mireuksa chime and the Gameunsa small bell are similar to the lotus striking point of Silla bells. Around the year 700, or sometime between 682, when the Gameunsa bell was cast, and 725, when the Sangwonsa bell was cast, Silla's bell making technology must have developed to such a degree that the casting of very large bells became possible.

A small bell more advanced than the one at Gameunsa was discovered at the Hwangnyongsa Temple site (Fig. 155). Severely damaged, it has been partially restored, but since the top half has been lost, it is impossible to know what the whole bell looked like. The remaining height is 24 cm and its original height would have been well over 30 cm. The nipple borders have been lost, so there is no knowing how the nipples were arranged. On one side there is a lotus medallion for the striking point, but it is not known whether there was one on all three remaining sides or just on the front and back. The mouth is four-lobed and all the four sides are of equal length (15.5 cm). As the sides are rounded, the mouth is close to a perfect circle. Bigger than the Gameunsa bell it, too, should be considered a small bell rather than a wind chime.

The three examples of bells above reveal how Korean bells grew progressively rounder in form. That is, the progress from the flat-sided Mireuksa chime to the oval Gameunsa small bell and then the nearly round Hwangnyongsa small bell, anticipates the develop-

ment of a bell with a round mouth. Therefore, while looking at the formation of Silla bells in relation to the chime bells and temple bells of China, the process of development within Korea in regard to the 7th-century Baekje wind chime and the small bells of Unified Silla should also be taken into consideration.

Korean bells can thus be considered to have their basis in the Mireuksa gilt-bronze wind chime of the Baekje period and the Gameunsa small bell of the early Unified Silla period, which modified and further developed the Chinese yongzhong with additional elements from Tang (唐) temple bells. Through a metamorphosis, in size, shape, and function, Korean bells became distinctive musical instruments and works of art in their own right and emerged as objects of worship around the year 700.

3. The Grandeur of the Divine Bell

1. Surface Decoration, Hook and Sound Flue

Because a bell is round it would appear not to have any distinct faces, but in the case of the Divine Bell, there is definitely a front. First, the stance and arrangement of the apsaras, or heavenly maidens, indicate that the two figures are headed toward the inscription with an offering of incense. This suggests that the inscription is very important and accounts for its profound content and excellent calligraphy. On the back, there is an identical arrangement. From this, it's clear that there is a front and a back, and that the two striking points are then located on the faces to either side.

The dragon of the bell hook, when viewed from the front as determined above, reveals itself wholly and clearly. The union of the hook and the sound flue is most beautiful when seen from the front, and it becomes even clearer that the face with the inscription honoring King Seongdeok is indeed the front. With this front face as the reference point, I shall describe the bell in detail, from the lower band of patterns to the upper band.

(1) *Bosanghwa* Floral Scrolls of the Lower Band

Because the mouth of the bell is eight-lobed, the lower band of patterns is not straight but beautifully curved in eight sections. At the top and bottom of the wide band of *bosanghwa* floral scroll, there is a thin beaded border. Between each of the eight lobes there is a single lotus medallion (Fig. 158).

The bosanghwa floral scroll band is raised about 1 cm, and the mouth is bordered by a raised edge higher than the pattern so that the big bell has a firm visual support at the bottom. That is, the lower band is quite three-dimensional and thus strongly sculptural in character.

The pattern in each of the eight sections of the eight-lobed band is basically the same,

but close inspection reveals that some parts are in higher relief than others and therefore different, and that the lengths are also slightly different. The pattern in each section of the band is symmetrical. A stem emerges from each end of the lotus medallion and in the middle of the section meets the stem from the end of the next lotus medallion. The stems bear rich and elaborate bosanghwa flowers. The wide petals are treated very sculpturally, emphasizing the flowers even more. Generally, such patterns are spread out flat but here the leaves curl up and overlap, adding depth to the pattern. The embossing of the leaves, petals and pistil is graded, the pistil being the highest part. And the most distinguishing feature is that the tips of the leaves are curled up. Such sculptural and dynamic expression of the bosanghwa pattern is similar to the treatment of plant patterns in Gupta-period India.

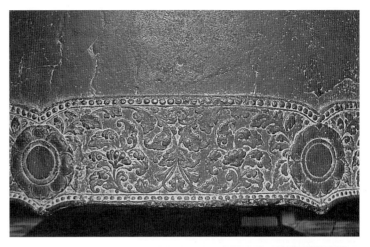

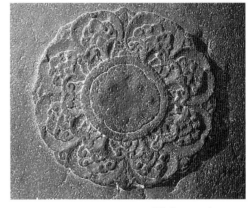

158. *Bongsanghwa* floral scroll on the lower band of patterns on the Divine Bell of King Seongdeok. (top)

159. Striking point on the Divine Bell of King Seongdeok. (bottom)

The eight-petal lotus medallion at each of the eight lobes is very simple, the ovary shown as a flat space without seeds, like a big circle. This serves as a contrast to the complex and elaborate bosanghwa floral scroll and emphasizes the effect of each. And because the ovary of each lotus medallion is sunken in, it pulls the sections together, giving the whole lower band of patterns a sense of elasticity. The lotus medallion below the striking point is very worn and the pattern is indecipherable. It appears that over the many years the bell was struck, the striking point was often missed and this spot hit instead. The bead pattern that borders the edges of the lower band enhances and enriches the floral scroll pattern. The lower band of patterns was thus designed to be majestic, powerful and elastic to visually support the bottom of this very big and heavy bell. (The width of the lower band is 33 cm, the length of each section 66 cm, and the lotus medallion 24 cm in diameter.)

As for the mouth of the Divine Bell, there seems to be a special reason for making it eight-lobed. In Buddhist art the octagon is the most important and widely used shape, and it seems that Silla artisans wanted to apply this shape to the bell. The number eight is a basic unit of Indian numerals, and the shape of the octagon closely approximates the shape of the circle and also its meaning.

(2) Striking Point

There is one striking point on the front of the Divine Bell and another on the back in symmetrical arrangement. It's a fancy design composed of an eight-multipetal lotus medallion with bosanghwa embellishments (Fig. 159). The ovary is formed of four overlapping circles, the overall shape more oval than circular. Within the ovary are nine lotus seeds. This medallion is deliberately made rather rough and carved with a sense of volume, a style that seems perfect for such a big and imposing bell. It is not known why the striking point was designed as an oval. Much more than the lower band of patterns and the heavenly maidens, the striking point has a surface texture that makes it look as if it were modeled out of clay. (The striking point measures 55 cm from left to right and 51 cm from top to bottom.)

From my own research, I have found that in temple bells made from the Unified Silla through the early Goryeo periods, the striking point is located at the most convex part of the body. It is not certain if this had something to do with resonance. But the combination of such functional concerns with a beautiful shape makes the value of Korean bells all the greater. In the case of the Divine Bell, the circumference of the body at the position of the striking point is about 15 cm bigger than the lower circumference. The bells of Japan and China, by contrast, are not so distinctly rounded, and the curve has nothing to do with the position of the striking point.

(3) Heavenly Maidens Offering Incense

The four pictures of heavenly maidens are placed in the middle of the inscriptions on either side of the bell such that the maidens seem to be directing their incense offering toward the inscriptions, a device that makes us focus on the inscriptions. Kneeling on a lotus flower pedestal, the maidens, who look as if they have just come down from heaven, hold in their hands lotus-shaped incense burners (Figs. 160−163).

At first glance it seems that the faces of the heavenly maidens are featureless, but a closer look at the apsara to the left of the inscription at the back reveals that definite facial features—two eyes, cheeks, and a nose—have been embossed, and the ends of the mouth sunken to form a smile. Actually, the face was rendered in higher relief than the rest of the figure for some reason, but it seems that it was worn away due to difficulties in production. There are some traces of hair, hair ornaments, and earrings. The delineation of the body, like the face, is not that clear, but the navel is emphasized, indicating that the upper body is naked. The heavenly maidens are wearing skirts and, on the upper body, only necklaces. But from the shoulders and back, long strands of cloth and a decorative sash flutter upwards in elegant waves, making the apsaras look as if they have lightly descended. One strand of the deva garment (天衣, extremely light garment worn by celestial beings) forms a circle above the head while the remainder and the decorative sash fly up

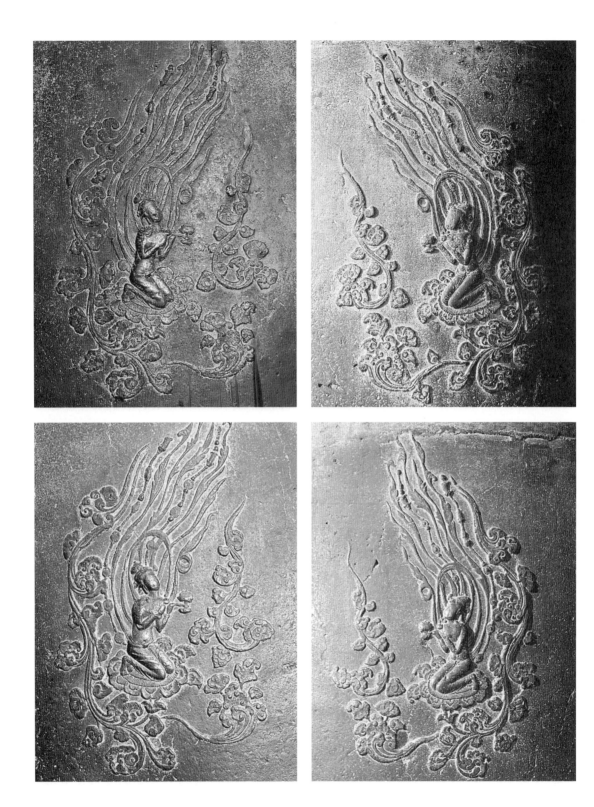

in long fluttering waves, creating a beautiful composition (Fig. 164). One strand that goes round the back winds round the right shoulder and armpit before rising up, and another strand does the same round the left shoulder and armpit. Two other strands fly up from both sides of the waistband while the other two fall from the knot at the waist, go through the legs, and fly up behind. (This pattern is clear in some of the four apsaras and not in others, so there are some differences in their depiction.)

In terms of composition, the complex garment is arranged very deliberately, with two strands of cloth going round the armpits, two flying up from each side of the waistband, and two going through the legs. So, all six strands are flying up, creating a very realistic picture. The closer we look, the more evident it becomes that not a single part of the design has been neglected and the complex composition has been so rationally put together that it has to be admired. The two strands of pendants would certainly have been attached to the waistband, but to avoid making the design too complex, they rise up

164. Rubbing of heavenly maiden pattern.

160–163. Heavenly maiden offering incense, left of front, right of front, left of back and right of back inscriptions. (p.228, from top, left to right)

from the back, suggesting that they originate from the waist. It's interesting to note that the strands of cloth have been turned into plant forms, with long leaves sprouting from the middle and the ends. In this way, the garment comes alive.

The bosanghwa scroll pattern is transformed into clouds and surrounds the apsaras; a close look reveals that the pattern consists of seven scrolls that may or may not be connected. The pattern, starting with the first scroll which has its tip up in the air, rhythmically surrounds the apsara, which is being born from the fourth scroll. There are two pistil-like stems that form a floral pedestal for the apsara. The flower of the pedestal is not a typical lotus but seems to be a combination of lotus and bosanghwa. The different nature of the lotus and bosanghwa is minimized by placing three leaves exactly like bosanghwa leaves around the edge of the pedestal. In this way the apsara is shown as being born from the lotus and bosanghwa. The seventh scroll, which draws elegant and dynamic curves, has been separated from the rest of the scroll pattern and curls in the opposite direction with its tip up in the air. The bosanghwa pattern has been exquisitely transformed. The connection between the apsara and the bosanghwa scroll pattern is different in each of the four sets of heavenly maidens as well as the connection between parts of the scroll, which shows that the four sets were not made from the same mold.

The bosanghwa pattern follows the line and flow of the celestial being, the flowing garment, and decorative band, embracing them and giving the whole design a sense of unity.

This pattern composed of flowers and leaves resembles a cloud pattern, and because it stretches out like a long, cloud-patterned band, it gives the impression that the apsara is descending from heaven perched on clouds. This cloud-like floral scroll pattern endows the apsaras with an even greater air of fantasy. This way of turning bosanghwa flowers into clouds has its origin in the unique Chinese method of expressing the life force in the form of clouds. (The total height of the pattern is approximately 105 cm, and the height of apsara 30 cm.)

Though the four apsaras give the impression of being the same in size and overall design, they are all a little bit different. Because the cloud-like floral pattern is different in each, it's clear that they were not cast from a single mold. It is certain that the differences were purposefully created to give the work variation, and this shows how carefully the artisans thought through their intentions.

(4) *Yugwak* (Nipple Borders)

The *yugwak* are made up of bosanghwa bands edged with beaded borders, at left, right, and bottom. Within the yugwak are nine lotus bosses, or nipples (Figs. 165, 166). The bosanghwa pattern of the nipple borders is a little smaller and in lower relief than that of the lower band of patterns of the bell but the workmanship is very fine. In general, small patterns tend to exclude details while big ones are very detailed. But on the Divine Bell the big bosanghwa pattern in the lower band is less detailed but has a sense of massive- ness that suits the size, and in the nipple border the leaves are relatively detailed and the pistils of the flowers are accurately shown. In the lower band the flowers are surrounded by five leaves, but in the yugwak, perhaps because the pattern is smaller, they are sur- rounded by four leaves.

Overall, the four yugwak are the same, but there are some fine differences between them, indicating that they were not made from the same mold. It is likely that there was one original mold, and based on this four different molds were made. This belief is based on the fact that the pattern in opposite corners of the nipple border and the point at which the stems meet to create a symmetrical honeysuckle-style pattern is different. In general, the bosanghwa pattern begins in the two opposite corners at the bottom and the stems spread out upwards and sideways. This movement of the scroll pattern, along with the apsaras and the lower band, gives the Divine Bell a strong sense of rhythm. Another dif- ference is the spatial arrangement, as each unit of the bosanghwa pattern in the lower band is oval but closer to a circle in the nipple border. The bosanghwa scroll pattern, which adds brilliance, vitality, richness, and a sense of rhythm, was newly introduced to Korea from India via China in the 7th century, and would definitely have been widely used from the early days of Unified Silla when the kingdom's national power was grow- ing and culture maturing.

Inside the nipple borders, instead of protruding nipples there are nine eight-leaf

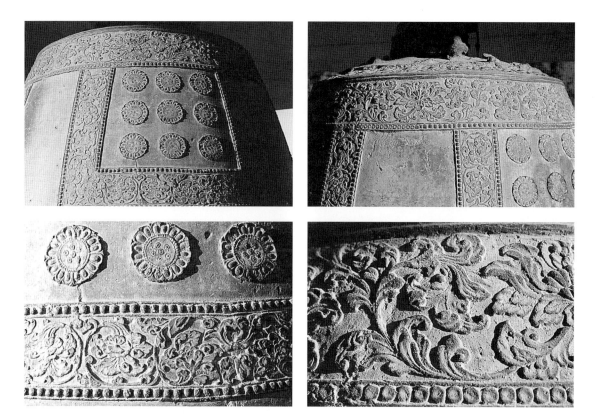

165. Nipple border on the Divine Bell of King Seongdeok. (top left)

166. Detail of nipple border. (bottom left)

167. *Bongsanghwa* floral scroll on the upper band of patterns on the Divine Bell of King Seongdeok. (top right)

168. Detail of *bongsanghwa* floral scroll. (bottom right)

dipetalous lotus medallions rendered in low relief, which form a contrast with the monopetalous lotus medallions in the lower band. The lotuses inside the nipple border appear to be monopetalous rather than dipetalous, and this was perhaps deliberately done to make the lotus pattern as simple as possible considering the complexity and elaborateness of the bosanghwa scroll pattern. The ovary has six seeds, one in the middle and five surrounding it. (The yugwak section is 110 cm in height and 72 cm in width, with the border measuring 19 cm in width.)

The upper band, which I shall discuss next, has a weaker sense of volume than the lower band. The pattern in the lower band is big, with a strong sense of volume, and rich and forceful, and this difference is related to the overall shape of the bell. The lower circumference of the bell is larger than the upper, meaning that the lower part of the body of the bell is much larger in volume. Accordingly, the lower band of patterns is big and voluminous, rich and forceful. In contrast, the pattern at the upper circumference is much smaller and weaker in volume but very fine in detail. The aesthetics of the bell are thus carefully planned and deliberate. The designer of this bell was undoubtedly familiar with the principles of aesthetic expression.

(5) The Upper Band of Patterns

As already mentioned, the bosanghwa scroll pattern on the upper band of the Divine Bell is

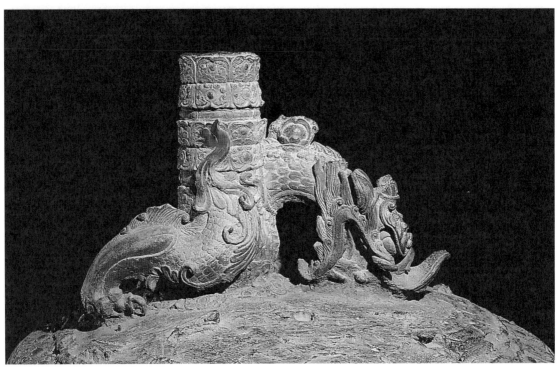

169. Dragon hook on the Divine Bell of King Seongdeok.

170–172. Dragon hook seen from various angles. (p.233)

the same style as that in the yugwak. But there is a thin beaded border on the lower edge only and none on the top, which is the top ridge of the body of the bell (Figs. 167, 168).

On the upper band, the pattern is repeated in three sections. The very complex and elaborate bosanghwa is placed in the center, and from this to the left and right spread out three gently curving stems with a flower at each end. Though the pattern is complex, it has been carefully arranged so that each of the three sections of the band is symmetrical. The width of the pattern band from top to bottom is 26 cm and each section is 174 cm long. Between each section there is clearly a seam indicating that they were cast from the same mold.

In this way, the lower band, upper band, and nipple borders are all composed of bosanghwa scroll patterns, though with certain differences—in the size of the pattern units, height of the reliefs, and details of the pattern—to create variations within the unified arrangement. However, all the pattern bands have in common a quality that might be described as the "fullness of cumulus clouds." That is, the flowers and leaves of the bosanghwa scroll pattern curl round and overlap, making them full and three-dimensional. At the same time, they give off the effect of fluffy clouds, which is related to the dragon and, for this reason, a very important design. There are no actual cloud patterns on the Divine Bell at all. But the edges of the numerous leaves of the bosanghwa scrolls curl up round and full, with a strong sense of volume, and the tips curl round and protrude powerfully, transforming themselves into the trailing edges of clouds. The scroll pattern surrounding the apsaras looks especially like clouds, and the apsaras look as if they are

232

descending from heaven on a cloud. And the rounded tips of the leaves protrude vigorously, giving the scene an added force. The big rounded lotus pedestal on which the apsara sits also looks like a cloud at first glance. That all the patterns look like clouds is one of the distinguishing features of the Divine Bell, which suggests that the sound of the Divine Bell is the sound of heaven. Though there's not a single actual cloud, the bell seems to be covered in clouds. It is the world of heaven.

(6) The Hook and the Sound Flue

Because the dragon functions as the hook, it faces downward toward the top of the bell, but the long upper lip and mane soar upwards, giving the impression of ascension (Figs.

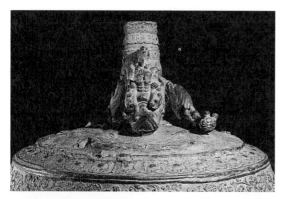

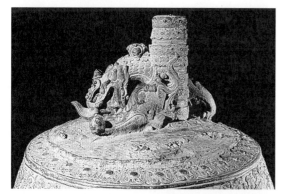

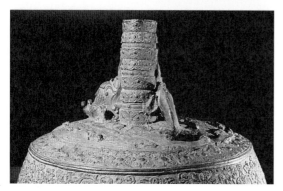

169–172). The eyes are not that big but are deep-set and thus look threatening and angry. The eyebrows seen from the side stick up powerfully like bracken tips and from the front they are very big and broad, so that they appear joined. The bracken-shaped ends are thick and voluminous. The nose is big and broad, and from each nostril protrudes a stem about 1 cm long, but since the ends have been damaged it is impossible to determine their original length. The head is resting on the top of the bell, from which the dragon seems to be rising up. Inside the raised upper lip there are two bow-shaped stems and on the long lips there is a pattern of tiny scales.

The two pointed front teeth stick out prominently beyond the lips, and at the back there are two pointed molars with a giant chintamani (wish-granting jewel) held fast between them. Engraved around the mouth is a small cloud-like pattern, similar to that of the dragon head of the bannerpole supports discovered in Punggi, Gyeongsangbuk-do province (Fig. 173), but the meaning of the pattern is unknown. Around the mouth is a vigorous bracken pattern that ends in a long mane-like feature that rises up powerfully. On top of the head there are two thick peaks, but there has been damage to the two horns that would have been connected to them. Around the base of the horns there is a simple lotus-like pattern, emphasizing the importance of the horns. The remaining part is about 15 cm long, and it is not known how long the original horns were and what they

looked like. Located behind where the two horns would have been, there are spots for what were perhaps two smaller horns, but because they have been lost it is impossible to know what they were exactly. On top of the nape of the neck, there is placed high on a lotus pedestal a kind of bead-shaped peak about 10 cm in diameter. There are scales engraved in the nape, and in the center of each scale there are engraved lines. There are no ears. This dragon functioned as a hook and therefore wire had to pass through it. If a wire is hung from the sides of the dragon's head then the ears would not only be not visible, they would also be in the way, which indicates that the ears were left out for practical reasons.

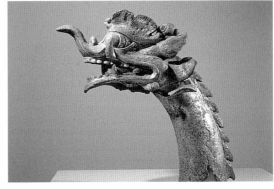

173. Gilt-bronze dragon head. Excavated from Punggi. Unified Silla, 9th c. H. 65 cm. National Museum of Korea, Seoul.

The dragon's trunk is directly connected with the sound flue to form one unit. That is, the body of the dragon is connected at a point below the middle of the sound flue, and a circled lotus pattern marks where the two meet. Because the dragon's body was made to emerge from the sound flue, its two legs extend out from it as well. The right leg extends out of the side of the sound flue and stretches out behind with its three thick, sharp claws grabbing the top of the bell. There are scales on the legs also. The top part of the legs has a thick cloud-like pattern winding round it like a scroll, and the tail rides up the sound flue giving an impression of ascension. The front left foot is thrust forward in the manner of a closed fist and is very much like a tiger's paw. But the claws are hidden and the toes are short and stubby; the rounded sole is thrust forward and, as though its surface were a face, something resembling eyes and a mouth are depicted there in an abstract manner. The front left leg also extends from the sound flue and has a cloud-like pattern above it rising gracefully but powerfully up the sound flue. Thus, the dragon and the sound flue emphasize a sense of unity by being joined to form a single body. The underside of the rounded trunk has been worn smooth and shiny from the bell being hung from this spot for many years. (The dragon measures 97 cm in length.)

The sound flue is decorated in three and a half segments. The pattern is basically the same as that around the edge of the top of the bell but more complex, elaborate, and finer in workmanship. Each of the top three segments consists of top and bottom rings decorated with a pattern of bosanghwa within a lotus outline, the two rings mirroring each other like upturned and downturned lotus leaves. The bottom half-segment consists of only of one ring of upturned lotus leaves. This arrangement shows that great thought and care was put into the composition of the patterns. Between the segments, there is a recessed section that is a thin band of semi-spherical flowers. Considered together with the pattern on the top surface of the bell, where the ends of the flowers in the bosanghwa pattern protrude in upward curls, the whole achieves a lively sense of movement. (The sound flue measures 63 cm in height and 23 cm in diameter.) The bottom edge of the sound flue bears the same pattern as the flue itself, but it is not cleanly finished, perhaps owing to

problems in casting. Nonetheless, the continuity of the pattern emphasizes the importance of the sound flue, with the pattern functioning as a sort of pedestal.

Around the edge of the top of the bell is a band of bosanghwa inside a lotus outline, with a slightly raised button in the center. The space between this band of patterns and the dragon is not smooth as there are lumps of bronze stuck to it. The unevenness of the top surface of the bell would have been unavoidable, resulting as it did from the process of casting, judging from the ten holes on the top for pouring in molten bronze and letting gas escape.

Going beyond its function as a hook, the dragon on the Divine Bell is a superb example of a dragon sculpture. It is bold and beautiful and, more than anything else, very much alive. Compared to the dragon on the Sangwonsa Temple bell, which predates the Divine Bell, and the dragon's head of the Punggi bannerpole supports, which comes later, it is incomparably lifelike and perfect in form. In fact, there is probably no dragon sculpture in the world that surpasses it. By joining the dragon, a mythical animal, with the sound flue, the Silla people tried to imbue the Divine Bell with important symbolism. However, I have yet to unravel the relationship between the dragon and the sound flue.[5]

Why was so much trouble put into the sculpture of the dragon? Why was it made so sturdy, so lifelike and so beautiful? The reason must have had to do with the symbolic significance of the dragon.

The dragon is a mythical beast that has been accorded all the best features of other animals. The ancient Chinese book *Guangya* (廣雅) says that the dragon has a head like a camel's, horns like a deer's, eyes like a rabbit's, ears like a cow's, a nape like a snake's, scales like a carp's, claws like an eagle's, and a fist like a tiger's. The dragon was believed to have magical powers, and having a close relationship to water, it was even worshipped as the god of water. *Guangya* says, "The dragon is born of the water and is a god with the power to change into anything it pleases. If it wants to be small, it can become as small as a pupa, and if it wants to be big it can become big enough to cover the sky. If it wants to fly high it can fly higher than the clouds and if it wants to go low it can dive into the deepest spring. The dragon is a god with the power to transcend space and time." The images and powers of the dragon as imagined by the ancient Chinese were transmitted almost unchanged to Korea.[6]

This form of the dragon is similar in characteristics to the dragons that appeared on Korean bells. (Hereafter, comparisons will be made specifically to the dragon on the Divine Bell.) For one, the ears are like the ears of a cow. The ears have been left off the Divine Bell dragon, but in dragons on other Korean bells or the Punggi dragon, the ears are indeed like a cow's. The nape is like that of a snake, the scales like those of a carp, the claws like those of a hawk, and the fist like that of a tiger. In particular, the claws of the back leg on the Divine Bell dragon are strong and sharp like the claws of a hawk, and the front foot closely resembles a tiger's paw.

Therefore, according to the inscription on the divine bell, the sound is said to be like the

cry of the dragon.

From India to China and to Korea, the nature of the symbolism of the dragon remains the same. As the god of water it can make thunder and lightning and send down rain. Because it brings rain, which gives life to all things and makes them grow, the dragon was a symbol of creation, growth, and fertility. Therefore, the dragon god was the most important deity in an agrarian society. It had the same attributes as Indra, the principal Indian deity who was the god of thunder and lightning and, as he brought rain to the earth, the god of fertility. The dragon of the Divine Bell is this kind of entity, and the sound of the bell is the sound of the dragon and, at the same time, the sound of absolute truth.

2. Sculptural Features of the Divine Bell

In Korea, Buddhist bells are generally categorized as metalwork and therefore are handled by scholars in the field of craft. This is probably because bells were not considered autonomous works of art or objects of worship, but just tools for announcing the time or a kind of instrument. In other countries, bells are not treated seriously in art history.

In general, the major patterns on Korean bells are bosanghwa flowers, lotus, apsaras, and Buddhas and bodhisattvas. In most cases the designs are rendered in relief and are considered simply as patterns decorating the bell, not independent works of art. But in the case of the Divine Bell, the dragon carved in the round and the bas-relief floral patterns and apsaras have excellent sculptural qualities. The Divine Bell was created as an object of worship from the beginning, and it is certain that various decorative elements were sculpturally treated to emphasize this aspect.

Sculpture is a formative art where objects are depicted in the round or in relief. The formative elements of sculpture are mass, volume, texture, proportion, and the play of shadows according to the light. I have always believed this last element to be the most important because it is light that brings mass, volume and texture to life.

In general, sculpture has referred to figures of human beings, gods in the shape of human beings, or animals. And such figures have made up the primary subject of research in the field of sculpture. But I believe that plants are also important subjects of sculpture as well. However, it is difficult and probably unnecessary to depict plants in the round. It is possible to depict them in relief but they are not independent subjects; instead they have been treated historically as decorative elements. For example, in most cases the honeysuckle, bosanghwa, and lotus patterns are rendered as flat patterns or as embossed linear designs. Therefore, plant designs were only considered to be patterns and were excluded from the study of sculpture. However, when looking at the lotus pedestals of stone structures or stone lanterns, I have noticed strong sculptural elements such as mass, volume, texture and the play of shadows according to the light, and so I believe that they too should be included in sculptural studies.

This belief became stronger while studying the decorations on the Divine Bell. The bosanghwa pattern that is the major decorative element on the body of the Divine Bell is hard to depict in the round. Therefore, it is generally stylized and rendered in relief. However, on the Divine Bell it is rendered very realistically and, though not in the round, made as three-dimensional as possible with rises and falls in the relief. The bosanghwa pattern in the lower band is particularly three-dimensional with the flowers raised highest and the leaves in distinct layers. There are probably very few cases where this pattern is so three-dimensional. The apsaras are also in high relief, almost off the surface, as well as their garments and the cloud-like bosanghwa surrounding them.

The striking points, which are a combination of lotus and bosanghwa, have also been rendered as three-dimensional as possible by depicting several layers of leaves and petals with rises and falls in the relief. In the nipple borders and upper band, which are less three-dimensional than the lower band, the tips of the bosanghwa pattern are raised and powerfully emphasized.

As for the dragon, it is completely three-dimensional. More than just a hook, it is an excellent work of sculpture commanding the top of the bell. Hence, all the decorative elements of the Divine Bell have sculptural characteristics such as ample volume and clear play of shadows according to the light. The surface texture is not smooth, but neither is it rough. It is a texture that is appropriate to the great mass of the Divine Bell, just rough enough to bring out the three-dimensional nature of the decorations. The decorations seem to have been kneaded and modeled from clay, which leads me to believe that the mold for the sculpture was made not out of wax but of clay. If the relief decorations had been smooth and flat, the Divine Bell would not have been so vibrant. Considered as a whole, the Divine Bell is a great work of sculpture.

3. The Relationship between the Lotus and the Sound of the Bell

There is a profound philosophy contained in the decorations of the Divine Bell. As already observed, the bosanghwa scroll pattern of the lower band emerges from the lotus and stretches out to the left and right, and from this metamorphosed pattern a celestial being is born. The bosanghwa pattern was introduced to Korea from China in the 7th century, after the lotus pattern, and was used in various combinations with the lotus, all of which come under the philosophy that all things are created from the lotus.

As is widely known, the lotus is a symbol of the womb from which all things are born. It is also the symbol of the sun, and as all things grow with the light, the lotus is the source of creation. That is, the lotus is the symbol of light and the source of life. Therefore, as can be seen in the lower band bosanghwa scroll pattern, the idea that all things are born from the lotus is generally depicted by placing the lotus at the center, accompanied by scroll, beads and lotus, and honeysuckle patterns.[7] For this reason, the modified bosanghwa pattern has a flowering lotus giving birth to a celestial being.

How was such iconography established? In China, the concept of *ki* (氣, *qi*), vital energy or spirit, represents a kind of world-view. Vital energy, which is the source of all things in the universe, was the only entity in the world and invisible to the eye, and the shape of all visible things in the universe was no more than a phenomenon of ki. Therefore, *ki* and *mul* (物, matter) represent the relationship between essence and phenomenon.[8] Thus, in ancient Chinese art, there are cloud-like shapes that cannot be identified as anything particular, and this is called *unki* (雲氣)—cloud energy or spirit—and this is the formative shape of ki that is immanent in all things.

Such cloud-spirit is often depicted coming out of the mouth of a dragon or other divine beast and is rendered in the form of long, scrolling clouds. It also appears in an abstract form accompanying a living thing; sometimes it is expressed in the form of a human being or animal, and at other times, it is shown issuing from the living thing itself.[9]

These various expressions of ki result from the differences in art genres. That is, it takes on different forms depending on whether the genre is painting or sculpture. The expression of ki as an entity independent of a living thing is difficult to achieve in sculpture, so it's found mostly in painting. Depictions of ki in all other forms are possible in sculpture, but because of the difficulty of expressing it in a freestanding sculpture, it is usually rendered in relief. A good example is the long strands of clouds or scrolls coming out of the mouths of dragons in the Unified Silla dragon-faced tiles.

In the case of the Divine Bell, the cloud-spirit of the dragon hook is depicted on the dragon itself. The body of the dragon—from the front legs to the back legs and including the trunk that is conjoined to the sound flue—is covered with a powerful cloud pattern in relief. The three strands of cloud-spirit begin on the body of the dragon as a cloud pattern, fuse together as one on the sound flue, and then extend into one long cloud strand on the tail, rising up into the air and vanishing. This powerful and rhythmic cloud-spirit pattern is the expression of the ki immanent in the dragon; and the dragon and the cloud spirit are of one body. In overall comparison to the bell, the dragon is small, but it appears powerful enough to lift the great mass of the bell. The dragon calls up clouds and then thunder and lightning, and finally sends down rain, giving life to all things. So, it can be said that the dragon is manifestation of the ki immanent in the universe.

On the body of the Divine Bell, such expression of the cloud-spirit can be found in the bosanghwa pattern turned into clouds that give birth to the heavenly maidens. Each strand of the pattern gradually becomes transformed into the heads and tails of clouds moving vigorously from the top down. On the patterns of the lower and upper bands and the nipple borders, the cloud-spirit is not clearly evident, but the flowers are rendered in thick clusters, giving an overall impression of clouds.

In contrast to the Chinese, who tried to give expression to ki as the origin of all things in the universe, the Indians chose the lotus as the origin. In the Indian world-view, the lotus is a mysterious flower that gives birth to all life. This is an idea that existed even before Buddhism. According to *Mahabharata*, the epic poem of ancient India, when the

heavens and earth opened, a lotus appeared from the navel of Vishnu, and from inside the lotus emerged Brahma (梵天), who then created all things. Thus the lotus gave birth to the creator of the world. Eventually the Chinese concept of ki and the Indian concept of the lotus merged in China, resulting in images such as the one at the Longmen caves (龍門石窟), which features lotuses floating around like clouds giving birth to Buddhas, bodhisattvas and heavenly beings.[10]

Let's consider, then, the significance of the single large lotus decorating the striking point of the Divine Bell. When the lotus is struck, a beautiful and majestic sound rings out. This signifies that the origin of sound is the lotus; the lotus gives birth not only to life but also to sound. Since heavenly beings, Buddhas, and bodhisattvas all emerged from the lotus, it is perfectly consistent to have the sound of the bell, the sound of truth, resonating from it as well. How this sound came to be the sound of truth is discussed next.

4. The Doctrinal Background of the Divine Bell

I have searched for the religious symbolism behind the Divine Bell in the belief that the Buddhist philosophy of the time can be deduced from the study of Buddhist art. As already mentioned, the significance of the Buddhist bell is clearly stated at the beginning of the inscription it bears: the ultimate purpose was to render "the perfect sound of the one vehicle," or the sound of absolute truth. I was deeply moved when I read this phrase. Here was revealed the secret of the Divine Bell. It was the product of the wholehearted efforts of the Silla people to perfect a vehicle that would deliver the sound of absolute truth.

Then, what is the sound of absolute truth? In his *Commentary to the Treatise on the Awakening of Faith of the Greater Vehicle*, Wonhyo (元曉), a great Silla monk, wrote about the sound of absolute truth: "It represents unlimited shapes and sounds in accordance with the character and ability of sentient beings. Each man attains one sound according to his ability and never listens to other sounds. The sound reaches everywhere in the world and embraces the universe and becomes *woneum* (圓音), the sound of absolute truth."

From the time the *Commentary* was written to the present, the sound of absolute truth has been understood in light of Wonhyo's explanation, which was based on the *Avatamsaka Sutra*. The bell was proof of the Silla people's aspiration to attain the absolute truth.

Tracing the starting point of the "Hymn of the Bell," which alludes to the sound of the bell as the truth of the *Avatamsaka Sutra*, all the way back to Wonhyo, I was overwhelmed by the steadfast adherence of Koreans to the teachings of that sutra. This is again very much in accord with the historical fact that the most vigorous Buddhist images since the 8th century up to the present are those of Shakyamuni Buddha displaying the

bhumisparsha mudra and Vairocana Buddha displaying the *vajra mudra* (K. *jigweonin*, 智拳, wisdom fist gesture). "Harmonization of Disputes," the epitome of Wonhyo's philosophy, seems to reverberate in the sound of the bell even today.

There is a series of equations here: the voice of Buddha = the sound of absolute truth = one sound = an entire sound = the truth of Avatamsaka = the sound of the Divine Bell of King Seongdeok. And the sound of the Divine Bell is the sound of absolute truth as expounded by Wonhyo. The "one vehicle" in the bell's inscription is not a concept that counters the doctrine of the *Lotus Sutra*, but the philosophy of one vehicle about the unlimited influence of everything on all beings and all things on everything, the basic premise of the *Avatamsaka Sutra*. As the sound of the bell is the sound of absolute truth and the One Vehicle based on the Avatamsaka philosophy, the bell that produces that sound becomes a dharmakaya (Buddha body), and thus an object of worship. This is why the bell was described in the inscription as a "divine bell," "divine instrument," "rare instrument," "heavenly bell," and "divine body," avoiding more direct terms such as "Buddha." Being a divine body, it was only natural that the bell should be so lavishly decorated.

5. Conclusion

This essay has dealt with the Divine Bell of King Seongdeok from the perspective of art history, and further, in connection with philosophy. This is because behind every beautiful work of art there is a lofty philosophy. Buddhist art in particular reflects the spirit of the times, including Buddhist doctrine and faith, and for this reason must be discussed in relation to its philosophical background.

First, the style of the Divine Bell could not be discussed without tracing the origin of Silla bells. Although there was the short essay on the subject by Tsuboi Ryohei, I reexamined the issue in order to supplement existing scholarship. Without tracing the origin of Silla bells, I could not advance my point about their originality and distinguishing characteristics. In many ways Silla bells are very similar to the yongzhong, or chime bells, of the Zhou Dynasty, rather than Tang bells. But "similar" is not really the right word, for the dragon and the body of the bell are much more advanced than their yongzhong counterparts, and in fact, they are almost incomparable. This was the result of the powerful will of the Silla people to create a bell that was not just a tool to announce the time but one that maximized the musical aspect of the yongzhong. The yongzhong did not undergo further development in China. It was in Korea that they were developed and elevated to works of art. We have seen that the yongzhong was reproduced in the gilt-bronze Mireuksa wind chime, then further developed in Unified Silla to the bronze small bell of Gameunsa Temple, and served as the model for the oldest extant temple bell in Korea, the Sangwonsa Temple bell. Progress continued until such works as the Divine Bell of King

Seongdeok appeared. Looking at this process, it can be said that Silla temple bells, although derived from the form of the Chinese yongzhong, continued to develop with Korea and eventually arrived autonomously at a distinctively Korean style.

Silla bells boldly departed from previous stylistic models to achieve their own unique, individual style. The people of Silla tried to show symbolically that the sound of the bell was the sound of heaven by endowing their bells with a magnificent dragon hook and splendid decorations such as bosanghwa and lotus flowers on the sound flue, upper and lower bands, nipple borders, and striking points, and always with the figures of heavenly maidens flying down from the sky offering incense. This style is unique to the bells of Silla and cannot be found in China, Japan, or indeed anywhere else in Asia. As a result, bells are studied as part of art history in Korea. This has no precedent in the world, and I have yet to find any instance of bells being studied as part of art history in any other country. Moreover, the acoustics and the method of manufacture of the bell have been studied by scientists hoping to unravel the mystery of its clear, beautiful sound.

Following a discussion of the form and style of the bell, I examined its philosophical background. As a result of investigating what the Divine Bell's inscription refers to as the "perfect sound of the one vehicle" (woneum, or the sound of absolute truth), I found that the term "woneum," used in a general sense in the sutras, was first given a specific, particular meaning by the monk Wonhyo. Woneum is "one sound," the sound of absolute truth, but the concept is interpreted according to the principle of the Avatamsaka philosophy, which posits that one and many are the same, and that sentient beings hear the sound differently according to their basic abilities. So in the end, woneum should be understood as arising from the principle of the Avatamsaka philosophy that one is all and all is one. That is, the creation of the Divine Bell was based on Wonhyo's Avatamsaka philosophy and, at the same time, the political objective of according King Seongdeok the attributes of Cakravartin, or the ideal ruler. The Divine Bell is the joint creation of god and man. As the sound of the Buddhist bell is the sound of absolute truth, the body of the bell becomes the body of Buddha, or the dharmakaya. Standing in front of the Divine Bell, we soon feel that we are standing in front of Vairocana. The bell as the dharmakaya becomes conflated with King Seongdeok, who becomes an object of worship. Befitting a devotional object, the bell took twenty years to come into being, and the greatest skill went into it to create the greatest truth and the greatest beauty—a sublime work of art that is without precedent.

Bringing this essay to a close, I would like to note the "three treasures" of Unified Silla: Seokbulsa (石佛寺 [Seokguram, 石窟庵]) Temple, which represents the body of Buddha; Bulguksa, which represents the dominion of Buddha; and lastly, the Divine Bell of King Seongdeok, which represents the sound of Buddha, or the sound of absolute truth. All of these are great works that brilliantly demonstrate unique artistry in order to realize the grand cosmology and philosophy of the *Avatamsaka Sutra*. All three were also completed during the period spanning the reigns of King Gyeongdeok through King Hyegong, a

time when the centralized authority of the throne was strengthened.

Sunyata and *alamkaraka*: in ordinary terms, these are truth and art. Sunyata, or *beop-gong* (法空) in Korean, means the emptiness or unreality of things and is the ultimate truth of Buddhism. Alamkaraka, or *jangeom* (莊嚴), refers to all the artistic and beautiful decorative elements in Buddhist art. I consider the relationship between the otherworldly sunyata and the worldly alamkaraka, not as a hierarchical relationship with one being superior to the other, nor as a conflicting relationship, but as being parallel. And in one sense, I came to the conclusion that sunyata cannot be expressed without borrowing the means of alamkaraka. That is, the ultimate truth of Buddhism could be most purely and perfectly expressed in the formative language of alamkaraka than in the infinite Buddhist sutras composed in the written language. This is the conclusion I have gradually reached in my study of Seokguram cave temple, Bulguksa Temple, and the Divine Bell of King Seongdeok.

Footnotes

2. Gilt-Bronze Pensive Image with Sun and Moon Crown

1. Though the crown on this statue is partially damaged, it has been restored on the drawing.
2. Hayashi Ryoichi, "Significance of the Jeweled Crowns of the Sassanians," *Bijutsusi* (*Art History*), Vol. 28, March 1958.
3. Yang Bo-da, "Style and Characteristics of the Dated Sculptures Excavated at Quyang Xiudesi Temple," *The Palace Museum*, Vol. 2, 1960.
4. Kang Woobang, "Essay on the Gilt-Bronze Pensive Image with Lotus Crown," *Misul Jaryo*, No. 22, National Museum of Korea, June 1978.
5. Koh Jong-geon and Ham In-yeong, "Investigation of Ancient Artworks Using Radio-Stereography I," *Misul Jaryo*, No. 8, National Museum of Korea, December 1963.
6. Yang Bo-da, op. cit.
7. Matsubara Saburo, "Essay on Eastern Wei Sculpture," *Study of Chinese Buddhist Sculpture, Yoshikawakobunkan*, 1966; "Pensive Images of Late Northern Wei and Eastern Wei," *Bijutsusi* (*Art History*), Vol. 17, 1955.
8. Kim Won-yong, *Hanguk Misulsa* (*History of Korean Art*), Beopgyosa, 1968, p. 51.
9. *Samguk Sagi* (*History of the Three Kingdoms*), Book of Goguryeo, "Yeongnyuwang."
10. The discussion has focused on the style of Buddhist images but for a general review of Goguryeo art refer to the following articles: Jin Heung-seop, "The Influence of Goguryeo Art on Baekje and Silla during the Three Kingdoms Period," *Art and Culture of the Three Kingdoms Period*, Donghwa Publishing Co., 1976, pp. 183–307; Moon Myeong-dae, "Stylistic Changes in Goguryeo Sculpture," *Collected History Papers Commemorating the 60th Birthday of Dr. Jeon Hae-jong*, 1979.
11. In a previous article titled "Gilt-Bronze Pensive Image Study on the Sculpture of the Three Kingdoms Period," (*Misul Jaryo*, No. 22), I compared the Baekje style of sculpture with the Silla style and identified the characteristics of Baekje style as rigorousness, sophistication, meticulousness, and calmness, and the characteristics of Silla style as stiffness, simplification, the co-existence of inconsistencies, dullness and heaviness, and artlessness resulting from a primitive sense of modeling and massive treatment. pp. 23–24.
12. Kim Jae-won, "Buddhist Images of Suksusa Temple Site," *Jindan Hakbo*, Vol. 19, 1958.
13. Ohnishi Shuya, "Tori Style Buddhist Images and the Seated Medicine Buddha," *Horyuji*, Syogakkan, 1982, p. 138.
14. Machida Koichi, "Kuratsukuri Tori and the Rise and Fall of the Asuka Period Tori Style," *History of Ancient Sculpture*, Yoshikawakobunkan, 1977.
15. Ohnishi Shuya, op. cit., pp. 137–138.
16. Ohnishi Shuya, op. cit; Machida Koichi, op. cit.
17. Sekiguchi Kinya, "Stylistic Relationship Between Korean Architecture of the Three Kingdoms Period and the Kondo of Horyuji Temple," *Nihon Kenchikuno Tokusitsu* (*Characteristics of Japanese Architecture*), 1976, pp. 74–88. I had almost finished this essay when I came across this article with the help of Kim Dong-hyeon, head of the Conservation Science Division at the National Research Institute of Cultural Heritage. I found this article greatly encouraging.
18. The doctrinal background of ancient Korean pensive images will only be revealed by investigating the meaning of the Baekje rock-carved pensive image at Seosan.

3. Gilt-Bronze Pensive Image with Lotus Crown

1. Koh Yu-seop, "Study on the Gilt-Bronze Maitreya Pensive Image," *Shinheung*, No. 4, January 1931; *Collected Papers on Korean Art History*, 1966.
2. Hwang Su-yeong, "Study on Baekje Pensive Images," *Yeoksa Hakbo*, No. 13, October 1960. This article explores the provenance of the Lotus Crown pensive image. There are various theories about where the statue was discovered, for instance that it was excavated at a temple site in Gyeongju, or somewhere in the Gyeongsang-do provinces, or a run-down village in Chungcheongnam-do province. But the story that it has been handed down is most likely to be true.
3. Koh Yu-seop, op. cit., pp. 158–159. Regarding the hem beneath the right knee, Koh says, "The lightness of the cloth over the right leg, as if being blown by the breeze, is the realization of the most wonderful sculptural technique."
4. Hwang Su-yeong, "The Pedestal and Foot Pedestal of the Deongmi Pensive Image," *Gogo Misul*, Vol. 3, No. 11. This article states that the form of the left leg is in the style of Unified Silla.
5. Koh Jong-geon and Ham In-yeong, "Study of Ancient Artworks Using Radio Stereography," *Misul Jaryo*, No. 8, 1962, and No. 9, 1964. This statue was discussed in No. 9.
6. "Study of Ancient Artworks Using Optical Science," Tokyo National Research Institute of Cultural Properties, Optical science research team, 1955, pp. 94–96, pp. 146–148; Noma Seiroku, "Casting Techniques of Buddhist Images," *Bijutsukenkyu* (*Art Research*), No. 110, February 1941, pp. 35–36.
7. Hwang Su-yeong, op. cit., pp. 3–4.
8. Koh Jong-geon and Ham In-yeong, op. cit., The Gilt-bronze Pensive Image with Sun and Moon Crown is discussed in *Misul Jaryo* No. 8, p. 2.
9. Some papers that deal with the Koryuji Pensive Image are as follows:
 Kohara Jiro, "History of the Materials Used in Ancient Sculpture," *Bukkyogeijutsu* (*Buddhist Art*), No. 13, 1951; Chisawa Teiji, "The Pensive Image of Koryuji Temple," *Museum*, No. 116–117, February 1960.
10. Chisawa Teiji, op. cit., p. 3.
11. Kohara Jiro, op. cit., p. 6.
12. In his article "Koryuji Pensive Image and the Introduction of Silla Style," (*Collected Papers Commemorating the 60th Birthday of Baekcho Dr. Hong Sun-chang*) Mori Hisashi states that the statue was brought in from Silla in 623.
13. Matsubara Saburo, "Pensive Images of Late Northern Wei and Eastern Wei," *Bijutsusi* (*Art History*), Vol. 17, October 1955, pp. 24–25.
14. Yang Bo-da, "Style and Characteristics of the Dated Sculptures Excavated at Quyang Xiudesi Temple," Published by *The Palace Museum*, Vol. 2, 1960, p. 45. This is a very important article. When the temple site was excavated in March and May of 1954 some 2,200 marble Buddhist images were discovered, 247 of them bearing the date of their production. This means Buddhist images from Northern Wei, Eastern Wei, Northern Qi, Sui, and Tang, covering the period from 520–750, were discovered in one single site, clearly showing the changing characteristics of Chinese Buddhist sculpture.
15. Matsubara Saburo, "White Marble Pensive Images of Eastern Wei and Northern Qi," *Bijutsukenkyu* (*Art Research*), No. 181, May 1955, pp. 32–35.
16. Kang Woobang, "Analysis and Interpretation of the 12 Zodiacal Figures of Silla," *Bulgyo Misul*, Vol. 1, September 1973, pp. 63–66.
17. Kang Woobang, "Gilt-Bronze Pensive Image from Gongju," *Gogo Misul*, Vol. 5, No. 6–7, 1964; Jin Heung-seop, "Stone Buddhas and Pagodas from Gwaneumni in Mungyeong," *Gogo Misul*, Vol. 1, No. 2, 1960.
18. Jin Heung-seop, "Study on the Buddhist Images of the Northern Part of Silla," *Daegu Sahak*, Vol. 7–8, October 1973, p. 43.
19. Papers that deal with this issue are as follows:
 Naito Toichiro, "Yumedono Kannon and the Principal Icon of Chuguji Temple," *Toyobijutsu* (*Asian Art*), No. 4–6, February, May, July, 1930; Mizuno Seiichi, "Essay on Pensive Images," *Toyosikenkyu* (*Asian History Research*), Vol. 4, Vol. 5, Kyoto Imperial University, Institute of Asian Studies, October 1940.
20. The inscription on this statue reads as follows: "丙寅年四月大舊八日癸卯開記橘寺智識之等詣中宮天皇大御身勞坐之時誓願之奉彌勒御像也友等人數一百十八是依六道四生人等此教可相之也."
21. Kim Sang-gi, "The Hwarang and the Cult of Maitreya," *Collected Papers on Korean History to Commemorate the 60th Birthday of Dr. Lee Hong-jik*, October 1969.
 This issue was also discussed in part in several papers on pensive images by Hwang Su-yeong.
22. Fujisawa Kazuo, "Legend of Kahuka Numi and the Baekje Stone Maitreya," (*Siseki to Bijutsu* [*Historical Sites and Art*], No. 177, 1947), posited that the stone statue of Maitreya Kahuka brought back from Baekje in 584 had the same form and size as the Lotus Crown Pensive Image. pp. 91–92.
23. Fellenosa, a painter who introduced Japanese art to the world, said that Korean art around the 6th century surpassed the art of even China and Japan. *Epochs of Chinese and Japanese Art I*, 1912, p. 46.

4. The Application of "*La Porte d'Harmonie*" to Seokguram

1. Yanagi Ryo, *The Golden Section*, Translated by Yu Gil-jun, Kimoondang, 1985, p. 13.

2. Yoneda Miyoji studied architecture at university and after graduating in 1932, he was assigned to work at the museum of the Japanese Government-General in Korea the following year. Until he passed away in 1942 at the young age of 35, he devoted himself to theoretical research of ancient Korean architecture. Yondea studied the floor plans of ancient temples such as Bulguksa Temple, Seokguram, Sacheonwangsa, Mangdeoksa, and Cheongamnisa, and the structural proportions of temple pagodas. In addition, he devoted a lot of energy to research of the mural tombs of Goguryeo and Lolang. His surveys and observations were accurate and scholarly. He published his findings for no more than three years from 1939, and his papers were later compiled in the book *Study of Ancient Architecture in Korea*, published by Kyoto Imperial University, Japan, in 1944.

3. Yoneda Miyoji, *Study of Ancient Architecture in Korea*, op. cit.
 "Influence of Cosmology on the Floor Plans of Ancient Korean Architecture," pp. 131–148; "Mathematical Consistency in Construction Plans Predating the Joseon Dynasty," pp. 181–220; "The Azimuth as Seen in Korean Architectural Relics," pp. 221–224.

4. Yoneda Miyoji, op. cit., "Construction Plans of Seokguram," p. 3–22.

5. Yoneda Miyoji, op. cit., "Mathematical Consistency in Construction Plans Predating the Joseon Dynasty," p. 213.

6. Ibid, pp. 215–216.

7. Nam Cheon-wu, "Silla Science as Observed in Seokguram," *Jindan Hakbo*, No. 32, 1969, pp. 86–94.

8. Kang Woobang, "Iconographical Study of the Principal Icon of Seokguram," *Misul Jaryo*, No. 35, Seoul, National Museum of Korea, 1969, pp. 54–57.

9. Nam Cheon-wu, op. cit., p. 90.

10. The 5 : 4 ratio was used in Bulguksa Temple and the Cheongunni temple site; the 1 : √2 ratio, derived from the diagonal of the square, was used in the Lolang Jowangni Tomb No. 69, the foundations of the Cheongamni temple site, and the main hall at Gunsuri temple site; and the equilateral triangle was used in the stone pagodas and temple layouts of the Unified Silla period. Yoneda Miyoji, op. cit., "Mathematical Consistency in Construction Plans Predating the Joseon Dynasty," pp. 194–213.

11. Song Min-gu argues in his paper titled "The Beauty of Muryangsujeon at Buseoksa Temple," that the golden ratio was used in Korean architecture also. *Geonchuk (Journal of the Architectural Institute of Korea)* Vol. 19, No. 22, 1975, pp. 2–11. In addition, the ratios of 1 : √2, 2 : 2√2 are applied to the floor plans of the Seokguram three-story stone pagoda. Yoneda Miyoji, Ibid, pp. 17–19.

12. Yanagi Ryo, op. cit., pp. 17–19.

13. Ibid, pp. 52–60.

14. Ibid, pp. 60–63; Gyorgy Doczi, "The Power of Limits: Proportional Harmonies in Nature"; *Art and Architecture*; Shanbhala Bolder & London, 1981, pp. 108–112.

15. Robert Lawlor, *Sacred Geometry*, Crossroad, New York, 1982, pp. 6–10.

16. H. E. Huntley, *The Divine Proportion: a Study in Mathematical Beauty*, Dover, New York, 1970, pp. 1–6.

17. Yanagi Ryo, op. cit., pp. 12–13.

18. Kim Dong-hwa, *History of Buddhist Doctrine*, Samyeong Publishing Co., 1977, p. 17.

19. Ibid, pp. 12–14; Takeuchi Shoukou, "Dependent Arising and Karma," *Study on Dependent Arising*, Ryukoku University Institute of Buddhist Cultural Studies, Kyoto, 1985, pp. 1–13.

20. Ibid, p. 478.

21. Francis H. Cook, *Hua-Yen Buddhism: The Jewel Net of Indra*, The Pennsylvania State University Press, 1977, pp. 1–19.

22. Garma C. C. Chang, *The Buddhist Teaching of Totality: The Philosophy of Hua-Yen Buddhism*, The Pennsylvania State University Press, 1977, pp. 121–122.

23. Ibid, pp. 168–170.

24. Ibid, pp. 122.

25. Ibid, pp. 123–124.

26. Fritijof Capra, *The Turning Point: Science, Society and the Rising Culture*, Simon and Schuster Edition, Bantam Books, 1988, p. 267.

27. Ibid, p. 275.

28. Ibid, p. 275.

29. Ibid, p. 278–279.

30. Kim Dong-hwa, op. cit. p. 15.

31. From some point in time the name "Seokguram" came into use both in and outside Korea instead of the name "Seokbulsa." "Seokguram," however, is an inaccurate name in two points. First, this temple is not a cave temple, or grotto. Though it has a similar basic composition to the cave temples built into rock walls in India or China, its method of construction is completely different. As many scholars before me have pointed out, it is rather more similar to the stone chamber tombs of Goguryeo or Unifed Silla. Although its exact form has not been discovered, it is clear that Seokbulsa had an exterior façade of some kind and was therefore in the form of a building. Second, the suffix "-am," as in "Seokguram," indicates a building of a subsidiary nature, so use of this name may diminish the importance of the temple. In *Samguk Yusa (Memorabila of the Three Kingdoms)* it clearly says, "Kim Dae-seong built Bulguksa Temple for his parents in this life and Seokbulsa Temple for his parents in his former life," thus giving equal importance to both structures.

32. Nam Cheon-wu, op. cit.; Yoneda Miyoji, op. cit., "Construction Plans of Seokguram in Gyeongju."

33. The sixteen-foot Buddha form refers to a standing figure and there are no old records of the height of the seated sixteen-foot Buddha.

34. Regarding this statue, refer to Kim Lena's article "Transmission of Indian Buddhist Images to China-the Diamond Seat

under the Bodhi Tree," (*Collected Papers Commemorating the 60th Birthday of Dr. Han Tak-geun*, 1982) which traces the origin of the image and its transmission to China.

35. Ibid, pp. 743−744.

36. The principal icon at Mahabodhi Temple in Bodh Gaya no longer exists. Various books and articles such as A. Cunningham, *Mahabodhi: The Great Buddhist Temple Under the Bodhi Tree at Buddha Gaya*, London, 1958; and Prudence R. Meyer, "The Great Temple at Bodh-Gaya," *Art Bulletin*, Vol. XL, No. 4., try to reconstruct the original statue but the evidence is insufficient.

5. The Iconography of the Buddhist Sculptures in Seokguram

1. I have asserted that "Seokbulsa," the original name of the cave temple, should be used. But as the name "Seokguram" has existed since the Joseon Dynasty and has been used internationally, I have decided to use this name as well.

2. A comprehensive paper that deals with the Buddhist images in Seokguram is Kim Lena's "Names and Styles of Seokguram's Buddhist Images," *Jeongsin munhwa yeongu*, Vol. 15, No. 3, The Academy of Korean Studies, 1992, pp. 3−19.

3. Regarding heaven (*cheon*) or the three realms, I referred to various books such as Mochizuki Shinko's *Great Dictionary of Buddhism*. As these are generally well known concepts, I have not gone into them in great detail.

4. There is no trace of the arm touching the head of this Vajrapani, so it seems that the head and body were sculpted separately. There is a hole in the remaining arm, which indicates that the hand was made separately and attached. The hand that was discovered in Seokguram during repairs is now preserved at the National Museum of Korea and I believe that it is the hand of the image.

5. The process of the image of the Vajrapani becoming one and the same as the door guardians in China was studied first by Paek Nam-ju (Art history society meeting, 1995) but the relevant paper has yet to be published. "Study on the Vajrapani," Master's degree dissertation, Ewha Woman's University, 1993.

6. Kang Woobang "Study on Pigmented Pottery Relief Figures from Sacheonwangsa Temple," *Misul Jaryo*, No. 25, National Museum of Korea, 1980, pp 1−46; *Principles of Ancient Korean Sculpture I*, Youlhwadang, 1990.

7. *Dunhuang Magao Ku (The Magao Caves at Dunhuang)*, Vol. 4, Heibonsha, Tokyo, 1982, pp. 255−256 (fig. 66, 67 and annotation).

8. Ibid, Vol. 5, fig. 24.

9. Ibid, Vol. 5, fig. 37, 38.

10. According to Zhang Yanyuan's *A Record of the Famous Historical Paintings*, inside the pagoda at Ciensi Temple, the eastern wall features a painting of Manjushri riding a lion and the eastern wall a picture of Samantabadra riding an elephant. The picture of Manjushri with a thousand bowls on the western wall is by Weichi.

11. Although this iconography is from esoteric Buddhism, on the eastern wall of the Magao cave No. 361 there is a mid-Tang painting of Manjushri with a thousand arms and a thousand bowls, which shows that the alms bowl is the attribute of Manjushri. *Dunhuang Magao Ku (The Magao Caves at Dunhuang)*, Vol. 4, fig. 119.

12. Sawa Ryuken ed., *Butsuzo Zuten (Iconography of Buddhist Images)*, pp. 81−82.

13. *Samguk Yusa (Memorabilia of the Three Kingdoms)* Book 3, "Pagodas and Images" 4, records that a clay statue of Manjushri was made at Sangwonsa Temple in the year 705.

14. Kang Woobang, "Establishment and Development of the Vairocana Buddha Image," *Misul Jaryo*, National Museum of Korea, 1989, pp. 46−48; *The Principles of Ancient Korean Sculpture I*, op. cit.

15. Mizuno Seiichi and Nagahiro Toshio, *Yungang Shiku (Cave-Temples of the 5th Century in North China)*, Vol. 12, Kyoto University, Institute for Research in Humanities, Japan, 1938−1945, fig. 125−135, 138; *Yungang Shiku* (2), Heibonsha, Tokyo, 1990, fig. 164, 166−169.

16. Duan Wenjie, *Magao Grottoes*, second edition, Heibonsha, Tokyo, 1981, p. 174, fig. 116−117.

17. *Dunhuang Magao Ku*, op. cit., Vol. 2, fig. 57.

18. Mizuno Seiichi and Nagahiro Toshio, *Study of the Longmen Caves*, 1941, pp. 115−122, Asian Culture Research Institute, 1941, pp. 115−122.

19. Mochizuki Shinko, *Mochizuki Bukkyo Daijiten (Great Dictionary of Buddhism)*, Sekai Seiten Kanko, Tokyo, 1960−1963. p. 2294.

20. I learned a great deal about the clothing found on the Ten Great Disciples from Prof. Lim Yeong-ja at Sejong University, and referred to Lim's book *Religious Vestments of Korea*, The Asian Culture Press, 1990.

21. Sherman Lee and Waikman Ho, "A Colossal Eleven-Faced Kwan-yin of the Tang Dynasty," *Artibus Asiae* XXII, Ascona, Artibus Asiae, 1959.

22. Images of eleven-faced Avalokiteshvara include one in the round, found on Mt. Namsan in Gyeongju, believed to date to the mid-8th century (National Museum of Korea); a carving from the same period found at Gubulsa Temple site in Gyeongju, as the northern Buddha of the four Buddhas of the four directions; and the high relief image found in Seokguram. Though there are only three images of eleven-faced Avalokiteshvara in Korea, they are sufficient for research of form.

23. *Seokguram and Bulguksa Temple*, Catalogue of Korean Historical Sites, Vol. 1, Government-General of Korea, 1938.

24. The Eleven-Faced Avalokiteshvara at Seokguram is most likely based on the prescriptions in Xuanzang's translation of the *Dharani Heart Sutra of the Eleven-Faced*

Avalokiteshvara (656), but this is based on Yasagupta's *The Sutra of the Buddha Preaching the Dharani of the Eleven-Faced Avalokiteshvara* (c. 570), which prescribes: "three heads with the aspect of mercy at the front, three heads with the aspect of rage on the left, and three heads with white fangs directed upward on the right side. There should be one head with the aspect of Vajrahasa (the great laughing Ming Wang) at the back and one head with the aspect of the Buddha at the front. Each of the eleven heads should wear a flower crown enshrining an image of Amitabha Buddha."

25. Kang Woobang, "The Principle of Avalokiteshvara and its Iconographic and Stylistic Change in Ancient Korean Sculpture," *The Art of Bodhisattva Avalokiteshvara: Its Cult Image and Narrative Portrayals*, International Symposium on Art Historical Studies 5, Sponsored by Taniguchi Foundation, 1986, pp. 36−42.

26. *Dunhuang Magao Ku*, op. cit. Vol. 3, fig. 34, 155.

27. Kang Woobang, "Brief Study on the Main Buddha of Seokbulsa Temple," *Misul Jaryo*, No. 35, National Museum of Korea, 1984; *The Principles of Korean Buddhist Sculpture I*, pp. 280−281.

28. Kang Woobang, "Application of La Porte d'Harmonie to Seokguram," *Misul Jaryo*, No. 38, 1987; Published in *The Principles of Ancient Korean Sculpture I*, pp. 261-280.

29. Mizuno Keisaburo, *Nara Rokutaiji Taikan (Six Great Temples of Nara)*, Vol. 7, Kofukuji Temple I, Tokyo, Iwanami Shoten, 1969.

30. Fukuyama Toshio, *Study of Japanese Architecture*, Bokusui, Tokyo, 1943.

31. Mizuno Keisaburo, op. cit.

32. Min Yeong-gyu "Doctrinal Background of Seokguram," *Gogo Misul*, No. 13, 1961, pp. 1−6.

33. Kang Woobang, "Application of *La Porte d'Harmonie* to Seokguram," op. cit.

34. Kang Woobang, "Essay on Application of Indian Theory of Proportions on the Main Buddha of Seokguram," *Misul Jaryo*, National Museum of Korea, No. 52, 1993, pp. 1−31.

6. Iconology of the Buddhist Sculptures of Seokguram

1. *Great Tang Dynasty Record of the Western Regions* is Xuanzang's record of his pilgrimage to Buddhist holy places in Central Asia and India over 17 years, from 629 to 645. The book deals with a wide range of topics including the customs, people, language and legends of the places that he visited.

2. Kang Woobang, "The Buddhist Sculpture of Seokguram," *Misul Jaryo*, No. 56, 1996, pp. 19−20.

3. *Lalita Vistara*, translated by Bijoya Goswami, The Asiatic Society, Kolkata, 2001, pp. 254−259.

4. Ibid, p. 260.

5. Ibid, pp. 262−264.

6. Ibid, pp. 265−269.

7. Ibid, pp. 278−287.

8. Ibid, pp. 293−310.

9. Ibid, pp. 312−316.

10. Ibid, p. 318.

11. Ibid, p. 319.

12. Mircea Eliade began writing *Cosmos and History* in 1945 but the book was later published under the title of *Archetypes and Repetition*. Quotations in this essay have been taken from the English version of the book titled *The Myth of Eternal Return, or Cosmos and History*, translated from the French by Willard R. Trask. *Patterns in Comparative Religion* was first published in French in 1949 under the title *Traite d'histoire des Religion*.

13. Mircea Eliade, *Patterns in Comparative Religion*, Translated by Rosemary Sheed, Meridian, New York, 1974, p. 270

14. Ibid., p.271.

15. Ibid, p. 3.

16. Ibid, p.378.

According to Eliade's *Cosmos and History*, Mt. Tabor in Palestine represents "omphalos," that is, the navel. Palestine was the highest country, being near the summit of the cosmic mountain and for Christians, Golgotha was the center of the world, since it was the summit of the cosmic mountain. Mircea Eliade, *The Myth of Eternal Return, or Cosmos and History*, pp. 13−14.

The summit of the cosmic mountain is not only the highest point of the earth, it is also the navel of the earth, that is, the place where creation began. As the embryo proceeds from the navel onwards, God began to create the world from the navel onwards. Mircea Eliade, *The Myth of Eternal Return, or Cosmos and History*, p. 16.

17. Mircea Eliade, *Patterns in Comparative Religion*, op. cit. p. 378.

18. Ibid, p. 378.

19. Ibid, p. 13.

20. Ichiro Suzuki, *Buddhism and Hinduism*, Translated by Kwon Ki-jong, Donghwa Munhwasa, 1980, p. 9.

21. *Lalita Vistara*, op. cit. p. 245.

22. Mircea Eliade, *Patterns in Comparative Religion*, p.239.

23. Ibid, p. 245.

24. Ibid, p. 240.

25. Ibid, p. 242.

26. Ibid, p. 244.

27. *Lalita Vistara*, op. cit.

28. Mircea Eliade, *Patterns in Comparative Religion*, op. cit. p. 286.

29. Ibid, p. 256.

30. Erich Neumann, *The Great Mother*, Second Edition, Translated by Ralph Manheim, Princeton University Press, 1963, pp. 39−54.

31. Ibid, pp. 332−333.

32. Kajiyama Yuichi, *Soranosekai (The World of Emptiness)*,

Translated by Lee Ki-yeong, Dongguk University Translation Center for Buddhist Scriptures, 1979, pp. 139–148.

33. Mircea Eliade, *Patterns in Comparative Religion*, p. 283.

34. Ibid, p. 146.

35. Lalta Prasad Pandy, *Sun Worship in Ancient India*, Motilal Banarsidass, Delhi, 1971, p. 79.

36. Kang Woobang, "Establishment and Evolution of Buddha Vairocana in Korea," *Misul Jaryo*, Vol. 44, 1989, pp. 26–34.

37. Mircea Eliade, *The Myth of Eternal Return, or Cosmos and History*, Translated by Willard R. Trask, Princeton University Press, 1965, p. 4.

38. Ibid, p. 5.

39. Ibid, p. 34.

40. Ibid, p. 34.

41. Ibid, p. 34.

42. Ibid, p. 35.

43. Ibid, p. 35.

44. Ibid, p. 43.

45. *Samguk Yusa* (*Memorabilia of the Three Kingdoms*), "Ado gira jo."

46. Ibid, "Gaseopbul yeonjwaseok jo."

47. Ibid, "Hwangyongsa Jangyuk jo."

48. Ibid, "Odaesan o-man jinsin jo."

49. Ibid, "Jeukji seungun jo."

50. Ibid, "Naksan idaeseong jo."

51. Kang Woobang, "Structure and Buddhist Sculptures of Boanam Cave Temple in Sacheon," *History of Korean Buddhist Culture and Thought*, Kayasan Bulgyo Munhwasa, 1992, pp. 334–352.

52. Choe Nam-seon, "Korean Buddhism," *Bulgyo*, Bulgyosa, Vol. 74, 1930, pp. 244–250.

53. Kang Woobang, op. cit. (refer note 36)

7. The Art and Philosophy of the Divine Bell of King Seongdeok

1. According to its inscription, the Divine Bell of King Seongdeok was completed on the 14th day of the 12 month of the 7th year of the reign of King Haegong. If this lunar date is calculated according to solar calendar terms, then the date is the 23rd of January, 772. I commissioned this conversion to Ahn Yeong-sook, a researcher at the Korea Astronomy and Space Institute in Daejeon. In this case, the year that the bell was actually finished should be 772, but in the domestic academic circle the lunar calendar is simply written in solar calendar terms and so the year of completion of the Divine Bell is generally known as 771. This is because all historical records in Korea are written in lunar calendar terms, and to convert all dates into solar calendar dates would be very difficult and complex.

2. Tsuboi Ryohei, *Korean Bells*, Kadokawa Shoten Publishing Co., Tokyo, 1974, pp. 19–20.

3. Ibid, p. 20.

4. Shigeo Kishibe, *Sekaikoukogakujiten* (*Encyclopedia of World Archaeology*), Shigeo Kishibe, Heibonsha Limited, Publishers, 1979, p. 505.

5. Prof. Hwang Su-yeong links the sound flue of the Divine Bell of King Seongdeok, and indeed of all Korean bells, with the legendary Silla flute called Manpasikjeok. If this is the case, then it is a most important point. However, the sound of the flute is fundamentally different to the sound of the bell, "the perfect sound of the one vehicle," or the sound of the dragon's roar. But if indeed there is a connection, then why is there no mention of it in *Samguk Yusa* (*Memorabilia of the Three Kingdoms*) which contains the story of the flute, or in the long inscriptions on the bell itself? Prof. Hwang, out of his great reverence for King Munmu, links even the main Buddha image in Seokguram to the underwater tomb of King Munmu, and says that the orientation of the rock-carved Buddha at Mt. Seondosan has some connection with the same tomb. For this reason, he also sees the Seokguram main image as Amitabha rather than Sakyamuni. However, as far as methodology goes, it is not correct to explain everything according to a single supposition. Doing so leads to the danger of distorting and diminishing the more important symbolism and significance of the Seokguram Buddha and the Divine Bell.

6. *Encyclopedia of Korean Culture*, Vol. 16, Contributed article by Cho Ja-dan, Academy of Korean Studies, 1990, pp. 311–312.

7. Cho Yong-jung, "Study of Patterns Used to Depict the Lotus as the Source of Life," *Misul Jaryo*, No. 56, National Museum of Korea, 1995, pp. 94–97.

8. Tadashi Inoue, "Buddhist Images of the Asuka Period," *Domon Ken Nihon no Chokoku* (*Japanese Sculpture by Domon Ken*), Vol. 1, Tokyo, Bijutsu Shuppan-Sha, 1979, p. 174.

9. Ibid, pp. 174–176.

10. Ibid, p. 178.

Bibliography

Works in Korean

Books and Articles

Hwang Su-yeong (黃壽永). "Essay on the Baekje Pensive Image," *Yeoksa Hakbo* (歷史學報), No. 13, October 1960.

Kang Woobang (姜友邦). "Gongju Gilt-Bronze Pensive Image," *Gogo Misul* (考古美術), No. 136, No. 137, March 1978.

Kim Lena (金理那). "Transmission of Indian Buddhist Images to China: the Diamond Seat under the Bodhi Tree," *Collected Papers Commemorating the 60th Birthday of Dr. Han Wu-geun* (韓沽劤博士停年紀念史學論叢), Jisik Sanup Publications Co. Ltd., 1982.

_____. "Chinese Seated Buddhist Images Showing the Bhumisparsa Mudra," *Studies of Ancient Korean Buddhist Sculpture* (韓國古代佛教彫刻史研究), Ilchokak Publishing Co. Ltd., 1989.

Kim Sang-hyeon (金相鉉). "Study on Seokbulsa and Bulguksa Temples: Architectural and Philosophical Background," *Bulgyo Yeongu* (佛教研究), No. 2, Korea Institute for Buddhist Studies, May 1986.

Koh Jong-geon (高鍾健) and Ham In-yeong (咸仁英). "Study of Ancient Artworks Using Radio Stereography," *Misul Jaryo* (美術資料) No. 8, 1962, and No. 9, 1964.

Koh Yu-seop (高裕燮). "Study on the Gilt-Bronze Maitreya Pensive Image," *Shinheung* (新興), No. 4, January 1931; *Collected Papers on Korean Art History* (韓國美術文化史論叢), Tongmungwan, 1966.

Nam Cheon-wu (南天祐). "Silla Science as Observed in Seokguram," *Jindan Hakbo* (震檀學報), No. 32, November 1969.

Yeom Yeong-ha (廉永夏). *Korean Bells* (韓國의 鐘), Seoul National University Press, 1991.

Reports and Catalogues

Joseon Gojeok Dobo (朝鮮古蹟圖譜), Vol. 5, Joseon Chongdokbu (Government-General of Korea), 1917.

Seokguram and Bulguksa Temple (石窟庵と佛國寺), Joseon Bomul Gojeok Dorok (朝鮮寶物古蹟圖錄), Vol. 1, Joseon Chongdokbu (Government-General of Korea), 1938.

Works in Japanese and Chinese

Fujita Kotatsu (藤田宏達). "Study on Cakravartin—Focusing on the Early Sutras," *Collected Papers on Indian Buddhism to Commemorate the 60th Birthday of Prof. Miyamoto Sadataka* (宮本定尊教授還暦記念 印度學佛教學論集), Sanseido Publishing Co., 1954.

Matsubara Saburo (松原三郎). "White Marble Pensive Images of Eastern Wei and Northern Qi," *Bijutsu Kenkyu* (美術研究), No. 181, May 1965.

_____. "Pensive Images of Late Northern Wei and Eastern Wei," *Bijitsusi* (美術史), Vol. 17, 1955.

Onishi Shuya (大西修也). "Half-Crossed Leg Image of Jorinji Temple, Tsushima," Tamura Encho (田村圓澄) and Hwang Su-yeong (黃壽永) ed., *Hanka Shiijo Kenkyu* (半跏思惟像の研究), Tokyo: Yoshikawa Kaobunkan, 1985.

_____. "Lineage of Baekje Pensive Images," *Bukkyo Geijutsu* (佛教藝術), No. 158, Tokyo: Mainichi Newspaper, 1985.

Tsuboi Ryohei (坪井良平). *Chosen Gane* (朝鮮鐘), Tokyo: Kadokawa Shoten Publishing Co. 1974.

Yang Boda (楊伯達). "Style and Characteristics of the Dated Sculptures Excavated at Quyang Xiudesi Temple" (曲陽修德寺出土紀年造像的 藝術風格與特徵), The Palace Museum, 1960.

Yoneda Miyoji (米田美代治). "Influence of Cosmology on the

Floor Plans of Ancient Korean Architecture," "Mathematical Consistency in Construction Plans Predating the Joseon Dynasty," "The Azimuth as Seen in Korean Architectural Relics," "Construction Plans of Seokguram," *Jodai Kenchiku no Kenkyu* (朝鮮上代建築の研究), Kyoto: Kyoto University, 1944.

Works in English

Cunningham, A. *Mahabodhi: The Great Buddhist Temple under the Bodhi Tree at Buddha Gaya*, London, 1958.

Digha-Nikaya: Dialogues of the Buddha, Translated by T.W. Rhys Davids, London: Oxford University Press, 1988 (1910).

Doczi, Gyorgy. *The Power of Limits: Proportional Harmonies in Nature, Art and Architecture*, Bolder & London: Shambhala, 1981.

Eliade, Mircea. *Patterns in Comparative Religion*, Translated by Rosemary Sheed, New American Library, 1973.

Foucaux, P.E., *Le Lalita VistaraDeveloppement des juex*, Paris: E. Leroux, 1884.

Gardner, Earnest. *Six Greek Sculptors*, London: Duckworth & Co., 1910.

Garma, C. C. Chang. *The Buddhist Teaching of Totality*, Pennsylvania State University Press, 1971.

Hallock, William and Wade, Herbert T. *The Evolution of Weights and Measurements and the Metric System*, New York: Macmillan, 1906.

Huntley, H. E. *The Divine Proportion: a Study in Mathematical Beauty*, New York: Dover, 1970.

Lalta Prasad Sandy, *Sun Worship in Ancient India*, Delhi: Motilal Banarsidass, 1971.

Laufer, Berthold. *An Early Document of Indian Art: The Citralaksana of Nagnajit*, Translated by B.N. Goswamy and A.L. Dahmen-Dallapiccola, New Delhi: Manohar Book Service, 1976.

Lawlor, Robert. *Sacred Geometry*, New York: Crossroad, 1982.

Lee, Sherman and Ho, Waikam. "A Colossal Eleven-Faced Kwan Yin of the Tang Dynasty," *Artibus Asiae* XXII, Ascona: Artibus Asiae, 1959.

Myer, Prudence R. "The Great Temple at Bodh-Gaya," *Art Bulletin*.

Neumann, Erich. *The Great Mother*, second ed. Translated by Ralph Manheim, Princeton University Press, 1963.

Panofsky, Erwin. "The History of the Theory of Human Proportions as a Reflection of the History of Styles," *Meaning in the Visual Arts*, New York: Doubleday, 1955.

Pollio, Vitruvius. *The Ten Books of Architecture*, Cambridge: Harvard University Press, 1914.

Rosenfield, John M. *The Dynastic Arts of the Kushans*, Berkeley and Los Angeles: University of California Press, 1967.

Rowland, Benjamin. *The Art and Architecture of India*, Penguin Books, 1984.

_____. "A Miniature Replica of the Mahabodhi Temple," *Journal of the Indian Society of Oriental Art* VI, Surrey: Oriental Art Magazine, 1938.

Soothill, W. and Hodous, Lewis. *A Dictionary of Chinese Buddhist Terms*, London: K. Paul, Trench, Trubner & Co. Ltd., 1937.

The Lalita Vistara, Translated by Bijoya Goswami, Kolkata: The Asiatic Society, 2001.

The Brhat-Sanhita; or, Complete System of Natural Astrology of Varaha-Mihira, Translated by H. Kern, London: Royal Asiatic Society, 1869–1874.

Index